A Culture of Light

# A Culture of Light

Cinema and Technology in 1920s Germany

F RANCES G UERIN

University of Minnesota Press
Minneapolis • London

The University of Minnesota Press acknowledges the work of
Edward Dimendberg, editorial consultant, on this project.

Portions of this book first appeared in "Dazzled by the Light: Technological
Entertainment and Its Social Impact in *Varieté*," *Cinema Journal* 42, no. 4 (2003):
98–115. Copyright 2003 by the University of Texas Press. All rights reserved.

Published by the University of Minnesota Press
111 Third Avenue South, Suite 290
Minneapolis, MN 55401-2520
http://www.upress.umn.edu

Library of Congress Cataloging-in-Publication Data

Guerin, Frances.
A culture of light : cinema and technology in 1920s Germany / Frances Guerin.
p.    cm.
Includes bibliographical references and index.
ISBN 0-8166-4285-0 (hc : alk. paper) — ISBN 0-8166-4286-9 (pb : alk. paper)
1. Motion pictures—Germany—History. 2. Cinematography—Lighting. I. Title.
PN1993.5.G3G84  2005
791.43'0943'09042—dc22

2004022373

Printed in the United States of America on acid-free paper

The University of Minnesota is an equal-opportunity educator and employer.

12 11 10 09 08 07 06 05          10 9 8 7 6 5 4 3 2 1

In memory of my father
Robert Langley Guerin

# Contents

# Acknowledgments

I have managed to involve many people in the research and writing of this book, all of whom have given generously and selflessly of their time and expertise. The number of people to whom I owe its completion exceeds that which I could ever have imagined at its inception.

Over the course of the book I became reliant on the patient assistance of librarians and archivists. In particular, I thank those at the Bundesarchiv-Filmarchiv, the Stiftung Deutsche Kinemathek, Museum für Technik, Berlin, and the British Film Institute in London. At the Netherlands Film-museum, I am indebted to Ivo Blom, who pointed me in invaluable directions for film viewing, and the other staff who went out of their way to accommodate my research demands. I am also grateful to those at the Munich Filmmuseum, especially Gerhard Ullmann, who generously put the collection at my disposal. My thanks also go to Charles Silver at the Museum of Modern Art for giving me access to the museum's silent film collections and guiding me through the accompanying documents. Anne Hoormann also assisted with bibliographic information and its location in Germany. And thanks to Joseph Yransky, who kindly supplied me with images from his private collection.

Likewise, the work would never have come to fruition without the generous financial support of a number of institutions. I thank the Deutscher Akademischer Austausch Dienst (DAAD) for funding two research trips to Germany and the Department of Cinema Studies at New York University for its generous support through the George Amberg Memorial Dissertation

Fellowship. Final research stages were funded by the Arts and Humanities Research Board in the United Kingdom with a Grant in the Creative and Performing Arts and a Colyer Fergusson Award from the University of Kent.

Many people at New York University where the project began had a formative influence on its direction and structure. In particular, I would like to thank Robert Sklar, Bernd Hüppauf, and Toby Miller for their insights on the manuscript. Thomas Elsaesser's influence goes beyond the inspiration provided by his work on Weimar cinema. The generosity of his suggestions forced me into areas I was not previously prepared to go. Richard Allen also provided unstinting support in getting the project off the ground and guiding it through its life as a dissertation. He was at all times unsparing in his astute criticisms, his good humor, and his patience.

I also wish to thank my colleagues at the University of Kent for their support. My thanks go especially to Andrew Klevan for his insightful reading of parts of the manuscript—though he would probably resist being associated with it! I have also reaped the benefits of Michael Grant's bibliographic knowledge and his always being at the ready to discuss light. Tony Kaes and Frank Kessler gave suggestions along the way, and I also thank Jack Zipes and the anonymous reader at the University of Minnesota Press for their thorough readings and input into the revisions. Doug Armato at the University of Minnesota Press and David Thorstad, the copy editor, guided the book through the various stages of publication; to them and others at the Press I am also very grateful.

My thanks go to friends who have let me turn the conversation to 1920s German cinema for a number of years now, especially to Brad Campbell, Jackie Geller, Katie Grant, Christoph Hildebrand, Kimberley O'Quinn, Brian Price, Ranjani Mazumdar, Joe McElhaney, and James Williams for discussions that have found their way into the book in some form. As the book went through its various research stages, my German had to improve, and I am lucky to have had teachers who made this task an enjoyable part of the research: I am grateful to Mirjam Honisch, Kristin Kolbe, Peter Rosenbaum, and Antje Terhechte, and to Peter Rosenbaum for his assistance with translations from the German (I am, however, responsible for any translation errors). Ruth Abbey, Antje Ascheid, John David Rhodes, and Amy Zalman went beyond the call of friendship by giving penetrating and challenging readings of the manuscript at various stages. They offered incisive criticisms at vital stages of the project and always gave me new ideas and renewed energy with which to return to the book the next day. My especial thanks go to Roger Hallas, who read the manuscript in its various stages and engaged with its ideas, its obstacles, and its

frustrations from beginning to very end. My research also required long stints away from home, and too much thanks would never be enough to Roland Ascheid, Paul Hendley, and Peter Rosenbaum, who opened the doors of their apartments to me in Berlin and New York. The ongoing intellectual and emotional companionship of all these people lies at the heart of this work, and their influence is everywhere in its pages.

Finally, my thanks go to my father and mother, Robert and Naomi Guerin, who gave their unconditional support for my academic pursuits over more years than they probably ever anticipated. This book is dedicated to the memory of my father, whose courage and enthusiasm are an ongoing source of inspiration, and from whom I inherited a love of things German.

# Introduction

Light is so crucial to cinematography that, in fact,
cinematography is unthinkable without it.

*Die Kinematographie ist mit dem Licht auf das engste verknüpft,
ja ohne das Licht überhaupt nicht denkbar.*

Wolfgang Jaensch

The cinema is a medium of light. The cinema does not exist without the beam of electrical light that passes through the celluloid strip to throw an image onto a screen before a viewer. Even before this, the production of the moving photographic image is as much a construction in light as is its process of projection. As the camera shutter opens, light passes through the aperture, and leaves an impression in negative form of what lies before the camera on a filmstrip. Although the production of the cinematic image is not necessarily achieved through use of *electrical* light, it is necessarily a *technically* manipulated image in and of light. In both the production and projection of the image, the cinema is married to light. Despite the medium's dependence on light for its very existence, it is surprising that an entire generation of film historians has, with one or two exceptions, paid little attention to this striking and, at the same time, conspicuous aspect of the cinema's aesthetic and history.[1]

The critical neglect of the role of light and lighting in the cinema has continued in spite of the persistent experimentation in these areas by filmmakers throughout the twentieth century. From the early adventures

in light of Georges Méliès, through the narrative use of lighting in the films of Cecil B. DeMille, and the experiments of László Moholy-Nagy and Stan Brakhage, to the unmistakable high-key lighting effects of Robert Richardson, filmmakers have continued to find new ways of deploying and representing the centrality of light to the cinematic medium.[2] In addition, the hermeneutic and ideological significance of film lighting was a preoccupation for both early film theorists such as Rudolf Arnheim and Siegfried Kracauer, and more contemporary scholars such as the *Screen* theorists.[3] Early filmmakers and critics were keenly aware of the role played by light and lighting in films and the cultures produced in their midst. Yet, in the ever-expanding field of film history, few have continued to investigate the consequences of the relationship between film and light in its various forms. This book goes some way toward addressing this gap in film history.

The technological revolutions of the latter half of the nineteenth century ensured that light would no longer have to be figured through words, paint, or any other medium. Manufacturing processes meant that light became powerful enough to constitute its own medium, a medium that poured over and through the nighttime streets of the new, modern industrialized cities. Light was extended beyond its symbolic function in painting, literature, and philosophy. In its material form, light itself came to constitute the modern technological world and shape the lives led therein. The intensity and longevity of artificial light revolutionized existing art forms and laid the foundation for others newly invented. The theater, shadow play, architecture, and photography were duly modernized by the availability of electrical light. And the exciting new medium of cinema as we know it today was inaugurated with the mass production of electrical light. Without the beam of light that passes through the static images of the filmstrip, there would be no image projected on the screen before the eyes of an audience.[4]

The fundamental role of industrial light in the production and projection of the film image made the new medium a particularly appropriate forum for representations of a historical world increasingly defined by the role of electrical light; its technological identity ensured that the cinema could contribute to the depth of the modern world it often chose to represent. The development of the cinema witnessed the coming together of a series of technological advances—including electrical light, the film camera, and the manufacture of the filmstrip. In its intercourse with other elements of the medium, a sophisticated use of light technology has the potential to be the material, subject, and referent of filmic representation.

To put it another way: light as the medium of film also has the capacity to be deployed as the content of representational images. These images might represent developments in light technology that take place in the historical world. Such representations can then potentially analyze the sociological function of artificial light formations such as the cinema itself. This is the potentially tripartite role of light and lighting in film representation. Moreover, it is a threefold use of light and lighting that has the capacity to represent the historical transformations that result from technological advances such as electrical light and cinema. Thus, through a tripartite use of light, the technologies of cinema and electrical light have the potential to contribute simultaneously to the very transformation they represent.

German narrative films of the 1920s enthusiastically embraced the products of late industrialization when they deployed light and lighting in all their variant possibilities. This book is about those films and their multifaceted relationship to light and lighting. The films I discuss in the coming pages, some of which have been omitted from existing histories of German cinema, demonstrate the potential of the cinema to engage with a tripartite use of light. Films such as *Der Golem/The Golem* (1920), *Sylvester/New Year's Eve* (1923), and *Algol* (1920) use light for compositional purposes, as a structuring device of the temporally unfolding narrative, and to represent the transformation to a modern life fashioned by technological advance in 1920s Germany. All of the 1920s films analyzed in the book go still further when they manipulate light and cinema to contribute to the said transformation. The films use light and lighting to envision the transformation of space, conceptions of time and history, modes of representation, and the pivotal role played by industrial entertainment in their midst. These cultural transformations are the effects on the everyday that result from Germany's intense and belated advance to technological modernity. Breathtaking displays of cinematically manipulated light are used to represent the flattening out of space under the dazzling streetlights that define the metropolis at night. Time and history are represented in films such as *Der Golem* as foreshortened and ill-defined via images of simultaneity between the past, the present, and the future. The lighting throughout the narratives of films such as *Schatten/Warning Shadows* (1923) is repeatedly manipulated to create images of films within films. Lastly, light, lighting, and the camera come together in *Varieté/Variety* (1925) and *Sylvester* to represent the instruments of Germany's burgeoning leisure industry in this period. The cinema was, of course, one of the most prevalent candidates within this industry. In all cases, the

films marry cinema and light technology to go beyond representing the cultural transformations to daily life. They extend these representations into visions of the consequences, or effects, of the transformations on the shape of everyday life in interwar Germany. Moreover, through their imaginative manipulations of cinema and light in its various forms, they contribute to these very transformations. Thus, the chosen selection of 1920s German films provides rich material for a study of the seminal relationship between the cinema and light, between films and their potential to use lighting creatively.

The cinema is only one of a number of media whose ontology can be lent to the representation of the world it both contributes to and analyzes. The magic lantern and other nineteenth-century devices also presented themselves as media with the capacity to exploit technical light for similar uses. Art forms such as architecture, theater, and photography also have this capacity both to manipulate a technically generated light to create buildings, environments, and images that are the material of the modern world and, simultaneously, to analyze that same world.[5] The innovation of these 1920s German films comes in their exploration of light and lighting that is not only commensurate to but places the cinema in a relationship of exchange and productivity with these other art forms. Thus works in these other art forms help to identify the specificity of the cinematic use of light and lighting. The works come together in and with the technologically modern world as both products and producers of a culture of light.

## Why Light?

My focus on light and lighting, a single aspect of the mise-en-scène, is motivated by a desire to understand the ever-elusive relationship between films and the world that produces them. In particular, the lighting in a number of 1920s German films offers insight into their unique representations of a new industrialized way of life. Although other aspects of the mise-en-scène are of integral importance to the films' structure and meaning, my focus on the lighting is informed by the innovations that the film medium brings to a technically manipulated light. Other aspects of the mise-en-scène can, of course, extend the film medium.[6] For example, as we see in the films of Lev Kuleshov, notably *The Extraordinary Adventures of Mr. West in the Land of the Bolsheviks* (1924), performance can function in concert with the camera and editing to produce a uniquely filmic vision. However, in the German film of the 1920s, the highly articulated,

gestural acting was no different from that performed on the Expressionist stage of the prewar period. Even if new acting techniques were developed by filmmakers in the 1920s, they were not specifically designed to interact with the film camera. The sets of films such as *Das Cabinett des Dr. Caligari/The Cabinet of Dr. Caligari* (1921) might have been innovative for the cinema, but they are effectively static, two-dimensional images that mimic the Expressionist paintings of artists such as Erich Heckel or Lyonel Feininger. In the use of light and lighting, we consistently find new and uniquely filmic visions of the mise-en-scène.

The centrality of light and lighting also connects the film aesthetic to the historical culture of technologically generated light, a culture that made its presence felt on the landscape of day-to-day life in 1920s Germany. This thriving culture of light was realized in both daily life and other 1920s artworks. It was a culture of light that was nurtured in the pre–World War I years and, owing to a number of historical circumstances, flourished in the 1920s.[7] This culture of light gives both definition and critical depth to films such as *Der Golem, Die Straße/The Street* (1923), *Varieté*, and *Schatten*. Of course, electrical light is only one of a number of technologies that came to define this period of intense industrial growth and social transformation. As others have noted, developments in sound, transport, and communications technologies, for example, all gathered force in the 1920s. The culture of light that gives a context to the films here discussed represented one among many emergent contexts for artistic and cultural activity. The cinema more generally and individual films also intersected with cultures of sound, speed, and telecommunications during this period. Thus, the films here examined and their elaboration through connections to the culture of light do not represent the only, or even a dominant, way of defining a silent German national cinema. They represent one important trend that emerges among a number of others during the period.

Like the cinema, contemporaneous artworks used light to represent the impact on daily life of the technological world to which they also contributed. In 1924 the architect Bruno Taut extended the visionary ideas of Paul Scheerbart to create glass constructions that interacted with both natural and electrical light.[8] Taut's was the architecture of a modern world marked by mobility, transience, flexibility, and expressivity. Taut's architecture was designed to define and analyze a modern world characterized by the availability of electrical light. In the theater, dramaturges such as Leopold Jessner, Reinhard Sorge, and Erwin Piscator took up the project begun by Max Reinhardt in the teens. They designed rapid scene changes by turning spotlights on and off as they beamed from above both

stage and audience. These dynamic and rhythmical mise-en-scènes created through light and lighting were designed both to incite and echo the frenetic pulse of the revolution that characterized everyday life. They formed a theater in which light was the language, content, and referent in representations of the turmoil of an accelerated and intense advance to industrial modernity.

The young Bauhaus artist Moholy-Nagy was one of a number of photographers working in Germany in the 1920s on the development of photographic images in light to expand the limits of human perception.[9] His photograms were compositions in light designed to invigorate a modern "technologized" way of seeing.[10] The 1920s German films discussed in this book use technical light as an invention of technological modernity to describe this same modernity in a manner similar to Taut's architectural, Sorge's or Jessner's theatrical, and Moholy-Nagy's photographic uses of light and lighting. At least, the principles of representation are the same: the material of representation is mobilized to describe and analyze the very social conditions it simultaneously represents and influences. However, films such as *Der Golem, Die Straße, Schatten,* and Hans Werkmeister's *Algol* also use light differently. First, *Der Golem* and *Schatten* use lighting—in its interaction with editing and camera work—for self-reflexive representations of the cinema apparatus and its mode of production. Second, the lighting is deployed in films such as *Algol* and *Die Straße* to offer unique visions of the reconfigurations of space and time, the effect of power relations, the status of visual representation, and the thriving entertainment industry that resulted from the rapidity of industrialization.

Perhaps owing to its omnipresence and historical reach within the visible world, *light* carries with it a multiplicity of meanings. Whether we consider light to be composed of particles emitted by luminous bodies, a wave phenomenon, or a form of electromagnetic radiation, it can be imbued with physical, physiological, philosophical, and aesthetic meanings.[11] In the ensuing chapters I refer to light in a number of its manifestations. Ordinarily, when I refer to light and its manipulations, I refer to that which interacts with the space and time of the real world. I also distinguish between light, artificial light, and technically produced light. These distinctions are critical to the uniqueness of the cinema as a medium that goes hand in hand with other inventions of technological modernity. When I use the term *light,* I refer to any type of light, be it natural, artificial, or technological. *Artificial light* is, as it suggests, that genre of light that is produced through artificial as opposed to natural means. Artificial light

differs significantly from technological light because it is not always mass-produced or mass-disseminated. The obvious example of an artificial light that is not technological is gaslight. Even though gaslight has its source in natural gas, it is artificial because it is subject to a number of refinement and dissemination processes. And yet, these processes are not technologically determined. In the 1910s and even into the 1920s, there were instances of films such as *Und das Licht Erlosch/And the Light Went Out* (1913) that used a technologically generated light to represent gaslight. The distinction is important in a discussion of German film because gaslight often does not have the power as an on-screen light source to illuminate the action. And yet, because of its continued use as a form of everyday illumination at this time, it is still represented in films well into the 1920s.

*Technological light* or *electrical light* is mass-produced and has the capacity for an increased physical intensity, widespread dissemination, and uninterrupted output. I also take care to distinguish between electrical/ technological light and a *technically manipulated light*. The distinction may sound pedantic; however, I have in mind here the common tendency for natural sunlight to be manipulated on the film set through a use of mirrors, filters, camera lenses, and adapters. Thus, technically manipulated light can have sunlight as its source, but along the way this light is manipulated and interfaces with technology of some description. To reiterate, this light is not mass-generated and -disseminated at its source, but it is manipulated by some technical form. Again, it is an important distinction when considering German silent film because glass-roofed studios provided natural illumination to the film set well into the 1920s. However, because of the interface of this light with, at the very least, the film camera, it is still, within the bounds of my argument, a technically manipulated light.

*Lighting*—whether in relation to film, theater, or any other of the arts—is found in representation. Most often representations manipulate light—before the camera, on the stage, or through the creation of architectural structures—and this aestheticization can be considered lighting. To put it another way, that which lies before the camera—in the case of film, the profilmic—is light. And once it is presented to us within aesthetic representation, this light becomes lighting. Although such clear-cut definitions and distinctions are always in some way unsatisfactory, I lay them out to limit slippage between different senses of light and lighting.

There are numerous instances when the powerful opportunities offered by electrical light in the first half of the twentieth century are manipulated

for spectacular displays that represent the wealth and progress of modern Germany. Similarly, the beam of light that enables the projected image on the film screen is a light merged with the representational dimensions of lighting. Thus, in these and other cases, the distinction I draw between light and lighting becomes untenable. In these instances, I use the term appropriate to the context of my discussion about light and its manipulation.

## Why German Film?

Works on silent cinema's metonymical relationship to modernity have, until now, primarily focused on the fin de siècle period.[12] At the end of the nineteenth and beginning of the twentieth centuries, everyday life became transformed by the effects of industrial development.[13] The cinema's emergence in 1895 coincided with the effects of these transformations. The birth of the masses, new ways of seeing the world, and redefinitions of the spatial and temporal coordinates of daily life, to name just a few of the effects of industrialization, were also fueled by the new medium of film. This convergence between cinema and modernity at the fin de siècle was as pronounced in other Western nations as it was in Germany.

However, in Germany, the relationship between cinema, technological development, and cultural modernity found an articulate embodiment in the 1920s. Usually for historical reasons, in other Western countries the metonymical relationship between the cinema and technological modernity was more intensely explored at the turn of the century, thus making the German displacement to the 1920s somewhat unique. The book's shift in focus to the productivity and experimentation of the interwar as opposed to the turn-of-the-century years is enabled by the specific confluence of German history and its silent film production.

Nevertheless, in the same way that the films here analyzed are informed by the historical, cultural, and artistic contours of 1920s Germany, they are also brought to life within the international arena of technological modernity. In particular, experiments with technological light in the films and other arts of France, Italy, Britain, and the United States are the silent context in the background of the film analysis in chapters 2 through 6. Films, photography, architecture, theater, and everyday life on the streets of these other modern nations often used light and lighting to represent and engage with technological modernity. Any number of examples could be cited here—Man Ray's photograms, films such as *La Roue/The Rail* (1922) by Abel Gance, the paintings of second-generation Futurists such as Ivo Pannaggi's *Speeding Train* (1922), and Frank Lloyd Wright's architectural

designs—all use light and lighting to discourse on the shape of modern life. Similarly, many of the representational issues—reconfiguration of space and temporality, self-conscious representations of cinema—are explored in these and other artworks from other countries. Thus, the films discussed in the book make sense within the larger landscape of an international preoccupation with and representation of technological modernity.

Despite the international enthusiasm for representing the contours of the technologically modern world through explorations in light and lighting, the German culture of light in the 1920s is also unique.[14] Although creatively informed by and in conversation with the products of industrial modernity in other countries, my argument regarding the group of 1920s German films comes to life at the intersection of the nation's delayed embrace of technological modernity. Thus the international arena of technological modernity and artistic modernism gives definition to the films here examined. Simultaneously, to place 1920s narrative German cinema within the international context enables identification of what makes them specifically German.

Germany's advance to industrial modernity was relatively late, and although many developments were under way by the end of the nineteenth century, it was only in the 1900s and 1910s that technological industry and concomitant social reforms began to take hold.[15] As they were gathering momentum, the Great War interrupted these processes, and their full effect was only experienced in the 1920s. This retardation founds the historical context that enables my interpretation of the uniqueness of the chosen 1920s films. The history of German cinema's metonymical interaction with technological modernity actually began at the turn of the century, twenty years prior to the films that are the focus of this book. Nevertheless, I argue that in Germany, the two phenomena—cinema and technological modernity—found an extremely articulate expression and intimate convergence in the 1920s. Thus, they came together in Germany at a moment when film was already developed as a narrative art form. This historical convergence of the checkered history of Germany's accelerated rise to technological modernity, the history of the development of electrical light, and the history of the development of cinema in Germany provides the context for German silent cinema's engagement with its historical world.

In keeping with the generative basis of the intersection of these historical phenomena, my focus on light and lighting in German films has as much to do with their historical and artistic contexts as it does with the films themselves. Again, the tripartite use of light and lighting is not specific to

these particular German films of the silent era. Neither is the discussion of the given thematic issues limited to the German context. However, the aesthetic configuration of light and lighting and the perspectives expressed towards modernity strongly reflect the German situation. Thus, justification for the films as comprising one form of German national cinema can be pinned to their particular thematization of and attitudes towards technological modernity as it was experienced in Germany. The characteristic ambivalence towards technological modernity of German artistic products has been remarked upon in a number of other contexts.[16] However, it is more than variant attitudes that mark the distinction of these 1920s German films. The transformations of technological modernity and their specific impact on the shape of everyday German life fuel the innovation of the films' use of light and lighting.

As was the case with the shift to modernization in other Western countries, the sociological and cultural effects of advanced modernization in Germany were immense. The population shifted from the country to the city, and there was an increase in white-collar workers, a decrease in blue-collar workers. More specifically to Germany, modernization brought uncertainty for the Jewish population, reorganization of foreign policy, and radical changes to, for example, attitudes toward sexuality. The effects of these crises in economy and governance on social and cultural formations are thematized by the films I discuss. Although it would be possible to analyze these issues through focus on other aspects of the films, I am specifically interested in how and where they are thematized through innovative uses of film lighting. Thus, a film such as *Varieté* represents the relationship between entertainment and illicit sexuality in the technological age. In *Jenseits der Straße/Beyond the Street* (1929), experimentation of light and lighting delineates public and private spaces as becoming confused, interchangeable. *Der Golem* envisages a modern historical temporality that enables Jewish integration. In all cases, these historical phenomena are shown as the effects of technological advance. Although the films have wide-ranging approaches to and conclusions about these concerns, whatever the thematic issues raised, I explain them as resonant with the transformations resulting from Germany's contradictory embrace of technological modernity. Moreover, the films represent this intense coming into technological modernity as always ambiguous, contradictory, and at times unfocused. They represent a technology that cries out for change, recovery, and decisions to be made at this critical point in the progression of historical events.

While other Western countries expressed their power as industrial

capitalist states at the turn of the century, for complex historical and economic reasons it was only in the 1920s that Germany as a nation-state fully embraced the possibilities of technological modernity. In the 1920s, Germany simultaneously waged its claim as the leading European industrial nation. Germany expressed its power through a boom in the production and dissemination of electrical light in the public sphere. At this time, it was also a country working hard to forge its identity as a powerful nation in an increasingly globalized economy. And it opportunistically seized the novelty and vast possibilities of electrical light as a means for self-aggrandizement and publicity. At this time sophisticated technologies of film lighting became available in Germany. Studios, directors, and other film workers may not have been directly involved in representations of technological modernity through light and lighting, but they did create films that engaged with the culture of light. Thus, the intersection of the three histories is both the context and rationale for my analyses of the tripartite structure of these German silent films' use of light.

## Viewing the Films in Historical Context

My placement of the films within the historical trajectory of Germany's advance to technological modernity founds a history that departs from the politically determined periodization that has governed previous histories of German film. In turn, this separation of German film history from the political and economic instability of the Weimar Republic uncouples it from a dependence on the *Sonderweg* model of early-twentieth-century German history. This dependence has traditionally undergirded film histories of the period.[17] The revival of industrialization and the political turmoil of pre–World War II Germany are, of course, inseparable. The economic policies that steered Germany back to political power in the 1930s were underwritten by "big industry." Governmental policy was no less determinate as the driving force behind the growth and alacrity of Germany's revived industrialization. Moreover, as becomes salient during my film analyses, the consequences of these political and economic factors impacted both the development of the film industry and the film aesthetic. Nevertheless, the growth of the medium and its representations are not direct tools of political persuasion, and neither were they developed in direct correspondence to political events and ideological changes of the teens, twenties, or thirties. The separation of German film from the politically determinist history is crucial to the continued reassessment of German silent film.

Given the confluence of electrical light, cinema, and the historical intensification of classical modernity, placement of the silent films within the history of Germany's rise to technological modernity does more than obviate dependence on reified political biases. It relocates this one branch of Germany's cinema within a set of processes that it expands and by which it is sustained. The cinema belongs to the increasing intensity of industrial modern life in 1920s Germany in a way that it does not belong to the political and economic turmoil of the same era.[18] Unlike the theater and other films of the period, the films I discuss are not directly engaged in representations of the political and economic events taking place outside of the cinema. Their relation to the historical world comes rather in their speculations regarding the effects of the changing forces of this same world. It is a world colored by the intensification of technology.[19]

The placement of my film analyses within the history of technological modernity and the culture of light not only relieves these 1920s films of the ideological histories of authoritarianism, racism, and national superiority that are traditionally imposed upon them. The book also offers a conception of a type of national German silent cinema that coheres around the discursive phenomenon of technically manipulated light. No longer do we have to identify the deeply conflicted German soul as the cohering principle of this film product. For too long, the Weimar film was burdened with the responsibility of expressing a national consciousness, and it was always a national consciousness in crisis.[20] My approach to these films on the grounds of a different historical context—that of Germany's embrace of technological modernity—obviates the familiar flaws in writing German film history.

In addition to the myriad, well-rehearsed flaws in traditional models of German film history, we live in a critical moment in which the borders of the nation-state are constantly under siege. Consequently, the conception of a national cinema is no longer so clearly defined by geographical borders or political constituents.[21] For this reason, it is also imperative to consider the not specifically German, the international context of the 1920s films. Light and lighting, technological modernity, the transformations to everyday life, and films in dialogue with these international phenomena are thus the ingredients of a German cinema that both reaches beyond national borders and marks out its singularity. Similarly, even within the geographical boundaries, a number of frequently contesting narrative forms and political positions are commonly taken by the film product. Accordingly, when I conceive of a national German silent cinema through the lens of Germany's post–World War I embrace of techno-

logical modernity, I do not claim to be speaking of all films made within this period in the German studios. On the contrary, the group of films here analyzed represents one kind of national German silent cinema, one mode of interaction with developments in Germany's self-identity in the 1920s. The culture of light and the films that make sense therein yield only one of many concurrent discourses of the German nation.

Perhaps more important than a sensitivity to current scholarly beliefs, the 1920s German film product, owing to its history, presents other obstacles to the identification and excavation of a national consciousness. German filmmaking in the 1920s was an international affair. German studio films were influenced by myriad international trends and personnel. From well-known cases such as the Austrian Max Ophüls to lesser-knowns such as Arthur Robison, the studios were populated by directors and film workers from other countries. The thriving of Soviet culture in cities such as Berlin also extended to the production and aesthetic of German film.[22] This is to mention nothing of the intimate relations between Hollywood and film development in Germany during the period.[23] As has been documented, the technology was often imported or designed by the Americans, and the aesthetic, in particular the urge to a narrative cinema, was informed by the Hollywood model. Beyond the cinema, in 1920s Germany, Berlin was an international city replete with international culture, industry, and ways of life. Thus, the notion of a German national cinema in the early decades of the twentieth century is always going to be fraught with exceptions, incoherence, and international influences. The development of technological modernity, electrical light, and the cinematic medium are, of course, international concerns. My privileging of technical light and lighting as a discursive phenomenon that describes and is described by the chosen examples of German silent cinema both opens the films up to their internationality and underlines their particularity.

The historical thrust of the culture of light as a background for understanding German silent cinema also enables me to interpret the continuities between the cinemas of the teens and twenties. The historical trajectory simultaneously avoids the potential to marry the films of the 1910s to an exclusively international style overwhelmed by the American studios. Further, it avoids links between what have become known as the Wilhelmine and the Weimar cinemas, links that reduce the pre–World War I films to precursors of the fully developed art cinema of the 1920s.[24] To be sure, the films of the 1910s explore technological, stylistic, and thematic concerns similar to those of Europe and America. However, as

is the case with the 1920s, there is also a specificity of focus and pursuit in the teens' films in Germany. Thus, the culture of light as a historical and interpretive backdrop to Germany's narrative films not only shifts attention away from previous periodizations but it also renegotiates the ever-problematic relationship between the cinema, the national, and the political across the years of silent film production in Germany.

Despite these conscious digressions from the historiographical legacy of Siegfried Kracauer, the book is indebted to, and in many ways revitalizes, the work begun by Kracauer and continued by Thomas Elsaesser in the 1980s and especially in his recent book *Weimar Cinema and After*.[25] In particular, I take up the project to investigate the relations between particular forms of industrial organization, technological modes of production, and everyday life in pre–World War II Germany. By approaching the films through the aesthetic and historical context of light and lighting, I shift the focus from dependence on the psychosocial dynamic of the text–spectator relationship. Ultimately, the analysis offered here continues in the spirit of these historians when it grasps and reveals the ambiguities of German film and its complex relationship to the potential contradictions of the political-social landscape of pre–World War II Germany.

Before accounting for the importance of the aesthetic context in which I understand the films, a word on the apparent placement of technology at the center of historical processes in 1920s Germany. The technological revolution to which the cinema and electrical light belonged spawned extensive changes to everyday life. Nevertheless, I assume throughout that technology is not the sole determinant of historical change within the culture of modernity.[26] Before the material developments of technological change took hold, there must have been, as Lewis Mumford argues in his classic text *Technics and Civilization*, "a reorientation of wishes, habits, ideas, goals."[27] As is reflected in the cross-pollination of cinema, electrical light, and social transformation in 1920s Germany, I place technological development within a more general social ecology. I thus assume that technology, and its increasing sophistication and dominance in the social landscape, is always in a relationship of exchange with the moral, social, political, and aesthetic dimensions of modern life. For example, there was always an ideological power behind technological developments that ensured its particular influence on the quotidian. In 1920s Germany, the powerbrokers of the postwar period such as the government, wealthy industrialists, and companies such as AEG or Siemens & Halske had enormous influence over the shape of these developments. The economically and politically influential made decisions that oversaw technological

advance in the interests of improving efficiency of industrial production and creating a flourishing market economy at home and abroad. Thus, the impact of technological development on the social and historical environment of its production and dissemination always materialized thanks to the ideology and cultural assumptions of those behind it.

Accordingly, technology was not an autonomous force. Nevertheless, for many in 1920s Germany, the experience of technological modernity was one in which technology (here, electrical light and cinema) came to dominate all aspects of daily life. From the perspective of those who lived in modern industrial Germany, technologies such as electrical light and the cinema profoundly influenced the movement and organization of existence. When people strolled through the city streets at night—in search of work or pleasure—they did so because the brilliant lights of night enabled such activities. Similarly, the experience of cinema as an exciting invention enabled by electrical light was an experience of pleasure and enjoyment with the relatively new medium. And yet, we must not forget that this surrendering to the new technologies was born of a human choice, a desire and readiness to adapt modes of living to the pace and capacities of technology. Thus, while street workers, revelers, and film audiences were often placed as cogs in the wheels of capitalist industry, they were not robbed of all agency. They were no doubt well aware of the profit motivations behind their interactions with technology, but they interacted nevertheless.

## The Aesthetic Context

The 1920s culture of light is at least in part determined by a German artistic modernism that enthusiastically took up the newfound capacities of a technically manipulated light. The films' location within the artistic culture of technological light emphasizes their kinship, though not identity, with the formal and historical concerns of other artworks. The book argues that the central conflict of a technological modernism—the conflict between the utopian aspiration for mythical cohesion and the recognition of the material rupture brought about by industrialization—becomes transposed in the narrative films. In the films I analyze, this conflict has become one between a melodramatic or mythical promise of narrative cohesion and social integration, and the abrasive experience of technological modernity.[28] Through this transposition of what I understand to be a constitutive contradiction of artistic modernism, I carve out a space for these 1920s German films as art objects.

This privileging of the German silent film as an art object may seem

an obsolete project. After all, it is already acknowledged as one of the first European art cinemas.[29] However, German silent cinema's status as art is most commonly founded on its ostensible kinship with Expressionist painting and theater.[30] In addition to the reasons outlined by Elsaesser, the labeling of these films as Expressionist does not appear to be the most productive approach.[31] And yet, because the films can be placed in generative conversation with other artworks of this period, I am reluctant to jettison the art-historical approach altogether. To understand the films as candidates of artistic modernism offers insight into their explorations of the unique capacities of film as the medium par excellence of the technological era. Similarly, these explorations are extended to provide unique visions of the historical context to which they contribute. This potential to usher in a new era of representation and to rearticulate the relations between the aesthetic and the world around it is opened up via a focus on the use of light and lighting.

Pre–World War II modernist architecture, theater, and photography—particularly in Germany but also elsewhere—embrace the irresolvable conflict between a utopian promise of spiritual harmony and the dynamic, fractured fabric of material, physical existence. In some examples of the avant-garde architecture of the 1920s, the dream of an existence defined through architectonics as spiritually integrated sat uncomfortably next to the disorientation of an existence devoid of spatial grounding. In the contemporary photography, the modernist contradiction is realized in the simultaneous concern to extend the limits of perception and cognition beyond oppressive bourgeois structures and its effective oiling of these same structures through dissemination in the capitalist press. In the film examples, the uneasy marriage takes place between a narrative marked by a striving toward the triumph of heterosexual love (including the repression or eradication of all "aberrant" urges) and the consistent eruption of technical excess. I argue that this conflict is left unresolved and comes to represent the troubled relationship to technological advance captured in the 1920s German film as a cultural proponent of technological modernism. This tension or conflict represents a specificity of 1920s German cinema. Further, it produces a disorientation for the spectator that, in turn, prevents easy consumption and promotes an analytical reflection. In addition, the two sides of the conflict are used to articulate the films' complicated images of German technological modernity. The uneasily juxtaposed multiple images of technological modernity, articulated as they are through different aspects of the narration, will become a familiar characteristic of a 1920s German filmic modernism.[32]

I argue that, like contemporaneous art forms, the German silent cinema manipulates light and lighting to represent and interact with transformations of space, conceptions of time and history, modes of representation, and the flourishing of industrial entertainment in 1920s Germany. Inevitably, the films address other aspects of Germany's technological advance in and through light that I discuss only fleetingly. Perhaps the most obvious of these is the recurrent concomitance of lighting and the camera for the representation of power. In particular, the power represented through the lighting is usually identifiable as the state's power over one or more citizens. For example, I do not discuss scenes such as the closing sequence in *Varieté* when the circle of hunched-over prisoners walk the exercise yard with a spotlight (coupled with a film camera) framing their backs in the dark pit below. The scene is shot from an extremely high angle; the prisoners are illuminated in white light by the searchlights that watch their every move. The film cuts and we see the protagonist as prisoner number twenty-eight, reduced to the number on his back in the spotlight, being led along a corridor striped by daylight. In this sequence, the camera and the spotlights are in perfect concert as they trap the group of prisoners and later the single prisoner, number twenty-eight, in an act of surveillance. In another example, we will remember the striking moment when one of the criminals in Fritz Lang's *M* (1931) is captured by the police as he crawls out of a manhole when in pursuit of the murderer. When the criminal appears aboveground, he is trapped by the police spotlight, the film's camera, and its spotlights. Much like Maria's incarceration to Rotwang's torch as she scurries through the dank passageways of the catacombs in *Metropolis* (1927), the criminal in *M* is immobilized and held hostage by the observatory apparatuses that are apparently inescapable in the time of technological modernity. It has become impossible to escape the observatory eye of searchlights as human beings are rendered luminous objects under the gaze of the light of the camera.

The metonymical relationship between film camera and lighting techniques in these films captures creative instances of the visualization of technological modernity in 1920s Germany. These moments are no less significant than any other instances that I discuss. Nevertheless, I do not analyze these compelling examples because they represent isolated moments that cannot be so easily woven back into the broader concerns of their given narratives. Similarly, they are not threefold filmic uses of lighting. Thus, *M* might be a film that is concerned more generally with mechanisms of state power and, particularly, the corruption and inefficacy of these institutions. However, these themes are not pursued across the entirety of the narrative

through the agency of the lighting.[33] As I will show, a film such as *Varieté* uses the lighting to articulate its particular vision of technological modernity. It is also a narrative structured by spectacular uses of lighting. And, as I shall also argue, it is a film that focuses on the dynamism of the modern entertainment industry. Any articulation through lighting of the mechanisms of state power in the closing stages is used to represent the fate of those seduced by the excitement of the entertainment industry. Thus, because *M* and *Varieté* either do not pursue manipulations of the lighting to represent state–citizenry power relations throughout the narrative, or they do not pursue the theme through a use of lighting, I do not analyze these issues. To reiterate, the book focuses on films that entertain a threefold use of light.

For similar reasons, despite its intimacy with developments in technical light in industrial modernity, I have omitted the question of vision and changing ways of seeing in the modern urban environment. Vision is pivotal to the films of Fritz Lang, in particular to his urban thrillers such as *Dr. Mabuse, der Spieler/Dr. Mabuse, the Gambler* (1922), *Das Testament des Dr. Mabuse/The Testament of Dr. Mabuse* (1933), *Spione/Spies* (1928), and *M*. In each of these and other of Lang's German films, the villain is invisible; he remains imperceptible to human sight. Similarly, there are moments in these films when the authorities saturate the nighttime streets with light in order to physically see, and thus trap, the villain of multiple, shifting identities. Yet these dramatic solutions always fail. As Peter Lorre's M runs desperately through the streets in search of a hiding place with the criminals on his tail, his path is exposed through the high-intensity lights of the streets. He is threatened and driven into an apparently empty building by the lights that find him on the outside. In the closing moments of *Das Testament des Dr. Mabuse,* the lights of police cars frenetically chase Mabuse through the darkened night, a chase that ends at the gates of an asylum. These headlights dominate the movement and space of the film as they fly through the darkness, forming a network of interpenetrating beams shifting around the screen. They are simultaneously the eyes that never lose sight of Dr. Mabuse, and as such they represent his temporary vulnerability in the face of police power. The lights that chase the action into the space of the asylum eventually confine Mabuse and bring about the end of the film. And yet, Mabuse continues to escape the line of vision marked out by the spotlights when he mutates into the body of Dr. Baume. Again, in collaboration with the expertise of cameraman Carl Hoffmann, Lang uses lighting in its marriage with the camera to articulate a mode of visual surveillance that typifies the changing parameters of vision in the technologically modern world. Light

both oppresses and is blind to the subjects of the surveillance systems of modernity.[34] However, vision and perception are either not centralized within the narrative, or they are not always articulated through light and lighting.

Another approach would be to juxtapose 1920s films and artworks that foreground phenomena inflected by a different technology—sound, movement, optics. This context would also create connections to films and artworks in other countries. Furthermore, it is likely that this would yield a different and interesting conception of the German silent film's relationship to technological modernity. Given such possibilities, I again emphasize that my particular approach, which privileges the culture of light, is one among a number of possible discursive frameworks that breathe life into interpretation of the films.

Lastly, a political argument that runs counter to that of this book can be made if one focuses on a different set of 1920s German films and their respective uses of technology. For example, the *Bergfilme* or mountain films of directors such as Arnold Fanck that were so popular in the 1920s use technological developments such as those in light and lighting, the camera apparatus, and editing to depict national attitudes.[35] It is often understood that these films are antitechnology in their search for a utopian flight from the "troubled streets of modernity." However, as Eric Rentschler points out, this assumption is misleading as the films look to technological developments as vehicles for their mythical journeys into sublime fantasy landscapes. Not only are their stirring visuals created through the technical prowess of the camera, but "[besides] snowy scapes, billowing clouds, and unpeopled expanses, the films show us tourists, resort hotels, automobiles, airplanes, observatories, and weather stations."[36] Thus, films such as *Der Heilige Berg/The Holy Mountain* (1926) and *Die Weisse Hölle vom Piz Palü/The White Hell of Piz Palü* (1929) are not so straightforwardly antimodernity. Nevertheless, for any ambiguity that the films harbor toward modernity, they still conceive of an uncompromising national power and glory. It is a very different conception of heroism from that put forward in the 1920s films examined in the following chapters. And indeed, there are none of the contradictions, none of the troubled relationships to change brought by technological modernity that are so dramatized in the films I discuss. The existence of the *Bergfilme* and other film genres from the period is further evidence that those films engaged in the culture of light account for only one perspective—albeit shifting and fractured—of the world that surrounded them.

Chapter 1 of the book sets the stage for the film analyses that ensue

in chapters 2 through 6. In chapter 1 I offer a detailed account of the historical and artistic culture of light in which the films make sense. In particular, I explore the developments in industrially produced light, cinema, and the other arts within the larger landscape of Germany's advance to technological modernity. When set against this background of the development of light and lighting in pre–World War II Germany, the unique visions of the films discussed in chapters 2 through 6 are brought to the fore. In addition, the strength of the connections between the films' articulations in light and lighting and those in other media establish the films' unique contribution to the culture of light in 1920s Germany and the development of a modernist aesthetic in Europe.

Because I argue for a German national cinema that develops across the interruptions caused by World War I and in spite of changes of government and economic turbulence, Chapter 2 analyzes the use of light and lighting in a number of films from the teens. These analyses establish the continuity between the pre– and post–World War I films against the background of the advance of technological modernity in Germany. Already in these films from the teens we see preoccupations with some of the thematic issues that are explored in depth in the 1920s films in later chapters. They are equally concerned with transformations to time, space, familial and power relations, and new forms of entertainment that are ushered in as a result of the burgeoning of technological industry. The films of the 1910s do not often sustain a tripartite concern with light and lighting across the entirety of the narrative. A handful do, and these are the focus of this chapter. I argue that films such as *Und das Licht Erlosch* foreground manipulations in light and lighting within the frame composition, narrative structure, and as the fulcrum around which thematic issues turn. As in the 1920s films, the thematic issues at stake directly touch upon the industrial world in their midst.

Chapters 3 to 6 analyze the use of light and lighting in eleven films from the 1920s. In each case, the analysis moves from a discussion of the filmic use of light and lighting for compositional purposes, through the unfolding of the story to the engagement with transformations to social and cultural life that result from technological modernity in Germany. Chapter 3 interprets light and lighting in *Algol* and *Schatten* as being used in particularly self-conscious ways. These representations enable discussion of the transformations that are brought to visual representation with the invention of electrical lighting and other industrial developments. Chapter 4 examines the cinema as a form of modern magic. The use of light and lighting in selected films—*Faust, Der Golem,*

*Siegfried, Metropolis*—provides a gateway to discussions of the cinema's involvement in and reconfiguration of historical time. Chapter 5 is given to uses of light and lighting in *Die Straße, Jenseits der Straße,* and *Am Rande der Welt* to examine the effects of redefined public and private space enabled by modern phenomena such as electrical lighting and the cinema. Lastly, chapter 6 looks at the social impact of technically produced light when it is integrated into the formation of a modern leisure industry.

In the same way that these 1920s German films move between the concerns of a national and an international cultural modernity, between film and its relative art forms, between light and other technologies as the machines of modernity, so my narrative gestures toward other fields of scholarship. Consonant with the films' engagement with the international concerns that surround light technology in modernity, the book reaches beyond the boundaries of German film history. Although the significance of the relations between the film aesthetic and the historical and cultural context of 1920s Germany is specific, the broader issues and general approach reconnect the book to a possible array of different cinemas. In particular, the book speaks to cinemas of different nations that foreground technical experiment in their attempt to reflect on and define issues of nation and identity. All the time, these cinemas look beyond national boundaries for inspiration to retain the flexibility and uncertainty that lie at the heart of definitions of the nation and its cultural products today.

The work also extends early film historians' preoccupation with the relations between cinema, technology, and sociocultural modernity into the post–World War I years. Scholars interested in the uneven development of a certain technology, technique, or other aesthetic attributes will find relevance in the similar dislocation of the histories they narrate; for implicit to the book's relocation of the ties between silent cinema and modernity to the 1920s is a reassessment of a trajectory of film history that looks to the birth of cinema, the birth of a new technology, or aesthetic tendency when in search of discourses of the new. These discourses tend to imply a teleological end point marked by the old, the familiar, in effect the no longer interesting. This book offers an example of the work still to be done on the resonance of the new throughout all phases of development. It is not only at moments of transition and invention that art and culture stride toward complexity and historical insight. At times when the new starts to become old and familiar, artists and filmmakers innovate in other, unanticipated ways.

At the heart of these innovations lies an interaction with the historical context of artistic production, a historical context that breathes new life into the otherwise timeworn. This group of German silent films' engagement with light and lighting, a technology that was not in itself new to the 1920s, provides a striking example of how art can be reinvigorated through the inspiration of broader historical and cultural change. The films here analyzed take up otherwise familiar concerns and, under the sway of their historical and cultural particularity, push them forward in surprising directions.

# 1

# The Electrification of Life, Cinema, and Art

This century belongs to light.
László Moholy-Nagy

## The Growth of Industrially Produced Light in Germany

From the unification of Germany in 1871 to the outbreak of World War I in 1914 Germany's industrialization was rapid.[1] The first wave of industrialization was, however, hampered by an economic crash in 1873, and it was not until the late 1890s that economic and social stability was reestablished. Germany's second wave of industrialization around the turn of the century was accelerated and exaggerated in comparison to that of Britain, France, and Austria, for example. London, Paris, and Vienna had become world centers at a time when cities were defined through their focus on government, commerce, and religious activities in the 1820s.[2] Berlin's formative years as capital of a nation-state coincided with Germany's rapid industrialization and rise to technological prominence following the Franco-Prussian war much later, around 1870. Because the very definition of Berlin as a city and Germany's first national capital was dependent on industrial imperatives and technological opportunities, all efforts were made to ensure its continued industrial growth. Moreover, while Britain, for example, maintained that the state should not interfere in a supposedly free market, in Germany the process of industrialization was expedited by considerable state intervention. Together with major investment from banks such as the Deutsche and Dresdner banks, the state financed the

widespread shift from the older coal, iron, and heavy-engineering industries to the newer chemical and electrical concerns.[3] State intervention in technological development was the German government's strategy in its zeal to become the foremost European economic and political power.[4]

The early Weimar government was eager to make reparations for Germany's disastrous defeat in World War I. It was anxious to reconquer the export markets lost during the war, and, by extension, in response to democratic pressures, to see Germany hold the political and economic power it did during the Hohenzollern monarchy.[5] And so the Republican government financed the growth of industrial production after the war. Big business was subsidized, machinery was modernized, mass production burgeoned. Of course, factories had not stood idle during the war: the growth of German industry had steadily increased as the demand for artillery grew. Nevertheless, with the focus on production for the armed forces, other modern industries were neglected. Then, as the war drew to a close, modernization of everyday life on the home front boomed around 1919. The manufacturing industries flourished, increased their share of the national income, and Germany slowly reestablished its stronghold on the European market in the early 1920s.

Electrical light was first put into widespread industrial and household use in Germany at the turn of the century. By the 1910s some 15 percent of private households in city areas were supplied with electricity (including light). And by the end of the 1920s, an estimated 70 percent of metropolitan households were connected to the city's power network.[6] This advanced state of Germany's power supplies is usually explained by reference to the economic support of industrial development, and in particular, the generous state financing of scientific research at the turn of the century.[7] Electricity and industry were pivotal to the forging of Germany's new identity as a powerful nation. Electrical light was one among a number of phenomena that were instrumental to the building of the German nation-state and its identity.

Central to this project of self-aggrandizement and the forging of a national identity was the urge to be the leader in the fashioning of a modern, industrialized way of life. Above all, artificial light was considered a marker of the city's modernity: its existence heavily influenced the architecture, organization, and way of life of modern society.[8] While other European countries slowly continued to develop their already-established networks of electrical light at the turn of the century, because the introduction of electrical light and lighting had come late in Germany, the transformation to a technology-based society took place there at an accelerated pace in the teens and twenties.

The two largest electrical industries in Europe—Allgemeine Elektrizitäts Gesellschaft (AEG) and Siemens & Halske—saw that the distribution of electrical power increased dramatically up until and following World War I. Thus, for example, in Berlin alone, the electricity supply increased from 70 million kilowatts in 1900 to 1,078 million kilowatts for the same area in 1933.[9] Between 1900 and 1910, the main thoroughfares of the major cities were gradually being transformed from the obscurity that came with gas lighting to a network of electrically illuminated arteries.[10] Lively discussions in industry trade journals spawned innovations in indoor artificial lighting for public places such as churches, theaters, museums, and indoor sports arenas.[11] The 175 electricity plants in Germany at this time were constantly testing, patenting, and marketing cheaper, safer, and brighter lighting for homes, businesses, factories, streets, and public institutions such as schools and theaters.[12]

The shine of Germany's modern facelifts in light and lighting was not lost on visitors from other countries. It was common practice for engineers and representatives from electricity companies to visit foreign cities either to give expert advice or, more usually, in search of inspiration for the lighting up of their own cities.[13] Berlin was a popular destination for foreign visitors. In 1912, a delegation of Australian electrical engineers visited Europe and confirmed Germany's prominence as the leader in electrical modernity:

> on the Continent one naturally visits Berlin, being electrically the most important city, not only from an electric supply point of view, but on account of the fact that the two most powerful electrical manufacturing concerns in Europe have their factories here.[14]

These same engineers waxed lyrical about the beauty and utility of the lifestyle enabled by Berlin's metropolitan streets. From this brief account of Germany's pride in and profit from its early-twentieth-century manipulations of technology, we already note the importance of electrical light to the country's self-conception as a leading industrial nation. Light offered an ideal medium through which to represent Germany's economic strength, scientific development, export capacities, and commitment to cultural growth. These qualities would ensure its perception of itself as a nation with which to reckon in the twentieth century.

Like many of the other technologies, light went through a number of developments thanks to its importance to the war effort. On the battlefield, the focus on developments in light usually stressed mobility and portability. For example, there was an emphasis on the strengthening and

lengthening of cables not only so they could extend through and across the trenches, but so they would withstand extreme climatic, geographical, and battle conditions.[15] On the German home front too, technological advance was dictated by the demands of the battlefield. For example, the war brought with it an acceleration in the size and interconnection of power plants. Massive plants such as that of Golpa-Zschornewitz—a subsidiary of AEG—capable of extreme levels of transmission were built in response to wartime shortages.[16] Personnel, financial support, and equipment resources were removed from production for the home front and redeployed to bolster the war effort.

Nevertheless, although the demand for electricity had escalated dramatically from 1,395 million kilowatts in 1909 to 14,006 million kilowatts in 1917, the factories could still not keep pace with the huge demands of war.[17] It was a common occurrence for the streets of German cities to be plunged into darkness during the war. Even if the lights themselves remained in place, money was better spent fueling factories that manufactured weapons than lighting the streets of the big cities.[18] At the beginning of the war, the voltage of public streetlights was marginally decreased to conserve energy, but as the war went on, the streets became darker and darker, until eventually, by 1917 they were returned to the pitch black of the pre-1900s. Thus, all the complexities of light production and dissemination that were set in motion in the prewar years were significantly retarded by Germany's involvement in the Great War.

That said, the excess of generating stations built to service the pressing needs for electrical power during the war continued to be maintained in peacetime.[19] The massive munitions and armaments manufacturing sites and interconnections were turned to high-voltage transmission for everyday peacetime Germany. Thus, electrical light, like the other modern technologies of this wave of industrial modernity, blossomed in the 1920s. In addition, the high-voltage searchlights, spotlights, and floodlights that were perfected for reconnaissance missions and nighttime drills were quickly integrated back into the civilian world following the war. Notably, these apparatuses found widespread usage on film sets and the theater stage.[20]

The light and lighting of public spaces had been extensive in the pre–World War II years. Night lights in streets, theaters, museums, and even beaches around the world were designed to imitate the intensity and brilliance of the midday sun.[21] Germany's dive into darkness during the war years also motivated a postwar aesthetic of light in public spaces that moved beyond the apparent crudity and wastefulness of early examples.[22]

It was no longer a question of simply illuminating public spaces. Rather, the streets, city squares, train stations, and workplaces all demanded different intensities of light and lighting. Thus, big industries such as Osram also set about developing different types, intensities, and qualities of light for the illumination of different spaces.[23] Given the exponential growth of manufacture, transmission, and use of electricity and electrical appliances after the war, it is understandable that the effects of these new inventions were even more significantly experienced in the 1920s than in the prewar years.

In the 1920s, electrical light was, above all, a symbol of economic success: it was a cog in the fast-turning wheels of the capitalist economy. Among those businesses that exploited the economic benefits of light were the cinemas. Despite the great expense and occasional struggles with city officials, movie theater owners knew that the brighter the colored lights that advertised their product, the greater the likelihood that passersby looking for entertainment would be tempted to come inside.[24] Although brightness was a criteria for luring customers, the aesthetic presentation in light was also critical to the efficacy.[25]

Despite, or perhaps because of, the professed importance of the brightness of advertising lights, in Germany, unlike other countries, the use of electrical lighting for advertising and night lighting of stores became highly regulated in the mid-1920s.[26] City administrations distributed their regulations to all business, and all outdoor lighting fixtures had to be approved by local officials.[27] In Berlin, for example, the city council introduced taxes on the size and intensity of advertisements on the streets.[28] This imposition of restrictions simply spurred the advertising industry to greater sophistication. Because the desired brightness was often deemed illegal, businesses had to rely on artistic innovation to catch the eye of potential customers. Because of regulatory pressures on the use of public light and lighting, Germany became a leader in the design of neon lights in which clarity and aesthetic design replaced brightness as the criteria for efficacy.[29] Such details as the placement of light through the arrangement of the lamps, and the discovery that different light sources were more suitable than others for the emission of different colors, were often discussed in the trade press. It was discovered that neon lights, for example, produced a red light, mercury lights were perceived by the human eye as blue, and helium-based lights generated a white-pinkish light.[30] Even though the United States was well ahead of Germany in its development of advertising by night, according to German journals, American companies could not match the aesthetic standards of German advertising in light.[31]

By the late 1920s, the city of Berlin was so proud of its technical achievements that in the week of 13–16 October 1928, the German capital celebrated its *Berlin im Licht* (Berlin in the light) festival. The festival was an event through which the city proved its status as *the* modern, progressive metropolis. Neon signs, illuminated shopwindow displays, product advertisements of colored light, a motorboat race on the river Spree, light displays along the city's major arteries, floodlit public buildings and monuments joined forces in a kaleidoscopic display of the city's technical achievements, economic power, and aesthetic appeal.[32] Keenly aware of its once secondary status to Paris, London, and New York as the cities of modern extravagance, Berlin was so proud of its light festival in 1928 because it proved that Berlin had not only caught up with, but had overtaken its rivals.[33] The spectacle of light that marked the modern city in the twentieth century may have come relatively late to Germany, but there was no question that Berlin was now a leading example of a metropolis defined through light and lighting.[34] As Mayor Böß said in his opening address at the festival:

> Characteristic of the fulfillment of the demand that light advertising must also have an aesthetic effect is, among other things, the fact that Berlin has relatively few big lights with blazing suns, dazzling, lighted letters, flashing lights, and glowing comets. Because there was concern over very intensive advertising, light with an overall soft effect has been installed.[35]

Berlin's lights were different, they were not all an empty spectacle. Rather, Berlin's lights had an aesthetic effect that was missing from those of other big cities. Böß's celebration of the subtlety of Berlin's light displays at the festival was, of course, a thinly disguised legitimation of the city's restrictions on the source and intensity of public lighting. Nevertheless, according to the German press, with this festival, Berlin proved to itself and the world that it was the vanguard city of modernity.[36] It was not long before the success of the *Lichtfest* (light festival) in Berlin spread to other German cities such as Hamburg and Cologne, which also hosted *Lichtwoche* (light weeks).[37] In the early months of 1929, the streets of these cities were duly lit up by the brilliance of electrical light in citywide advertisements for their status as jewels of modernity. Light rendered visible the city's status as the historical location of all that was new, beautiful, and tastefully designed.

As a way to bridge the gap between "popular" and "serious" entertainment, the November Group organized a musical component to Berlin's festival of light. Ten simultaneous outdoor concerts took place on the major

squares of Berlin on 15 October 1928. Kurt Weill was among those commissioned to write compositions for the event. Weill's *Berlin im Licht*, scored for a military band, was heard under the direction of Hermann Scherben as part of the concert at Wittenberg Platz.[38] Rather than casting suspicion on the "auspicious" occasion, Weill and the other composers joined forces with the city officials and celebrated the thrill of the events. Contrary to what we today might expect, Weill and his fellow members of the November Group seemed more interested in seizing the forum for a public performance of their works than in questioning the gentrification of their city.

Predictably, many people were not invited to join the celebrations in and of light that legitimized the modern grandeur of the 1920s German metropolis. Indeed, the significance of electrical light and lighting extended beyond the realm of the symbolic to that of a structural force in the redefinition of a modern way of life. It shaped and affected the real lives being pursued in its midst. And those who were cast onto the shadowy margins of modern life were left out of the celebrations in and of light. The electrification of the streets in 1920s Germany altered conceptions of space, temporality, class distinctions, state–citizenry power relations, the capitalist economy, and the entertainment industry.

## The Cinema as an Instrument of Modernity

The cinema was intricately bound to these transformations to space, lifestyle, class relations, state–citizenry power dynamics, and perception on the metropolitan streets. The cinema as a form of mass entertainment servicing both rich and poor, employer and employee, men and women, was a nighttime activity that invited all walks of life into the streets, into a world where once intractable social boundaries became easily transgressed in 1920s Germany. Immediately following World War I there was a boom in theater construction. Prior to the war, Germany had approximately a thousand movie theaters, and by the end of the 1920s, some five thousand were operating, hosting up to two million visitors daily.[39]

The marquees outside the opulent new cinemas became one of the many attractions in light and lighting that gave the night city facade its energy and powers of intoxication. Thus, on the face of these buildings, the cinema and electrical light combined to contribute to the fashioning of technological modernity in 1920s Germany. For example, when Fritz Lang's *Frau im Mond/Woman in the Moon* (1929) played at the Ufa-Palast, the outside wall of the theater turned into an image of the universe. The

rocket in which "the woman" flies to the moon soars through a plethora of lightbulbs that represent the star-studded universe in the hoarding.[40] In addition, the facade of the same theater doubled as a miniature film screen depicting a neon-lit moving image of a city street at night, an image that advertised *Asphalt* in 1929.[41] These dazzling and sensational theater facades became integrated into the architecture of the city at night. Thus, the cinema as a play of light and darkness began for the spectators on the streets outside as their eye was arrested by the sparkling marquee. Light and lighting tempted spectators inside to see the promised film. Or perhaps their curiosity had been aroused while strolling along the main streets, upon seeing a fragment of the film in a shopwindow.[42] The technological innovations in light and lighting associated with the cinema were not limited to the image projected onto the screen before an audience.[43] In diverse ways, the cinema exploited and contributed to the culture of light and technology that radically altered day-to-day existence in 1920s Germany. Once inside the theater, it was, nevertheless, the film itself that aroused the awe and interest of the audience.

Despite Germany's industrial and economic strength, the development of cinematic technology was not as sophisticated as it was in France and the United States at the turn of the century. Neither are the names associated with German developments as well known as those of Edison, Lumière, or Biograph. Nevertheless, the Skladanowsky brothers did design and construct their own Bioscope, culminating in the first public screening to a paying audience at the Winter Garden in Berlin on 11 November 1895.[44] Generally speaking, the same is true of the development of film lighting: the technology in Germany was not as sophisticated as in the United States. The German companies were not leading the field in the design and construction of film or projection lighting. Thus, around 1907, when the majority of American studios on the East Coast relied solely on electrical light, in Germany alternatives were still being sought owing to the unreliability and prohibitively high cost of electricity.[45] If electrical lights were being used in the German studios, they were typically acquired from the United States. In the early 1910s, Guido Seeber was using arc-lamp floodlights that had been used at the New York Biograph studio in 1909.[46] For the most part, lighting in the first two decades of German cinema was achieved through manipulating diffuse sunlight coming through the roof of a glass studio.[47] Nevertheless, German-based companies such as Osram continued to research and produce safer, cheaper, and more effective lighting for film production and projection throughout the teens.[48] And Siemens & Halske, for example, worked in tandem with film and

theater companies to produce ever more intense and enduring lighting facilities.[49] They may not have been integrated immediately by the studios, but technological developments were continually pursued.

There was also ongoing discussion in the trade and intellectual journals of the time regarding the latest innovations in electrical light usage in the cinema. In his regular column on film technology for the journal *Bild und Film*, critic Friedrich Felix recognized the urgency to install electrical light capabilities in all production and projection facilities. The clarity, precision, safety, and cleanliness of electrical light was, according to Felix, at the foundation of its necessarily widespread installation.[50] The use of electrical light in film production and exhibition may have been slow to take off, but there were individuals and companies that recognized its centrality to the future of a thriving German film industry. Nevertheless, in spite of the enthusiasm for innovations in film technology in the early 1910s, it was not until toward the end of World War I that the German film industry began to flourish and come into its own.[51] With the technological blossoming of cinematic production would also come the exploration of the artistic possibilities of these types of light and lighting.

Although the energy and enthusiasm of the academic film reformers in Germany ensured the development of film as a public tool for education, the cinema culture of the 1910s was not uniquely German. From the cinema's earliest days it belonged to the world of urban spectacle entertainment of all kinds: variety shows, café-concerts, music-hall reviews, circuses, automobile and sports shows. As was the case in turn-of-the-century France, for example, in Germany, the cinema was housed by and contributed to a modern leisure industry characterized by the principles of international commodity culture and mass consumption.[52] It belonged to the world of commerce and marketing, consumer goods, fashion, the lifestyle of leisure and travel. The cinema contributed to the reconfiguration of modern life effected by industrial-capitalist modes of production and exchange in Europe. The cinema sat side by side with modern technologies such as trains, photography, the telephone, and electric lighting, as well as large-scale metropolitan streets populated with anonymous crowds, all of which blossomed in or were the invention of an international technological modernity. In Western countries, modernity realized itself in and through the cinema.[53] Likewise, the cinema played a key role in the struggle over the meaning of an international modernity.

Through film, adults and children alike were educated in national concerns and cultural values.[54] There were also distinct aesthetic tendencies in the German film product of the 1900s and 1910s.[55] In addition, German

film theory and criticism from this early period enthusiastically pursued animated discussions regarding the possibilities of film as a new art form for enhancing aesthetic and political education.[56] Film lighting technology may not have always been at the cutting edge, but from these early days onward, it certainly contributed to the development of the specifically German film aesthetic. As early as 1913, an awareness of the importance of light and lighting to the identity of film is evidenced in the writing on film. In an article on the new "glasshouse" studio in the Berlin suburb of Tempelhof, the anonymous author gleefully exclaims: "everything depends on light, light is the force of everything!"[57] As we will see in chapter 2, both natural sunlight and artificial light were skillfully explored by filmmakers such as Franz Hofer, Oscar Messter, and Joseph Delmont for sophisticated creations of space. And in films such as *Und das Licht Erlosch/And the Light Went Out* (1913), the lighting is given compositional and discursive prominence in a narrative that touches on the impact of the modern world. In some of the earliest examples of the German feature narrative we find films that engage with the processes of modernity and modernization in their midst.

Following World War I, the film aesthetic was consistently explored in imaginative ways by German filmmakers. In the 1920s these explorations yielded a product that repeatedly used cinematic lighting to represent the transformation to modern life resulting from technological developments such as electrical light and the cinema itself.[58] The impact of World War I technological developments on the 1920s film was immense.[59] Even if the technology was not integrated into every production, the film industry profited enormously from war-influenced expansions to the intensity, duration, portability, and quality of electrical light. The increasingly widespread use and amelioration of nighttime light and lighting in the cinema, for example, came courtesy of the necessary night lighting during the war.[60] Similarly, innovations made to the intensity and efficiency of arc lights during the war years were appropriated by the 1920s film industry.[61]

This said, even in the 1920s when the German studios consciously sought to extend the film product, innovation was not always focused on the development of the technological apparatuses themselves. More consistent were the particularly innovative uses to which the available technology, such as that needed for lighting the set, was put. After the war, the film camera was not alone in the technological production of images made from manipulations of light. The walls and roofs of the studios were closed in and lighting equipment, which had become commonplace in the United States a number of years earlier, was installed in the German studios. In the United States and other European countries at this time, floodlights were

already being used to sharpen the focus of the image, and shadow plays were no novelty, having been seen in the films of Cecil B. DeMille and Ralph Ince, for example.[62] However, Germany was just beginning to explore possibilities that had already been superseded in the United States. By 1922, the larger companies such as Ufa and Decla-Bioscop were in the habit of using artificial lights such as arc spotlights and arc floodlights in blackened-out studios. Robert Müller explains the use of the "coal arc light" and the "mercury steam light" as the two primary artificial lighting sources in the German studios after the war:

> The coal arc light existed in two different models: the first being the open low-voltage arc light and the other being the high-voltage arc light, which was placed underneath an airtight glass bell. The low-voltage arc light emits a very harsh, white light, throws strong shadows, and creates images of contrast. It would be employed as a front and side light. The high-voltage arc light, however, gave out a soft, modest brightness, but a big "radiation" . . . [The mercury steam light] produced a soft, even, nearly shadow-free, greenish light that is insensitive to the exposure of the red colors suitable for "orthochromatic" films.[63]

Whereas the coal arc lights were generally used when filming in complete darkness, the mercury light was usually used as fill light, sometimes as a key light for frontal shots in daylight. These two types of artificial light provided the source. Mirrors, reflective surfaces and light-focusing devices were always used to control, intensify, diffuse, or redirect the light beams.[64] It was in such manipulation of otherwise standard technologies that a number of exponents of German cinema in this period excelled.

As had been the case throughout the 1910s, even though the major developments in film lighting technology did not take place in Germany, there was sustained interest and lively discussion in trade journals devoted to the development of technologies of light and its effects.[65] German filmworkers and critics often emphasized the centrality of light and lighting to the medium of film. In an article on the quality of the light and lighting at an exhibition for film and photographic technology, a reviewer for a trade magazine confidently claims the pivotal role of light to the film and photographic process:

> Photography and cinema are areas for which light plays a particular and decisive role. Light is here everything: raw material, tool, and lastly, the formed artwork. In all phases of the formation of a film or photograph, in all technical methods and aids that use light, in all its possible forms and applications, light is the decisive factor.[66]

Because of their commitment to the conception of light and lighting as two defining features of film, film workers were always interested in different ways of using light and lighting for new effects. An article in the *Reichsfilmblatt* from 1923, for example, recommended the latest developments in the use of mirror lighting. The improvements to the mirror lamp already on the market—use of a curved glass mirror, protection of the silver on the mirror to ensure against overheating—made the product safer and more cost-efficient.[67] Writers continued to discuss the possibilities for manipulating light and film lighting in contemporary film journals. Thus, for example, an article in *Filmtechnik* explained the various ways in which lighting could be used to "lie," or create a subtle mise-en-scène in which it is impossible to determine where and how the light source is placed.[68] Discussions were also devoted to other technical developments that would enable further manipulations of the light and lighting, such as the invention of a trolley to move the lighting setup in tandem with a moving camera, or effects created through the use of mirrors.[69] Suggestions on how to film various light phenomena were also given space in the pages of the more technical journals, and books on the subject were also published.[70] In one of many very technical essays on the effects of a cinematically manipulated lighting, an engineer considered the effects of various types of light mediated by the film camera upon the retina.[71]

These discussions extended to reflections on the use of light in projection, and the importance of the light design in the movie theater interior. For example, an article from 1927 asserts the importance of emergency lights. The author is not only concerned to emphasize the importance of emergency lights for the safety of customers, but extends his discussion into a consideration of the types of light and number of sources that would be appropriate for the movie theaters.[72] The German studios and other film businesses experienced a belated introduction to the revolutionary potential of light and lighting in the cinema, but it was an introduction that spawned a sustained fascination with the potential of technically generated light and its mediation through the film camera.

German filmmakers did not develop what have become the standard film lighting setups—such as back lighting, frontal lighting, fill lighting—deployed in the interests of illuminating and encoding narrative action. These techniques were the work of American and other European studios, all of which were made possible by electrical energy in the early 1910s, at least ten years prior to the German studios' full electrification. Nevertheless, the reputation of the 1920s German film as a product identifiable by its lighting innovations is not totally misleading. The truth is not al-

ways, however, as has been previously assumed, to be found in the contrast of light and darkness for expressionistic purposes. In fact, in each of the films consistently placed under the "Expressionist" umbrella, the set is illuminated by a diffuse, even sunlight that highlights the artificiality of the set and character movement.[73] The renown of the German silent film's association with light and lighting can be more appropriately located elsewhere. One area of innovation resulted when technically manipulated light and lighting were concurrently used as compositional materials in the construction of the mise-en-scène, agents in the narrative progression, and bearers of discursive meaning.

In the 1920s films I discuss, the lighting has both a literal function when, for example, it defines the space or subject matter of the mise-en-scène, and a metaphorical function when it simultaneously motivates thematic issues. To give one example, in *Schatten*, a shadow maker steals the shadows of a party of dinner guests gathered in an eighteenth-century mansion. He throws the shadows onto a screen where they mutate into characters who tell a story of love, jealousy, revenge, and corruption in a film within the film of *Schatten*. The characters themselves do not carry out the pivotal narrative actions. Rather, their shadows are confusingly engaged in struggles of the heart. In this film, shadows are the visible realization of conflicting human emotions; they are the dramatic agents of the narrative, and in their centrality to the film frame, the shadows cast a mise-en-scène of distortion and disquiet.

These manipulations of light and lighting are not always aesthetically unique. However, their deployment to represent the reorganization of life in industrial modernity is innovative. Thus, in *Schatten*, characters are reduced to servants of light and shadow, their shadows are the organizing principles of the mise-en-scène, and they drive the film's thematic concerns. The same could be said for the use of light and shadow in Cecil B. DeMille's 1917 film *The Cheat*. Therefore we can observe *Schatten* as a striking example of a film whose lighting patterns are visibly in conversation with aesthetic tendencies in international cinema. However, Robison skillfully experiments with the possibilities of light and lighting as a medium for the construction of a film narrative that discourses on modernity. Robison's film is thus also unique because of the use to which technological developments and aesthetic constructions from elsewhere are put.[74]

The organization of studios such as Ufa and Decla-Bioscop contributed significantly to the development of the German film aesthetic, an aesthetic that often embraced the possibilities of light and lighting.[75] Details of the production processes alert us to the studios' emphasis on the

technical training of the film worker as skilled artist, and the high number of artists extending their creative specialties to film production. Unlike the Hollywood studios in which all members of the production crew were under the direction of the studio and the demands of the popular genre film, production heads such as Ufa's Erich Pommer in the 1920s gave film technicians and artists total autonomy and freedom with their work. This did not mean, however, that the director had decisive control over all aspects of film production. As a cross between an artist and a technician, the director always worked closely with other film workers when developing the aesthetic and technical operations of his or her films. In 1920s Germany, the film director was one of many creators on the set.

In keeping with these practices, the 1920s cameramen had control over the lighting of the set and were among the primary creative forces behind this product. Cameramen such as Karl Freund and Carl Hoffmann were at liberty to experiment with their instruments (including light) as they wished. For example, it was not only F. W. Murnau's direction, but also the lighting techniques of Carl Hoffmann, in particular his renowned "Two-Sun-Phenomenon," that enabled the old philosopher to conjure the devil through rings of fire in *Faust*.[76] Fritz Lang also attributed the often lauded effects of *Die Nibelungen* to their various creators—Carl Hoffmann's shimmering light evoked the spiritual atmosphere of Siegfried in the forest, Carl Vollbrecht's masterful dragon, Otto Hunte's breathtaking set for Worms, and so on.[77] Lang himself admits his debt to the work of his collective for the film that is otherwise known as his. As he says, it is not only that members of the collective built the film with their skilled knowledge, but these workers gave each other the energy to reach the highest levels of film achievement.[78] Karl Grüne, director of *Die Straße*, reiterates this respect for the artistic and technical expertise of the production crew. He insists on the stylistic vitality of films that foreground the personal inspirations of individual skilled workers.[79] Grüne argues that the film promised to be a unique product if workers skilled in exclusive areas of film production had control over their particular specialty. Owing to the presence of these highly skilled workers on the film set, their work was not pushed to the background of the visuals. Thus, the sophisticated use of light and lighting in these films was ensured by the employment of skilled workers who were given significant responsibility for their creations.

Some artists came to the cinema from other arts, such as the architect Hans Poelzig, playwright Gerhard Hauptman, and the circus artist Frank Wedekind. Other technical personnel, and especially cinematographers such as Carl Hoffmann, Karl Freund, and Fritz Arno Wagner, served

traditional apprenticeships under established artisans. In addition, each film shoot was approached as the teamwork of the crew, a team known as a *Bauhütte*.[80] Klaus Kreimeier quotes set designer Hermann Warm in his explanation of the communal participation in the highly imaginative "miracles" produced by these modern-day *Bauhütte:* "The workers were so in harmony that it was difficult to attribute the creations to one or other of them."[81] Thus, in spite of the strong creative influences of some film personnel, it was considered impossible to label a film as the creation of either Karl Freund (cameraman), Carl Mayer (scriptwriter), or F. W. Murnau (director). Often contemporary reviewers of the studio films testified to the collaborative process through their reluctance to attribute the technically innovative displays of the films to the director, photographer or scriptwriter.[82] This was particularly the case when directors such as Murnau, who often distanced himself from the details of shooting, or photographers such as Freund or Seeber, both renowned for their command of lighting and camerawork, were involved in a production.[83] All aspects of the film aesthetic were organized by specialized artists who brought an education and sensibility to the cinema. Their experience contributed to its overall quality. These film workers embraced the possibilities of modern technology for their aesthetic control over individual aspects of the films, most significantly, the available uses of light and lighting.

The multifaceted use of artificial light and lighting for compositional, narrative, and thematic purposes is the basis of a group of films' representations of the effects of technological modernity on the everyday. In addition, the films I discuss self-consciously acknowledge their own place as a technological form of visual representation within the landscape of modernity. Thus, they realize their own contribution to the modernity whose effects they also represent. They are, as we shall see, quintessentially modernist artworks. And, the cinema is not the only art form in 1920s Germany to exploit the possibilities of artificial light, and electrical light in particular.

## The Art of Light

Like the cinema, certain strains of German architecture, theater, and photography also contributed to the landscape of modern industrial life through their use of technically manipulated light and lighting. In the first three decades of the twentieth century, a number of German architects, dramaturges, and photographers used light and lighting as their medium to redefine the spaces of public and private existence. They used them also

to transgress the apparently intractable divisions between social classes, and to forge new ways of seeing in the technological age. These artists also created buildings, plays, and two-dimensional images in light that represented the social phenomena resulting from the technological advance that began with Germany's unification in 1871. Through their use of light and lighting they represented, among other things, the mobility, transience, flexibility, and frenetic pace of everyday modern life. The relationship between the art form itself and light was complex. As was true in the cinema, the development of twentieth-century architecture, theater, and photography was enabled by developments in artificial lighting. In certain of the vanguard artistic examples of 1920s Germany, a technically manipulated light was, at one and the same time, the artistic material and the thematic concern of representation. In addition, these artworks used light and lighting to contribute to shifting definitions of the modern world. Thus, in its interaction with other technologies, industrial light was mobilized for rhetorical and thematic purposes in works from German architecture, theater, and photography as well as in art films. Each of these forms was also explored to pursue a tripartite use of technically generated light. Moreover, like the films, these other artworks take up thematic concerns such as the reorganization of space and historical understanding, reflections on the entertainment industry.

At the turn of the century and through the 1920s, certain German painters and writers were also preoccupied with the transformation to daily life brought about by the industrialization of light. For example, the astounding power of the kaleidoscopic lights of the merry-go-round at the fairground is the focus of both the viewer of Hans Baluschek's *Berliner Rummelplatz/Berlin Fairground* (1914) and the spectators within the painting.[84] Despite the apparent lack of engagement with modernist formal and thematic concerns, *Berliner Rummelplatz/Berlin Fairground* is charged with the use of paint as light to depict the novelty of modern urban nightlife. Lesser Ury's compelling depiction of Berlin's Friedrichstraße train station (*Am Bahnhof Friedrichstraße/At the Friedrichstrasse Station*, 1888) reveals the extremes of class stratification that come alive under the night lights: a wealthy woman is isolated and melancholy, she is oblivious to a nearby flower vendor who is also cut off from the passersby by the empty space that surrounds her. In Ury's painting, artificial light is at the core of this social definition. The light that animates the train station enables the lady to travel, the vendor to work. Moreover, as indicated by the long, dark shadows cast by the figures in the painting, lights enable the extension of the activities of daylight hours into the night. Similarly, the use of

light to represent the place of the individual's relationship to the changing world reached innovative levels in the 1910s in German painting. For example, in Erich Heckel's *The Glass Day,* (1913) or *Crystalline Day* (1913) we see decentered figures trapped by a geometrically derived, fractured landscape of color as light. And to name one of many examples from the literature of the period: Franz Biberkopf in Alfred Döblin's *Berlin, Alexanderplatz* is fascinated by the city lights upon his release from jail, and on his first night of freedom finds himself at the cinema in central Berlin. But it is not long before he seeks refuge from the dazzling lights of the city center. These spectacles in light were unfamiliar to him after years of solitude and darkness in his prison cell.[85]

These works engage with the sociological conditions of industrial modernity through a use of light to explore human alienation, and to challenge artistically traditional forms of representation. Painting and language represent light and lighting to explore similar thematic concerns to those of architecture, theater, photography, and cinema. In addition, these artistic and literary works contribute to the shape of modern life in the technological age: the paintings are often concerned to create changes to physical perception, and the formal parameters of the literature are intended to negotiate contemporary fragmentation and alienation. Thus, through their use of light to engage on a number of levels with the world around them, these paintings and literary works also contribute to the 1920s culture of light. Nevertheless, we must keep in mind that painting and literature are not connected to the cinema on the same level as are photography, theater, and architecture. For painting and literature do not use light itself in their representations. Rather, they depend on their own media of paint and language to represent the social innovations in light and their ramifications. Thus, strictly speaking, painting and literature do not engage in a tripartite use of light. For this reason, I do not include them in my discussion of the 1920s German culture of light.

As in the cinema culture, German exploration and exploitation of light and lighting in the early twentieth century belonged to an international movement. The rayographs of Man Ray, the architectural designs of Frank Lloyd Wright, and the films of Jean Epstein and Marcel L'Herbier, to name a few, are as radical in their rhetorical, structural, and thematic determination through light and lighting as anything produced in Germany. Even in the early examples of narrative film, the Pathé and Gaumont films inventively exploited the possibilities of artificial light.[86] In interwar Germany, artistic and cultural production makes a significant contribution to the international exploration of industrial modernity through aesthetic uses

of light and lighting. Here we find light and lighting deployed to conceive of the historical moment concurrent in each of the arts that depended on light for its very existence—cinema, photography, architecture, and theater. In each art form we find significant examples of the tripartite use of light and lighting.

Central to an understanding of the coherence of the artistic culture of light is the artworks' engagement with the long tradition of uses of light and lighting within representation. Although they converse with this tradition in different ways, that the works within the culture of light privilege the issues of this tradition as the defining characteristics of their modernist aesthetic binds them together. It is therefore not simply at the level of style, but also at that of their historical and representational influences that these works are connected. Further, they all appropriate the tradition of representation in light to explore common themes of the shifting definitions of public and private space, temporality, perception, social relations, and the role of technology within representation.

Generally speaking, representations in and of light can be grouped under two umbrellas. First, from Plato, through the Middle Ages and into the nineteenth century, light was put in the service of mythical and mystical narratives that searched for metaphysical truth.[87] In these representations, light was characteristically the symbol of truth and knowledge. In nineteenth-century representation in particular, light was juxtaposed with darkness to signify the possibility of a truth defined by social integration, freedom from the burdens of everyday life, and the attainment of spiritual wisdom.[88] Second, from the work of Euclid, through Galileo to Albert Einstein's 1919 theory of energy quanta, light has functioned in the realm of science in attempts to quantify and rationalize the elemental universe.[89] In these discourses, technically manipulated light makes possible the findings of physicists throughout history. Moreover, the measurement of the speed of light, for example, places man, not God, at the center of a scientific organization of the world. Thus, these two traditions are antagonistic: the one searching for an escape from routinization, the other for analysis of and empowerment through the same routinization.

The two traditions of the mythical and the scientific or technical uses of light can be found in the architecture, theater, photography, and cinema of 1920s Germany.[90] Their manifestations are, of course, transformed and vary in form and intensity from work to work. Nevertheless, in all cases, the tension created through the mutual integration of these two conceptions of light drives a specifically modernist representation. Again and again in these artworks we find a use of light and lighting that discourses

on the fabric of everyday life. This is then placed in conflict with a use of light and lighting put in the service of the utopian aspiration for a co-herent, spiritually integrated world. The first use negotiates the physical perception and earthly understanding of the world through sight: it is a use of light that is physically, sensuously experienced. The second solicits an inward contemplation that brings spiritual enlightenment, a mystical knowledge. The tension between these two aspects—a fascination with the contemporaneous modern world and a nostalgic longing for a premodern utopia—is a central feature of the modernist artwork. Its presence in the 1920s German arts speaks their modernist commitment. And what binds the works that I discuss here is the fact that the modernist contradiction is played out through the use of light and lighting, a medium that has itself traversed the generational shifts from pre- to postmodern.

Although the 1920s works are bound together through a common ex-ploration of this contradiction through light and lighting, each artwork embraces the contradiction in a different way, to different degrees. Thus, the appropriation of the contradiction can be assumed as the stamp of both identity and difference. The silent German narrative films I analyze are unique because they efface the mystical search for knowledge and truth from their aesthetic. This does not mean, though, that they eschew all utopian yearnings. Unlike experimental films of the same period, the narrative films do not imagine a possible spiritual transcendence enabled through the interaction of light and camera technology.[91] In the narrative films, light and lighting are manipulated for an exploration of social, not spiritual, experience. However, the unique place of the narrative film in the culture of light still involves a utopian dimension, at least the striving for a totality of sorts.

The mythical or mystical dimension is transferred onto the realization of a moral melodramatic narrative. In the melodramatic dimensions of these films we find, as Peter Brooks would have it, the secularization of the premodern impulse to a religious spiritual enlightenment.[92] Melodrama is the modern narrative device through which representation conceals the violence and enormity of the contradictions that brace the historical world that produces it: the overwhelming conflict between the hero and the barbarians, good and evil, the individual and society.[93] Typically, a dis-illusioned and frustrated hero now moves through and with the undula-tions of history. Where he once longed for and ultimately attained spiritual reconciliation, in the modern melodramatic narrative he fails and accepts his failure. Although, in most of the 1920s films, we find more idealistic heroes, the dystopian tendencies of the melodrama are displaced onto the

impossibility of narrative coherence. It is an impossibility staged through the persistence of narrational interruptions at the level of the lighting.

In the films, a tension develops between the stylistic explorations in technological light and lighting and the moral utopian narrative in which all conflict is usually resolved through the triumph of heterosexual love. The two modes of articulation are placed in conflict when the technological spectacle in light commonly interrupts the temporal flow of the melodramatic narrative. Moreover, the two are in pursuit of different intentions: the melodramatic narrative strives to reinstate social order and harmony, while the technological excess works to celebrate the possibilities of technology, possibilities that also disturb, frustrate, and force change to the routine of the narrative, and, by extension, daily life. Thus, in the narrative film, the contradiction between a sensuous experience of the material world and its spiritual transcendence is transposed to a conflict between technological representation and the continuity of the narrative that accommodates it. On the one hand, a manipulation of technical light and lighting extends to represent complex disruptions and transformations to the physical everyday world. On the other hand, the films strive for a narrative in which all moral conflict is resolved and, by extension, social order is tentatively reestablished through the triumph of a love interest. The nature of this conflict is what makes the films' contribution to the culture of light a unique one. It is a contradiction transferred from a struggle between physical and spiritual existence to a tension between the physical, substantial world and the moral order of this same historical world. Thus, it is a shift into secularization enabled by and concomitant with the foregrounding of light and its representation in the secular world.

Although tensions created by processes of narration that stymie the smooth progression of narrative are characteristic of the modernist novel, for example, the German film's embrace of this conflict is notable for its platforming of industrial light.[94] The films here discussed garner their energy from quintessentially modern materials. They technically manipulate light—a material that has a long tradition within metaphysics—as the language through which to represent a historical world marked by the impossibility of spiritual wholeness and transcendence. Technologies such as electrical light and cinema—with their impetus toward instantaneity, fragmentation, and ephemerality—arguably frustrate the totalities and hinder the reconciliation between the world of things and that of the spiritual in technological modernity. In these films, the material of technological light that shapes our daily lives and forces the shift from a metaphysical to a historical experience of the world is the very material used to represent

this same shift. And these same uses of light and lighting as rhetorical device and thematic concern create a modernist aesthetic that connects the films to other candidates in the 1920s German culture of light.

The identification of a shift from a pretechnological to a technologically motivated modernity, from a belief in God as the orchestrator of all things to the human as occupying the central position in a natural universe to be explored, invaded, mastered, and understood, is central to my conception of the 1920s culture of light. However, of equal importance is the fact that I do not conceive of this shift as a definitive break; for this would imply a radical division between the pretechnologically modern and the technologically modern. Such a dissociation belies the films' continual reach to the past for inspiration. As Lewis Mumford argues in his authoritative history and sociology of technology, contemporary machines developed out of centuries of inventions.[95] The scientific and technological developments of the twentieth century would not exist without the mass production of the nineteenth century, which, in turn, is the result of mining and textile machinery developed in the eighteenth century, and so on, all the way back to the invention of the wheel in the tenth century. Developments in light technology may reach unprecedented sophistication in the twentieth century. However, as Mumford points out, the Chinese were using natural gas for illumination in times as distant as 300 BC.[96] Likewise, although attitudes toward machines and technology change and develop over the centuries, the contemporary disposition is always dependent on or a version of that of previous generations. All of these inventions are driven by the same desire to dominate and regulate the natural world. The use of light to represent artistically the historical experience of the world draws on centuries of explorations of light in the search for answers to spiritual, scientific, and metaphysical questions. Thus, on the one hand, because of its particular technological parameters, the cinema is one of a number of art forms that underscore a shift between the pretechnological and technological appropriation of the medium of light. On the other hand, this shift is only visible because of the mediums'—both electrical light and the cinema—productive relationship with both phenomena in their historical milieu and the way ancestral phenomena were approached by previous generations.

The 1920s German artworks are in all senses nourished by artistic, cultural, and scientific developments that precede them, as well as by those in their immediate surroundings, both within and outside of Germany. Likewise, the sociological impact of technologies such as cinema and electrical light is not as sudden as it might otherwise be imagined. Nevertheless,

the intensity of production, the extent of dissemination, and the modes and speed of assimilation do take on unprecedented proportions. And certain dimensions of their use and impact are brought to the fore as in any other period.

As already indicated, a defining characteristic of this group of 1920s German films and their embrace of the tensions of modernity through light and lighting is their deployment of the melodramatic narrative. Critics writing contemporaneous with the films consistently dismissed the melodramatic, and later critics also tended to underline the independence of the technical spectacle and the melodramatic plot. However, when both aspects are afforded equal significance, the complexity of these film visions of technological modernity is brought to the fore. Often the two aspects are used in a single film to put forward conflicting, but equally viable, images of technological modernity. Thus, the issues played out through technical virtuosity and melodramatic plot come together to form a complicated representation of Germany's embrace of technological modernity. For example, through *Schatten*'s marriage of illusory spectacles in lighting with the diegetic events of the narrative, the film offers a complex image of the blurred distinction between illusion and reality in technologically advanced forms of representation. In addition, the tension between *Schatten*'s reflexive explorations in lighting and its developing melodramatic plot points up the film as an allegory of the historical development of the relationship between the cinematic apparatus and the cinematic experience. In the case of *Schatten,* the two levels of representation may be in conflict, but they also work in tandem to put forward a multivalent image of technological modernity.

Alternatively, the stylistic excesses in light and the dramatic actions are woven together into a cause-and-effect relationship: the spectacle leads to an engagement with moral or social issues that are, in turn, explored through the melodrama. In *Varieté,* for example, displays in light vividly represent the excitement of the technologically inflected entertainment industry. These instances often retard a narrative they nevertheless fuel. In *Varieté,* the narrative reflects on the impact of the entertainment industry (displays in lighting) on morality (the plot) in the 1920s. Thus, in addition to my attention to both the spectacular and the plot as legitimate sites of social exploration, I privilege the relationship between the two for its significance to the films' vision of technological modernity. Moreover, in the conflict between these two modes of articulation, between the technical experiment in light and the dramatic events, comes the potential for a pro-

ductive spectatorial engagement. The conflict creates films that are open-ended, rather than confusing or illogical. These images of technological modernity often create a difficulty for the spectator that, in turn, prevents easy consumption. Indeed, faced with various, sometimes disconnected, images, the spectator is pushed to reflect upon the complexity and hetero-geneity of the films' representations of technological modernity.[97]

But first we must consider some other artworks, for only then can we fully grasp the dimensions of the 1920s German culture of light and the films' role within it. For example, in both the functionalist works of architects such as the Bauhaus masters and Expressionist works such as those by Bruno Taut we see a manipulation of light used to challenge ex-isting distinctions between public and private space. In chapter 5 we will see the same challenge articulated through a different use of lighting in *Die Straße, Jenseits der Straße,* and *Am Rande der Welt.* In the architecture and photography of the period, we also see attempted transformations to human perception and vision, transformations akin to, but distinct from, the thematization of the same in films such as *Schatten.* And *Varieté*'s pre-occupation with the changing role of an entertainment industry that must access a mass public is conceived in altogether different terms—though still through an innovative use of light and lighting—in the 1920s staging of plays by Sorge and Piscator. The films thus converse with the other arts via their thematic concerns as well as through their technical uses of light and lighting.

### Architecture

Irrespective of the differences between 1920s German architects, all were committed to the realization of a modern architectural art, which, in the words of Walter Gropius, "like human nature, should be all-embracing in its scope."[98] That is, they all believed—Bruno Taut, Hans Poelzig, Erich Mendelsohn, Arthur Korn, Walter Gropius, Ludwig Mies van der Rohe—in architecture as the *Gesamtkunstwerk* or total work of art. Architecture carried the potential to unify all forms of art. Moreover, in its presence, communal identity, and the cultural aspirations of modern humanity could be realized through a reinforcement of sensory completion and in-tegration. Architecture would both unite the different forms of art and, in the eyes of the Expressionists but not the Functionalists, unite the people in a common ritualistic, religious experience. Humanity would no longer be isolated by the tattered world of postwar Germany. Even though these architectural visions usually remained on the drawing board, the 1920s avant-garde believed in a social-utopian project that was, in turn, deeply

committed to, although not always accepted by, the Weimar Republic's urge to democratize everyday life.

These dreams would be built in the material of light, especially in its interaction with the newly available fabric of mass-produced glass.[99] This interaction of both artificial and natural light with glass was the foundation of modern German architecture's engagement with technological modernity. Light and mass-produced glass were the technologically inflected materials in which German architects throughout the interwar period searched for an understanding of the chaotic, contradictory forces of the new era. Similarly, they were the materials with which architecture fashioned a socially conscious public and private space to define life in this same world.

The avant-garde architecture of immediate post–World War I Germany was led by Taut with his publications *Alpine Architecture* and *Stadtkrone*, together with his organization of the Crystal Chain group.[100] The architects were driven by a passionate desire to conceive of a future world in which people would be liberated from their present material existence, an existence scarred by the debris of war—the dead and wounded, an oppressive state that insisted on class stratification, the misery and humiliation of defeat in the war, alienation from nature.[101] For Taut, the medium of glass would capture the vicissitudes of natural life and enable the perfect unity between man and "the eternal."[102] And through its interaction with the transparency, strength, and durability of glass, light was at the basis of the architecture of this new world. Light—sun, moon, and stars—as the ultimate expression of a universal consciousness would be captured in glass palaces to provide energy and harmony for earthly existence.[103] The interior of a glass building was designed to extend and open upward and outward onto the world, into the cosmos. Through its interaction with light, glass as both reflective and transparent surface would capture, reflect, and exude the ever-changing movements of nature. The lights of the sky would beam through its resilient matter, give energy to that which lies on its other side, and, through issue of light, the human world inside would bleed into the universe in a gesture of connection. Light and glass could enable the mystical union of the human and the beyond in a movement towards transcendence. Similarly, this world of glass was weightless, and through its walls the breath of God was free to waft.[104]

Although he was clearly interested in the possibilities of artificial light, nowhere in his writings does Taut specifically discuss electrical light. Neither did he venture to imagine the practical implications of his architecture for the day-to-day life of those it was intended to house. Taut's and his circle's cosmic aspirations remained on the level of the abstract, an abstrac-

tion that befitted the utopianism and infinity made possible through these unrealized forms. Despite their utopianism, however, Taut's sketches do illustrate the radicality of his architecture's potential reorganization of the material world. For example, they are not buildings to be seen from a single perspective. In designs such as those of the *Sternbau,* or star-buildings, in the fifth section of Taut's *Alpine Architecture,* we see a glowing glass cathedral floating in the dark of the night; the cathedral is seen from high in the sky, in harmonious balance with the stars and moon that provide its background. In other of Taut's drawings, fantastic worlds of lighthouses and airports made of glass, brilliantly lit by illuminated glass towers that double as structural supports, are seen from the sky, or from the distant horizon at sea. Navigation of the earth takes place from the sky for the first time: "every light tower will be built differently, emit a different light, and be fitted with glass elements of widely differing form. Uniformity in light towers is consequently out of the question."[105] They would be jewels of aesthetic beauty for all to marvel at and to be "enraptured by." In their individuality, the lights would be the navigational markers of the earth's surface from above. Glass motorboats would travel across water, seen from the sky as sculpted light floating on the water surface in the distance.[106] In Taut's future there would be no center from which to understand and perceive the world: with the mobility of the glass structure, shining in all of its jewel-like splendor, perspective of and on the world would become mobile, transient, elastic.

Taut's drawings also indicated an understanding of the much talked-about transformation of day into night. This transformation was enabled through the exciting possibilities of artificial light. Through the construction of glass walls in railway trains, airplanes, palaces, cathedrals, factories, and homes, the activities of day were seen to extend into the night. The concept of time had become permanently transfigured in this world fabricated in glass and light. Thus, this architecture's vanguard contribution to the conception of public and private space was marked by both the mobility and flexibility of vision within the modern technological world, and a transcendence, mastery, and assimilation of the same world from above. As such, it embodied the conflict between an idealist, secular experiment and religious aspiration at the heart of much modernist art.

To be caught in this bind, pulled between the desire for a transcendental experience—that is, the need to escape the pain and anxiety of historical existence—and an indulgence in the excitement of an earthly, mobile, and conscious vision of an ever-changing world, is typical of the modernist artwork. These works were produced at a time Georg Simmel

explains as being without faith in the church for the provision of spiritual understanding. This left the longing for spiritual transcendence without object or goal.[107] Artists such as Taut saw the reidentification of this lost goal as their responsibility. Simultaneously, the growing interest in the external world and the urge to connect the individual to the social led to concerted attempts to integrate and examine this external world for its possibilities. In the case of Taut's architecture, light and glass would fashion an external world that would, in turn, influence the individual and his relationship to that world. The way that Taut used these materials was at one and the same time mystically idealist and socially oriented, but always utopian. Thus glass and light were the vehicles for both a spiritual retreat from the details of daily life and a conscious mastering of one's place in a machine-governed world. This very predicament or contradiction made these architectural designs the measure of the historical moment in which they were produced. And ultimately, Taut's visions developed the discourse on the rapidly changing contours of everyday life. His exciting new modes of perception and representations of time and space within the industrial landscape are echoed in the films from the same period.

The Bauhaus architectural commitment to its contemporary world left behind the mystical, utopian aspirations that Taut and his circle considered pivotal to the realization of a successful modern architecture. For the Bauhaus masters and their followers, architecture's contribution to the formation of the technological world was defined by its rationality, physicality, and pragmatism. They eschewed all traces of the tradition that used light for mystical representations of unfathomable, chaotic worlds. The Bauhaus compositions in light and glass formed an art that used its medium for both fashioning and understanding the relationship between the world and the earthly limitations of being human.

The Bauhaus saw its aims and teachings undergo radical shifts with each of its well-known changes in personnel and location.[108] However, the commitment to glass as a primary material for the building of the future was begun in its earliest days and continued until the closure of the Bauhaus by the Nazi Party in 1933.[109] Under the direction of Hannes Meyer, the interaction of mass-produced glass with both daylight and electrical light took on a new and exciting role in the modern building. Glass was considered practical, easy to clean, hygienic, hard, protective. Most important, glass had the simultaneous advantage of enclosing and opening up space in more than one direction. In short, it could render an outside wall practically nonexistent. Thus, in certain examples of Bauhaus architecture, the barrier between inside and outside, a barrier always enforced

by stone, wood, metal, or marble, was dissolved by glass. In the residential and commercial buildings built by the Functionalist Bauhaus architects, glass was used as the skin of a construction in which the core (commonly, walled rooms) was always visible. Similarly, the space in between walls and core was filled with light. One step further than the Expressionist visions of architects such as Wassili and Hans Luckhardt,[110] in buildings such as Mies van der Rohe's "A Glass Skyscraper" (1920–21),[111] the administrative buildings or Gropius's "Masters' Houses" of the Bauhaus in Dessau,[112] a *physical* contact was established between inside and outside. This was achieved through the extension of spaces of light between the core and skin of a building and the outside world.[113] Similarly, the inside walls were often made entirely of glass, rendering the space inside totally visible and coherent. These buildings were "forms assembled in light," public buildings and residences defined by "the impression of an endless flow of space."[114] Here, in this dissolution of boundaries through an interaction of glass and light, this architecture forged new conceptions of the relations between inside and outside, public and private.

In the case of the residential buildings, inside and outside became integrated: the walled-in outdoor patio and the large, symmetrical, sparse dining or indoor living room were often separated by floor-to-ceiling glass panes. Thus, walls of these Bauhaus buildings dissolved into light and the indoor spaces were shaped by the light filtering in from outside. At night these same buildings, seen from outside, were reversed: in daylight the buildings were defined by the light flowing in from outside, and at night they were modeled by the light that emerged from within. The artificial light of nighttime blazed out through the structures of such buildings: the translucence of the indoors flowed into the world outside through the transparency of glass. With the architectural innovations set in motion by the Bauhaus masters, the spatial and experiential environment became revolutionized. To reside in these buildings meant to be connected to and integrated with the world outside their walls. Unlike the works of Taut and the other Expressionists, the Bauhaus designers conceived of a built environment in which all spiritual existence had become divorced from the religious notion of God as the all-seeing, all-knowing master. Through the facility of both natural and electrical light, it was the physical world and its discordance that dictated the spatial composition and logic of the modern world.

Bauhaus architecture was not alone in its revolutionizing of the built environment through glass in the latter half of the 1920s. The onetime Expressionist architects Erich Mendelsohn and the Luckhardt brothers,

for example, began to integrate aesthetic beliefs of the Bauhaus with their own idealistic visions from the early part of the decade.[115] Nevertheless, in spite of their Expressionist heritage, architects such as Mendelsohn and the Luckhardt brothers were sympathetic to Bauhaus principles and now conceived of buildings that rejected the utopian aspirations they had once annexed.[116] Thus Mendelsohn built constructions such as his famous Schocken department stores, including that in the industrial town of Chemnitz (1928–29), the Petersdorff department store in Breslau (1927–28), and the Cinema Universum in the Woga Complex on Kurfürstendamm, Berlin (1926–28). Whereas department stores had always been modeled on Renaissance palaces, Mendelsohn's were asymmetrical, dynamically changing shapes, devoid of any ornamentation. Like eyesores in the midst of a Renaissance cityscape, Mendelsohn's buildings fashioned of concrete and glass ribbons, stacked one upon another, created a struggle between solidity and transparency. The glass panes were vertical, the concrete bands horizontal, thus placing the solid and the transparent in further tension. They were full of vivid, conflicting angles and volumes, the entrance always off center. Thus, for example, at Chemnitz one facade of the Schocken store that stood on a corner was curved, another rectilinear, and the base of the building occupied an entire street block while the roof decreased to a third of this area as the building gradually moved upward towards the sky. In his provocation of the one-dimensionality and monotony of the cityscape, Mendelsohn created buildings that were always in motion, always dynamic in the dissonant, yet fluid, interaction of the various planes and fields of their action.

It was, yet again, the interaction between glass and light that enabled Mendelsohn to fashion these flexible, dynamic structures. Not only were natural and artificial light manipulated to create a unity between inside and outside, but they were both also used to disconnect inside from outside. In keeping with the contradictory logic of their physical design, these buildings both redefined the city space and remained marked by their isolation owing to their dominance of the same space. They were designed to be self-enclosed, secluded from the world in daylight hours.[117] In the daytime these buildings appeared as modern, streamlined sculptures of concrete and one-way glass. Although, when seen from the outside, they did give shape to the cities in which they stood, their interiors were nevertheless completely inaccessible to the eye, sequestered from the industrial world that surrounded them. Similarly, from the inside, the space beyond the walls of these buildings belonged to an elsewhere mitigated by these same walls. And at nighttime, the lights inside were turned on and the

buildings became sculptures in light. The electric lighting beamed out so that the function of the building dissolved into a sea of light that, in turn, merged with the surface-like nightscape of lights. At night, via buildings such as the Chemnitz department store and neon advertising, the city became reduced to a two-dimensional surface of light: it was a glittering image completely dissociated from the same buildings in sunlight. But it was also an extension of the daytime city: the three-dimensional, spatial definitions of the bustling, energetic activities of the daytime streets were extended to encompass the kineticism of the differentiated space of the nightscape. Through its fragmentation, disconnection, and simultaneous extension of the spaces of the city, electric light, and its partner, natural daylight, were intertwined to define and redefine the city as a multiplicity of spatial fields marked by their uncertainty. By the 1920s, light, in particular electrical light, was no longer the backdrop to city life. Rather, light had become the very matter out of which the city and the life led therein were determined.[118] Light was the facilitator of times and spaces that challenged the preexisting contours of public life.[119]

All of these post–World War I buildings in Germany, however utopian in intent, enjoyed a flexibility, transparency, and movement that had never before embraced the built environment. Even when they straddled the contradictory logic of striving to facilitate both spiritual reintegration and a physical reorganization of the material world, they always looked forward to new conceptions of the modern world. They envisioned this modern world as constantly changing shape, and abutting a perspectival system in which there would be a single center from which to view and inhabit it. The spatial designs were ostensibly free of hierarchies, able to adapt to the changing needs of daily life. In addition, they all challenged existing definitions of the distinction between public and private space.[120] Even as the designs and buildings embodied the idealist dreams of a world in which it was hoped that art could provide the moral and spiritual end by way of a salvation of the soul, it was a communal soul. It was not the isolated, individual, alienated spirit that had already become familiar to the post–World War I German city. In addition, these architectural designs set in motion an aesthetic that looked to the external world of machines and their product as tools with which humanity could attain harmony and perfection. If the fabric of the built environment formed a unity with nature, then those who inhabited it would experience the same without further mediation.

The parameters of this architectural revolution through and in light were specific, and yet related to those that took place in the other arts. If there was a specificity to the architectural, it lay in the fact that these designs

were determined by the spaces and relations to space in which everyday life was led. These spaces were thought to be inescapable, all-encompassing, and in a process of eternal development. All of the avant-garde architects of the 1920s can be said to stand at the helm of the processes of development of a world in which technology was the defining feature. They shaped the future modern, technological world largely in response to the fractured and alienating landscape before them.

## Theater

The innovations of the 1920s German film mise-en-scène, and the lighting in particular, have been identified for their relation to, at times their derivation from, early experiments in the theater.[121] The modern German theater did deploy lighting in what might loosely be called "cinematic" ways. However, the meaning and effects of this lighting were usually quite different from those of the cinema. Nevertheless, certain films and theater performances had in common the privileging of artificial light as the vehicle for a sustained engagement with the new modern world. In works in both media, light was used imaginatively to represent the effects of Germany's rise to technological modernity on the lives of ordinary citizens. In the theater, electrical lighting was central to the creation of productions that would be accessible to a wider audience.[122] If one of the most significant innovations in the modern German theater was the turning of the stage play away from a pastime for the privileged few into a socially relevant "theater of the people," the other was the attempt to explore the role of the individual in an era of massive political and social upheaval.[123] Both of these themes were repeatedly explored through manipulation of stage lighting. Although these themes are not directly addressed in the films, similar concerns with class and social struggle are represented in films such as *Jenseits der Straße* and *Am Rande der Welt*.

In Germany, prior to World War I the stage became revolutionized: the theatrical mise-en-scène and narrative were no longer naturalistic backdrops to a "literature on stage." Rather, the mise-en-scène of modern German drama became a space of aesthetic experimentation. The mise-en-scène was given precedence in the creation of performances that challenged the conservative, bourgeois traditions of the theater. Max Reinhardt's (1873–1943) experiments in the 1900s realized the attempt to foreground the poetic and stylistic elements of the stage play that had pervaded the writings and design sketches of, for example, the Austrian Adolphe Appia.[124] Generally speaking, Reinhardt's developments with electrical lighting transgressed three entrenched borders of the traditional

theater.[125] First, he reorganized the spatial and temporal limitations of the theater through innovative creations in the lighting; second, he used the lighting to create an impressionistic mood rather than to illuminate objects and characters; and third, he manipulated the lighting to blur the boundary between audience and stage, between the two different realities of the drama and the audience. These strategies, he maintained, would break down the barriers between the theater and the people. This new theater would engage the people's emotions through the heightening of atmosphere over narrative, and through challenging the old stage–audience hierarchies, people would understand the theater to be a reality integral to their own daily lives.[126]

Although Reinhardt is the name associated with revolutionizing the theatergoing experience and the style of dramatic presentation in Germany, in the 1920s his conceptual innovations were taken up by others to create a truly contemporary theater. The postwar dramaturges drew on Reinhardt's creations and developed a new abstract theater for the masses. This varied theater employed many innovations in and through lighting, thereby placing it in lively conversation with other artworks in the 1920s culture of light. Unlike Reinhardt, 1920s dramaturges no longer staged modern productions of classical plays.[127] Rather, figures such as Karl Heinz Martin, Paul Kornfeld, and Georg Kaiser produced scripts of their own and of their contemporaries. In their eagerness to break definitively with monarchical classist society, the playwrights wrote and directors staged plays that focused on a fatherless "New Man" who was usually given the task of reorganizing and leading "Humanity" into a future without either war or the social structures that had occasioned war.[128] In turn, audiences were alerted to the necessity to pursue the revolution and become enlightened along the way.

In their concentration on the central figure of "the Man" on his journey to insight, lighting always played a major role. Through the hard-focused white spotlights—which had become common usage after Reinhardt—the hero was given unprecedented prominence as he moved through a dreamworld of darkness. A single, intense light beam often followed the protagonist in his movements around the stage while all else remained eclipsed by darkness. The contemporary reviewer Ernst Leopold Stahl says of Richard Weichert's 1918 production of Hasenclever's *Der Sohn/The Son*:

> Herr Weichert . . . places the son—as the only truly physical presence—spatially in the center of the action, a center that becomes the objectified focus of the play because it is he that gathers the illumination of the spotlight about him.[129]

In addition, the spotlight, usually shining from above the proscenium, cast violent shadows on his face to create a mood of fear and uncertainty for which the Expressionist theater became renowned.

This technical and stylistic departure from the naturalistic environments of the classical theater used the lighting to remove—for both the characters and the audience—all familiar reference points, all resemblance to a tactile, tangible world. The protagonist and the audience were wrenched from reality and thrust into the hostile, fragmented space of the hero's mind. Thus, the protagonist was a piece, but still the centerpiece, of a world out of kilter, a world of which he was victim, and a world he had to negotiate in order to guide the way to humanity's future. Expressionist playwrights and dramaturges abstracted lighting in their representations of the landscape of the mind and soul of the psychospiritually anxious and socially alienated individuals at the center of their plays.[130] Thus, they used light and lighting as a vehicle for their vision of the individual's suffering at the hands of destabilized social and economic forces.

Playwrights such as Walter Hasenclever, Paul Kornfeld, and Reinhard Sorge wrote expressive lighting cues into their stage descriptions for *Der Sohn* (1916), *Die Verführung/The Seduction* (1913), and *Der Bettler/The Beggar* (1912), respectively, all of which would be performed in the 1920s. In the opening scene of Sorge's *Der Bettler,* for example, the Poet and the Friend are introduced conversing in a coffeehouse divided into four distinct sections, each marked by the presence of different characters, engaged in different activities. The Newspaper Readers, the Girl and her Nurse, the Coquettes as "decorations," and the Poet and the Friend are in turn picked out by a single spotlight. This spotlight would have differed in intensity and direction depending on the character's significance at any given moment. His or her significance was determined by their role within the Poet's imagination.[131] The Coquettes glittered under the intense, harsh force of the single-beam spotlight that fell diagonally across the stage. The Girl and her Nurse, on the contrary, sat bathed in a soft light before a window that looked out onto a night sky filled with shining stars. Walter Sokel describes the function of Sorge's lighting in *Der Bettler:*

> The lighting apparatus behaves like the mind. It drowns in darkness what it wishes to forget and bathes in light what it wishes to recall. Thus the entire stage becomes a universe of mind, and the individual scenes are not replicas of three-dimensional physical reality, but visualized stages of thought.[132]

The lighting opened up the space of the dramatic stage: it not only extended the literal spaces occupied by characters, but it also opened out the

reality of the stage to embrace the reality of the emotions and inner life. The lighting enabled the coexistence of the flesh and the life of the mind. Again, we see the cinematic quality of Sorge's use of the lighting in this opening scene. As attention shifts around the landscape of the Poet's mind in search of some form of inner, essential truth about his metaphysical condition, the different spaces and times onstage become abstracted. They only accrue meaning through their juxtaposition with one another in the Poet's mind in a montage-like effect.

Corresponding uses of light and lighting to create spaces of the mind can be found in the cinema. However, it is more common in 1920s German film to use a series of superimpositions, an unusual camera movement, a blurring of the image, or a moving collage of fragmented images to represent the workings of the mind. In F. W. Murnau's *Der Letzte Mann/The Last Laugh* (1924), when the man gets drunk the marvelously drunk camera movements reveal his inebriated state. And young Freder's dream in Lang's *Metropolis* (1927) is prefaced by a dazzling display of Cubist-like geometrical patterns, a preface that sets consciousness and dream state apart. This urge to give representational form to emotions and psychology in 1920s theater and film is historically consistent with the increased interest in the processes of individual mental life, and the historical agency of the individual that gained currency in Western countries at this time.[133] Nevertheless, in the cinema, it was not usually achieved through light and lighting.

The same contradiction that pervaded Taut's use of light to fashion both a physical and a spiritual experience is rearticulated with a particularly Expressionist dimension in Sorge's theater. All productions of a play such as *Der Bettler* used the vanguard lighting technologies to achieve a not so radical goal: the goal of this theater was to encourage spectators to identify with the plight of the lonely figure. In turn, spectators would be elevated to a state of spiritual regeneration. Thus, even though the struggle of the mind and body are fused in the play itself, for the audience, the spectatorial process is one of identification with and contemplation of the spiritual confusion and subsequent enlightenment. In addition, the radicality of the lighting effects lay in their disruption of the familiar comfort of the spectator as a distanced, disengaged party to representation. The harsh, jarring effects of the spotlights as they carved out the psychological reality of the Poet had a visceral effect on the audience. The traditional contemplative distance between audience and stage was thus dissolved, and the spectator's experience took on a physical dimension when she was confronted by the harsh rhythms of the light.[134] The intellectual and emotional contemplation of the lone individual's spiritual crisis was constantly

interrupted, in effect underlined, by the visceral, physical experience of the harsh lighting effects.[135]

This contradiction between a visceral response and a contemplation of humanity's spiritual crisis sustained the so-called Expressionist theater. In its oscillation between the physical and the spiritual, in its puncturing of the invitation to reflect with abrupt incursions of technological wizardry, this theater was the modernist relative of its architectural contemporaries. If some of the architectural examples were caught in a struggle between a yearning for transcendence of and an immersion in the innovations of the everyday, Expressionist theater transposed that struggle to the conflict between the inner life of the mind and that of social existence.

Dissatisfied with the apparent bourgeois luxuries of ideal inner freedom and individual regeneration as the staple of the Expressionist theater, writers and directors such as Leopold Jessner and Erwin Piscator turned their energies to an absolute theater of political revolution. Their work characteristically spoke to the working classes. It was the first credible theater of the proletariat—free of individualistic irrationalism and filled with the collective reality of an age in which machines brushed up against human flesh in the creation of the working-class masses. Playwrights such as Jessner and Piscator still chose to build on the technical developments of their predecessors in their depiction of this reality. However, the relationship established between stage and audience was consciously quite different. Sorge, Hasenclever, and Kaiser had, after Reinhardt, believed that it was enough to involve audience members by bombarding their senses with an excess of light, and overwhelming sounds. Such strategies were considered to bridge the chasm between representation and the perceptual experience thereof, between stage and audience, that had become characteristic of traditional theater. The dramaturges also maintained that a theater for the masses should confront contemporary reality by presenting abstract images of its essential truth. Thus, in the case of *Der Bettler,* the lighting was used as an expressive device that communicated the burdens of the Poet's mind. It was not deployed in the interests of verisimilitude, but rather to create the effect of various psychological states as the truth of the modern experience. In the 1920s so-called political theater, however, the audience of working people saw themselves as a collective on stage. Spectatorial involvement with the action continued to have the physical continuity between stage and auditorium as its basis, technical innovations extended to the use of conveyor belts and other stage machinery reminiscent of the factory, and the texts performed were often written by the proletariat. Most important, this theater of revolution was

deindividualized: it was about collective action, not individual intellection or emotion.[136]

The documentarist Erwin Piscator redefined the limits of the theatrical stage in the mid-1920s when he introduced the projection of film in the place of a stage set.[137] Piscator used film to extend the space of the stage, and to intensify the political urgency of onstage events.[138] Thus, for example, in his documentary of Germany during the war years, *Trotz alledem/In spite of Everything* (1925), the character of Karl Liebknecht undertook his revolutionary activities against projected newsreels from World War I. The disturbing images of the newsreels functioned as both commentary on and elaboration of Liebknecht's activities. The newsreels were also a visual extension of the space of the stage into the streets of Germany. In his production of Ernst Toller's *Hoppla, wir leben!/Hoppla, Such Is Life!* (1927) Piscator used film to extend the dramatic space physically when the protagonist—Karl Thomas—loosened the bars on a prison window to allow a group of inmates to escape. As Thomas reached for the window, a film projected onto a gauze at the front of the stage depicted a frightening image of guards laughing as they fired their guns for fun.[139] These guards, or soldiers, evidently occupied a space that was not intrinsically associated with that of the prison cell. However, the layering of film and live action worked to convince the audience that the film represented the action on the other side of Thomas's window. In this example, Piscator brought the spaces of inside and outside together through the projection of a physically absent, but conceptually contiguous space. However, it was not the dimensions and characteristics of these contiguous spaces that were the focus of this use of projected film. Rather, the impossible bringing together of these disparate spaces was created to depict what awaited the protagonist's escape from prison. It was an extension of space that was in the service of the character-motivated narrative. Similarly, through juxtaposition of otherwise unrelated film and live action, Piscator's production afforded the audience the omniscient role of actively conceiving the significance of the scene. Through this and other film projections, in their interaction with live action, Piscator communicated the crucial claims of Toller's script: that the fate of the individual is always derived from the historical events, such as the injustices and non-sense of war, that surrounded him. Piscator's use of film in such sequences was unique because he was able to carve out a conceptual juxtaposition of otherwise separate spaces—inside and outside the asylum walls—on the representational plane of the stage.

In 1920s Germany, lighting repeatedly figured as one of the primary

devices through which dramaturges expanded the boundaries of theater as an art form. Whether it was through the physical involvement of the audience in the action on stage, the bombardment of spectators' perceptions, or the harnessing of the spectators' desire to identify with representation, the new possibilities of electrical light were instrumental in the search for a proletarian theater. Once again, like the architecture of Bruno Taut and the Bauhaus, light and lighting were used in this theater both to represent and to contribute to the modern, technological world. Most important, in the theater we see an unapologetic rejection of the immediate monarchical past, a rejection that began with the redesign of the theater buildings and the technology used therein.[140]

Through this literal alteration of the relationship between audience and stage, modern German drama contributed to the reorganization and regeneration of everyday life. It had been centuries since working-class people had participated in the theater. In 1920s Germany, the theater assumed a prominent place in the capitalist leisure industry. The redesign of the theaters and the plays performed therein were public forums in which seemingly intransigent class distinctions were outwardly flouted. In practice, the theater may not have disrupted systems of class oppression and exploitation. However, its apparent contempt for conventional class boundaries was one of many expressions in Germany of the need to rethink these divisions. And they were expressions articulated through light and lighting.

None of these theaters were worlds of complete imagination. They were not theaters that encouraged total escape from the everyday world. Even when the Expressionist theater focused on the individual's search for clarity and enlightenment, it never intended to provide a gateway to a contemplative reverie. On the contrary, it was always confrontational and designed to have a physical effect on the spectator. Even if only through, for example, the bombardment of the senses by an excess of lighting and sound effects, there was always a concerted attempt to stymie escape into contemplation. Similarly, while the dramaturges and playwrights believed that all humans must suffer on their road to enlightenment, the politically motivated audience would be enlightened nevertheless.

The theaters of Sorge, Kaiser, and Piscator also embraced the contradictions that characterized other modernist works of the 1920s artistic culture of light. These dramaturges and playwrights directly engaged with the political disquiet and social unrest of the period, and thereby anticipated that their audiences would identify with the revolutionary spirit. Similarly, they optimistically believed that their unapologetic cries

for social reform through an assault on naturalism and an embrace of contemporary technological developments would impact upon spectators such that they would bring about changes to their everyday lives. However, in the case of the Expressionists, this overthrowing of the oppressive strictures of an outworn culture still demanded a journey outside of everyday reality, a journey into the disturbed world of the protagonist's mind, in order to attain enlightenment. This journey was mapped out through the excitement of the lighting. The theatrical search for a "new day" and a "new man" was largely academic and did not affect its audiences as anticipated. Indeed, it was not until the work of Brecht in the 1930s that the German theater would, as a product that was both instructive and entertaining, simultaneously urgent and fun, reach the audiences for which it was intended.

While the theatrical productions of 1920s Germany engaged with the chaos of political and social upheaval in very different ways from the architecture of the same period, these works also embraced contradictory uses of light. On the one hand, the plays deployed light and lighting to explore radical transformations to the physical parameters of everyday existence. Lighting was used to render the experience of theater a physical one. In turn, this physicality, or sensuousness, was intended to induce a physical, revolutionary action in the attempt to control a new social world. On the other hand, however, they persisted with a use of light and lighting that espoused the utopian possibility of social change through psychological turning away from the everyday world. It was anticipated that the spectator would identify with the dramatic protagonist and be led on a journey to enlightenment. The spectator would, having experienced the profound psychological insights of the protagonist, leave the theater committed to social change through action. Thus the dramaturges held on to a utopian belief in the ability of art to effect social revolution. Admittedly, it is not an idealism marked by spiritual transcendence, but rather looks toward secular goals. However, it is still a utopian aspiration nourished by a retreat from the material world. The 1920s cinema takes the engagement with industrially produced light one step further from the theater's nostalgic turn away from reality in search of metaphysical enlightenment. Like these theatrical examples, the 1920s films also offered a narrative art that exploited the possibilities of technical lighting to imagine a social interaction (though not necessarily integration) free of spiritual transcendence. In addition, the films anchor their narratives in and encourage edification through the examination of material social conditions. Thus, the proximity of 1920s film and theater can be identified in the similarities

of their staging of the defining modernist contradiction. This common ground between theater and film is also more generative than one that situates film's appropriation of lighting techniques from the stage as the basis of their relationship.

## Photography

Although 1920s German cinema is repeatedly said to have depended on the Expressionist theater, little mention is ever made of its productive relationship to photography. The literature that focuses on the points of intersection between German cinema and the other arts pays scant attention to the cross-pollination of film and photography during this period. This is perhaps because links between film and painting are immediately visible—the sets and artworks share aesthetic characteristics. Similarly, the visual correspondences between the stage and film mise-en-scènes are striking. The differences between film and photography are numerous: photography produces a single, stable image, while film is a series of images; photography is developed into a positive image, film is projected. Nevertheless, the fundamental content of the two is ostensibly identical— both are mechanically reproduced mimetic representations achieved by capturing an image generated by a ray of light in an emulsion of silver salts. Thus, materially the two media would appear to belong together. Indeed, their mutual engagement with the representational possibilities of a technically manipulated lighting in the 1920s gives them an affinity that has been curiously neglected.

The writings of critical theorists such as Benjamin, Kracauer, and Theodor Adorno aside, there was little to no critical reflection on the relationship between film and photography at the time in Germany.[141] This was perhaps owing to the fact that until the 1920s the German photograph was thought to be used for portrait and documentary purposes only: Peter Panter, writing in the left-wing *Die Weltbühne*, argues that photography could be reduced to one of two categories. Either, in the hands of the layman, it was a means to take family portraits ("Aunt Anna as a young girl") or, in the hands of the professionals, it was a means of doing the same but with "brocade curtains" and "dignified stances."[142] However, the reality was that, in the 1920s, photography was also taken up in Germany as a medium for artistic experimentation. In particular, it was used to push the boundaries of artistic representation.

In their inspiration to use the camera most advantageously, photographers such as Albert Renger-Patzsch and his circle were inspired to create a "New Vision," a technically reproduced image that would see the world

from new, mechanically derived perspectives and create a new awareness of the aesthetic possibilities of phenomena.[143] The passionate, politically motivated, Hungarian-born artist László Moholy-Nagy was an instrumental figure in this "New Vision" of German photography. For Moholy-Nagy, the mechanically produced image had the capacity to transform perception and visual communication. It was a medium unlike any other; a new mode of creativity that would help to develop the senses through exposing them to otherwise unfamiliar optical data.[144] Clearly, Moholy-Nagy did not believe that the function of photography was to reproduce "data" that existed in the visible world. On the contrary, according to his writings, photograms, photomontages, and camera photography extended and explored the visual issues raised by modern painting in entirely new directions. They achieved these goals by breaking photography down into its constituent properties: it was a new medium of light. If pigment was the medium of painting, a traditional form of visual representation, so Moholy-Nagy considered artificial light to be the medium of the photographic image, the art of the future.[145] In Moholy-Nagy's teachings at the Bauhaus, his writings and photographic works, light was the language of the photograph. Light did not illuminate an object. It was the very material of the photographic image. All representational meaning was replaced in Moholy-Nagy's photograms. This was even the case in representational photographs such as his 1929 *Portrait of Lucia Moholy*[146] or *Marseilles* (1928). In these images, we see a formal rendering of light that penetrates the blackness of space to produce an immediate visual experience. Moholy-Nagy's theories of light embraced both electrical light and natural light that was re-presented with the aid of technical visual apparatuses. The yoking together of the behavior of light in different environments and the technical visualization of this behavior interested Moholy-Nagy.[147] Thus, light was artificially generated, controlled and re-presented with the aid of lenses, mirrors, screens and so on. Through this process of manipulation, light created new and unforseen spaces.[148]

In keeping with his determination to use technical apparatuses to create a new vision for the technological age, Moholy-Nagy's interest in photographic reproduction extended to the cinema. He knew that, unlike any other medium, the cinema had the capacity to realize visually the articulation of space and time through light in motion. Moholy-Nagy maintained that only photographic-based art forms had the capacity to give light a materiality, a materiality derived from their being captured artificially on a chemical plate.[149] Cinema, of course, entailed a literal kineticism that was absent from still photography. In 1930 Moholy-Nagy

realized his preoccupations with light, motion, and technological representation in his film *Lichtspiel Schwarz-Weiss-Grau/Lightplay Black-White-Grey*. In this film he examined various degrees of reflected illumination and the overlapping movements of familiar Constructivist shapes such as circles, spirals, and poles. These shapes of light were, in turn, regarded from varying angles, and were illuminated by even more various lights. As the shapes mutated in size and distance within and across the frames, they created the space of the film: its depth and surface, breadth and width, on- and offscreen were shown through permutations of stasis and motion. In short, the film was a representation of the possibilities of abstraction in light by the kinetic photographic apparatus. It was, as the fulfillment of Moholy-Nagy's intentions, the total kinetic experience of the interaction of the cinematic apparatus and the sculpting of light for the articulation of space.

In his experiments with light, Moholy-Nagy did not intend to explore form for form's sake. He was firmly committed to the revolutionary project of the Bauhaus. All of his work looked toward fulfilling its function as "a seismograph of the relationships of the individual to the world, intuitive re-creation of the balance between the emotional, intellectual and social existences of the individual."[150] For Moholy-Nagy, art had the potential to reintegrate the individual biologically, emotionally, and socially so that she or he, as a functioning part of nature, could contribute to the spiritual regeneration of society. Within this utopian program, the light experiments functioned to stimulate the eye and expand visual capacity, hence consciousness.[151] The kineticism of film, the obscure angles of photography's vision, the play of light on the surface of both static and moving photographic images expunged the traditional, unified, and monolithic "natural" vision of the world through centered vistas and vanishing point perspectives. In practice and theory, the revolutionary medium enjoyed the capacity to edify through its fragmentation, distortion, multiple perspectival spatial forms in light. Unlike the representational art of the past, Moholy-Nagy's images shifted responsibility away from the artist to the viewer for the construction of an objective vision. In this way, the radical images of Moholy-Nagy and his students at the Bauhaus resembled the architectural fantasies of Paul Scheerbart. Moholy-Nagy saw the photograph and cinema as belonging to a whole family of "light machines" that would create form through the penetration and sculpting of light: neon signs, illuminated advertisements, searchlights, expanded spectacles of illumination in a night sky.[152] His vision bears unmistakable similarities to that of Taut.

Despite the political impetus of Moholy-Nagy's experiments, and without ignoring the important revolutionary aspirations of his project as they appear in *Lichtspiel Schwarz-Weiss-Grau,* the spaces are nevertheless abstract formal phenomena. Neither the spaces nor the light out of which they are crafted have any referential or representational dimension. And to attribute such to them would be to misconstrue Moholy-Nagy's project. Both kinetic space and light are objects in and of themselves; together with the potential regeneration of perception, they are the primary elements of the film. Thus, once again, similar to the conceptions of Taut, Moholy-Nagy's light plays are motivated by a constitutive contradiction, a contradiction that is realized through the extension of the two traditional forms of light in representation. Moholy-Nagy implemented light in its interaction with the camera in order to develop the physical, sensuous relationship to the world. Simultaneously, he used it to stimulate a transcendence beyond the artwork that would found a spiritual enlightenment, a utopian integration. He conceived of a fragmented, multiperspectival world that could be beheld, cognized, and mastered by the spectator of his light plays. Consequently, this fractured world would become integrated through contemplation of the dynamic image. Once again, technological art in and of light held the promise of a cure for the alienation and isolation of life in the technological world. And in Moholy-Nagy's photography, as in the Expressionist architecture and theater, this cure came through a shift from a spectator's reverential contemplation to a sensuous experience of a fragmented "landscape."

## Cinema: An Artform for a Secular World

The narrative cinema of 1920s Germany never promised the representation of or encouragement to revolutionary change. Similarly, unlike the other arts, there were no manifestos, and few theoretical writings by those involved in the industry; for the narrative cinema belonged to, and never sought to escape, the systems of production that enabled it to exist. The cinema was striving to legitimize itself within the very circles these other arts were attempting to assault. It was, in this sense, perhaps less radical than the artistic production that surrounded it. However, certain films represented similar thematic contradictions and tensions to those that propelled the other modernist artworks. In addition, the group of art films that explore light and lighting embraced a tension between a reactionary narrative outcome in which heterosexual love or morality triumphs, and stylistic experiments that question these easy solutions to the contradictions of everyday life. Thus, self-conscious examination of the effects of

technological modernity become complicated by the resolution of a narrative in which heterosexual love triumphs against all adversity and/or mystical goodness banishes all evil. Although this apparent contradiction between stylistic innovation and the teleology of the cause-and-effect narrative is not the ontological priority, it was the place to which the fundamental contradiction between a scientific as opposed to a mystical use of light was transposed in this handful of 1920s German films.[153] Within the logic of the threefold use of light, the melodramatic narrative is, as I argue, structured by light and innovations in lighting. Moreover, the uses of lighting that spawn the narratives are extraordinary displays in and of technical light. In turn, these narratives reflexively represent the technologically sophisticated society. It is here, in this often unresolved conflict between style and narrative trajectory, that the constitutive paradox of the culture of light is played out in these modernist films.

This clash between a melodramatic, at times atavistic, dramatic resolution and the celebratory displays of technical light and lighting represents these German silent films' specific contribution to European modernism of the 1920s.[154] Other 1920s European films also embraced this contradiction, and indeed, they were in a dialogue with the German examples. However, the German films are also specific because the thematic issues—namely, the particular contours of the German ambivalence toward modernity— raised through the conflict between stylistic innovation and cause-and-effect story do not bind other European films of the period together. The complex qualities of technological modernity might be represented through cinematic explorations free of entanglement with a cause-and-effect narrative—Fernand Léger's *Ballet mécanique/Mechanical Ballet* (1924) or René Clair's *Entr'acte/Between Acts* (1924). Alternatively, films such as Alfred Hitchcock's *The Lodger* made in Britain in 1926 embraced a stylistic creativity to articulate ambiguous or complex characters and their relations. Hitchcock's eerie close-ups in *The Lodger,* for example, momentarily delay the progression toward narrative closure. However, they do not always represent a vision that contributes to a conflictual narrative. Although the close-ups contribute to *The Lodger*'s vision of the disaffection of modern life, it is not a film that pursues the turbulence of technological society. The same could be said of Carl Dreyer's remarkable close-ups and camera movement in *La Passion de Jeanne D'Arc/The Passion of Joan of Arc* (1928). Dreyer's stylistic innovations contribute to the searing critique of the church and social beliefs pursued through the narrative, but not to a critique of modernity.

Throughout the 1920s, these German films also communicated with technological modernity as an international phenomenon. By extension,

they belonged to a thriving artistic modernism. The filmmaking that perhaps came closest to the German aesthetic was that of Abel Gance in France.[155] In *La Roue/The Rail* (1922), for example, a highly melodramatic version of the Oedipus myth is distinguished by its poetic use of rapid cutting and accelerating montage. Similarly, Gance's rhetorical wizardry does more than narrate a story. It depicts the overwhelming presence of the machine within the railway workers' milieu. The stylistic brilliance of *La Roue* creates conflict within the melodrama, and indeed, it ruptures and retards the narrative at various moments along its trajectory. In turn, this conflict offers a more complex image of the alienation of industrialized working life.[156] Although Gance's film does not use light and lighting to articulate its complex images of industrial modernity, it does tackle the uneasy existence of technical display within the narrative. This palpable correspondence between the German and other European films, especially the emergent art film of the period, is, as others have noted, the measure of the German film's engagement with an international modernity, an internationally developing film culture.[157]

Because of cinema's very definition in light, one could argue that every film technically manipulates light. By extension, numerous films, German or otherwise, could be interpreted as engaging with questions of technology and technological society. However, the threefold use of light and lighting in the selected 1920s films is unique, for in films such as *Die Straße, Schatten,* or *Sylvester,* electrical light is manipulated to represent the impact of technology on everyday life in 1920s Germany. These films do not simply deploy lighting as the vehicle or language for any thematic concern. They are specifically concerned with questions concerning technology and a society molded by technology. A film such as Fritz Lang's *Der müde Tod/Destiny* (1921) can be marshaled as a counterexample to illustrate the qualities of the films here analyzed. Lang's *Der müde Tod* was made at the beginning of the 1920s, at a time when experiments with light and lighting were beginning to flourish in the studios. In addition, the film incorporates light at every level of its representation. Lighting is used in the composition of the mise-en-scène, as an agent in the narrative progression, and for the articulation of thematic issues. Nevertheless, despite the extraordinary role played by lighting, *Der müde Tod* does not represent the transformation to a modern life fashioned by technological advance in 1920s Germany, for it is a use of lighting that does not engage with questions of technology. In *Der müde Tod,* lighting symbolizes the characters' role, it structures the composition of the frame and the progression of the narrative. The film's larger concern is one of a struggle

between life and death, eternity and human limitation, the inevitability of death and the immortality of love in death. This drama of opposites is played out as a conflict between light and darkness. Thus, light and lighting are also central to the film's thematic concerns. Because it is a cinematic manipulation of natural light and darkness, Lang's film might be considered a technological reiteration of an age-old mythical struggle between life and death. Nevertheless, the film does not contribute to a more developed understanding of technological modernity in 1920s Germany or the cinema's place within that modernity. Even though it may be interpreted as an allegorical tale, the value it places upon the immanence of life in death and so on is transhistorical. *Der müde Tod* is not specifically concerned with the modern technological world. The films I analyze all technically manipulate light and lighting to represent the transformations of technological modernity in their historical moment.

## Theoretical Ramifications

The intellectual landscape of 1920s Germany could never be complete without some mention of critical theory. Although a very different type of sociocultural analysis, the theoretical writings take up similar issues to those raised by the films and other cultural products in the culture of light. A number of writers also focused on the centrality of technologies such as electrical light in the social transformations that resulted from Germany's embrace of technological modernity. In effect, theoretical works can be seen to develop synchronically with the artistic and cultural products in their address of the redefinition of space, time, entertainment, and other aspects of everyday life in 1920s Germany. In the closing pages of this chapter, I draw attention to the relevant sociological insights of this critical theory. In the same way that the connections to aesthetic trends of the 1920s give the films an artistic status, their juxtaposition with theoretical works values them as intellectual discourses of sociological importance.[158] Although the critical theory does not belong to the culture of light, its concerns parallel those raised by the films and other works that do. In turn, this parallel further underscores these issues and further clarifies the films' relationship to technological modernity. Thus, I do not turn to critical theory as a lens through which to perceive the films; I detail it here so that the two phenomena can sit side by side and complicate our understanding of the films.

The work of figures such as Simmel, Kracauer, Benjamin, and Ernst Bloch is still in circulation today. However, there were also countless

other less prominent, German critics who examined the everyday, seemingly inconsequential, phenomena of the world around them in their analyses of modernity. Indeed, sociological analyses of modernity proliferated in Germany up until National Socialist rule. None of these writers focused solely on the role of electrical light in the fashioning of modernity. However, light always contributed to their pictures of modernity. For Kracauer, for example, the reflections, facades of light, neon advertising, and illuminated monuments of nights in the city contributed to the chaotic world of modernity, a world of external gloss that gave birth to the ideological and spiritual homelessness of humanity. This "profane" lighting fills empty spaces with fortuitous distractions that cover over what lies beneath the surface.[159] Thus, like the masses of non-individuated people absorbed into the network of city streets, like hotel lobbies and variety shows, lighting is one of the "hieroglyphs" born of industrial capitalism.[160] When Kracauer deciphers his hieroglyphs, again and again, he finds evidence of an unintegrated, isolated, and spiritually void individual who has become lost to the superficial surface of everyday existence.

Electrical lighting also plays a significant role in the "phantasmagoria" of Benjamin's dream world of commodities. It is a phantasmagoria that lulls human senses and cognition into a shared state of delusion in modernity.[161] The nineteenth-century arcades—labyrinthine cities in miniature—with their "intoxicating," "shiny enameled signs of businesses," and lighting from above shining on all who pervade their corridors are Benjamin's showcase of the kaleidoscopic distractions that shock and successfully dull the senses in modernity.[162] Like the capitalist exchange of commodities that are on sale therein, the kaleidoscopic arcade also alienates the subject of modernity. Significantly, for Benjamin, the "dreaming collectivity" of the modern world knows no history: in the arcade the spatial labyrinth takes on a temporal location because it belongs to an empty homogeneous time continuum. Nothing is remembered or recalled in the arcade because it is the architecture of a fetishistic, reified conception of cultural progress in which the present continues to reinvent itself (fashion) and no events can be politically or consciously experienced, thus remembered. "Every period appears to itself as unavoidably new."[163]

Although for Bloch the picture of the modern industrialized world is not as pessimistic as it is for Kracauer and Benjamin, the same fragments of social reality inform aspects of his theory.[164] For Bloch, the film star, the newspaper, the cinema, café culture, and "signs, much too illuminated for them not to be suspicious,"[165] are the myths that both "sustain the flow in

which [the employee] finds himself"[166] and reveal the possible transcendence of a world yet to be realized. The possibility of the restoration of the secular spirit will come from the recognition of the repressed past, the nonsynchronous, in the surfeit of myth. Unlike Benjamin's myths, Bloch's past does not return to the present in a new form, thus in a flattened-out ever-sameness. Rather, according to Bloch, the past has an explosive relationship to the present: it energizes the dialectic, the contradictions, that will spark the spirit of a utopian future. And art, such as the cinema, contains fragments of *Vorschein*, or "anticipatory illumination," that will enable the sensuous revelation of a truth. In turn, this truth will spawn a viable alternative to the modern life overwhelmed by rationalization.[167] Thus, each of these cultural critics and sociologists arrives at a very different conception of the impact of industrial modernity on the shape of history. However, their evidence for these changes is virtually identical in each case: they are all concerned to explicate and theorize the fragments of modernity, everyday cultural objects and events, as the parts that speak the totality of a thoroughly rationalized society. Similarly, they look to these artistic fragments for an alternative to the instrumental rationalization of modernity. And lastly, in certain passages of their writing, all are fascinated by the cinema as a potential vehicle for realizing the escape.

None of the films provide sociological theories or explanations of the unfamiliar, the exotic, the dramatic, or the angst-ridden in the experience of modernity. Rather, like other artworks, through their deployment of light and lighting, they engage with the issues raised by industrial capitalism and the consequent development of an instrumentally rationalized social world. However, the films are akin to the critical theories of Kracauer, Benjamin, and Bloch when they engage with the transformations to time, space, entertainment in the mechanization of the world. Nevertheless, in my history the "photographic image" does not reveal the fragmented memory of a buried layer of history, a history that is in turn a reality to be redeemed as the key to a meaningful existence in the future.[168] Neither does photographic and filmic representation have the capacity to enable a new sense of perception by liberating human consciousness from its bind with myth. The filmic and photographic image is not seen to reveal forgotten moments that consequently give depth to history as they do for Benjamin.[169] I do not want to imply that the photographic image is unable to fulfill all aspects of the emancipatory potential attributed to it by Kracauer, Benjamin, and Bloch. Certainly, these critics are correct to assert the capacity of the photographic image to see what we cannot and do not. However, Kracauer, Benjamin, and Bloch are concerned with the

photographic image as medium qua medium. Consequently, they believe that the technologically produced image in and of itself possesses the capacity to stage historical consciousness; it is a fragment in which the totality of modernity appears. In contrast, my study of this small group of German silent films shifts attention away from the medium qua medium and examines the content of individual films for their semantic meaning. Accordingly, the films do not hold out the promise of filling history with meaning because they do not function as a substitute reality. Thus, we must keep in mind that the two discourses of film and critical theory operate on two different registers. Nevertheless, when placed in the environs of the critical theory, the moving image can be read as an analytical discourse, as a text that represents or examines the world with a critical eye. The films are not emancipatory, visual attempts to pose an alternative reality; they merely envision the contradictions of the reality that is given. This said, while the German critical theorists approach the cinema from a different perspective, my study of the films demonstrates that modernity is as vexed for the films as it is for Kracauer, Benjamin, and Bloch. It is the nature and implication of this vexation that the films, it can be argued, conceive anew.

# 2

## Bringing Cinema to Life through Light: German Film to World War I

### Insights in Light and Lighting

We have become accustomed to thinking of pre–World War I German cinema as a cinema motivated by the necessity to entertain and educate the masses. In a film production and exhibition climate dominated by imported films, the emphasis of early German narrative film was ostensibly placed on attracting audiences, and educating them in the importance of national cultural, scientific, industrial, and social achievements.[1] Nevertheless, there were many teens films that placed a fascination for the medium at the center of their concerns. For example, the early film pioneer Oscar Messter pursued his interest in the technological possibilities of the cinema into the teens.[2] In films such as Franz Hofer's *Hurrah: Einquartierung/Hooray: Billetting* (1913) the young heroine blows soap bubbles that float offscreen only to reappear across an edit against a black background. When they reappear they are filled with the woman's fantasy images. This kind of masking and editing to represent the fantasies of a young woman is both exceptional for its exploration of the techniques and typical of Hofer's inventiveness. A director such as Julius Pinschewer, who owned and worked his own studio in prewar Berlin, also pursued methods of animation for advertising purposes.[3] These kinds of developments continued throughout the war with many, though not all, taking place in the interests of the war effort.[4] Thus, to focus solely on the educational and entertainment goals of the 1910s film provides an incomplete picture of the period's production.

In this chapter, I offer a close analysis of two films that embrace a tripartite use of light and lighting: Fritz Bernhardt's *Und das Licht Erlosch* (1914) and the industrial film *Der Stahlwerk der Poldihütte während des Weltkrieges/ The Poldihütte Steelworks during the World War* (1917). Bernhardt's film is one of many narratives from the period that tell of the lust, love, jealousy, and revenge of a fragmented family. The film uses light and lighting compositionally, as a motor of the cause-and-effect narrative, and thematically in its discourse on the contours of modern life. *Der Stahlwerk der Poldihütte* is somewhat anomalous within the scope of the larger project because it is an industrial documentary. It is the only documentary analyzed in this book. However, I include it here because so many of the technical experiments of the teens were taking place in documentaries made by industrial organizations such as the steelworks. Steelworks such as Poldihütte, and the more widely known Krupp facility, had their own camera people and invested in film both to encourage employee productivity and to advertise their production methods and the product itself to the world outside the factory.[5] Given the centrality of industry films to innovations in light and lighting use in pre–World War I Germany, it is appropriate to give them some consideration. In addition, although clearly a documentary, the narrative of a film such as *Der Stahlwerk der Poldihütte* mimics the arc of a fictional narrative. Thus the relationship between technical innovation and the cause-and-effect narrative is comparable, though not identical, to that found in the fiction films of the period.[6]

As pointed out in chapter 1, the development of the pre–World War I German film aesthetic was retarded by relatively unsophisticated technologies. Nevertheless, there were a number of outstanding examples of uses of light and lighting that signaled the cinema's active engagement with technological modernity during these years.[7] Although these early examples do not always display tripartite uses of electrical light, they do foreground light and lighting in their representations of modern life. Similarly, they provide a creative context for films such as *Und das Licht Erlosch* and *Der Stahlwerk der Poldihütte* as two films that do explore tripartite uses of light and lighting. Thus the innovation of these two films is not isolated within the German prewar studios; however, it is more extensive in its reach.

To give some examples: the cause-and-effect narrative of Oscar Messter's *Hochspannung/High Voltage* (1913) is enabled by electrical light. However, the lighting for the film and the depictions in light are not exceptional. Messter's film narrates the story of Hans Grüber, an engineer who works for an electricity plant. Grüber must prove his manhood and his indispensability as a worker to his boss, the father of the woman he

courts. Only when he has rescued a worker who has fallen down a cliff by acrobatically walking across the electricity wires does Grüber win the hand of his boss's daughter. Not only is Grüber an electrical engineer—a profession of modernity—he also works for an electricity plant and must negotiate the perils of the apparatuses themselves before he is deemed worthy of marriage to the woman he loves.[8]

Joseph Delmont's *Das Recht auf Dasein/The Right to Live* (1913) offers a sophisticated representation through light and lighting of the processing of photographic fingerprints as a form of police evidence. Delmont's film overflows with technologically advanced methods of criminal identification. In addition, it marshals all possible means of mechanized transport for the chase of the (wrongly accused) criminal.[9] Intercut with images of technologically enabled kinesis, *Das Recht auf Dasein* depicts the processing of the criminal's fingerprints through a dactyloscope in a sequence of luminescence.[10] The detective turns out the main light in the room and only his hands, his face, the photographic paper, and a bar of light in front of and above his figure are seen to glow in the dark. This compositional use of light and lighting is used to depict a modern photographic invention, an invention that is itself dependent on light. Thus, in this short sequence from *Das Recht auf Dasein* the criminal is identified through a process enabled by technical manipulations of light. Moreover, this process is depicted through a mise-en-scène dominated by the lighting's focus on the apparatuses involved. In *Das Recht auf Dasein* the narrative trajectory is not sustained by episodes in light and lighting. Neither does the film analyze the role of technologies such as light and cinema in the historical world. It is typical of the teens films to exclude critical judgment in their representations of technology. The critical attitude toward technology and its implications is more characteristic of the product of the 1920s. However, films such as *Das Recht auf Dasein* do marry technically manipulated light and cinema to depict social worlds that are impacted upon by the advent of technological advance.

Other striking examples of the use of light and lighting in 1910s German film can be found in Franz Hofer's compositions that extend into different planes of action, often taking place in deep space. Although Hofer's mise-en-scènes are admittedly sophisticated, the tendency to manipulate light for the forging of complex spaces is also characteristic of the 1910 films. In many examples, light and the camera join forces with mirrors and other reflective surfaces to create space.[11] Hofer's film *Der Steckbrief/The Wanted Poster* (1913), another detective drama, utilizes a number of these strategies.[12] The film's most memorable moments are associated with height-

ened emotional tension between the hero, Egon Valier, and Nelly Feron, the woman he courts. Their first meeting is—appropriate to the romantic couple in this technological world—on an electrically operated cable car. Nelly is inside the car, and Egon rides outside on the side step. The glass window of the cable car separates them, but this does not stop the potential lovers from striking up a connection. While the camera sits inside the car with Nelly, looking over her right shoulder, Egon is still clearly visible on the other side of the glass pane. He beckons her outside, and she goes without hesitation. Rather than going outside with the characters, the camera remains on the inside of the cable car and watches the courtship take place through the window. On two occasions the car goes through a tunnel, and as it emerges on the other side, the mountainous landscape through which it now travels is depicted with clarity in reflection on the window. In these sequences that deftly capture the picturesque landscape on the glass surface, the two lovers are still seen to continue their courtship on the other side of the window. We see an expert manipulation of light to create both depth and flatness across the surface of the film screen. The depiction of the lovers' wooing through the cable-car window extends the space of the action into the middle ground, and simultaneously, the reflections draw attention to the foreground of the frame. All the action is played out across the surface of the window, and yet, light, lighting, and camera work come together to create a tension between surface and depth.

In 1913 the lenses, filters, film, and shutter mechanisms were not so developed that such lucid images in deep space were always successful. On the contrary, too often, when the camera was positioned on the inside, looking onto an outdoor space, the foreground would be underexposed and the outside washed out through overexposure. A contemporary viewer was more likely to see experiments in the vein of Hofer's result in a reduction of the mise-en-scène to a series of silhouettes. Hofer's refined and highly complicated extensions and abstractions of space through light, lighting, and composition were exceptional. Irrespective of the artistic ambitions of many of the filmmakers, equipment constraints and a general inexperience with the behavior of light in its interaction with the camera and film material eventuated in many crude representations.[13]

There are many examples of Hofer's mastery of mise-en-scènes constructed through light and lighting. Nelly and Egon continue their courtship when they get off the cable car and take a walk through a mountain garden. The landscape they traverse is marked by rock face, trees, and paths that wind through the park. As the lovers stroll through this idyllic landscape, the play of natural light on the different surfaces and textures

of the garden creates an abstract space that reminds us of the curious patterns in light found inside Rabbi Loew's house in Wegener's *Der Golem*. As the couple stroll through a small tunnel-like cavity in the rock face, Hofer melds the natural sunlight with artificial highlights to transform the materiality of the space. The garden becomes a pattern in various shades of light and darkness, thus creating a full and textured mise-en-scène. Without this highly complex painterly image in light and lighting, the mise-en-scène would be empty. Even though Hofer depicts patterns using supposedly natural light, he does so through the use of the film camera, a technical device. In addition, as the characters stroll in long shot through the landscape, their bodies are never eclipsed by the shadows that surround them. Thus, Hofer must have supplemented the natural sunlight with technical lighting to highlight the characters. Thus *Der Steckbrief* offers a striking example of the type of explorations of light and lighting to create cinematic spaces in the 1910s.

This breaking up, or in the case of the sequence on the cable car, extension of space through a play with light and mirrors, was a feature of the abstractions that flourished in contemporaneous modernist representations. We only have to look as far as the images of Erich Heckel or Lyonel Feininger to see distortions in space through light based on similar principles, albeit to meet different ends.[14] However, in films such as *Der Steckbrief* the primary concern is not the abstraction of the landscape, but the motion of the characters through it. In contrast, for Heckel and Feininger, the relationship between the human figure and its background is the focus. Despite these differences, there is an interest in the representation of nonperspectival spaces through manipulations of light and lighting common to both painting and film of the time. Even if not always successfully executed, the flattening out and confusion of space was found in a number of the 1910 German films.[15]

Hofer's creation of different types of space through an interaction of light and camera was a particularly sophisticated example of the cross-pollination of prewar German film and the contemporary culture of light. They did not always play out the possibilities of technical light to their full potential; that is, they did not necessarily use the new technology metonymically in conjunction with the cinema to represent the transformations of technological modernity. Neither did they exploit the relationship between the camera and the light and lighting to interrogate the social transformations inspired by electrical light. However, there is ample evidence that *Und das Licht Erlosch* and *Das Stahlwerk der Poldihütte* were

not anomolous in their curiosity for the possibilities of their medium as a function of technically manipulated light.

Furthermore, the foregrounding of light and lighting in these teens films testifies to a continuity between the pre– and post–World War I films. The films' engagement with the social and cultural shifts to techno-logical modernity can be thrust into relief to marshal an argument for the development of a national cinema that transcends the political divisions of Wilhelmine and Weimar Germany. To reiterate, the manipulation of light and lighting in both the social world of contemporary Germany and its cinematic product is at the center of this conception of German national cinema. It is important to remember, however, that in spite of the continuities that I am stressing here, there were also marked differences in the use of and attitude toward light and lighting between the teens and twenties films. These differences are indicative of the fact that the teens films were not a naive precursor to those of the twenties, and likewise, that the later films did not simply imitate or extend the concerns of the earlier ones. The two film products were engaged in broader cultural dis-courses belonging to their respective historical moments, and these con-texts helped to fashion two independent, yet related corpuses of films.

In one last example, Richard Eichber's little-known *Das Bacchanal des Todes/The Death Orgy* (1917) contrasts light and darkness to distinguish between the different spaces of inside and outside, day and night, safety and danger. The film tells the story of Baroness Lona Dalmar on her wed-ding night. It is a dark, morbid tale that ends in the death of the bride, driven to suicide by the haunting memory of Lars, a man she once took into her confidence and, from his perspective, betrayed through her mar-riage to the artist Alexander Andrea. The events that take place indoors, in the safety of Lona's home, are brightly and evenly lit. And these sequences are constantly interrupted, or complicated, through cutaways to images behind the scenes, behind the curtains of this happy marriage. Those se-quences that involve Lars—with or without confrontations between him and Lona—are always shot through high key lighting. In fact, his presence is usually noticeable through his silhouette as it moves past windows and doors when he stalks through the night, looking for Lona.

Equally impressive, and what makes *Das Bacchanal des Todes* both typical and exceptional of contemporary trends, is the use of contrasting color tints to emphasize further the difference between these different physical and conceptual spaces. As was popular at the time, the scenes that take place outside in the deep of the night are tinted blue. In contrast, those shot inside Lona's house at her wedding celebration are tinted with

warm, sepia tones. In a departure from the standard contemporary uses of color tinting for expressive purposes, *Das Bacchanal des Todes* does not use red to signify danger, passion, and other intense emotions.[16] Rather, the same dark blue used to mark what goes on outdoors, behind the facade of the wedding celebrations, evokes the anxiety and fear experienced by Lona as she is stalked—both literally and psychologically—by Lars, the man from her past. The chill of the dark blue, dimly lit outdoor sequences is stressed through their juxtaposition with the warmth and ease of the evenly lit celebrations indoors. We can almost feel the harmony and joy of the wedding celebrations thanks to the rustic sepia of these images. Likewise, the anxiety and fear that pervade the blue of the night also leave us shivering on Lona's behalf.

*Das Bacchanal des Todes* here gives insight into one of the numerous functions and effects of color in early narrative cinema. Applied color is used to extend different hues and temperatures of light to represent both physical and conceptual spaces in conflict. In these examples from *Das Bacchanal des Todes,* monochrome color is applied to underline the contrasts of light and lighting. It is the different conditions of light and lighting that are tinted here: the objects within the image are not, for example, colored to create different textures. Rather, the image itself is colored to enhance the environment, the spaces otherwise created through light and lighting. We cannot generalize by claiming that all monochrome color applications from the prewar years were designed to interact with light to produce different emotional and narrative effects. However, the tinting and toning of film stock was often a complication of the function and effects of light and lighting.[17] Color offered filmmakers more dexterity with light at a time when other technologies were either not available to the individual production, or had not yet been developed.

Color and light are also married in *Das Bacchanal des Todes* in a unique moment of pure spectacle. At her wedding celebrations, Lona gives an impassioned dance performance dressed as a Pierrot. In the representation of this performance, color and lighting come together to replicate aspects of the film itself as a performance in lighting effects and colored light. The depiction of Lona's dance is not a self-reflective moment. However, its construction in kinetic fragments of lighting and color effects marks it unmistakably as a performance of the modern world.

In anticipation of the performance to come, the diegetic audience at the wedding celebration sits before a stage, just as it would in the movie theater. The camera is placed above and in front of the diegetic audience, looking down directly into their awaiting gazes. Thus, the film sees the au-

dience as though from the point of view of the raised stage, or the would-be screen at which they look. In keeping with the notion of an audience in a modern theater, the diegetic guests are depicted en masse, indistinguishable from one another, crammed into the frame. Their image of ecstatic approval in neutral earth colors is then intercut with rainbow-colored sequences of Lona's performance. As Lona moves rambunctiously, wildly twirling her cloak, the film stock rapidly shifts from green to yellow to red to yellow to green to yellow and so on. The floor on which Lona dances has the appearance of transparency, and the colored lights shine through from underneath. The yellow, red, and green beam through the floor up into Lona's swirling white petticoats. Thus the colors of the film stock are diegetically motivated.

The energy and rhythm of this montage of colored film segments also represents an exciting example of the sonic dimensions of the silent film. The lights flash on and off to the beat of the music, just as a disco floor would. We can feel the beat of the music, and all but hear its sounds when we watch the pulsation of color and light.[18] *Das Bacchanal des Todes* explores the marriage of color and light, together with the possibilities of editing, to create a spectacular attraction. And just as the diegetic audience is in awe of Lona's passionate performance, so we are enthralled by the spectacular performance of Eichber's film.

*Das Bacchanal des Todes*'s use of light to distinguish between two different spaces—that of the activities of the wedding night and the dark, other world of Lona's past, her other life—is a strategy used repeatedly by filmmakers in the 1920s.[19] Similarly, the visual representation of sound, often through manipulations in light and lighting, is also found in the German 1920s films.[20] The narrative of *Das Bacchanal des Todes* is not motivated by light and lighting. The film does not extend its representations to a discourse on modernity. However, together with films such as *Das Recht auf Dasein*, for example, the film does testify to the existence of a number of 1910s films engaged in explorations of light and lighting on a number of levels. These earlier films explore issues of modernity through the marriage of electrical light and the film medium in a way that is extended, interrogated, and pushed to its limits in the 1920s. *Und das Licht Erlosch* and *Der Stahlwerk der Poldihütte* provide teens examples of these same tendencies. Both films embrace a tripartite use of light and lighting; they offer concrete evidence of the German cinema's interaction with contemporary industrial developments from the earliest days of its narrative development.

Fritz Bernhardt's *Und das Licht Erlosch* and the industrial film *Der*

*Stahlwerk der Poldihütte* are two very different films made under very different production circumstances. One is a melodrama/detective film and the other a wartime documentary made to boost industry. Both create a mise-en-scène through technically manipulated light and lighting. Further, the films use their mise-en-scène to discourse on the processes of modernization. And, in both films, the discourse on light leads to the representation of the effects of modernization on people's everyday lives. Both films use technically manipulated light and lighting for compositional, narrative, and thematic purposes. With this tripartite use of light in mind, the two films offer penetrating insight into a striking continuity between a number of German films from the teens and twenties.

### Und das Licht Erlosch (1914)

*Und das Licht Erlosch* is a film narrative driven by forbidden love, jealousy, and obsession. The film tells of Werle, a merchant, who competes with his nephew Gerd Lind for the love of Inge Sörensen, the daughter of a shipowner friend of Werle. When Werle notices that Inge has begun to reciprocate Lind's romantic interest in her, he sends the young man to India on business and intercepts all letters written back to Inge. Faced with her father's bankruptcy and Lind's mysterious disappearance, Inge succumbs to Werle's overtures and marries him. Lind eventually returns and Werle's response to his nephew's advance notice of his return is to turn out the light in the lighthouse. Werle's anxious attempts to destroy Lind backfire, the lovers are eventually reunited, and Werle receives his just deserts. Like *Das Bacchanal des Todes*, *Und das Licht Erlosch* uses contrasts in light and lighting to create distinctions and tensions between different spaces and articulate the differing values of variant spaces, at different times of the day.[21] However, the most remarkable feature of *Und das Licht Erlosch* is the adroit use of the lighthouse, the light of which is referenced in the film's title. The chain of events that leads to Gerd's near death, Werle's downfall, and the young lovers' eventual union is structured around the beaming light of the lighthouse. Moreover, the mise-en-scène in these scenes underlines the centrality of the lighthouse to the narrative structure; for the lighthouse and its regular, pulsating warnings in light either sit at the compositional center of the image or dominate its design in other ways. True to its function as the beacon of modernity, in this melodrama of jealousy, immorality, and criminality, the lighthouse and the steady rhythms of its light are also the fulcrum around which the film's thematic concerns turn.

There is nothing remarkable about the lighting or the use of profilmic

light in the first few sequences of *Und das Licht Erlosch*. Then, at a dinner hosted by Werle in his richly decorated home, we are struck by the prominence of the flashing light of the lighthouse when it shines through the window of his office. Furious at the sight of Inge and Gerd's flirtations, Werle retires to his office to think things over. He summons Gerd to inform him that he must travel to India. Our attention is immediately drawn to the lighthouse, which is seen through the window in the background owing to the intensity of the flashes. Similarly, the harsh, bright light of the distant lighthouse is made prominent for its penetration of the soft sepia tones that tint these images. Although the character performance is animated, the stark beat of the light in its rotations overwhelms the otherwise static frames. These contrasts established between the flashes coming from the lighthouse and the color, lighting, and framing of the shot create a sense of urgency and anxiety around Werle's decision to banish his nephew. And indeed, subsequent important conversations that take place at night in the space of Werle's office are dominated by the light of the lighthouse (Figure 1). Even though the lighthouse is in the background, its imposing flashes puncture the otherwise calm environment captured in the sepia-tinted frame. In ensuing sequences it continues to

Figure 1. Werle (center), Nina, and a vagabond in Werle's study in *Und das Licht Erlosch*. Courtesy Netherlands Filmmuseum.

underline the intense emotions that pass among the characters who converse, and the actions that take place in its midst.

When Lind sends Werle word of his impending return, the film cuts to a local inn where seamen gather. Werle decides to employ two low-life characters to knock out the lighthouse keeper and extinguish the light that is pivotal to Lind's safe return on the ocean. When the camera first enters into the tavern, the lighthouse light is turned off and the men enjoy their drunken gathering. Then simultaneous with the fall of night, Werle arrives to propose his plan to hinder Lind's return. And the beam of the lighthouse pulsates through the window in the background as they plan their attack on its keeper. Again, the light is way in the distance, and yet it dominates the frame of these scenes. The light gains prominence either through its occupation of the frame's compositional center, or through the intensity of its flashes, which, in otherwise steady compositions, continue to arrest our attention. Once again, the narrative tension created by conversations about the knocking out of one man and the consequent elimination of another is captured through this movement of light.

Meanwhile, Lind is at sea, on his way home to his beloved. The light of the same lighthouse in the distance radiates security as it guides his ship on its safe homeward journey. In brief cutaways we see the ship on the distant horizon in evenly lit, blue images, slowly making its way towards land. The same light that underscores the urgent and nervous activities of Werle and the lowlife he employs functions to comfort and reassure the young sailor. Furthermore, the light of the lighthouse binds the three different spaces—Werle's office, the tavern, the ship—and the three groups of characters who inhabit them. It may mean something completely different to each of them, but it binds them together in the same narrative nevertheless. Thus, light is a central organizing principle of the mise-en-scène and the narrative, as well as setting the emotional tone and creating narrative tension. This extraordinary deployment of light in *Und das Licht Erlosch* is indicative of the pre–World War I German filmmakers' sensitivity to the capacities of the medium in which they were working.

When the action of the film moves inside the tower of the lighthouse, the film's relationship to the light that has guided the narrative thus far reaches yet another level. The sequence in which Werle and the two vagabonds sabotage the smooth operation of the lighthouse is introduced by a flame moving from left to right across the screen.[22] The criminals have arrived at the scene of their crime. This light is the beaming torch of the criminals as they negotiate their way into the otherwise blackened tower. Their figures are hardly distinguishable, but the light that guides them

shines throughout their climb upwards. And as they disappear up the ladder that leads them to their victim, we are left with the image of their radiant torch in an otherwise motionless frame. The film then cuts to the lighthouse keeper, high in the tower, the camera face-to-face with the rotating mechanism of the warning light. The brilliant red light (and here the tint encourages us to feel the intensity of the burning light) turns on and off as the mechanism turns on its regulated path. As it moves past the opening in the walls, the light shines directly into the lens of the camera. In this marriage of the mechanisms of film camera and lighthouse fire, the image before us is dependent on the rotation of the light. As the light turns towards the camera, it overwhelms all else in the frame. At these moments, the white light of the flame becomes the primary content of the image. Thus, the warning signal in light is further extended from its role as narrative pivot and compositional focus to become the subject of the film and its images. We see Werle and the scoundrels arrive at the top of the tower, assault the keeper, and the image is suddenly interrupted: the next thing we know, an intertitle tells us ". . . the light went out" (Figure 2). With the extinguishing of the light, the film itself must be stopped and an intertitle left to explain the absence of the image. The light tower is not only pivotal to the characters' ability to carry out their

Figure 2. Werle (left) and the scoundrels (right) arrive at the top of the lighthouse to knock out the keeper (center) in *Und das Licht Erlosch*. Courtesy Netherlands Filmmuseum.

narrative goals, but it is now the engine of *Und das Licht Erlosch*, the film to which we are spectators. The striking and spectacular flashes of the beacon have become linked to the mechanisms of film production.[23]

When we first meet the lighthouse keeper, he is shown stoking and regulating the flame of the fire as it smolders in a great glass bulb. Thus, we must take care before making claims for the marriage of technological light and cinema in these sequences from *Und das Licht Erlosch*. For in fact, the beam of the lighthouse is not electrically produced. However, like the naked flames of the torches used by Werle and his hired vagabonds, the light that represents it is technically derived. The turning on and off of the lighthouse beam is always the result of screenings and maskings produced in conjunction with the mechanism of the film camera. In addition, when the film moves inside to show the keeper attending the fire, the reflection of the light on a mirror behind the camera is refracted back onto the wall that stands around the rotating light. This technical manipulation of mirrored light functions to accentuate further the brightness and overwhelming nature of the warning light. Thus, the technical capacities of film are used to represent and exaggerate the effects of an otherwise natural light. The integration of light, lighting, camera, and other technical devices is a manipulation of light made possible by the parameters of the film medium.

Although there are other films from the period that use light and lighting to create more sophisticated mise-en-scènes—for example, those of Franz Hofer mentioned earlier—unlike many others, *Und das Licht Erlosch* embraces the multiple possibilities of light and lighting. The complex deployment of light, lighting, and other technical devices within the mise-en-scène and narrative of *Und das Licht Erlosch* guarantees their mobilization at all levels of the film. Narratively, light is Werle's answer to the downfall of his ward, thus the continuity of his marriage to Inge. Light is also Gerd Lind's lifeline, thus binding the characters together when they occupy distant spaces. The film also uses both pro-filmic light and filmic lighting as the compositional focus, and by extension the emotional barometer. Moreover, the narrative climax is represented through an equation of film mechanisms and light—the light is extinguished, and with it, the film cuts to black. Lastly, the film completes its assumption of the tripartite concern with electrical light and cinematic technology as the instruments of modernity through its primary thematic concerns. Despite the fact that *Und das Licht Erlosch* does not fully embrace the parameters of technological modernity (the light mechanism of the lighthouse is naturally rather than technologically produced), it utilizes these representations of natural light to discourse on things modern.

That said, the lighthouse is by no means an invention of modernity, as its role in the protection of ships at sea dates back to medieval times. Nevertheless, there are certain periods that are particularly important to the development of the lighthouse. Most notably, the lighthouse's dependence on the beam of light that gives it its raison d'être has led to its transformation with each new advance in light technology. Thus, the mid-nineteenth century was a significant time for the development of the lighthouse as the use of gas and other artificial substances became increasingly widespread for nighttime illumination. And at the turn of the twentieth century, the lighthouse was duly revolutionized along with the electrification of light.[24] It was not only a question of the intensity, longevity, and range of the beam of light that captured the imagination of engineers in the first decades of the twentieth century. Rather, much discussion took place about the position of the light above sea level for optimal projection, the mechanics of the apparatus that turns the light, the effectivity of the glass lenses, and such topics as the quality of the light: should it flash, sparkle, or remain a solid beam throughout its cycle?[25] The lighthouse was not an invention of technological modernity, but all of the issues raised in relation to it at the turn of the century were spawned by the industrial developments of this period.

*Und das Licht Erlosch* appropriates these characteristics of the beam of a modern lighthouse as the primary vehicle for its discourse on contemporary modes of socialization. Like many other of the prewar sensational dramas, *Und das Licht Erlosch* depicts familial and social relations that are typical of the contemporary world. The film represents an incomplete family, the jealousies of a father figure toward a younger man, perverse romantic relations by which an unsuspecting woman is hindered from achieving her goal, and anxieties and tensions that had become hallmarks of life in the midst of technological modernity.[26]

*Und das Licht Erlosch* is not a film that directly engages questions of technological advance—particularly developments in light and cinema—as will become common in the 1920s German films. Even though it does depict a social drama that is enabled by the complexities of light, the film does not claim a cause-and-effect relationship between technology and social relations. Neither is one used to comment on the other, as was the case in the 1920s. Rather, the two coexist in the same narrative, and come together to envision the same modern historical world. This noticeable difference is characteristic of the use of and attitude toward light and film lighting in the film products on either side of World War I. Thus, the 1920s examples did not simply extend the concerns of their prewar

counterparts, but they reconsidered their relationship to technology and modernity. However, what does remain consistent across the rupture created by World War I is the tendency seen in *Und das Licht Erlosch* to create conflict between stylistic explorations and the development of the plot.

The moments of light and lighting display—that is, those moments when the pulsating beam of the lighthouse seen from afar or its raging fire seen in close-up come to dominate the frame—are, on the one hand, designed to motivate the narrative of jealousy and criminality. On the other hand, the light's domination of the frame also arrests our attention in these fragments. We, sometimes only momentarily, wonder what is going on, and our attention is distracted from the story at hand, it is pulled away by the intensity of the display of light. Indeed, as much as the prominence of light serves to underline the tension between characters, the film also consciously pulls us away from the contest between Werle and Lind. It does this through techniques that deliberately isolate the moments in light. As mentioned earlier, the stark vibrations of the light beam are compositionally centered in shots taken inside both Werle's office and the tavern in which the lowlifes plot their attack. Clearly, the scenes are shot in the same space, only with different props. However, as spectators we are struck by the discontinuity of the narration at these moments. Our desire for logical distinctions between different interior spaces alerts us to the impossibility of windows in both locations giving identical views of the lighthouse. Again, when the vagrants climb the tower to extinguish the light that would guide Lind to a safe reunion with his loved one, the continuity of the film itself is also interrupted. When the camera looks directly into the beam of the rotating light, the image is eclipsed either by the intense brightness of the light or the blackness of its absence. When the light is eventually extinguished, we are not privy to the action itself. We are left to ascertain the information at second hand, from an intervening intertitle. At these and other moments in *Und das Licht Erlosch* the film's primary concern is the turning on and off of the light, not the smooth flow of the narrative. We are asked to focus on the film's sensitivity—in both its material and conceptual inflections—to the exciting possibilities of technological light. Consequently, it is not unusual to momentarily lose track of the plot, and be forced to negotiate a rupture between the two narrational discourses: style and plot.

Other critics have suggested that *Und das Licht Erlosch* is crudely edited, that its "sensationalistic story line" is weak, confusing, and only "held together by the intertitles."[27] Although this is certainly a valid observation, it is also possible to argue that the film is working according to a logic

that does not always place stylistic exploration in the service of seamless narrative continuity and easy consumption. This principle of narrative construction is privileged and indeed becomes a distinguishing hallmark of the German 1920s films. In the 1920s films, the conflict between two registers of narration is commonly used to represent a negotiation between two different attitudes towards technological modernity. Similarly, it becomes a strategy to deny ease of narrative consumption and to engage a thinking, reflective audience. *Und das Licht Erlosch* may not juxtapose opposing visions of technological modernity through its stylistic excess. However, its narrative is built on ellipses that create inconsistencies in the spectator's mind. In turn, these inconsistencies ensure that we marvel at the film's technical achievements in and of light, the domination of light and darkness in the mise-en-scène and narrative construction, as well as attending to the chain of narrative events. These three different discursive layers often appear to clash, and effectively rupture the smooth surface of the narrative film. According to this mode of narrative development, *Und das Licht Erlosch* offers a sophisticated example of a film motivated by the contradiction between a utopian narrative pattern and technological experimentation. The argument that this contradiction can be identified as a defining principle of those German narrative films that showcase innovations in and of technical light and lighting gathers conviction through the film analyses in the following chapters.

## Das Stahlwerk der Poldihütte während des Weltkrieges (1917)

*Das Stahlwerk der Poldihütte während des Weltkrieges* is different from the other films here analyzed in that it is a documentary. As its title suggests, the film tells the story of steel production during the war.[28] *Das Stahlwerk der Poldihütte* belongs to the important genre of the industrial film that flourished in Germany at this time.[29] From the earliest days of cinematic invention, the new medium was often conjoined with big industries such as steel and ironworks.[30] These industries and the cinema matured in the same industrial climate. As everyone who writes on the subject points out, the landmark Lumière brothers' film shows the workers leaving the factory at the end of the day's work. By the 1910s, most of the major German steel and iron industries were using film, not only for the advertisement of their industry, but for the development of their product and production methods. Thus, Krupp used film from as early as 1908 for inspecting the mechanics of its artillery manufacturing at Meppen.[31] Film was considered the perfect medium to showcase the production methods and

products of companies such as Krupp AG and Siemens-Schuckertwerke GmbH. Not only was film dependent on some of the same production materials and methods as other industrial goods, but it had a force of attraction that guaranteed access to a vast audience.[32] There was praise for the cinema in specialized steel and iron journals.[33] Similarly, from the beginning these films were professionally produced with the involvement of some of the cinema's most prominent figures, including Messter.[34]

All this said, *Das Stahlwerk der Poldihütte* is the only documentary analyzed in this book devoted to an exploration of the German silent film's engagement with a pre–World War II European modernism. Accordingly, the structure and logic of *Das Stahlwerk der Poldihütte* in places departs from that of the other films here analyzed. Nevertheless, I include it here because on the precipice of World War I, it was in the arena of these industrial documentaries that many of the innovations in German film were taking place.

With the outbreak of war, the industrial film mutated into political propaganda that sang the praises of the German war effort on the home front and in neutral countries abroad. Typically, these documentary films proudly depicted the production methods and aestheticized the products of shipyards, airplane hangars, and munitions factories.[35] The Poldihütte steelworks in Kladno near Prague manufactured crankshafts for airplanes, and, like other films in the genre, its in-house documentary of 1917 brings the shared interests of the steel industry and the film camera together during the First World War. Although *Das Stahlwerk der Poldihütte* is not a fictional dramatic narrative, its striking use of light and lighting as a primary narrational strategy places it firmly within the tradition of German films that deploy light to discourse on the intersection of technological modernity and the cinematic medium. In this case, technological modernity is captured in the steel production process, a process depicted through the coming together of light and cinema.

Critics have already noted the thrilling and intimate relations between industry, cinema, and the rationalization processes of modernity as they are represented in *Das Stahlwerk der Poldihütte*.[36] However, what remains striking about the film's representation of the spectacle of steel production, and its simultaneous images of modernity and progress for a Germany at war, is the articulation of these attributes through a manipulation of light and lighting. For *Das Stahlwerk der Poldihütte* the enthrallment of the processes of steel production is both depicted and aroused in the audience through an equation between steel fabrication, the construction of the cinematic mise-en-scène, and displays of light. This symphony

of technological agility and splendor is the primary language for inter-rogating the transformations of technological modernity in the 1910s. However, unlike the later films, and in keeping with the tendencies of the films of the teens, *Das Stahlwerk der Poldihütte* is not a critical analysis of the upheavals of technological modernity. The film is effectively a piece of national propaganda: it aims to assure its public of the strength and direction of the German war effort. Thus, there is no social analysis of the processes of steel, light, or cinema production in *Das Stahlwerk der Poldihütte*. Instead, we are offered a celebration of the "magical theater of modernity and efficiency."[37]

As Kimberly O'Quinn remarks, perhaps the most outstanding aspect of the film's mise-en-scène is the abstraction of the image in what amounts to a repetition of the mechanization and rationalization processes of the pro-duction line. The abstractions, through a manipulation of light, lighting, and frame composition, also create a distance that sparks our fascination for the otherwise alienating processes of steel production. The film opens with a pan from left to right across the yard of the steelworks in broad day-light. On its way, the camera observes various machines and the setting of the yard itself. The camera then follows a forklift into the mill where it sees the raw iron being placed into a blazing oven. Shortly thereafter, in what will be an oft-repeated shot throughout the film, a long-take, static frame watches the activities of the factory floor from an apparently objective posi-tion at the end of a row of blazing ovens. The image is organized around rail tracks that cut through both the image and the space of the factory floor. They run from the bottom left-hand corner of the frame to a diminishing point in the background, a point made indistinguishable by the daylight that bursts through the rear factory entrance. The tracks will be used by the wagons that transport steel around the factory through its various produc-tion phases. Burning ovens line the left-hand side of the factory space, and occupy the upper left-hand corner of the frame. To the right of both the tracks and the film frame the bodies of anonymous workers move parallel to the line of the tracks and perpendicular to the distinct plane of the brick floor. The primary task of the workers is to pull the now roughly formed iron out of the ovens. The camera in this shot is positioned to capture the brilliantly glowing iron as it is taken out of the oven. Thus, the center of the frame is occupied, not by the workers or the ovens, but rather, the steel in process, represented as a shape of intense light. The workers on the right-hand side of the frame are only important as facilitators of the material they work with. The star of this film, that which is afforded compositional promi-nence, is always the red-hot, radiating light of the manufactured steel.

In all of the following sequences, the compositional center of the frame is given over to the vivid light of the iron as it is placed inside the electrical ovens for firing and shaping. In addition, its importance is accentuated by the darkness that surrounds it. Everything else in the frame—the machines, tools, conveyor belts, and men—is cast in darkness. The fires of the ovens and the amorphous shapes of would-be weapons illuminate the screen and constitute the most distinct organizational markers of the frame. Even the human form is virtually indistinguishable as the camera's attention is entirely focused on the metal as light, always ensuring that it is the focal point of our attention. In a strategy that underlines the wonder of the material here produced, a single ray of what appears to be sunlight beams in from the upper right-hand corner of the frame, through an opening in the factory wall. This illumination is not simply the aleatory condition of the pro-filmic. On the contrary, the sunlight is very carefully integrated into the overall composition and meaning of the image. The light falls onto the tracks, which in turn hold the wagons, which are the molds into which the now molten steel is tipped when it comes out of the ovens. Thus, the intense light, whether it be natural sunlight or cinematically produced, acts as a spotlight to illuminate the action.

In this first part of *Das Stahlwerk der Poldihütte,* we are struck by the brilliance of the metal as light, and also by the precisely drawn lines of the composition. Our attention is drawn away from the particulars of the steel production process by both the technological spectacle of the raw material in process and the precision of the film image. Both attractions are depictions in technically manipulated light and lighting. In the images divided by the tracks, the tracks determine the lines of the movement on and around them. Thus, the ovens are neatly lined up behind the tracks and the men positioned in front of them, at a distance that ensures their safety from the burning ovens. The rods they use to take the formed iron out of the ovens cut perpendicular to the tracks. Thus, the patterns created by the tracks, the ovens, the machines, and the men are generally geometrical and static. The movement within the frame is then provided by the metal on its journey through the production process.

In stark contrast to the structured pattern of the mise-en-scène's static objects, the movements of the iron and steel are elliptical and often unfinished. Thus, the abstraction of the image is effected through a tension between stasis and movement, geometricization and apparent arbitrariness, all of which is achieved through the stark contrast between darkness and light. We lose sight of the substance of what is being produced at Poldihütte and become enthralled by the spectacle of technological

production and its film rendition. We forget any hardship or danger that may, for example, be experienced by the men working in such threatening proximity to molten metal. And we conveniently forget that the end product of these early stages will be used for destruction on the battlefield. In keeping with the intent of *Das Stahlwerk der Poldihütte,* we are struck by the beauty of the glowing metal and the capacity of the camera to record it in all its splendor (Figure 3).

O'Quinn discusses *Das Stahlwerk der Poldihütte*'s repetition of the contradictions of modernity's technological rationalization in the contradictions between on-screen and offscreen spaces.[38] The same conflict between the coherence of Poldihütte's factory spaces and the enigmatic, nonrational spaces that exist behind the otherwise highly organized facade can be easily transposed to other aspects of the aesthetic. Indeed, typical of the German cinema's emphasis on the image and mise-en-scène over and above the use of montage,[39] *Das Stahlwerk der Poldihütte* returns the processes of technological rationalization and its tensions to light and lighting composition.[40] The conflict between the geometrically structured mise-en-scène and the less systematic movement of the glowing metal as it moves around the factory is also a potential site of contradiction. The

Figure 3. Working with molten steel on the factory floor in *Das Stahlwerk der Poldihütte.* Courtesy Netherlands Filmmuseum.

spectacles of red-hot steel represented as intense, moving light extend beyond the representation of the mechanization process. They are in excess of the containment so central to modern mechanization processes, so vigorously depicted in the geometricization of the mise-en-scène of *Das Stahlwerk der Poldihütte*. Thus, the film's aesthetic tensions point toward the inherent contradictions of a world dominated by, yet never fully contained by, the systematization and efficiency of technological modernity.

These compositional tendencies continue when the film shifts to a depiction of the movement of slabs of metal around the factory on conveyor belts. Once again, as the iron is maneuvered around the factory, we do not see the distinct shape of the slab itself. Rather, the static long shots represent a glowing abstract shape in motion. Little else in the frame is distinguishable, save for, now and then, the glistening machines and cogs that reflect the light of the metal in motion. Thus, we cannot distinguish the different stages of production through which the metal moves, the rationale of its journey and various stops. Instead, we are treated to a marvelous display of special effects in light. In these final phases of the film's first part, the abstraction of light moving across and around the frame is even more pronounced than in the earlier sequences. Without the context of the factory that is given by the film in the opening sequences, these passages could be mistaken for an experimental, nonrepresentational film that engages questions of movement and perception as it is expressed through an abstraction in light. Thus, *Das Stahlwerk der Poldihütte* quickly leaves behind its ostensible function—to educate in the processes of steel manufacture. Instead, the film invites its audience to revel in the enchantment of industrial production through awakening its fascination for marvelous depictions in technically produced light. The fundamental content of the first episode of *Das Stahlwerk der Poldihütte* is a marriage of light and cinema for the celebration of the wonders of technological modernity.

The film's second part depicts the shaping of the amorphous steel blocks into recognizeable objects—missiles and grenades. These sequences are shot in a noticeably more even light. The specific production processes are of more importance, and therefore the belts, cables, machines, and the objects themselves, again arranged in geometricized patterns, come to the foreground in this second part. They are shot away from the ovens, in the strong, even light of the factory's interior. Much like the film studios of the time, the factory at Poldihütte is built of steel-reinforced glass, and the walls and roof let in enough light to provide a uniform key illumination. Nevertheless, the contradiction between the strict geometricization

of the mise-en-scène and the unpredictability of the movement of steel as light is maintained throughout this section.

In the long shots of the factory floor, the tracks continue to dictate the organization of the machines and people in their midst. The image of the factory is always one of extreme organization, and likewise, the end products are always shown very carefully and systematically stacked. And yet, when the camera cuts to a close-up, these compositions of rationality give way to an abstraction of a different kind. The film lighting is dimmed and the glowing, often burning slabs of steel and their movements are discernible. It is here, in the space between long shot and close-up that, in its second part, *Das Stahlwerk der Poldihütte* embraces the contradiction between the rationalization of technological modernity and that which cannot be contained. Once again, we are able to discern the contradiction through an aesthetic tension driven by a skillful manipulation of light and lighting.

The third part of *Das Stahlwerk der Poldihütte* depicts the production of crankshafts for airplanes and cars. When approached through the lens of light and lighting, this final part is a recapitulation of the first. Again, in this third section, *Das Stahlwerk der Poldihütte* depicts the production of steel as exciting through its marriage of steel, light, and the possibilities of the cinematic medium. Similarly, the aesthetic tension is once more created between the geometricization of the image in long shot and the looser movement of the steel as light in medium shot and close-up through the ordered yet darkened space of the factory. We watch the preparation for crankshaft fabrication: the unformed steel slabs are fed into the ovens at right angles to the camera. Again, the men who manually guide the metal are sidelined within the frame while the glowing slabs of steel are carefully placed at its center. In a clarification of the ambiguous status of the film's lighting in the first part, here the illumination of the end product is quite clearly ameliorated by the lighting of the film. We see different images of varying metal objects. Some are lined up against a wall, others stacked on the floor, others seem to be suspended in midair because of the way they are lit. Common to all of them is their glistening surface surrounded by the darkness of the factory. Although of a different order from those seen in the film's first part, these objects nevertheless form abstract patterns in light and darkness. The finished products are no longer red hot and glowing from the fires. Thus, lighting has to be applied to them from outside: the light of the film gives them their luminosity.

In another striking sequence that emphasizes the use of light to enthrall the audience with the wonder of technological production, the near-complete crankshafts are shot in the beam of a brilliant ray of sunlight.

The camera follows the huge metal object through various stages of further refinement. However, it does not simply follow the metal object as it is lifted and relocated by a crane, but rather, the camera is repositioned across a cut to ensure that the metal stays centered within the beam of sunlight. The crane and the camera together ensure that the steel bar comes to rest in the exact center of the beam of light. Light here dictates the composition of the mise-en-scène. Like *Und das Licht Erlosch*'s manipulation of fire light, *Das Stahlwerk der Poldihütte* appropriates natural sunlight and reworks it through the technical devices of the film production process in a film that is ultimately about the changes of the technological age.

As the would-be crankshafts undergo further processes of softening, firing, reshaping, and casting, the film once again captures the brilliance of their materiality through an extraordinary use of light and lighting. In long shot, for example, we see the anonymous workers carefully working on different stages of this casting procedure. One man attends to the molten iron as it is dipped in a flammable liquid. Another beats the solid but softened metal into shape, while a third paints it, presumably with some kind of seal. All the time, the men are rendered indistinguishable from one another and the shapes of the formed metal are given prominence by both the light that shines on them and their position within the frame.

In the closing stages of what O'Quinn identifies as a fourth and final part of *Das Stahlwerk der Poldihütte,* there is a sequence in which the steel as finished product is bathed in the soft lighting we associate with that given to a human protagonist. As the steel object is slowly filed into shape by a machine, we see the shavings peel away in two separate shots. The first is taken from a very high-angle close-up, and the second through a slightly raised camera to the right of the crankshaft. In both of these static long takes, the key lighting source is placed above the steel with a side fill light. The sensuousness of the steel crankshaft in rapid circular motion is underlined by the sensitive lighting. As the camera quietly sits and watches the steel in its final stages of refinement, the material gently glints in the soft lighting. In these, the film's penultimate images, the steel shapes in motion have become adoringly personified by the soft light that would ordinarily be given to a star actor. The manufactured steel and the dexterous film lighting are here coupled to articulate the beauty and expressivity of mechanized processes and products. The grace of technological modernity is depicted here in a confluence of steel, cinema, and lighting.

The tendency to celebrate the processes of rationalized production is seen in a number of other wartime steel production documentaries such

as *Stahlfabrik Krupp* (1917) and *Thomaswerk* (1917), another film made by the Krupp firm in Essen. Like *Das Stahlwerk der Poldihütte,* these and other films return the equation between the excitement of the steel production process and a manipulation of lighting to the mise-en-scène. They too tend to cast human figures to the visual and conceptual background, and give prominence to the metal as light when it moves through various processes. Similarly, the frame in these films is composed according to the rationalized organization of the factory floor. It is typically composed of the striking geometrical patterns of the machines, conveyor belts, ovens, and stacks of finished product. To be sure, *Das Stahlwerk der Poldihütte* is not anomalous among the industrial films of the late teens. Rather, it is an articulate embodiment of aesthetic issues taken up elsewhere. In addition, *Das Stahlwerk der Poldihütte* stands out for its abstraction of the frame through a contrast in the mise-en-scène between light and darkness. Although other films equate light and metal to capture the thrill of the processes of production, they do not return the economy of technological modernity to the surface of the image, thus the film medium. Unlike *Das Stahlwerk der Poldihütte,* films such as *Stahlfabrik Krupp* and *Thomaswerk* do not reduce the film image to a two-dimensional play between light and darkness. Their mise-en-scènes are evenly lit and they clearly visualize the particulars of the production process. Therefore, they do not extend their claims to include the film medium as another product of technological modernity, and thus lack the consciousness of a film such as *Das Stahlwerk der Poldihütte.* By extension, these other films do not capture the inherent contradictions of technological modernity in their aesthetic. Hence the exceptional status of *Das Stahlwerk der Poldihütte.*

Lastly, like *Und das Licht Erlosch, Das Stahlwerk der Poldihütte* captures the central conflict of a technological modernism; that is, it embraces the conflict between a utopian aspiration for order and cohesion and the recognition of the material rupture brought about by industrialization. However, owing to the difference of its genre, *Das Stahlwerk der Poldihütte* does not transpose the conflict across the melodramatic narrative and eruptions in light. The utopian aspiration of this film might rather be located in the perfectly ordered, perfectly rationalized mise-en-scène of production. Accordingly, the brilliance of the steel as light, that which distracts us from the smooth running of the factory and the geometrical composition of the film frame, punctures or disrupts the otherwise coherent diegesis. The excess of these unrestrained movements in light is a feature of the unpredictable ruptures of the modernist aesthetic. And this excess can, simultaneously, be understood to represent the unevenness

integral to the theater of technological modernity. Indeed, these aesthetic tendencies in light and lighting reappear in various forms throughout the films analyzed in the chapters to come.

## Conclusion

To fully appreciate the maturity of the uses of light and lighting in films such as *Und das Licht Erlosch* and *Das Stahlwerk der Poldihütte*, we must remember that in Germany the first "quicksilver lamps" were used in filming by Oscar Messter as late as 1908.[41] Up until this time petroleum and gas were the only available artificial means of lighting in the cinema. Even after 1908, it was rare to find anything other than daylight used in German film production. Electricity was too expensive to run, and by the time of the outbreak of war in 1914, it was not even available for nonarmy use. Gas and petroleum were more readily available, they were easily transportable, and were the chosen fuel for lighting the film set. However, their high flammability made them dangerous, and for this reason, they were avoided when possible. Thus, filmmakers such as Fritz Bernhardt, Franz Hofer, and the Poldihütte Steelworks worked at the cutting edge of film's production possibilities when they used techniques and technologies that were still in the process of introduction.[42] These filmmakers brought inventions such as color to complicate light, mirrors to manipulate sun and artificial light, and what was known as "the brightener" to mute the contrast between bright light spots and shadows. Thus they innovatively enhanced and fine-tuned their limited lighting resources.[43]

These filmmakers extended their resources and embraced the possibilities of their medium to create works that engaged the most contemporary of preoccupations. They did not use light, the camera and other technologies to pass judgment on the radical social changes inaugurated by the same technologies. Rather, these films functioned in an expository mode usually of celebration. However, the films were sensitive to the necessity to negotiate the demands of their audiences and their experiments with the new medium. And light was the pivot of this negotiation. Light and lighting were deployed in their films as the key to creating spectacles that enthralled the audience, that placed viewers on the edges of their seats in wonder. Simultaneously, light was appropriated as the structuring principle of the all-important narrative, that layer of film entertainment that maintained the audience's attention and the respectability of the film medium as more than a cheap, lowly entertainment. And their deft ma-

nipulations of light and lighting were the indication of the filmmakers' fascination for the creative possibilities of their chosen medium.

Like the many films that were to be made in the 1920s German film studios, *Und das Licht Erlosch, Das Stahlwerk der Poldihütte,* even *Bacchanal des Todes* and *Der Steckbrief,* foregrounded the cinema's intimacy with light and lighting. In the 1920s, this intimate relationship was transposed to new levels of awareness when it became overtly linked to the culture of light that had been developing over the first decades of the twentieth century. Well before the supposedly groundbreaking and creative use of light in 1920s films of F. W. Murnau and Fritz Lang, filmmakers in Germany were using light and lighting to envision the transformations of technological modernity. Thus, films such as *Und das Licht Erlosch* and *Das Stahlwerk der Poldihütte* testify to the development of this national film aesthetic and industry that is interpreted to cohere around the discourse of technological light.

# 3

## Legends of Light and Shadow:
## The Mythical Past in *Algol* and *Schatten*

Photography and cinema are areas in which light plays a unique
and decisive role. Light is here everything. Raw material,
work tool, and, lastly, formed artwork.

*Photographie und Kinematographie sind Gebiete,*
*auf denen das Licht eine einzigartige und ausschlaggebende*
*Rolle spielt. Licht ist heir alles, Rohmaterial, Werkzeug*
*und schließlich gestaltes Kunstwerk.*

The film is after all the art of the defenseless: it should not
show reality, but what and how reality appears to us.

*Der Film ist nun einmal die Kunst des Wehrlosen: er soll nicht zeigen,*
*was ist, sondern er soll zeigen, was und wie es uns erscheint!*
**Guido Seeber**

The narrative cinema in 1920s Germany provided the perfect forum for a
rearticulation of popular German themes and legends. A number of
films from the period reveal an eagerness to embrace available techno-
logical innovations, thereby signaling a rupture with the past. Simultane-
ously, they represent familiar, legendary themes, thus establishing conti-
nuities with the same past. In this chapter I analyze Hans Werkmeister's
*Algol* and Arthur Robison's *Schatten*, two films that revitalize thematic
concerns, such as the struggle between good and evil, and that between
reality and the imagination, that have preoccupied German legends for

centuries. In addition, these two films are unique for their revivification of compositional qualities that recur throughout the history of German art. In particular, they explore the compositional possibilities of light and lighting as a vehicle for their reanimation of familiar concerns. As in the art of the past, in these films, the struggle of opposites is often depicted through a conflict between light and darkness. This re-presentation of familiar themes, through familiar aspects of the mise-en-scène, also establishes a continuity between the concerns of the past and those of the modern technological world. In their oscillation between a recourse to the familiar legends of the past and an embrace of the most contemporary technologies, *Algol* and *Schatten* reveal the atavism at work in some of Germany's most modern experiments.[1] Thus, the foregrounding of light and lighting in these films offers access to this complex relationship between the 1920s films and their artistic predecessors.

*Algol* is distinct from the majority of films discussed in this book because it does not stage conflict between a melodramatic story and technical displays in light and lighting. In *Algol* the tension arises between themes of the legendary past and their articulation through the technologies of the present. At the level of the thematic, *Algol* is somewhat retrogressive, nostalgic, and in search of mythical solutions to real historical problems. At the level of the stylistic, however, *Algol* explores the newest technologies—cinema and electrical light—as languages with which to represent the themes of the past. Through this dynamic tension between the mythical legends that motivate its themes and the stylistic exploration in light and lighting, *Algol* also reveals a tension inherent in the utopian aspirations of some of German modernity's most ambitious experiments. *Algol*'s recapitulation of the cosmology through its reliance on the familiar Promethean myth is characteristic of the tendency to retain the organic or the mythical as a vehicle for a modernist aesthetic. This gesture of *Algol*'s is a more general feature of the German film's contribution to a 1920s European modernism. We also see this return to a mythical past for the successful development of avant-garde technologies in films such as *Der Golem* and *Metropolis*. On the one hand, as we see in *Algol*, experiments with technology were radical for their disruption to, for example, deeply entrenched social hierarchies. On the other hand, these explorations were, like the myths from which their representation derived, utopian. They looked toward an impossible future free of social injustice. In reality, as *Algol* illustrates, the most socially conscious experiments replicated existing social hierarchies elsewhere.

However, *Algol* is also distinct because the tension between the atavistic

return to the past and the embrace of the newest technologies is played out through innovative uses of light and lighting. In *Algol,* the reliance on the mythical, utopian past and the relatively new technology of electrical light undergirds the particular brand of European modernism identified in other 1920s German films. It uses the lighting to articulate the role and effect of technologies such as light and cinema within modernity. It also uses light and lighting as the structuring device for an atavistic, mythical narrative that, in turn, is the vehicle for a critique of the coveted rise to power within that same modernity. Thus *Algol* brings this contradiction to the fore through a use of light and lighting that works to underline both its aspects.

Given that developments in artificial light reached a particularly intense moment in early-twentieth-century Germany, together with the enthusiasm for artistic explorations in light at the time, it comes as no surprise that filmmakers seized the opportunity to reanimate familiar themes through a use of light. Traditionally, themes such as the conflict between good and evil, reality and illusion are represented through the shifting dynamics of light and darkness. And the films appropriate the latest technological developments to discourse on the contours of the contemporary historical world in which they are produced. Thus, themes from the past become a vehicle for reflecting on the significance of the present of technological modernity.

Both *Algol* and *Schatten* move beyond this thematization of the utopian aspiration within technological modernity when they reflect on certain tendencies within contemporary modernist culture. In *Algol,* there is a concern with the contradictory tendency to replicate the nostalgia claiming to be critiqued through technological experiment. The film both embraces and exposes the utopian reach of the 1920s German modernist aesthetic when it inhabits and implodes the mythical narrative yearning for completion through the agency of technology. In *Algol,* the protagonist Robert Herne presides over a power plant that generates electrical light. He abuses his position of power, destroys nature with technology, and is ultimately brought to his knees by his own paranoia.

I also interpret *Schatten* for its metadiscourse on the implications of the increasing sophistication of moving light forms in their progress toward cinema. The film reflects on the increasing lack of distinction between reality and the illusion of representation that results from the increased sophistication of light representations. *Schatten*'s exploration of the fluid boundaries between illusion and reality—an exploration executed through tensions between light and shadow—ultimately claims that the more tech-

nologically developed the form of representation, the less discernible the distinction between illusion (here coupled with representation) and reality. Thus, both films establish the simultaneous continuity and break with the past that is effected through the embrace of technological media such as the cinema.[2]

In the literature and painting of the German past, light and lighting were used repeatedly to articulate the same struggles represented in *Algol* and *Schatten*. Words and color that describe or figure light are used again and again to represent struggles between life and death, the theological contest between the devil and the pure of heart, the tension between the imaginary and the real. As critics have pointed out, German Romanticism brings to the fore a conflict of opposites that are figured through a deft rendering of light and darkness. The light that is represented in these images and words is commonly recognizable as the light of the natural world. For example, in his poignant "Hymnen an die Nacht" (Hymns to the Night) (1800) Novalis retreats from the light of day and earthly life when he journeys into the night in his search for a communion with his now-deceased love.[3] In the depth and blackness of night, Novalis's eyes are opened to a heavenly religious light that leads him to a timeless union with his once-earthy love. For Novalis, the light of the night is the eternal life in death, the escape from reality into the imagination.[4] In another example, time and again in Romantic painting and literature, for example, in the works of Carl Gustav Carus, Ludwig Tieck, and Johann Gottfried Herder, a landscape bathed in the unearthly light of early morning or twilight sits at the center of the work.[5] These moments of temporal suspension—neither daytime nor nighttime—signify the moment of imaginative creativity for the isolated individual thinker who traverses the natural world. Thus the light, and its indistinction from darkness in these works and others, represents the blurred boundaries between human imagination and reality.[6] Alternatively, the interstitial light of dusk mimics the ineffable space between life and death.[7] Romantic painters also employed paint as the light of a setting sun in landscapes that depicted the immanence of death in the midst of life. Karl Friedrich Schinkel used a striking contrast of light and darkness in his famous depictions of Gothic and medieval cathedrals surrounded by expanses of water.[8] In these paintings we see the great hulks of empty, one-dimensional cathedrals like tombstones soaring into the sky of the setting sun, blocking all light from the foreground of the image. These are representations of the foreboding presence of a dead past impinging upon the life of the future. Arnold Böcklin's *Toteninsel* (Island of the dead) (1880) is simultaneously "a picture for dreaming about"[9] and a

landscape of darkness pierced by brief instances of harsh light receding into the distant background. This haunting, unsettling image uses light to represent the inconsistencies of the subconscious states aroused by nature and the journey toward the experience of darkness as death. The conflict between light and darkness in Böcklin's famous image represents both the struggle between the imagination and reality and that between life and death.

The most obvious and well rehearsed use of a contrast in light and darkness for the representation of the conflict between good and evil, the pure of heart and the devil, is found in Goethe's enigmatic reiteration of the *Faust* myth.[10] Faust the alchemist is usually bathed in soft, natural lighting. His antagonist, Mephistopheles, is cast in shadow, and he eclipses entire mise-en-scènes with his dark, looming presence on earth. Likewise, for Goethe, when Marguerite is tempted by the devil, she is cast into the dungeon, and her status as sinner of the highest order is marked by the casting of her body into darkness. If we believe that the *Faust* legend is the direct descendant of the Baroque triumph of the light of God over the shadow that has eclipsed the world in the form of illness, it seems logical that this mystical tale of the rise and fall of piety and wisdom be represented through light and darkness.[11] *Algol* and *Schatten* reiterate these familiar themes through their manipulation of cinematic light and darkness.

Although this elegant and imaginative foregrounding of light as a source of representational significance was particularly prominent during the Romantic period in Germany, it was not limited to the late-eighteenth and nineteenth centuries.[12] Two of Germany's greatest Renaissance artists, Matthias Grünewald and Albrecht Dürer, used light as the defining feature of their religious works.[13] However, in spite of well-known instances of figurations in light in premodern German art and literature, in the modern age light is used in specific ways by German artists and writers. In addition, in the premodern period, we do not usually associate explorations in light specifically with German painting. From the sixteenth and seventeenth centuries we are more likely to recall Caravaggio's extraordinary use of color as light to imbue the everyday scene with a religious magic and power (*The Calling of St. Matthew* [1599–1602]) or Rembrandt's use of intense light pouring into otherwise blackened spaces to heighten the drama or to signify moments of deep and complex emotion (*The Adoration of the Shepherds* [1646], *The Blinding of Samson* [1636]).[14] Once again, we cannot forget the international context within which even the Romantic and classical German artworks were conceived. In the late-eighteenth and nineteenth centuries in Germany, light and darkness enjoyed a prominence

and were explored to represent metaphysical issues in an ever-changing modern world. Thus, it is not surprising that, as Eisner and others have argued, the 1920s films look to the early-modern period for formal and thematic inspiration.[15]

Like the other films I discuss, *Algol* and *Schatten* engage in a tripartite use of light. Typically, light is central to frame composition, it is a principle of narrative structure, and it is the language through which the themes about technological invention are communicated. For example, in both films, the conflict between characters is depicted through the light and darkness that surrounds them in their various mise-en-scènes. In addition, *Algol* and *Schatten* use light and lighting as an organizing principle in their narrative development. Thus, in *Algol*, Robert Herne, the protagonist, acquires wealth and power through his exploitation of electrical light when he occupies the helm of an industry that generates light. As he moves from a lowly coal miner in the beginning of the film to the heights of industrial power, the mise-en-scène appropriately changes from one characterized by darkness to one bathed in light. In both films, the themes are articulated through the role of lighting within the narrative development. *Schatten* often places light and darkness in stark contrast as the vehicle for its discussion of the blurred boundaries between the imaginative and the real, illusion and reality, in certain forms of representation. Specifically, *Schatten* examines the distinctions between illusion and reality in art forms created in light: the shadow play, the magic lantern show, and, of course, the cinema. In *Algol*, the devil is the Promethean bringer of light who tempts the protagonist, Herne. Herne is then taken out of his dark coal mine and placed at the center of the world of electrical light, an industry that defines his power. Here, enclosed by the lights of the power factory he inherits, the protagonist is punished and forced to face his own destruction for misappropriating the machine to wield his power over nature. These organizational and thematic concerns are also articulated through stylistically innovative uses of lighting. Moreover, both films use light to represent the changes to life brought by technologies such as light and cinema. Thus the tripartite use of technical light and lighting in *Algol* and *Schatten*.

### Algol, Tragödie der Macht/Algol, Tragedy of Power (1920)

*Algol, Tragödie der Macht,* a little-known film by Hans Werkmeister from 1920, narrates, as its subtitle indicates, a tragedy of power in which power is both a form of industrially produced energy and the measure of the

protagonist's ability to act upon the wills and lives of other people. The industrially produced energy at the center of *Algol* is that of electrical light. *Algol* is a film about Robert Herne, a man who becomes "heir to the world" when he rises to the top of the bureaucratic ladder of an electrical light plant. Ultimately, however, according to *Algol,* it is not only electricity or industrially generated light that harbors the potential to destroy. It is also the power that one human wields over others that must be mitigated and controlled. Thus, if electrically generated light is a metonym for the mechanized, modern, capitalist world, then *Algol* is a film that criticizes both the machine itself and the people who manipulate the machine to satisfy their hedonism and greed.

As mentioned, the theme of a Promethean visitation that leads to the temptation of an innocent human is nothing new to the German tradition. The use of a devil figure who steals fire from the gods, gives it to man, and with it teaches him arts and sciences, is the subject of many German adaptations, literary and otherwise. In the Romantic period, for example, the myth is repeatedly appropriated to explore the anxiety around the burgeoning of rationality and its demarcation of the limits of humanity. From Beethoven's overture through the lyrics of Franz Schubert to Goethe's poem, there are any number of precedents to the myth of temptation, success, and punishment that Herne undergoes in *Algol.*[16] In the 1920s, the story of the Promethean myth was not only retold in Werkmeister's film, but it reappeared in works as diverse as a poem by Carl Spitteler and an opera by Carl Orff.[17] Herne's story is one of several contemporary filmed versions of the tale.[18] The ramifications of this appropriation range according to individual films, but in *Algol,* the myth is mobilized to articulate a fear and anxiety for the pernicious effects of industrial advance. Both the "fire" and the man who is given fire for his self-advancement must be contained for the status quo to be reestablished. Moreover, *Algol* self-consciously uses this familiar myth, and transforms fire into technological light in order to establish a simultaneous continuity with and break between technological modernity and that which historically precedes it.

In *Algol,* the abuse and successful taming of the fire that appears in other versions of the legend is replaced by an abuse and subsequent control of electrical light. Thus, narrative and social order are reestablished through the domestication of fire light. Simultaneously, however, *Algol's* experiments in light and lighting are not compromised by the utopian trajectory of the mythical legend. Rather, they rupture the story and point up the immense possibilities of a technically manipulated light and lighting. By extension, because their force is retained rather than equivocated

by the mythical story, these stylistic experiments work to underline the discontinuity between the cinema and past representations based on light. These moments then inscribe modernity and its representational possibilities on the film's surface.

*Algol* also uses light and lighting to articulate its thematic concerns. Herne's rise to power at the helm of an electrical light industry is represented via the mise-en-scène as a journey from darkness into light. Herne moves from the bowels of the coal mine that is his workplace and the dark confines of his residence to the luminescent, brilliantly lit rooms of his modern home in the latter part of the film. The critical junction in Herne's path to wealth and power is a visitation by Algol, a servant of the devil, who appears in the form of crystallized light. This fantastic event is represented through Brennert and Köhne's manipulation of lighting and in-camera editing. Characteristic of the fantastic narratives of many German films of the period, the movement from temptation to redemption in *Algol* is represented through a manipulation of the lighting. This stylistic use of lighting also represents the film's engagement with the culture of industrial modernity. *Algol* criticizes the advance to technological modernity, and in particular, the moral implications of an intense and uncontrolled rise to mechanistic power over humanity. Moreover, through a conflictual juxtaposition of the mythical idealism and the disruptive potential of the technical explorations in the lighting *Algol* represents an ambivalent and heterogeneous relation to and representation of technological modernity. The two modes of articulation come together to represent a troubling image of the rise of technological industry in 1920s Germany.

In an opening remarkably similar to that of Paul Wegener's *Der Golem* of the same year, *Algol*'s first frame is filled entirely with the stars in the sky. Moments later, a telescopic apparatus appears through a dissolve and it rotates of its own accord, turning around and upward so that it might see the stars in the sky. Across the ensuing cut we see the telescope's point of view in a masked image. One star gradually grows bigger and brighter. An intertitle before the ever-growing star tells us that it is named "Algol, the riddle of the sky." The star has, since time immemorial, been obscured for ten hours for three nights at a time, and then on the fourth night it has reappeared. Every culture has a different explanation for Algol, but all—Greek, Arabic, and so on—refer to it as the eye of a devil of some description. In contradistinction to the traditional practice of summoning the devil—a process we will see in Murnau's *Faust*—this star Algol will appear of its own accord to the film's earthly protagonist, a miner named Robert Herne. And its appearance is depicted through a metamorphosis in the lighting.

Because technically manipulated light is used to animate all levels of *Algol*—plot, theme, and image composition—Algol's appearance to Herne in human form is not simply Herne's momentary awakening into the possibilities of "escape" from the coal mine. The event represents the trigger to the remainder of the film's narrative. Hard at work, deep beneath the surface of the earth in the coal mine, we first meet Herne as he wipes his brow in a moment of repose immediately following the sequences that introduce Algol. Herne's image is crowded by the dark, oppressive "walls" of the mine. He is angry, presumably at his oppression, and he grabs at nothing in particular in front of him. The film then cuts to the star we have been introduced to as Algol. Through the seeming magic of the double exposure of a strip of film, the star begins to take another shape in superimposition: it transforms from pure light to a rock much like those that surround Herne as he toils in the mine. However, this rock is exceptional because it is transparent and its outline is made of light. Subsequently, as if the rock were made of glass, its hidden contents are revealed when the image of a man slowly forms inside it. It is as though this man is born inside the rock, as though he too is made of glass. Thus, in a process of anthropomorphosis, Algol is born of light, a birth facilitated by the capacity of the cinema to represent multiple images transforming in time.

Algol is also the creator of light: he literally creates the light that will catapult Herne to the throne of an industrial empire. In this, he is the catalyst of the narrative to come. Algol is the devil incarnate, masked as both the bringer of light and light itself. He will light up the world of Robert Herne and, in turn, the events of the film to which the characters belong. Thus, Algol is a 1920s German film translation of a cross between Prometheus and Lucifer. Like Prometheus, Algol is the figure who brings light for Man's edification, but more like Lucifer, he is the evil that tempts Man into his own destruction.

This quest in and for power through light continues throughout the first third of the film. Still inside the mine, Algol leaves his star, which has by now taken the form of a transparent crystal, and announces himself to Herne, who in turn takes him home. Like the subterranean hollows in which he spends his days, Herne's home is sparsely lit by candlelight. It is almost impossible to distinguish the objects in the room because of the darkness in which they are cloaked. Shortly after the miner and his new friend return home, Herne receives an invitation to a party given by the owner of the coal mine for the workers and their families. As the invitation explains, it is a party in "Licht und Sonne" (light and sun), a party that will take place in broad daylight aboveground, an environment that is

far removed from that of Herne's daily life. Already, at this very early stage of *Algol*, the power associated with light is made evident. Those who live aboveground, those who have access to light, also have access to power, while those consigned to the dark bowels of the earth are simultaneously devoid of all power. Light within the mise-en-scène is already a metaphor for authority and influence.

Oblivious to the invitation that has arrived, Algol asks Herne for light so he can show him what is written in his book, a book that states that Algol will light the way to prosperity and grandeur. For three days and three nights—obviously, the three days and three nights that Algol cannot be seen in the sky—they must ensure that an antenna is in place on the roof of Herne's house. The antenna is connected to a strange, fabricated machine with moving wheels, levers, and pistons. Every now and then a lever touches a wire and a tiny charge of light is emitted from the machine. Simultaneously—a simultaneity depicted through crosscutting—a burst of light with the magnitude of fireworks flares from the top of the antenna. These intermittent flashes are intercut with images of Herne looking through the telescope at the star from which Algol was born. The star in the sky is causing these electric charges. When Herne turns back to Algol, the film is once again inside the miner's meager abode. Algol waves his hand across a section of a wall and, as if pulling back a curtain, the words of the devil's wisdom appear on a board that previously went unnoticed. This board is only now made visible thanks to the turning on of a nondiegetic spotlight. The words read:

> A thousand ways lead toward the light!
> Look for one and do not be afraid!
> Algol will lead you through misery and night!
> Wish and the power of the earth will be yours!

Thus we see the devil leading Herne out of darkness into the light through this conjuring of electrical light by the most primitive of machines. The sequence comes to a close when Algol disappears in a puff of smoke. An intense beam of light—presumably, the devil masked as God and goodness—beams in from the world outside Herne's study and he falls on the floor, overwhelmed by the power of these creations. In these expositional sequences, *Algol* shows Herne being transported to the precipice of a world without misery and poverty. It is a world both ignited for Herne by the energy of electrical light and brought to life by the film through its lighting.

The expositional sequence is a preface that lasts one third of *Algol*'s running time. Act 1 of the film proper begins with Algol sitting on a planet

in the sky surrounded by clouds of light filtering through smoke. He grins from ear to ear at his successful manipulation of both the light machine on Herne's roof and of the coal miner himself. Algol's appearance at this point reminds us who is in control of Herne's ensuing rise and fall. From here on *Algol* will proceed with its narrative proper regarding the destruction and danger that results from the exertion of power through the use of machines that are also, in themselves, destructive and evil. Even though the machines over which Herne exerts his power are of the most contemporary kind and Algol's are more like toys from a fairy tale, all the machines in the film are, nevertheless, the outcome of the devil's work.

In act 1, Herne rises to the top of the administrative ladder of the new *Bios-werke* in the town of Nissen. Here, in his geometrically designed offices, which boast the clichés of sparse, functional modern architecture, Herne secretly designs a Nissen without coal, free from the crippling effects of manual labor. Herne's empire of electricity will be the sole provider of energy. Of striking significance in these sequences is the different lighting from that in Herne's previous existence. The formal precision of his presidential company offices shows them brilliantly lit with neon light strips running as cornices where walls meet ceiling and vertically down the joints in the walls. In addition, the lighting of the film in these sequences is noticeably different from the flickering candle lights that provided minimal illumination in Herne's home, or in the coal mine. The new *Bios-werke* offices are evenly and brightly lit through a three-point lighting design. Herne is surrounded by light and lighting appropriate to the heir of an electrical light empire. This space is not constructed entirely in light and lighting as are, for example, the spaces in light of the streets in *Die Straße* or the eerie, nighttime woods in *Siegfried*. Rather, lighting comes together with other aspects of the mise-en-scène to mark the diametrically opposed spaces occupied by Herne the worker and Herne the industrialist. Nevertheless, lighting plays a significant role in the narrative as Herne is seduced by the devil's temptations in light. Herne is then led to a liberation through electrically generated light, and, in turn, this liberation is depicted by *Algol* through the lighting. Lastly, the mechanization of light, as the work of the devil, gives Herne a power that crowns him, in the words of the film, "heir to the earth."

In Herne's temptation and subsequent liberation we see Algol's ancient mystical power fuel the utopian modernist lifestyle of Herne the industrialist. Thus, in *Algol* the acquisition of power over and through cutting-edge technologies is only possible via an atavistic dependence on the mystical. Accession to power is enabled through recourse to the fantastic

promises of yesterday's myths. Effectively, *Algol* translates the knowledge and skill acquired through the gift of fire into control over the contemporary world through the agency of electrical light. Although *Algol* also goes on to critique the supposed utopia spawned by the temptations of electrical light, the acquisition of power is nevertheless dependent on a retreat into a mythical utopia—namely, the utopian legend of the devil's exploits.

In 1920 the neon light strips seen in *Algol* represented the latest form of lighting. As Wolfgang Schivelbusch explains, neon light was clean, concentrated, mobile, and effective.[19] Unlike previous forms of lighting, especially in public spaces, neon was a breakthrough form of lighting because it did not give off excessive amounts of heat as did gas and elementary forms of electricity. There was no discharge with neon. In the early years of its existence the neon light was extremely expensive because each was individually handmade. But when General Electric took over its manufacture (and mass production) in 1912, neon light became a sign of the times: "Modernity, speed, severed from all traditional forms. Streamlined forms were the buildings of modernist architecture, locomotive trains, cinema theaters and their foyers, nightclubs, zeppelins, and racing cars. The neon light was the light version of the streamline."[20] The neon lighting of public buildings was also instrumental to the changes to perception that went hand in hand with technological modernity. Neon strips were placed along the vertical and horizontal joints in the walls of buildings. Thus, people could stand at the base of a building at night, and look up to see the diminishing point at the uppermost reaches of the building.[21] Never before had people been able to see the outline of a building from such obtuse angles. Because it enabled these new forms of perception, neon was considered to be at the forefront of the transformation to daily life in the technological world of 1920s Germany. When approached through this context, Herne's office boasts the most up-to-date lighting fixtures: a form of lighting that captures his business as the epitome of modernity.

Similar to the manipulation of the neon light of the night city for the purposes of advertising discussed in chapter 1, neon light in *Algol* represents the wiles of capitalist greed; for it follows the contours of the building inhabited by the protagonist in the same way that the "natural" outlines, both inside and outside, of all the most important buildings in the capitalist cities of 1920s Germany were outlined in neon. Neon literally defines the space of Herne's business offices; it is the material reminder of his ambition and success as an industrialist. However, in *Algol* this light also becomes a constraint to Herne: his discovery and exploitation of electrical light also bring about his eventual downfall. Ultimately, he voluntarily

journeys back into literal darkness at the end of the film when he destroys his machine, and extinguishes its lights. It is in Herne's decline that *Algol* announces its damning critique of the technologically inflected world. Appropriately, this outcome is narratively triggered and compositionally marked by technically manipulated light and lighting.

As the film progresses, Herne's kingdom increases in size, and he becomes megalomaniacal in his pursuit of more power. His glory lasts only so long before the accidents begin to happen. A man on the land, Peter Hell, gets his hand caught in a machine. An intertitle tells us of the representative nature of this accident. It announces that there have been many such victims of Herne's promise of wealth and freedom for all. Once Herne's empire stretches to include the farming community, the danger begins. The land workers from around the county begin to rebel: they strike and gather outside the offices of the government to protest the danger of their jobs and Herne's broken promises. They have seen the accident of their coworker and want justice for their suffering. Herne ignores his workers' protests, and plots to extend his electricity kingdom into neighboring countries. However, he also becomes more and more lonely at the top of his world. He isolates himself when he becomes paranoid that someone will steal his secret for the generation of electrical light, a secret given to him by the devil. Finally, he cannot bear the solitude and isolation that is demanded by the magnitude of his power. He goes mad, opens the door to his palatial generator room, and fiddles with the levers, wires, and handles. At this, a flurry of sparks of light flies and the generator dies. The firework-like flashes of light remind us of the generation of electricity by Algol's antenna at the beginning of the film. The flashes of light continue to burst into the mise-en-scène, smoke pours out of the machine, and its wheels eventually stop turning. The lights of both the heart of Herne's kingdom and the film are extinguished.

Whereas a film such as *Metropolis* remains ambiguous as to whether human destruction is the product of the machines themselves or of the greedy mind that oversees their operation, *Algol* does not equivocate. For *Algol*, the machine is as dangerous as the man who uses it for his power over others. Even though the film insists that Herne's power be negated, this can only happen through the destruction of the machine. There are a number of instances in the film that de-emphasize the injurious nature of the machine and stress the turmoil that results from its abuse owing to man's desire for riches and "freedom." For example, after Peter Hell catches his hand in the machine in the accident that effectively sets the dissolution of Herne's dynasty in motion, an intertitle alerts us to the fact that it is Herne's megalomaniacal desires that are to blame. The text reads:

"A cripple for Robert Herne. Who is he who is allowed to play with human life in this way?" Thus the blame for this accident is laid on Herne.[22] However, although the film reminds us that Herne is responsible for Hell's accident, it is the machine that enables the rise to power of Herne, once the most humble of men. In addition to the fact that the machine is shown early in the film as the work of the devil, it is clearly the cause of Herne's ultimate downfall. Herne must destroy his invention in order to repent for his misdoings and forgo his power. The machine is the crutch that Herne must disable to cure his megalomania.

Thus, *Algol* is a film about the tragic results of a megalomaniacal power acquired through the growth of electrical light as a metonym for thriving industry. Throughout the film, the protagonist's desire is both fueled and satiated by the acquisition of power via his control over mechanically generated light. From the beginning, Herne's encounter with the devil is an encounter with a light that shines so brightly it is impossible for him to resist its radiance. Effectively, light propels the narrative: it provides the foundation for the character's journey to capitalist wealth and prominence. Herne's greed and unhealthy desires for power bring about his ultimate destruction. The realization of Herne's dream as power is also represented through the lighting in the film's mise-en-scène. Accordingly, *Algol* may be a critique of the crippling effects of technological progress, but it is, simultaneously, an imaginative exploitation of a technological medium.

*Algol*'s concern for the debilitating effects of the misappropriation of machines and technology was shared by other German films, cultural objects, and critics—both scientific and cultural—in the interwar years. Many critics from the time acknowledged the damaging effects that a product such as electricity could have on human nature. As Richard Birkefeld and Martina Jung explain in their discussion of the radical transformation of public space through motorization and electrification, electricity was thought to pave the way for the dark shadows of consumerism:

> The promise of the progress of electricity appears to shine the bright
> way to a better and more comfortable future. But the instant availability
> of energy lays the foundation for a consumer demand and attitude that
> smooths the way for the consumer mass society.[23]

Birkefeld and Jung echo the oft-cited disillusionment with electricity that permeated Germany at this time. Because electricity was the first industry to be taken over by big industry after World War I, it set the tone for further mass production in a supply-and-demand economy. Once the big companies such as Siemens and A.G. Mitteilung took over the electricity

industry (from individual inventors/producers), other production industries followed suit and mass production of goods became the norm.[24] All the trappings of capitalist consumerism therefore were often considered to have their genesis in the development of electricity in the 1920s.

*Algol* appropriates a favorite theme from the long traditions of German representation. The film relates the temptation of a man pure of heart by the devil. Similarly, the film reiterates this theme for the purposes of investigating the contours of a new era. Given the emphasis placed on the transformation of fire into technological light, the film is noteworthy for its engagement with contemporary issues. And, as I have argued, it does not applaud the new technological sources of power. Although the subjugation of the worker in the coal mine may be inhuman, the greed and devastation caused by the new energy and those who control it is potentially deleterious. Similarly, by virtue of the fact that the film lighting predominates in this representation, the film breaks with past, natural forms of lighting. Yet, *Algol*'s mere engagement with the Promethean myth for its articulation of this warning also creates links between the past and the present. Through its very appropriation of the story and its characters, the film represents the concerns of the past refocused on the danger of a power motivated by the temptations of technology. Thus *Algol* oscillates between a continuity with mythological tales and the ruptures effected through the advent of the technological. Like a number of these films, *Algol* animates the ambivalent relationship of the past to the present of industrial modernity in 1920s Germany through recourse to an ancient, mythical power.

Beyond this ambivalent relationship between the past and the present, *Algol* depends on the Promethean myth to expose the dangerous utopian aspirations of the most vanguard experiments within German modernity; Herne's temptation by the light of the devil, a temptation that will lead him to an extraordinary position of power on earth, is a dream that backfires. Herne's struggle against a bourgeois order of things is a struggle waged with the technology at his disposal. Similarly, his struggle for daily existence very quickly gives way to one for higher and deeper goals: to become king of the earth through technological power. The belief that these goals were within reach was common among those who subscribed to the transformative powers of technology in Germany and elsewhere in the 1920s.[25] However, what is significant to *Algol* is the fact that light and technology ultimately play havoc with these utopian aspirations. When he is given the power of light, Herne is overcome with greed, paranoia, and, ultimately, social isolation. Thus, *Algol* both represents and disputes the modern dream for a technological utopia.

Generally speaking, *Algol* relates to the negative view of a modern Western, industrialized society that was first articulated by Germany's two classical poets laureate—Friedrich von Schiller (1759–1805) and Johann Wolfgang von Goethe (1749–1832).[26] *Algol* does not draw directly on Schiller or Goethe, but rather, can be put in communication with the uniquely German attack on utilitarianism and functionalism that goes back to the restoration. Termed *Kulturpessimismus* by Werner Hofmann, this trepidation felt toward the dehumanizing effects of mechanization that went hand in hand with the vigorous and successful pursuit of technological industrialization resurfaced in the 1920s.[27] Most notably we see this ambivalence toward technological progress in the *Neue Sachlichkeit* painting and photography, and, for example, in the works of Bertolt Brecht and Max Weber. Much as it is in *Algol*, technological progress is criticized by artists such as Georg Scholz or Karl Hubbuch and writers such as Brecht for its assumed objectivity, an objectivity identified as the thin disguise behind which lurk power, avarice, and exploitation.[28] However, even the harshest of technological modernity's critics at this time remained fascinated by the machine and believed in its necessity for progress. *Algol* reiterates this ambivalence. On the one hand, the film is concerned to reveal the damaging effects of the machine and the fragile humans who manipulate it. Accordingly, the machine—or, more specifically, electricity—is corrupt and produced by the design of the devil. These new inventions may be in the name of technical and social progress, but they are certainly not in the interests of the development of the individual or the common good. Like Goethe in his most eloquent contribution to the discussion of the upcoming industrial age in *Wilhelm Meister*, *Algol* understands the motivation behind the development of the machine to be human greed. On the other hand, the film's representation of the potential destruction of technology is only enabled by two media which are, in themselves, the products of this same phenomenon—technically produced light and cinema. Through the film's critical engagement with this long German tradition of allegorical myths, it draws attention to the tendency to replicate the utopian aspirations of the myths while all the time claiming to critique them.

### Schatten/Warning Shadows (1923)

From the opening frames of Arthur Robison's *Schatten* the audience is drawn into a world in which shadows, reflections, and silhouettes dance on screens within screens, on mirrors, and on the walls of a maze-like mansion. In a gesture familiar to other films from the period, *Schatten*

opens with an introduction of the players in the film to come. However, in *Schatten* the introduction comes as a performance of shadows: one by one the cast of players is introduced walking onto a stage. Having made his or her appearance in the form of a brief performance, the husband, the wife, the lover, the cavaliers, the servants, and the shadow player each metamorphose into a dilated shadow cast on a screen behind him or her. The shadow of an anonymous hand then erases the given character's shadow from the screen and the next character enters the stage. Like a narrator only known to us through his or her voice, the caster of the shadow that wipes the characters from the screen is never revealed. This dematerialization of the characters' bodies as they metamorphose into shadows literally prefaces the narrative of the film to come. It is not the actions of the characters themselves that function as the agents of the cause-and-effect chain of events in *Schatten*. Rather, the shadows they cast are the primary figures that propel the narrative from event to event.

*Schatten*'s narrative development is enabled through a skillful manipulation of the lighting. In turn, light and shadow are the language through which *Schatten* articulates an allegorical discourse on the historical development of the relationship between the cinema apparatus and the spectator's experience of the cinema. If we follow the increasingly sophisticated shadows through *Schatten*'s narrative, we find that their development approximates a reiteration of the increasing complexity of modes of light representation through history. Thus *Schatten*'s metadiscourse engages the cinema as apparatus and institution, as distinct from *Algol*'s drawing attention to a particular aesthetic tendency.

*Schatten*'s narrative moves from the representation of silhouettes through figures in a Chinese shadow play-cum-magic lantern show, to the shadows produced by the technology of cinema. In another strategy characteristic of the films in the 1920s culture of light, *Schatten*'s centerpiece is a film within the film created by a traveling shadow maker at an aristocrat's dinner party.[29] As the shadows become increasingly complex, so they are created through increasingly sophisticated technical manipulations of the film medium. Furthermore, in *Schatten* the transformation of representations in light and lighting across the narrative are linked to two significant transformations in the relationship between shadows and caster. First, the more complicated the light representation, the more independent the shadow is from the body that casts or creates it. As the narrative progresses, the shadows themselves as independent entities become the subjects of the narration. Second, as the allegorical narrative of light representations progresses from represented shadow plays to a film within a film, the relation-

ship between these illusory representations and *Schatten*'s diegetic reality becomes increasingly confused. These changes across *Schatten*'s narrative represent the film's discourse on the ambiguous status of the film medium's relationship to reality. This metacinematic aspect of *Schatten*'s allegorical narrative—an aspect explored through its emphasis on the compositional and technical qualities of light and lighting—represents the film's contribution to modernism. Similarly, the film self-consciously represents the bleeding of the reality of the film within the film into the reality of the diegesis, and vice versa. Through this strategy, *Schatten* represents an identification or interchangeability between spectators and diegetic characters. In turn, I argue that this blurring of the two realms is a reflection on the spectatorial relationship to technological representation.

Again, the confusion between illusion and reality, or the imagination and reality, is one of the central representational concerns of German Romantic painters and writers. Similarly, in the eighteenth and nineteenth centuries, the confusion is invariably depicted through the liminal light of daybreak or twilight. In addition to those examples offered earlier, Joseph von Eichendorff's well-known poem "Tageslicht" (Daylight) is set in the sorrowful light at the end of the day.[30] It is a time of deceptive peace that will be lost with the onset of the darkness of night. For Eichendorff, these times of day are the expressions of a mind, deceptively content with the calm of its natural surroundings, always on the precipice of war and death. In paintings from the same period we see similar ambiguities between life and death, the imagination and reality, expressed through striking uses of light. In the most oft-cited examples, Caspar David Friedrich's wanderers so often contemplate the extension of a vast landscape that is poised on the precipice of nightfall or sunrise. Friedrich's fishermen, his solitary, yet coupled women, his two men at the sea—are all lost to their imaginations as they gaze out beyond the horizon lines over which the moon is rising or falling. The distinction between creative fantasy and the external world has become effaced in the haunting interstitial light of these paintings.[31]

*Schatten* reinscribes the ambiguous space between imagination and reality found in the Romantic appearance and fall of daylight in a curious way. Rather than representing confusion through the agency of the half-light of dusk or daybreak, *Schatten* creates an ambiguity between the characters and their shadows by setting light and darkness against each other. Like Friedrich's silhouetted figures, *Schatten*'s figures oscillate between embodiment and incorporeality. However, this ambiguity between characters and their shadows underlines issues relating to representation, rather than to metaphysics. In particular, the film uses these manipulations in light and

lighting to examine the often indistinguishable line between reality and illusion in representation. Accordingly, the drama of light is transposed from an interrogation of the characters' inward contemplation to a reflective blurring of illusion and diegetic reality in cinematic representation.

Unlike the eighteenth-century paintings, *Schatten* does not erase the distinction between light and darkness in a representation of and invitation to transcend the routinized perception of daily life. The erasure in *Schatten* effects the very opposite: the viewer is discouraged from reverie and contemplation, always called upon to attend to the many narrative turns and inconsistencies. The play of light and darkness, illusion and reality, in *Schatten* creates moments of confusion that keep our curiosity and desire for cohesion alive. Although the transcendence provoked by the Romantic paintings enables a human, rather than a divine, understanding, it is still mystical and always underlined by a proximity to God. *Schatten*'s dissolution of the line between reality and imagination, between shadow and corporeality, is, however, mobilized through a fully secularized use of light and darkness. Characteristic of its modernist counterparts, *Schatten* exploits the film aesthetic and apparatus to interrogate the physical, social, and historical impact of the medium itself. Thus, *Schatten* is both an example of the secularization of artistic concerns in light and a specifically modernist instance thereof.

Contemporary critics were not as convinced by the clarity of *Schatten*'s claims regarding the blurred boundaries between reality and illusion in representation. In what will become a familiar celebration of the technical attributes of the 1920s film, critics generously applauded the stylistic effects. In particular, the effects created through light by the noted cameraman Fritz Arno Wagner in *Schatten* were considered to be at the cutting edge of filmic development. Consequently, critics turned to films such as *Schatten* to legitimate the virtuosity of film as a medium. Time and again, however, they voiced their disapproval of the confusion that arises through the film's crossing over between reality and illusion. Thus, Roland Schlacht is charmed by *Schatten*'s narration solely in images—without recourse to the literary in the form of subtitles—and the resultant dramatic effects. However, he complains that the shadow effects create a merging of fantasy and reality that, ultimately, makes the narrative incomprehensible.[32] After applauding the film for its skillful implementation of the available technology and directorial skills, Kurt Pinthus is harsh in his critique. Among his problems with the film is the fact that the dream narrative of the shadow maker's film "is not divorced from reality, so that the tension and intensification is straightaway turned into fatigue and rigidity."[33] The

proximity of the diegesis of the film and that of the film within the film is tiresome and unproductive.

Alternatively, there was the odd critic who recognized the importance of this blurring of the boundaries between illusion and reality in *Schatten*. For example, a reviewer for the *Licht-Bild-Bühne* recognized that the magical use of technically manipulated light plunged spectators into an eerie world in which they could no longer determine the difference between reality and illusion.[34] For the *Film-Kurier* reviewer from the same year, the obfuscation of the definition between reality and illusion made *Schatten* a "product of pure, artistic principles."[35] However, the review in *Licht-Bild-Bühne* stands out for its identification of the link between technical vangardism and the thematic development of a self-conscious conception of the cinema as a medium of entertainment. This anonymous review also acknowledges the confused boundaries between illusion and reality as possibly the film's strength rather than its weakness. My interpretation of *Schatten* extends this review to argue that, through its allegorical narrative, *Schatten* performs and thematizes the cinema as a medium that confuses these boundaries.

The characters' introduction completed, *Schatten* depicts guests arriving one by one at the aristocratic mansion in which the night's activities will take place. The film then cuts to a low-angle long shot of the mansion's upstairs window. Shot from the courtyard below, the camera shares the point of view of two men who will become known to us as the lover and his comrade cavalier. From the perspective of the two men in the courtyard, we watch the shadows of a man and a woman passionately embracing in the window above. The animated gestures reveal that the man and woman are lovers. As if to satisfy our curiosity to find the bodies to which these shadows belong, the film cuts and the image reveals the scene indoors. We find the husband holding his head in his hands, helplessly overcome with anxiety. Moments later, the camera accompanies the lady and the cavaliers to her dressing room. Although we see nothing untoward taking place between the lady and the men who are present, when the film cuts to the hall outside her door we see the lover caressing the adulterous wife. This image is seen by the helpless husband: he is tormented by jealous fears of his wife's infidelity. However, it is not the young cavalier and the infidel who are depicted as fornicating. It is their lustful shadows that caress one another on the curtained glass door of the lady's dressing room (Figure 4). We assume that behind this door the lady and her lover are indulging in carnal pleasures. However, when the film cuts back to the inside of the room, we find that the shadows have deceived us. While the adulterous shadows continue their affectionate interlude,

Figure 4. The husband bows his head in dismay as his wife and the young cavalier "make love" in the next room in *Schatten*. Courtesy BFI Stills and Photo Archive.

the lady prepares herself for dinner and the lover animatedly gesticulates with his friends. A key light source placed in the left foreground of the set casts strong, dilated shadows of the characters on the wall behind them. The human figures do not touch; their shadows merely give the impression that they are involved in adulterous acts. Thus the film alerts us to the fact that the love affair between the lady and her young suitor appears to occur only on the surface of a glass door made opaque by the thin curtain behind it. This deceptive image is nevertheless taken for reality by the woman's husband. In addition, even though the affair is rendered insubstantial for us by the film, we nevertheless leave open the possibility of its taking place. In the minds of *Schatten*'s audience, the status of the affair remains ambiguous. We continue to wonder if, despite the fact that the wife and the cavalier are not physically touching in this scene, they might nevertheless be having an affair. After all, he and his friends do accompany her inside the dressing room. Similarly, the reality of the shadow's embrace in the mind of the husband—a reality created through the selective powers of the film frame and a manipulation of lighting—provides the impetus for the remainder of the film narrative.

Already this exposition sequence reveals a significant shift in the type of shadow that propels the narrative. Although both types of shadow are executed through an equally creative manipulation of the film's light sources, their relationship to the bodies of the casters is quite different. The shadows of the husband and wife animated in the window that compel the camera to move inside the mansion are not, strictly speaking, shadows. Unlike the shapes we see in the window, shadows cannot exist on their own: they are always dependent on, although not necessarily attached to, the solidity of the object that obstructs a ray of light.[36] The profiles in the window, however, are not the companions of the two figures. They are the figures themselves. This image depicts the actual bodies of the characters reduced to two-dimensional outlines through their placement before a hard background key light and the absence of fill light. They are silhouettes created through the use of harsh backlighting. In these early stages of *Schatten*, the shadow, or silhouette, is no more than a reduction of the material body. And yet, unlike a projected or attached shadow, the silhouette is substantive. It exists in its own right.[37] The distinction between the silhouette and the shadow is significant when considering the narrative's progression toward the appearance of the film within the film. If the silhouette represents a fidelity to and certain truth regarding the body of its subject, the film as a series of projected shadows dancing on a screen is autonomous. As a subject in and of itself, the film "shadow" is totally severed from the material of its origin.[38] Thus, in their detachment, the cast shadows reflected on the wall and curtained glass door of the woman's dressing room are a step away from the truth of the silhouette, a step closer to the illusion of the cinema.

Although I do not want to overstate the silhouettes' fidelity to the reality of this married couple and their relationship, we will note that in these early stages, the silhouettes still belong to the bodies of those whom they represent. Like the silhouettes of, for example, Johann Caspar Lavater executed as portraits that penetrate to the "true character" of court figures in eighteenth-century France, the film's objective representation casts no doubt over the signifier and referent of the silhouettes.[39] They are a man and a woman involved in impassioned communication. Increasingly, across the course of the narrative, the shadows are severed from the bodies that create them. In this opening shot of the united couple, we do not doubt that the actions are taking place, and that it is the couple that is involved, not someone else in their stead. Such certainties will be gradually withheld from us as the film progresses.

We already see the destabilization of the film's reality in the next sequence. Once inside the lady's dressing room, the shadow becomes increasingly

severed from the body to which it belongs. The shadows of the "lovers" ca-
ressing seen by the husband on the curtained glass door have no apparent
depth or materiality. The film shows us that these shadows are not attached
to material, diegetic objects. Rather, they are fabricated through a cinematic
manipulation of a stark key lighting behind the door with the express inten-
tion of depicting an illusory event. It is a specifically filmic collaboration
of lighting, framing, and editing that creates shadows designed to deceive
*Schatten*'s audience momentarily and the woman's husband for the remain-
der of the film. From this point on, the relationship between the shadows and
the bodies that cast them becomes marked by an increasing independence.

Once the husband, wife, and their guests are seated at the dinner table,
a shadow maker comes knocking at the mansion door. He beckons the
household to allow him to perform his show. In an effort to convince the
man of the house of his skill and creativity, the shadow maker uses his
hands to cast shapes of rabbits, birds, and strangely disfigured people on
the walls behind him.[40] Unlike the shadows cast on the door of the lady's
dressing room, in these animal shadows there is a discontinuity between
the objects that cast the shadows and the shadows themselves. The shad-
ows created by the shadow maker are not simply shadows created through
manipulations in light to suggest actions that never take place between
identifiable characters. The shadow maker distorts his hands to create
shapes and cast shadows that imply the presence of people and animals
that exist nowhere but in the shadows themselves. Thus, for the first time
in *Schatten* we not only see the shadow as a form of entertainment, but it
is an entertainment born of the potential to manipulate light and light-
ing to create the impression of a reality that is, in turn, an illusion. These
shadows are not only for the enjoyment of *Schatten*'s audience, but they
will also "entertain" the diegetic audience. Moreover, they are more than
shadows created by Robison's film, specifically Wagner's lighting. They
are also created by a diegetic character and exaggerated again through the
selective powers of the camera. The shadow maker may be off-center right
with his shadowed images at the center of the screen, but we know that it
is he who produces the illusions in light and lighting with the help of a
single, unseen spotlight behind him. This collaboration between the film
and a diegetic character produces a form of entertainment that is based on
the creation of an illusion. It thus foreshadows the coming film within the
film. Once inside the film within the film, the boundary between diegetic
reality and illusions in light will be even more difficult to discern. This is
because of the means by which the shadows are cast and also because of
their increasing detachment from the human body.

Following the shadow maker's arrival at the mansion, the dinner guests no longer depend on the presence of a body or character for meaning. The embrace of the woman and her lover refers to a possible affair between the two. However, the ensuing tricks of the shadow maker are a different order of shadow: the rabbit, birds, and grotesque figures are a manipulation of light and lighting. In keeping with this shift to the cast shadow as a form of entertainment, owing to framing devices, the attention of *Schatten*'s spectator is shifted from the characters who cast the shadows to the shadows themselves. The shadows do serve as demonstrations of the shadow maker's skillful creativity; however, we do not look to the relationship between him and his creations as a source of narrative intrigue. The shadows are an illusion that he creates; they tell us nothing of his character or self. Furthermore, this independence of the cast animals and faces from the character who manipulates them is underscored by Wagner's camera. This scene is shown through a camera that has little regard for establishing the relations between the shadow maker and his manipulations. Thus, the camera does not shift to frame the shadow maker himself following his short demonstration. Rather, having depicted the shadows on the wall, centered in the frame, the film finally cuts immediately to the wife performing a dance for the guests. Thus, the relation between shadows and source is secondary to the movements of the shadows: the shadows are now at the center of the narrative and the image. In this sequence, the shadows have not only become independent from the bodies that cast them, they are also privileged over the characters' bodies as narrative agents.

Having seen the demonstration of shadows, the husband is convinced that the shadow maker will provide his party with agreeable entertainment, and invites him to project the wonders of his magic lantern. Through the magic lantern we see an even more complex projection in light as entertainment. The play projected by the shadow maker is a favorite Chinese tale of an empress who is pursued by, and finally has an affair with, a neighboring prince. The play has the appearance of a traditional shadow play in which cutout figures are attached to rods and manipulated from below or the sides of a screen. This screen would be appropriately lit from behind so that the shadows seen from the other side are clearly defined.[41] However, although the shadow maker's play in *Schatten* has the appearance of such a play, the film cuts to reveal that he manipulates the figures in front of a light from behind the dinner guests. Accordingly, the shadows are projected onto the screen before all present. The shadow maker uses cutout figures (as in the ancient Chinese entertainment) and projects them using an artificial light that passes around the preconstituted figures onto a screen at some distance

in front of the audience (as in the magic lantern show). Thus, this curious form of representation crosses the traditional Chinese shadow play with the modern phenomenon of the magic lantern show.

The Chinese shadow play enjoyed great popularity in Germany at the turn of the twentieth century as a form of cabaret entertainment.[42] Most usually, the stories of the cabaret shadow plays were taken from the tales of Romantic writers such as E.T.A. Hoffmann, Joseph von Eichendorff, and Ludwig Tieck. The Romantics had themselves shown much interest in shadow plays, and works such as Goethe's renowned *Wilhelm Meister* are, still today, considered among the icons of eighteenth-century German cultural production. These modern German forms of the shadow play were employed for the very same purposes as their ancient Chinese counterparts: to tell the stories of the mythical, the fantastic and the irreal. They were used for journeying into the dark worlds of the imagination, to represent the otherwise inarticulable. Nevertheless, whereas the Asian form of shadow plays was used for religious purposes, in eighteenth-century Europe, and again at the turn of the twentieth century, the shadow play was a form of secular entertainment. The tale told by the shadow maker's play in *Schatten* is, on the surface, no more than an entertaining story without allegorical or religious significance.

In the Chinese shadow play, the shadows also take another step away from the bodies of the characters, and their performance takes a step closer to the blurring of the boundaries between the illusions of representation and reality. By this point in *Schatten*, the casting of shadows has become a process of production that is almost completely detached from the use of the human body. It is the result of moving paper cutouts before a bright light so that their outline is projected onto a screen. The Emperor, the Empress, and the young suitor are illusory cartoon figures created through the lighting. Nevertheless, the play also mimics the reality of the diegetic characters' lives: the actions and fate of the Emperor, the Empress, and her young lover are identical to those of the husband, the wife, and the young courtier in *Schatten*. The gap between the diegetic reality and representations within this reality begins to close.

The Chinese shadow play in *Schatten* also nods toward what was then the new medium of film. The play is only made possible through a modern, technologically developed form of lighting: it is staged through a mode of projection that resembles that of the magic lantern. Much to the wonder of its eighteenth-century audiences, the magic lantern marked a technological leap in the possibilities of representation because of its exploitation of artificial light, its presentation of a succession of images for

storytelling purposes, and its portability, thus its availability to numerous audiences.[43] Although the shadow maker's play is not a genuine magic lantern display—the image is placed *before* both the lantern and the lens, as opposed to *between* the two—neither is it, strictly speaking, a shadow play because it is projected rather than etched onto the screen. In the shadow maker's story we see this projection technology coupled with the cardboard cutouts of a Chinese shadow play take on a unique form. Lastly, the technologies of Wagner's camera and lighting successfully create the special shadow play for the audience of *Schatten*. Thus, the shadow maker's play is, in fact, a coming together of three different forms of manipulation in light and lighting that span a number of centuries: the Chinese shadow play, the magic lantern display, and the new medium of film.

In the shadow play, the distinction between the diegetic reality and illusion of the allegorical events becomes even more hazy. Immediately following the Emperor's confrontation with his wife and her lover, *Schatten* cuts to the shadow maker, slowly turning the source of his illumination on the wife and young lover at the dinner table. Their hands are perilously close, reaching for each other under the table. The husband suspiciously watches from the door and is horrified at the sight before him. He imitates the Emperor's interruption of the Empress's affair in the Chinese shadow play, and rushes to unveil his wife's infidelities. However, the look of surprise and offense on the wife's face as her husband insists that she separate from the young man next to her suggests that perhaps her infidelities occur nowhere but in her husband's imagination. And yet, the viewer too continues to question the fidelity of the wife. When the film cuts back to the hands under the table, we learn that the hands are not touching; rather, it is only their distorted shadows that caress one another. But perhaps the woman and her lover have moved in the space between the image of the husband's shock and the eyeline match of the offending image? The film then cuts to the shadow maker as he shifts the light from the dinner table to the screen. We begin to wonder whether the affair is now in the hands of the shadow maker. Is it through his impressive abilities to manipulate light that the boundaries of representation (Chinese shadow play) and diegetic reality (the wife's infidelities) are confused? Does he fabricate the affair that mimics that of his Chinese shadow play through the tendency of shadows to distort the shape of the bodies to which they belong? Does he construct infidelities where none exist? Or does he simply illuminate what is already taking place under the dinner table for all to see? In short, we are beginning to suspect the shadow maker to be the director and the narrator of both a Chinese shadow play in moving cardboard cutouts

and the fortunes of those who watch this representation within the film. However, we do not yet understand the status of either his role as director or that of the images he narrates. With such questions never decisively answered, the distinction between the representations in light and the reality of the diegetic world has become obscured for the audience of *Schatten*.

This confusion arises from the disjunction between two modes of articulation—technical experiments in light and lighting and the melodrama. In turn, the confusion creates a conceptual space that provokes audience reflection on the meaning of these moments and the film as a whole. Even though the shadow maker's manipulations in light fuel rather than interrupt the drama between the characters in the diegetic reality, there are still two distinct worlds in play here. We may lose sight of the distinction between the world of the shadows and the world of embodied characters, but they are nevertheless of a different order. The hazy distinction here stands in for the coexistence of two different approaches to technological modernity. The thrill, yet disorientation, of the technological becomes intertwined with the bourgeois moral order played out in *Schatten*'s drama.[44]

This bleeding of one reality into another becomes further intensified when the shadow maker proceeds to steal the long and dramatic shadows of the dinner guests. He effectively assumes the role of director of a film within a film when he literally throws the diners' shadows onto a screen. This performance becomes the entertainment of *Schatten*'s audience, much as the Chinese shadow play was the entertainment of those at the table. However, this new projected image is not a form of animation in which life is given to otherwise static two-dimensional objects. Rather, with this crossover from reality to illusion, while the dinner guests are deep in a hypnotic slumber, their shadows perform for us in a film. Finally, the shadow as a medium of entertainment reaches its most sophisticated form: the film within the film.

This moment of transformation in which *Schatten* shifts to a film within a film is a moment articulated cinematically. The dinner guests are happily enjoying their meal when the shadow maker casts a spell with his hands over their elongated shadows. Shot from an extreme high-angle long shot, the shadows of the diners become foreshortened until the light source that moves overhead (but is not seen) shines on them at right angles from above. At this point, as would be the case under the midday sun, the characters have no shadows. Through a dissolve the figures disappear from the left-hand side of the table and reappear on the right-hand side.

Then in a cut to a diegetic screen, we, *Schatten*'s audience, have taken the place of the diegetic audience and are watching the dinner guests seated at their table on the screen before us. We watch the film within the film, the image of which consumes the entirety of our screen while the dinner guests are assumed to slumber offscreen.

Once inside the world of the film within the film, *Schatten* continues the narrative that commenced (if only in the uncertain world of shadows) with the wife's embrace of her young lover in her dressing room. She sneaks away from the dinner table to join her lover in the bedroom. Of course, the suspicious husband follows his wife to the bedroom and catches her kissing her lover. However, in keeping with the illusory quality of the husband's visions in the film thus far, he will only ever see his wife's adulterous embraces reflected in a mirror that sits in the hallway outside her bedroom. Moreover, at crucial moments, the light reflected in the mirror becomes so strong that the image of infidelity spied by the husband is whited out and we wonder if we are, once again, witness to the husband's subjective, deluded narration. Alternatively, if this is not the husband's projection, is the shadow maker now deceiving us with his manipulations in light? Unlike the previous scene in the dressing room, the film does not give us privileged access to the room inside where the woman is supposedly cavorting with her lover. Rather, we are forced to witness the events with the jealous husband, outside the room in question. Although it may not be an excess of shadow that creates confusion here, the intensity of light shining in a mirror produces just as much uncertainty in us as spectators.

*Schatten*'s audience may question the veracity of the husband's vision, but he does not. Enraged by his wife's illicit affair, he begins to plot his revenge. Crazed with jealousy, he orders his servants to capture the wife who has betrayed him. Subsequently, in a scene played out entirely through shadows of the characters (who are already imaginative figments) in the film within the film, the pursuit of the now-fearful wife begins as the servants chase her through the labyrinthine corridors of the mansion. The audience of *Schatten* never actually witnesses the wife being caught by the servants; rather, their dilated shadows act out this drama. In a review of the film that reveres the creativity that *Schatten* brings to the medium of film, a writer for the *Licht-Bild-Bühne* is in awe of the fact that this central scene is entirely represented in light: "In [the murder scene], the most gruesome moment is painted in shadows on the wall. It is done with an artistic discretion, as is the case for the whole film, that is only made possible through shadows."[45] As the writer goes on to say, the "ghostly," "treacherous" illusions of *Schatten* are the art of fantastic light.

But the film is much more than this: ultimately, *Schatten* is so confusing to the viewers that they can no longer determine where dream ends and reality begins.

Because we have been warned to view the activities of the impassioned shadows with suspicion, we are left wondering whether or not the wife is caught by the servants. Or are these events only taking place in someone's imagination? Perhaps the shadow maker as film director is once again manipulating the shadows of shadows as independent phenomena? We know now that the shadows are severed from the bodies to which they once belonged, and therefore, their actions may have no relationship to those of the embodied characters. For we have come to be skeptical of the veracity of the action of shadows that are independent of bodily agents. So the shadows function as a source of mistrust and confusion.

The film within the film continues until the wife has been murdered and the husband violently hurled from the window of his mansion by his servants for having killed the lady of the house. Yet again, we do not witness the wife being murdered by the servants: we see only the shadows acting out this scene. The husband commands the servants to bind his wife to the table, which thus becomes a sacrificial altar. He stands to the left of the screen, and holds a candelabra that, together with his body, blocks the view of the wife's struggles and eventual murder. To reiterate, the actual slaying of the wife only appears etched in shadow on the wall behind the characters, to the right of the screen. Having reached this tragic conclusion, the husband's dead body lies in the square outside the house, then disappears like that of a vampire through a dissolve. The lights in the film within the film go out, and the camera pulls back from the window out of which the husband was thrown by his servants. The lights in the mansion's diegetically real dining room come back on. We see the blank diegetic screen on which this tale of heated passions was projected, and in a process that mimics in reverse the shadow maker's stealing of their shadows, the dinner guests are given back their shadows. At this point in the film, *Schatten* gives us the distinction between the diegetic reality and the shadow maker's film as representation. The transition from film within the film to nonfilm at least creates visual boundaries: we see and know that the film within the film has ended and the action of *Schatten* has returned to the events of the diegetic reality. At least we tell ourselves this is certain. The shadow maker continues with the relatively sedate Chinese shadow play. When the shadow maker has packed away his entertainment, a servant opens the curtains to reveal that it is now daylight outside and people are busy at work in the square below. The husband has been

cured of his jealousy as he and his wife happily watch the goings-on below through their dining-room window. Thus, the moral chaos caused by the shadow maker's interventions in light and lighting has been resolved by the conventions of melodramatic closure.

In keeping with the development of the creation of shadows across the narrative, the film within the film is *Schatten*'s most sophisticated form of projection in light. It is the most technically advanced in its projection of a beam of light through a series of static images that, when they move, give the appearance of one continuous image. Similarly, the embodied characters of *Schatten* and their "shadows" in the internal film act independently of each other. While their bodies are deep in a hypnotic slumber with their heads resting on arms at the dinner table, their shadows perform this most passionate of screen dramas. The shadow no longer needs a body of any kind for its creation and definition. It is an agent in and of itself. Lastly, the blurring of the distinction between diegetic reality and illusion in light has become so magnified that it is impossible for us to know what exactly the film within the film represents. We may be aware of where the one literally begins and ends (with the shadow maker's theft and return of the diegetic characters' shadows); however, the conceptual boundaries are difficult to map. Perhaps the film within the film represents the characters' unconscious desires personified,[46] or, maybe, once again, the adventures are the construction of the all-powerful shadow maker as filmmaker? Perhaps, as some critics have suggested, the film within the film is the figment of the anxious husband's imagination?[47] Perhaps it is that of the guilty wife's? All we can be certain of is the uncertainty of the relationship between the film within the film and events of the diegetic reality.

*Schatten*'s ever-more complex and technologically sophisticated shadow projections can be interpreted as allegories of the intricate weave of reality and illusion in the medium of cinema. As silhouettes are transformed into shadows, shadow plays, and ultimately projections on a screen, *Schatten* gives its own allegorical vision of the cinema's development as a light representation. This narrative thrust toward a representation of the cinema runs parallel to the gradual dematerialization of the human body. In addition, the boundaries between diegetic representation and reality are blurred. *Schatten* represents the cinema as a medium of shadows so technologically advanced that it does not depend on the presence of the bodies that originally give life to its images. Similarly, its reality cannot be trusted. Certainly, the status of the relationship between the diegetic reality and illusory fables (particularly those of the shadow maker-cum-filmmaker) is always ambiguous in *Schatten*. What is the status of the film within the

film? Does the wife really have an affair with a young cavalier? Or does this affair belong solely to the husband's imagination? The shadow maker's magic wand? The dinner guests' unconscious minds? Perhaps the affair is the creation of Robison's direction? Or of Wagner's skillful lighting arrangements? In turn, given the ambiguity of the relationship between the film within the film and diegetic reality, when *Schatten* is over we are also left to ponder the question, What is the relationship between the reality of the film and that encountered upon leaving the theater in which *Schatten* has screened? It is not a question *Schatten* ventures to answer; rather, the film simply raises it in the minds of its spectators.

This same question of the relationship between film and reality often underpinned contemporary debate concerning the validity and effects of film as an artistic medium. For example, in his article on the bankruptcy of German film, Carl Einstein points to the same confusion between filmic representation and reality as that highlighted by *Schatten*. He cites the mimetic function of the moving image as the cause of audience confusion.[48] He claims that "the soul of a film is confusingly compared with an analyzed children's home. The only thing whose impact is as stupid as art is the strikingly cheeky improbability of these things that are photographed as realistically as possible."[49] Contemporary audiences were nevertheless arrested by the confusion of this new medium and its proximity to reality because, despite its confusion, it was preferable to the tedium and insubstantiality of daily life. In another example, Kurt Biebrach draws on the respective relationships to reality of both theater and film in his explanation of the difference between the two media.[50] Biebrach articulates the different ways the two media manipulate reality, noting specifically that film is "no more than a mechanical repetition of real events."[51] At least this is how he imagines we experience film to be. In the theater, sets can be fabricated and actors can feign death, whereas in the cinema, anything less than the apparent replication of reality is unacceptable to audiences. The result of this demand for visual and sonic mimicry of actual events is, according to Biebrach, that we forget that we are watching a representation rather than the real thing. Of course, he acknowledges that the film image is twice removed from the original events, and that it is an instrument of industrial capitalism: reality is first filmed, and this footage further manipulated in postproduction, all for the entertainment of a mass audience. Nevertheless, he argues that we *experience* the film as though we are present at the events. The plausibility of Biebrach's claims aside, like many of his contemporaries, he bases his argument regarding the specificity of film on a certain notion of its proximity to reality.

Although the critics' arguments resonate with *Schatten*—the blurring of boundaries between illusion or fantasy and reality, and the confusion brought about by the mimetic function of the moving image—*Schatten* refrains from making the judgments that compel critics such as Einstein and Biebrach. *Schatten* does not have the same ideological or moral investment in legitimizing film as an art form. The film is not committed to explaining the value of its own images. Rather, *Schatten* is content to raise, but not answer, questions regarding the nature of the relationship between representation and reality in the film medium. The film's refusal to answer the questions gives way to a confusion in the audience, and this is *Schatten*'s innovation: it uses the technology at its disposal to return its thematic confusions to the level of style.

The similarities between *Schatten*'s questions and those of 1920s German film critics prompt us to consider the film as a speculative discourse where it might not otherwise be understood as such. The film testifies that the written word was not the only medium in which filmic properties and technological potential were being examined in order to understand the larger philosophical questions raised by film as a medium. Lastly, *Schatten* enters into these debates through a multilayered deployment of technical light. It uses light and lighting both to experiment with the capacity of shadows to carry narrative agency and to play with the shadow's distinction and indistinction from embodied characters. Through this creative use of light and lighting, *Schatten* manages to disorient its viewers, and ultimately, encourage them to reflect further on its *mise-en-abîme* of representations. Thus the film's complexity as a metafilmic discourse on the status of its own representative dimensions. And because *Schatten* does not resolve the issues raised through the metafilmic dimension, it pushes its audience to critical awareness.

*Schatten* reiterates a German Romantic preoccupation with a necessary retreat to the threshold of reality—a threshold represented by a natural half-light—in order to understand the asceticism of daily life. This concern is revivified by *Schatten* in its allegorical reflection on the historical development of the relationship between the cinematic apparatus and the cinematic experience. Thus, Robison's film appropriates a familiar concern from the past in what is effectively a modernist representation of the filmic manipulation of the image. *Schatten* takes a preoccupation also found in works such as those by Friedrich and Eichendorff to investigate film as a representational process. At the level of the film's form, *Schatten* is distinct from the aesthetic of the past. In *Schatten*, the onetime crepuscular mysticism represented through color as light becomes a cinematically

manipulated struggle between light and darkness. This use of the cinema and its particular self-reflective capabilities signal a representational break with the myths of the past. However, in the allegorical representation of the gradual development of cinema from silhouettes, through cast shadows, Chinese shadow plays, and magic lantern shows, *Schatten* also boasts the continuity between the cinema and the more traditional forms of light representation out of which it has been acknowledged to have grown.[52] Thus, the film can be understood, at one and the same time, to inscribe both the radical changes of the technological revolution—specifically, in the development of the relationship between representational illusion and reality—and the continuity of modern history.

To put this simultaneous engagement with and departure from the past in another way: *Schatten* appropriates light as the material of metaphysical realization, and also secularizes it in what is an example of the modernist tendency to manipulate artistic form in the interests of exploring the formation of these realizations. It is true that the film represents a hero who is overwhelmed by his conflictual relations to those around him. Similarly, the husband as hero journeys to the edge of reality—here, into the illusory uncertainties of representation—and returns having resolved the conflicts that plague him. Thus, like the mythical hero and unlike the modern melodramatic hero expounded by Peter Brooks, *Schatten*'s hero does not fail in his quest for enlightenment. And his emotional "enlightenment" is achieved through following a light (that of the shadow maker) into the unchartered landscape of representation.[53] Thus, *Schatten* uses light in the service of regeneration through a transcendence of sorts. At this level of the plot, therefore, the film imitates the premodern aspirations for social and spiritual integration. Similarly, Romantic painting, for example, is always reflective of its medium, as can be witnessed in its tension between surface and depth, light and darkness, color and transparency. *Schatten*'s arguable concern with its own image production is, in principle, nothing new.

However, like many of the 1920s German films, *Schatten* does not introduce a protagonist in search of a spiritual ideal, nor is the film's spectator seduced into spiritual reverie. The protagonist becomes reconciled through the force of a material representation achieved through light that he experiences together with others—not through a turning inward, thus away from the world. Similarly, the audience is invited to respond intellectually, not spiritually, to these light images. Thus, when approached via its formal appropriation of light and lighting, the film engages with the intellectual and emotional levels of understanding. From this perspective, once

again, *Schatten*'s explorations of light and lighting are in tension with the dramatic action. While the one aspect is content to reproduce the aspirations of narratives of the past, the instances of light and lighting counter their urge toward integration.

## Conclusion

*Algol* and *Schatten* technically manipulate light and lighting to expound narratives about the introduction of advanced technological apparatuses into everyday life. *Schatten* does this through its metacinematic discourse on the cognitive and perceptual confusion that results when the boundaries between representation and reality are blurred. This blurring of boundaries is only possible owing to the mimetic capacities of the film medium. *Algol* uses light and lighting compositionally and thematically to put forward its narrative on the potential destruction of a technologically generated world. The phenomenon of electrical light thus becomes the very language through which *Algol*'s narrative is communicated. There is ostensibly little that binds two films such as *Algol* and *Schatten*. It is true that they were both made during the first half of the 1920s, but by different studios, directors, cameramen, and production crews with different backgrounds, all of different nationalities. However, in their technically and thematically diverse uses of light and lighting, *Algol* and *Schatten* each use artificial narratives. Similarly, they utilize the technical possibilities that both give definition to their medium and alter the fabric of the historical world in which they were produced. Moreover, the two films use technically manipulated light and lighting to represent the fabric of this same historical world. *Schatten* even uses light and lighting to speculate on its own definition within this world, and, by extension, that of the film medium more generally.

In both films there is also an engagement with the historical definition of traditional, mythical tales. They signal the simultaneous continuity with the past in what is nevertheless a distinct present. In its turn to the past for the definition of the present, *Algol* encapsulates a disjunction between the peculiarly atavistic and the vanguard of technological experiment. Through this uneasy marriage, the film warns of the liability of utopian technological aspirations, based as they often are on mystical notions of greed and power. This is *Algol*'s moment of self-consciousness. *Schatten*, however, marshals its recourse to the past in order to articulate the confused boundaries between illusion and reality once technological processes of representation are set in motion. If there is a tension created

in the narrative of *Schatten,* it is at the level of the narrational process. *Schatten's* representational illusion and reality are manifest in technical manipulations of lighting (and shadow) and the melodramatic plot, respectively. These two aspects of the film, in turn, signify two aspects of the modern industrial world: the marvels of technological entertainment and their consequent confusion of the moral and social order. Although neither film is particularly equivocal in its vision of technological modernity and life in its midst, through their respective narrative tensions, *Algol* and *Schatten* still ask their viewers to question further the experience of complex processes of modernization. By leaving such questions in the minds of their viewers, these films display an openness and multidimensionality common to 1920s German films.

# 4

## The Spell of Light:
## Cinema as Modern Magic in *Faust,*
## *Der Golem, Siegfried,* and *Metropolis*

If this be magic, let it be an art
Lawful as eating.
William Shakespeare

. . . if one turns from . . . the old story that remains eternally new,
to the really new and newest history, to the fantastic changes of
technology, then it is not surprising to see even here a place for
forming fairy tales, i.e., for technological magical utopias.
Ernst Bloch

Ernst Bloch was not alone in his characterization of technologically pro-
duced narratives as modern versions of the traditional fairy tale. Many
of Bloch's contemporaries identified the cinema's creation of illusory
realities, its magical transformations, happy endings, and timeless, uto-
pian dreamworlds to be twentieth-century fairy tales. Like Bloch, other
contemporary journalists and literary critics regarded the "magical" possi-
bilities of the cinema as the basis of its differentiation from the traditional
arts. Friedrich Sieburg, for example, reflected on the role of the actor's
body in film for its production of magical effects.[1] According to Sieburg,
the magic of the cinema lay in the potential for the filmed face and eyes
to express the soul outwardly, an expression seen in the performances of
Asta Nielsen. Similarly, despite Charlie Chaplin's deadpan facial expres-
sions, Sieburg considered his dexterous, acrobatic bodily movements to

be equally magical in their expression of intense inner emotions. Sieburg believed that Nielsen's and Chaplin's physical expressions were "magical" because, unlike acting in the theater, their facial and bodily expressions did not *interpret* the sentiments of everyday experience, but rather *suggested* what could otherwise not be expressed.[2] This suggestion is achieved through the agency of the camera. In addition, again analogous to the magic act, film acting calls on the spectator's imagination to complete the movement or gesture to give it credibility and meaning. Thus this notion of *suggestion* is central to film acting as magic: it is the effect achieved through the specifically cinematic *and* that which ties it to stage magic.

In distinction to Sieburg's celebration of the magic of the filmed actor's body, many contemporary critics were unimpressed by the cinema's "magical" possibilities. Literary critics such as Walter Muschg were vitriolic in their disapproval of the illusions yielded by the cinema's magical elements. Muschg, for example, considered the camera's distortions of the pro-filmic set and the manipulative strategies used to glorify the star as nothing short of "obscene," "debased," and "confusing."[3] Commonly, among these film critics, the magic of film lay in its technical creation of impossibilities, which, in turn, spoke its vacuity and vulgarity. In short, the cinema as magic was considered by such critics as a spectacle of technology rather than a serious art form.[4]

Whether they looked on the magic of the cinema with utmost disdain or with reverence, none of these journalists or literary critics was interested in interrogating the relationship between cinema and magic. In their musings on the cinema, these writers simply invoked the notion of magic as a descriptive shorthand for attributes, either revelatory or superficial, that they deemed essential to the medium. Strongly implied in their discussions of film as magic was the notion that the films were utopian fantasy worlds that provided sentimental entertainment and escape.[5] Alternatively, film critics from the period who invoked the notion of cinema as magic did so in the absence of any other language with which to articulate the seeming mysteries of the technical "tricks" of the medium.[6] What none of these writers reckoned with was the fact that the "magical" potential of the cinema was not restricted to its capacity to create illusory realities through surface manipulations. Similarly, the notion of magic was more than a rhetorical solution to the otherwise inexplicable processes of film production. Indeed, the relationship between cinema and magic has a depth and a history to which these critics remained blind.[7] This relationship, in turn, affords the cinema a significance that is nowhere identifiable in the 1920s film criticism.

In this chapter I analyze the relationship between cinema and magic in F. W. Murnau's *Faust* (1925), Paul Wegener's *Der Golem* (1920), and Fritz Lang's *Siegfried* (1922–24) and *Metropolis* (1927). Through this relationship we find the films' discourses on the shape of history and the changes to temporality in a technologically powered world. In each of these films, cinema and light conjoin as the medium of magical transformation. Thus, the films not only invoke the cinema as magic to represent the nature of history in their midst, but they use light and lighting to effect the representation. Light is either transformed by the "magic" of the cinema or it is used to represent magical, specifically cinematic, transformations. Thus, light and lighting do not simply accompany, or illuminate, the magical transformations of objects, people, or creatures of the night. They are either the objects to be transformed or the vehicles that enable transformation. In *Faust, Der Golem, Siegfried,* and *Metropolis* we see a self-conscious display of film lighting as a form of magic, and these displays engage with questions of temporality that can only be addressed visually through the moving image. In turn, the temporal distortions of film as magic lead to the films' discourses on the shape of history in the technologically developed world.

Three of the four films discussed in this chapter extend the concerns raised by the films of chapter 3. *Faust, Der Golem,* and *Siegfried* foreground cinema technology in their rearticulations of familiar myths that have gained popularity in Germany over the course of at least two centuries. This reiteration through technological means ushers forth a continuity with the past in a present that is simultaneously defined by its difference from the same past. Like *Schatten* and *Algol,* this complex relationship between past and present is identifiable if we understand the films as modern technological visions of tales of the past. *Faust, Der Golem,* and *Siegfried* take this relationship to time and history one step further; for it is not simply historical relations between past and present that are at stake in *Faust, Der Golem,* and *Siegfried.* Rather, the magical manipulations in light extend to representations of time itself, and in particular, transformation to time and temporality in the technological age. Always in these films, the moment of magic represents a distortion of the flow of diegetic time. Time is foreshortened, collapsed, or impossibly reorganized in the breathtaking cinematic moments of magic. These self-conscious reflections on the movement of time are subsequently reintegrated into the remainder of the cause-and-effect narrative. This complex narrative pattern then offers access to the films' discourses on the altered shape of time and history in the modern industrial world. Thus, through their retelling of popular German myths,

*Faust, Der Golem,* and *Siegfried* establish the connection between their worlds and those of more traditional tales.[8] *Metropolis,* however, works slightly differently. The central, albeit brief, moment of magical creation in *Metropolis* also represents the inconsistencies of temporality in modernity. However, it does not draw on past mythical traditions for this representation. Rather, for *Metropolis,* the magic is always the representation of a new technological invention; that is, technology as magic is the innovation of the present and a fictional future.

Through the metonymic relationship of electrical light and cinematic "magic," *Faust, Der Golem, Siegfried,* and *Metropolis* also announce their contemporaneity. Again, the films draw on a tradition within representation that uses light for the articulation of history and historical time. In literary and theatrical dramatizations of myths and legends on which the films draw, moments of magical transformation are always cast as spells surrounded by configurations of light. Unlike any other medium before it, the cinema as technically manipulated light has the capacity to create a metonymic relationship between magic and the medium of representation. No longer must words be used to create the image in which light emanates from or illuminates matter in the process of unearthly transformation. No longer must paint represent the elements of fire and thunder that are summoned as media for fantastic journeys through time and space. With the advent of cinema, light itself can be magically transformed. Furthermore, through the cinema, journeys transcending the limits of spatiotemporal reality can take place ad infinitum. With these technological capacities at its disposal, contrary to the opinions of contemporary critics, the relationship between cinema and magic, the cinema as magical transformation of electrical light, embraces its potential to go far beyond the creation of superficial and illusory realities for the purposes of mere entertainment. The magic of the cinema must not be dismissed as vacuous or mere entertainment. These films are testimony to the fact that the magical moments of cinematic visualization offer insight into technology's redefinition of time. In particular, the cinema as technology is shown to redefine time and the shape of history. In this way, *Faust, Der Golem, Siegfried,* and *Metropolis* engage in the discourses of everyday life in a technologically rationalized world, rather than simply providing utopian worlds for escape from reality.[9]

The national and cultural significance of these films is also critical to their historical discourses. The turn to mythical narratives, in particular, those involving magical transformations, enables these films to fulfill a number of goals. First, during the 1920s, the local German film market was under threat of colonization by Hollywood. In their urge to rival

Hollywood as a commercially successful cinema at both domestic and international levels, German film financiers and makers recognized the importance of creating a uniquely German product.[10] Thus, legends and myths traditionally mobilized for analysis of the national psyche provided fitting subject matter.[11] Second, the recurrence of extraordinary special effects to represent magical forces strongly suggests that these myths and legends presented the challenge and opportunity to explore the technological capacities specific to the medium. Magical transformations were ideal for foregrounding the wonders of cinema. Third, these explorations of the technology also gave the German product an international respectability. They gave it a relevance and an appeal beyond the home market as they connected to issues being explored in other Western cultures. Fourth, under pressure from critics, the filmmakers strove to make a product that could be legitimized as art, and was thus acceptable for the enlightenment as well as the entertainment of bourgeois audiences. By producing filmic versions of myths that had already found a place in the highest intellectual literary traditions, their artistic valence was guaranteed.[12]

### *Faust* (1926)

In their 1926 film interpretation of the classical German legend of *Faust,* F. W. Murnau and cameraman Carl Hoffmann foreground the lighting in the eerie mise-en-scène. Murnau and Hoffmann make significant changes to the legend of Faust's temptation by Mephistopheles, the servant of the devil, not the least of which are those brought about by the use of the cinema.[13] Together with Lang's *Metropolis, Faust* was hailed as one of the great "pioneering works of special effects" of the 1920s.[14] In particular, in the filmed *Faust* we see an unprecedented exploration of technically manipulated light and lighting.

In *Faust,* Murnau and Hoffmann do more than contrast light and darkness in the fabrication of an environment, or mood, that expresses the Faustian struggle between the forces of good and evil. Light and darkness are contrasted to articulate the action of this familiar, dark story. Mephistopheles is always dressed in black and his presence often casts a shadow that is so overwhelming that at times it eclipses the whole town. By contrast, the virgin Gretchen is usually bathed in light, and sometimes she even appears to radiate soft light, especially in the scenes in which Faust courts her.[15] Murnau and Hoffmann go still further to create an ambience and the moral status of their characters through lighting. In arguably some of the most imaginative uses of lighting in 1920s German

cinema, each turn that Faust the old philosopher takes on his journey from metaphysical blindness to insight across the course of the film is rendered through a display of the lighting as technological magic.

In the four centuries since Johann Spies's *Faustbuch* of 1587, the *Faust* legend has continued to engage questions of time and history. If only in its retelling of a tale that has its genesis in a concrete point in the past, any version at the very least encompasses questions relating to the "pastness" and the "presentness" of the myth.[16] If Goethe's play moves between the modern and the medieval,[17] then Murnau's film brings these concerns into an era of technological modernity. In distinction to past literary versions and earlier film adaptations, Murnau's 1926 film uses the technologies of light and cinema at critical narrative moments to articulate the effect that technologies have on the shape of history and temporality.[18] In particular, the technologies of light and cinema impact on time and history.

The attitude taken by *Faust* toward the ostensibly disturbing impact of these technologies on history and temporality is complicated. Despite the fact that Mephistopheles is the diegetic orchestrator of these transformations, the representational substitute for the filmmaker as magician, it would be misleading to conclude that Murnau sees these transformations as negative. On the contrary, the bursts of cinematically manipulated light testify to Murnau's celebration of the medium at his disposal. Thus, the film revels in the potential manipulation of time and the flattening out of history that comes courtesy of the cinema as modern magic. Nevertheless, according to the narrative logic, the film also rejects, even effaces, the world that enables these unique temporal and historical constructions. When Faust rejects the world of Mephistopheles and opts to return to the historical world with human love as its defining feature, he chooses to live in a more traditional relationship to time.[19] This relationship is articulated through the melodramatic plot. Typical of the 1920s German film, the relationship to technological advance and the extremity of its effects is never resolved in *Faust*. The melodrama—which, in the case of *Faust*, concludes in a spectacular display of light—may be brought to an end with the triumph of heterosexual love, but the disruptions along the way still remain vital to the film's overall relationship to the effects of technological advance. The two visions of the conception of history and temporality within modernity are incompatible, yet everywhere coexistent in *Faust*. Like the much-discussed melodramas of Douglas Sirk in which the stylistic excess of the melodrama clashes with the plot to puncture the sheen of Eisenhower America, films such as *Faust* sustain the excess of their spectacular displays in light.[20] In turn, this stylistic energy

hinders any moral closure to the drama, thus creating tensions that offer the potential for social analysis on the part of the audience. Moreover, the film's indecision resonates with conflicting discourses regarding the representation of time and history in the modern industrial age that were in circulation in 1920s Germany.

The film was rejected on its release in 1926. Virtually every one of the negative reviews of the film (of which there were many) expressed dissatisfaction with its distance from Goethe's canonical version of the myth. The esteemed Bernard von Brentano, of the *Frankfurter Zeitung,* was outraged that the love story between Faust and Gretchen consumed so much of the film. Apparently, Murnau "threw away what he failed to understand of" Goethe's version and turned it into a love story.[21] Von Brentano did not object to the mythical melodrama, but rather to its digression from Goethe's canonical version of the myth. Willy Haas's critique is representative of another complaint about the film: Murnau should have filmed either the story of Dr. Faustus or the Gretchen tragedy, but not both.[22] Haas maintains that the film is uneven because it tries to encompass too much, that is, both stories. Similarly, all of these critics complain that as a result of the shape of the melodramatic plot, *Faust* strives for coherence and unity, whereas, traditionally, the tale is fragmented and incoherent.[23] The film was considered a trivialization of the integrity of German art and its traditions.

In response to these critics, I propose a turn away from consideration of Murnau's film in relation to Goethe's play. If we approach the film primarily on the basis of its *difference* from previous adaptations, we access its challenging representation of the world in which it was produced. Similarly, if we attend to the film in its entirety, rather than solely to the utopian elements of the narrative, we understand this representation to be complex, even contradictory. Once again, we must give equal weight to both the discourses of dramatic action and technical fortitude. Similarly, the tension between them must be examined for its opening up of multiple interpretations, rather than the difficulty it may pose to easy consumption. This friction between the two narrational aspects is also precisely what gives the film its relationship to the contemporary: I argue that the narrational use of lighting continually brings us back to the fragility of modern morality. It actively stymies the potential for a metaphysical journey through contemplation to spiritual unity. Such might be the result if the technical experimentation were married to other narrational aspects to provide a seamless narrative.

In the opening scenes of the film, Mephistopheles as the master of the cinematic image manipulates the lighting. An angel makes a pact with

Mephistopheles: if he can tempt the saintly Faust into a life of sin and corruption, the earth will be his. Appropriately, the angel is depicted surrounded by beams of shining light, and he dissolves into the radiant beams of the moon once the pact has been agreed upon. In contradistinction, Mephistopheles is the personification of darkness and looming shadows. He spreads his cloak over the town below and casts the spell of death in the form of the plague as his preparatory measure for tempting Faust. When the film cuts to the town below, it is carnival time and people have gathered to watch circus amusements. Among these attractions is a medieval shadow play. As the townspeople are marveling at the shadow play, the first victim is struck down by the plague.

Elsaesser draws on Alexandre Astruc's and Eric Rohmer's observations when he claims that the coherence of Murnau's narratives is not found in the cause-and-effect logic so familiar to the Hollywood narrative, but "in the urgency of a desire, an obsession, an anxiety or a wish."[24] The example offered by Elsaesser is from *Nosferatu*. When a terrified Jonathan Harker presses himself against the side of his bed at the approach of the vampire, the film cuts to his wife Ellen in Bremen suddenly wakened from a terrible nightmare. *Nosferatu* proceeds to show the vampire halt his approach to Jonathan, look offscreen, and as if to reveal his point of view, Ellen is then shown sleepwalking through indeterminate spaces. Thus, through this editing pattern, a relationship between Ellen and the vampire is established in the mind of the audience. It is "an architecture of secret affinities too deep or too dreadful for the characters to be aware of and even for us, happening only at the edge of perception."[25] This same highly developed montage style binds Mephistopheles as a dark, evil shadow to the figures of the shadow play on earth below in *Faust*. In our minds, although beyond the comprehension of the diegetic world, it is as though Mephistopheles has sent these shadows to earth as his medium, to cast doubt and illness over the people of Faust's town. It is as though he is manipulating these specters, as an early form of cinematic visualization, to darken the life of the community.[26]

Alone in his musty study, engulfed by the books that have enabled both his wisdom and his lifelong abstinence from human pleasures, Faust sits hunched, anxious to find a remedy for the plague that is rapidly killing his townspeople. Unable to find an answer in his scientific books, he reaches for the Bible. Helpless in the face of this apparently natural catastrophe, his last resort is to pray for an end to the nightmare. As he sits, his old and angst-ridden face is gently illuminated by the glow of a candle on his desk (Figure 5). He is already distinguished from the evil, dark Mephistopheles.

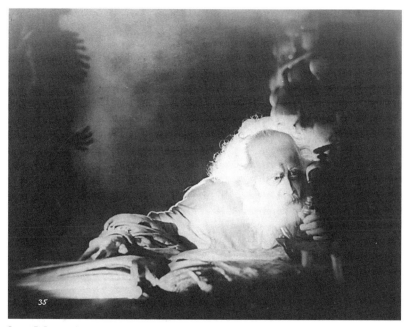

Figure 5. Faust in his study in *Faust*. Courtesy Photofest.

Frustrated at the apparent inefficacy of his constant prayers to the Lord, Faust hurls the Bible along with his other books into the fire that now rages in his study. This image of the angry philosopher in his study is shown through the flames of fire that burns his books.[27] Despite his profanity, Faust's face glows with grace as he stares in disbelief at the unhelpfulness of his books. When the film cuts back to Faust's point of view, he is taken aback by the energy of the fire miraculously turning the pages of the Bible. When he excitedly, but cautiously, strains to see what wisdom lies before him on these burning pages, the book that was once his Bible tells Faust that the "Prince of Darkness" will give him the power to cure his towns-people of the plague. His task thereafter is to summon this prince at the crossroads on the other side of town.

Mephistopheles' arrival on earth is represented as a burst of light.[28] Faust stands at the crossroads and repeatedly utters the magic words, and, as he does so, the old philosopher becomes encircled by multiple rings of light that rise up his body and evaporate into the night sky. Thunder and lightning shatter the sky and a blazing fire in the foreground dissolves into Mephistopheles, who is invisible to Faust, his conjurer. It should be recalled that *Faust* is a silent film, and therefore, the deafening sound of the thunder that accompanies the electricity of the lightning is visually

constructed through frenzied flashes of broken light. The thunderous coming of Mephistopheles is thus represented through the combination of lighting and editing. Both the devil's first appearance as circles of fire that enclose and ascend the length of Faust's body, and his magical embodiment, visible to the spectator but not the protagonist, literally born of apparently self-igniting flames, are created through editing techniques of superimposition and dissolves. Similarly, as Thomas Brandlmeier explains, these magical effects are made possible through Carl Hoffmann's "Two-Sun-Phenomenon." One light source creates the flaming concentric circles that emanate thin spherical beams of light in motion, the other gradually illuminates Faust in the foreground.[29] This moment of cinematic magic ignites the narrative of Faust's journey into temptation.

Having conjured the devil's servant, Faust has the power of eternal life at his command. In keeping with the familiar legend, Mephistopheles tempts Faust to deny his human mortality. The servant of the devil conjures a reflection in light of a strikingly handsome young Faust on the surface of a bowl of deadly potion. Once again, the appearance as if through magic is achieved through Murnau's in-camera dissolve of the face onto the liquid's gently rippling surface. Faust is on the precipice of poisoning himself as he now knows that it was the devil he summoned at the crossroads. Thus, when he gives in to the good looks of youth, he knows it is the devil who has enticed him with the image of youth and the promise of erotic fulfillment. By granting the old philosopher the satisfaction of earthly desire as well as his youth, Mephistopheles both gives Faust access to being human and saves him from the poisons of old age and death.

What Mephistopheles can do is what the cinema can do. He can cover Faust in the cloak of the devil and, before a cauldron of boiling potion, utter the magic word and enable the philosopher to shed the tedium of an aging life of learning. Under the magic wand of Mephistopheles, the "director," Faust becomes the handsome young man he saw reflected in the poison that would have killed him had Mephistopheles not intervened. As in the cinema, the logic and limitations of historical time are of no concern to Mephistopheles. He can transcend the temporal logic of the diegetic world and take his protagonist to relive a past determined by his hopes for the future. Moreover, Mephistopheles brings about this impossible transgression of historical time in a matter of seconds; for Mephistopheles takes the dashing young Faust on his cloak to travel the world in search of the Duchess of Parma, a beautiful woman who will appear in a vision that is the result of yet another of Mephistopheles' spells. In the world of the film, light mutates into the devil's servant, who, in turn, joins forces with

the new medium so that together they can transport us along with Faust through impossible temporal and spatial logics.

A cinematically rendered light not only ignites, but also facilitates, and ultimately impedes Faust's realization of his quest for earthly passion, a passion that signifies his desire for eternal life. Having landed in Parma, Mephistopheles stands before the Duchess, her groom at her side, and announces that he has come to present a noble lord to her. A servant appears carrying a treasure that gradually opens like the leaves of a tulip and radiates an intense white light that blinds the Duchess (Figure 6). When she opens her eyes again, Faust is standing before her. She is instantly enraptured by him, and together they steal away from the nuptial celebrations. These duplicitous actions occasion both the understandable wrath of the groom and a delightful series of cinematic effects as Mephistopheles punishes the groom for his jealousy. Mephistopheles holds up his hand to the servant, thereby extinguishing the treasure of light, and with it, erases the servant's image. The groom wakes to witness the absence of his bride and the ugly little devil in her stead. He thrusts his sword through the would-be heart of Mephistopheles, who in turn picks himself off the ground, leaving behind an apparition of himself, complete with the sword still stabbed through his heart. With a smile from ear to ear, Mephistopheles

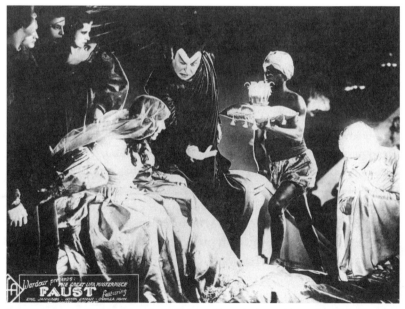

Figure 6. A servant makes an offering to the Duchess of Parma on her wedding night in *Faust*. From the collection of Joseph Yranski.

extracts the sword from his body on the ground—which is a shadow of himself—and, with utmost delight, uses it to kill the groom.

In this sequence we see a light formation as the oracle of the devil's cunning. Mephistopheles performs magical tricks: he transforms the treasure carried by the servant into a light that simultaneously blinds the Duchess and produces the "noble" Faust. Thus the light is placed as the pivot around which the fulfillment of Faust's carnal desires is realized. The lighting does more than accompany or illuminate the magical transformation taking place within the frame. Light is also used by Murnau, Hoffmann, and Mephistopheles as that which is transformed and transformative. It both metamorphoses into Faust and transfixes the Duchess such that her assumed devotion to her groom is transformed into enrapture with Faust. In addition, these magical transformations of light and lighting give way to the devil's trickery of the groom, tricks that can only be visualized through the possibilities of the cinema. The dissolves and superimpositions that communicate various images of the groom's attempted murder of Mephistopheles and Mephistopheles' subsequent murder of the groom make this sequence quintessentially cinematic in nature. Once again, Mephistopheles dexterously and cunningly controls this cinematic spectacle. This time it is not to transgress the logic of human time and space (as was the case when he took Faust around the world), but to transgress the logic of human corporeality. Mephistopheles proves himself invulnerable to attack with lethal weapons and proceeds to kill an innocent man. And, like the cinema, Mephistopheles transfigures himself such that he is no more than a series of immaterial shadows that nevertheless give the illusion of embodiment.

In the same way that lighting mediates the fulfillment of Faust's carnal pleasures, it is the medium of his prohibition to moral servitude in earthly love. Having tasted the pleasures of the body in Parma, Faust has had enough and orders Mephistopheles to take him home. Standing outside his town's cathedral on Easter Day, Faust watches Gretchen, a pretty young maiden, enter for Mass. Even though Faust cannot follow Gretchen inside the church because he is with the devil, the camera does. As she says her prayers, she and the rest of the congregation are striated by multiple sculpted beams of light, which presumably represent the presence of God in the cathedral. These beams, apparently created by the sunlight shining through the windows, carve their way across the heads of the congregation, fall through the door and onto the front steps. Faust is prohibited from coming into contact with these beams of light as he now belongs to a mutually exclusive world, overseen by a mutually intolerant master: the

devil. God in the form of brilliant light beams stands between Faust and his love for Gretchen. Nevertheless, at Faust's insistence, Mephistopheles again performs his tricks to grant the philosopher his wishes for earthly love. They leave the church and Mephistopheles makes himself invisible so he can break into Gretchen's bedroom and place an exquisite necklace in her jewelry box. Faust anticipates that Gretchen will also be tempted by the devil and ultimately reciprocate his desire for her.

In these displays of light and lighting we gain insight into the way in which Murnau's cinema revels in its mobility, dexterity, and creative energies.[30] Here we see that the connection between Mephistopheles and the cinema is not simply a denigration of the medium in Murnau's hands.[31] Murnau also marries the devil and the cinema when he exploits and flaunts the inimitable possibilities of his medium. Shimmering creatures of the night, of darkness, of death such as Mephistopheles, Nosferatu, and Tartüff are the perfect vehicles for the display of the cinema at its most adventurous.[32] They are proxy diegetic figures who enable a filmic representation of that which is most magical about the cinema. They perform magical tricks that transgress the logic of earthly time and space. And they revel in the special effects of the cinema to make these transgressions.

These spectacular moments of magic in light, lighting, and cinema are more than empty displays of cinematic spectacle. In their narrative marriage to the distortions of the time and historical passage experienced by Faust, these moments provide access to *Faust*'s ruminations. By extension, they prompt reflection on the transformation of historical time effected by technological inventions such as the cinema. The historical world that surrounds the cinema, like that experienced in the world touched by Mephistopheles, is typically distorted. For Mephistopheles and the cinema, distant, unrelated historical times and geographically isolated places can be brought together through the instantaneity of their magic. Ultimately, Faust himself will reject the supposed emancipation that is enabled by the immediacy and compression of time and history within the technological world. He will cast off his allegiance to the devil, eschew the exciting passions of youth, and return home to embrace his moral responsibilities within the historical world of the diegesis.

In *Faust* there is another type of celebration of light and lighting. The film also revels in light and lighting as the trigger to an ultimate reestablishment of moral order in its utopian ending. True to the closure of the popular tale, the good angel oversees the uniting of Faust and Gretchen in the face of Mephistopheles' defeat. At the end of the film, the good angel is cinematically created through the gradual mutations of a brilliantly shining

star. The angel in heaven is represented through special effects in light and lighting and he exists in the historical, as opposed to Mephistophelean, time of the diegesis. The fire of Gretchen's funeral pyre slowly dissolves into the luminescent angel. In a quasi-religious ending, the angel demands of Mephistopheles that he utter the word that will ensure the perpetuation of humankind. Of course, Mephistopheles is ignorant as to what it might be. When the angel tells him what it is, an enchanting array of special effects in light and lighting appears, and the star metamorphoses into the word *love*.[33]

This display of the magic of cinema articulates the human needs and desires of Faust, and thus appears in contradistinction to the trickery and illusory creations of Mephistopheles. It is a moment of ostentation that does not announce or provoke transgressive acts such as Faust's stealing of the Duchess of Parma from her wedding nuptials. Rather, the brilliance of the angel's emanations in light slowly transmutes into the word *love* and the heterosexual union between Faust and Gretchen is realized. Thus, light and lighting in this ending articulate the utopian goals of being human in the historical world. Here we see a use of technology for ostensibly conservative moral ends.[34] This said, the magic of the angel is as superhuman as the tricks performed by the devil. However, the actions and events that transpire from the work of the angel obey the demands of historical time, whereas Faust's journeys through impossible times and spaces are the fantastic outcome of Mephistopheles' tricks, tricks that enjoy a time all of their own. Herein lies the tension between two contradictory uses of light and lighting. On the one hand, they are used to meet the desired utopian ends of the moral melodrama, and, on the other hand, to flaunt the technical magic of the cinema with the devil as its agent.

This quasi-religious, utopian moral ending is typical of this group of 1920s German narrative films. Caught between an experimentation with the wonders of the cinema and an imperative to entertain their middle-class audience, these films characteristically stage a conflict between the happy-ever-after ending in which heterosexual love triumphs over all and the interruptions, elisions, and narrative abrasions created by spectacular displays of technological effects. In these films this conflict, or clash of purpose, can be extended to the conflict between a desire for coherence, social accord, and the inevitable traumas of the intense advance to industrial modernity. We have already seen the tension in *Schatten* between the bourgeois desire for moral order (the plot's thrust toward a happy conjugal union) threatened by the tricks in light and lighting of the shadow maker. In *Faust* we see a Mephistophelean creature who has control over

the cinema as magic. He is, like the *Schatten*'s shadow maker and Robison or Murnau, there to show off the possibilities of his medium, and the marvelous changes it brings to the experience of temporality, the conception of history. Simultaneously, the film narrative concludes by privileging the time of human life over the temptations of a technologically manipulated time. Even though the narrative resolution is motivated by the angel's awe-inspiring display in light and lighting, the display sanctions Faust and Gretchen's union as it takes place in diegetic historical time. Within the historical world of modernity, this utopian desire for order and the attachment to conservative institutions such as heterosexual marriage and the family were pursued concomitant with the pursuit of technological experiment.

Like the endings of so many of these films, the triumph of heterosexual love at the end of *Faust* does nothing to mitigate the interruptions to the status quo experienced along the narrative trajectory of the protagonist's descent into hell. The two are left in excess of each other; they are juxtaposed to accentuate their dynamic contrast. In *Schatten*, we came away with questions about the status of the relationship between the married couple, questions provoked by the shadow maker's manipulations in light and the film's experiments with the lighting. In *Faust*, we are left admiring the devilish acts of Mephistopheles. Similarly, we wonder if Faust and Gretchen will actually "live happily ever after." Gretchen's "joy" at being reunited with Faust verges on the ironic when she laughs as Faust approaches her. Is their ideal union merely an adherence to conventions demanded by extra-filmic forces such as the studio? Thus, we are left with incompatible images of the transformative capacities of electrical light, cinema, and other technologies. In turn, these different images in *Faust* represent conflicting visions of the effects of technologies such as the cinema on formations of time. On the one hand, the film exposes and, to a certain extent, celebrates, the distortion and flexibility of time that are now made possible through technological representation. On the other hand, through the use of the "love stars," the film also represents the imperative of placing technology in the interests of maintaining the status quo through a reinforcement of the bonds of heterosexual love and fidelity, that is, through privileging the linear progression of time.

Ambivalence toward the effects of technology's distortion of time was also typical of the 1920s German attitude toward modern technology's significant alteration of the coherence of conventional notions of historical progress. With the Enlightenment and the industrialization of human labor and life, as Marx noted, the machine manufactured a conception of

history as linear. Never before had time and history been regulated into teleological linearity, regulated with all disrespect for the temporality of being human. With the intensification of industrialization in the technological era, time and history become further regulated. Technological innovations of 1920s Germany demanded that people always be preparing for the future while rejecting the conservatism of the past.[35] The new rationalized world of the future was on display everywhere in the 1920s—in magazines, movies, advertising, musical comedies. Nevertheless, the average German income at this time was so low that, in reality, people could not embrace this new world.[36] With up to 20 percent unemployment, an average annual wage of no more than two thousand Marks, and a basic cost of living (food, rent, heating, electricity, and clothing) estimated at two thousand Marks, there was little hope of participating in this lifestyle of the future.[37] People were nevertheless overwhelmed by the advertisements, and somehow saved their money for a moment in the future—a trip to the country, a night at the movies, a telephone, or a transistor radio—a moment when they would have time and money to immerse themselves in this exciting new world.[38] They lived in a present that only acquired meaning through a plan for the future. And so the future came to be lived as an extension of the present. The future became a reality: it was no longer a remote, unforeseeable point toward which all fears and desires were projected; it was the here and now. To reiterate, however, for many working Germans, this future remained a promise that never materialized.

The cinema's unique acceleration and distention of time was not a phenomenon conceptualized solely by German filmmakers and critics at the turn of the century.[39] Indeed, figures such as Georges Méliès and Boleslas Matuszewski in France, and J. Rosen in Britain, testified to the "instantaneity of the cinematic image."[40] They were fascinated by the camera's ability to capture, freeze, compress, and even "annihilate" the logic of temporal order as early as 1898.[41] In addition, Matt Matsuda cites critics who point to the experience of going to the cinema as itself a transformed experience of time. Going to the cinema was "spontaneous," at times "accidental," unlike the making of reservations and preparation for going to the theater. The event did not require planning; one could spontaneously see a movie, much like taking a break from the toils of the day in a café. In addition, films presented capsule worlds that condensed time, thus producing yet another experience of time. The cinema was itself a shortened experience of time.[42] These conceptions of both film and the cinemagoing experience were discussed as widely in other countries as they were

in Germany. This was another level on which the German cinema engaged with the international rise of commodity culture and mass consumption. Similarly, the concern to explore the transformation to temporality and history is pursued in films other than those produced in Germany, thus confirming the German film's participation in the concerns of an international modernism.

The concern with questions of time and history is raised with particular frequency and emphasis in discourses other than the cinema in 1920s Germany. The interrelation of the cinema's manipulation of time and the passage of history was explored by intellectuals, predominantly by critical theorists and cultural critics such as Benjamin and Kracauer.[43] *Faust* engages with some of the most renowned commentaries on the changes to history and time via new technological media in its discourse of ambivalence. In *Faust,* technology is heralded for its use in the enrichment of human-centered time and history. The film also celebrates the temporality of the cinema as magic. Through the film's special effects in light and editing, *Faust* boasts its representation of the temporality of a technologically modern world marked by instantaneity, and a present that extends to create a new past, so that, in turn, this past can reformulate the future.

### Der Golem: wie er in die Welt kam / The Golem: How He Came into the World (1920)

Immediately following the opening credits of Paul Wegener's *Der Golem,* the screen is lit up by the bright lights of the stars that pierce the black night sky. This image gives way to a series of crosscuts between an omniscient view of Rabbi Loew reading the stars through his telescope and his point of view of the luminous, celestial bodies in the sky. These two images are framed identically: Loew's point of view is masked by the limited, circular vision of the telescope through which he looks, and *Der Golem*'s point of view is framed by an identical circular black mask. An intertitle tells us that the constellation of stars warns Rabbi Loew of the impending misfortune that will befall the Jewish people of his land. Through the graphic matching of the framing devices of the two shots in the crosscut sequence, the cinema and the telescope come together to provide entry into the cosmic forces that will determine the course of diegetic history. In the same way that Rabbi Loew is alerted, via his telescope, to the possibility of threatening events in a future still to come, so we, the audience of *Der Golem,* will be taken by the film into a world beyond the logic of cognizable history. Furthermore, from this opening scene onward, Rabbi Loew will assume the role of the diegetic "director"

of events.[44] When he looks through his telescope, the reverse shot of the universe could be his point of view, as if he is looking through the camera that films *Der Golem*. Loew, the religious leader, is the ersatz director of Wegener's film. Loew creates the magic that forges a relationship between age-old religious mysticism and modern technology.

*Der Golem* is another film in which the manipulations of light and lighting can be traced to follow an enthusiastic representation of the cinema as a form of modern magic. Its images also offer a pivot for representations of the changes to history and temporality wrought by technological developments such as the cinema. If we take *Der Golem*'s narrative trajectory at face value, we may be led to believe that the film is skeptical of technological advance and its effects. However, if we attend closely to the tensions established by the magical moments as ruptures to a smooth trajectory, then the film's more ambivalent attitudes toward technology are thrown into relief.

The use of light and lighting in *Der Golem* has been noted by Eisner for its creation of a world of confusion and disturbing events.[45] Wegener was concerned to represent the haunting, poetic world of medieval Prague, and its Jewish ghetto, through the composition of the film image.[46] As with many other 1920s German films, the creation of this environment is often remarkable for the innovations it brings to the carving out of both interior and exterior spaces. The eeriness and confusion of the organic, medieval interiors of *Der Golem* are accentuated through lighting strategies that effectively abstract spaces into aesthetic surfaces. As Wegener explains, the spaces inhabited by Rabbi Loew are made mysterious and dreamlike by their composition through lighting.[47] Thus, for example, one alcove, one section of a cavernous wall, and/or one strip of the floor behind the on-screen characters will be fully illuminated while the rest of the space is shrouded in darkness (Figure 7). Such a composition renders the image abstract and difficult to determine: the mise-en-scène is reduced to a pattern in light and darkness.[48] The scenes that take place in the streets of the medieval town are similarly constructed of multiple spaces that, through the placement of the lighting and the selectivity of the film frame, are made strange owing to a lack of perceived continuity. As one contemporary critic points out, the fantasy world of the city's Jewish quarters is created through the architecture of space and light.[49] Walls fall in upon each other, the lines of architectural forms are inconsistent, the shapes of the buildings are incompatible, from different historical periods, and part of the image is often shrouded in a mystical, inexplicable haze of light.

This said, the novelty of *Der Golem*'s construction of impossible spaces does not represent the film's most innovative use of light and lighting, for

Figure 7. The cavernous space of the winding staircase leading to Rabbi Loew's study in *Der Golem.*
Courtesy BFI Stills and Photo Archive.

such uses of light and lighting to create sometimes ineffable spaces are common among German films of the period.[50] What remains distinct about the lighting in *Der Golem* is its use as a vehicle of magical creation. Like Murnau's *Faust*, Wegener's *Der Golem* continues the established literary tradition of surrounding magical transformations with bursts of light in a mystical tale of misfortune and ultimate salvation. Again, like Murnau and Hoffman, Wegener, together with Karl Freund—one of the most accomplished cinematographers working in the 1920s—extends these traditions by deploying cinematically constructed light and lighting as the medium of magic. By extension, cinematic light and lighting is the language for representing the cinema as magic.[51] However, unlike *Faust*, the use of light and lighting to conjure magical forces in *Der Golem* is not a structuring principle of the narrative as a whole. There are only two scenes in which Rabbi Loew conjures magical forces—the first being when he brings the Golem to life as his servant, and the second, when he performs his magical tricks at the Emperor's court. Nevertheless, given their centrality as turning points in the narrative in which the Jews are saved from exile from the imperial city, they are significant enough to warrant close attention. Moreover, these striking moments lead to the contortions of history and time that are mobilized in *Der Golem*. As Wegener says, this

is a tale that is as much about history, centered on a historical figure who wanders through centuries, as it is a story of magic.[52]

The opening equation between the insight provided by the telescope as a diegetic object and that promised by the cinema is intensified as the film progresses. Cinema as the latest form of magic will be put in partnership with the centuries-old traditions of cabalist ritual in the effort to save the Jewish people from the fate Loew reads in the stars. Rabbi Loew heeds the stars' warning and turns to the Cabala. From the Cabala, he learns that when the astrological formations are in place, when Venus enters the constellation of Libra, the dead spirit, Astaroth can be summoned. In turn, Astaroth will utter the magic word to be placed on the Golem's heart to bring him to life so he will save the Jewish people. Accordingly, when the cosmos is in place, Rabbi Loew performs the appropriate ceremony to summon Astaroth. The dead spirit's magical appearance comes as an ethereal drama of flashing lights, raging flames, incandescent creatures, and luminous shapes and faces that glide and float around the image, in and out of the frame. Loew dutifully traces the circle on the floor of his laboratory and, before long, the floor splits at this circle and fire rises up through the cracks. A thunderstorm breaks out, lightning flashes across the screen, torches fly through the air, and the spirit Astaroth floats into the frame to utter the word (AEMAET) that will save the Jewish people (Figure 8).

Eisner quotes Carl Boese (technical director on the set of *Der Golem*) in his explanation of the sophisticated techniques used to produce these images: up to three thin double negatives were superimposed (presumably in camera); the apparitions were filmed at three times the usual speed to create their extremely slow gliding movements; a mobile camera was used to film the static magic word AEMAET to give it the impression of movement as it mutated out of the smoke breathed by Astaroth. In contradistinction to *Faust*, the coming together of magic and cinema in this first scene of conjuring in *Der Golem* is not associated with evil and immoral temptations. Even though Faust does not know that he summons the devil at the crossroads, it is, as explained earlier, the devil himself who is ultimately put into relationship with the cinema. In *Der Golem*, however, at least initially, it is the good rabbi who assumes the role of enabler of magical images. Rabbi Loew's magical realization of his cabalist beliefs and the cinema come together to bring an end to human suffering.

As the film progresses, Loew's creations continue to be enabled through the cinema: he is the ersatz orchestrator of magic events within the narrative. Rabbi Loew takes his Golem servant to the Rose Day celebrations at the Emperor's court, where he has been granted an audience to perform

Figure 8. In *Der Golem*, the Spirit Astaroth utters the word *AEMAET* that will save the Jewish people. Courtesy BFI Stills and Photo Archive.

his magic tricks. In anticipation of being offered frivolous entertainment, the Emperor and his guests are a little puzzled when Loew announces: "I will show you our people's history and our patriarchs. And if you value your lives, let no one speak or laugh." Loew stands on the stage, casts his spell, and appears to make himself mutate into a simple torch of fire and smoke. In turn, this torch dissolves into an intense white light. This blinding light materializes into the screen of a film depicting the history of the Jewish people, a film within the film of *Der Golem*. The film within the film opens with many people in the distance, winding their way through a snow-covered, mountainous landscape as though on a pilgrimage toward an unknown place of worship. A group of men gather in the left foreground, and suddenly, one of these men walks at right angles toward the diegetic screen. Although the Emperor and his guests had accepted Loew's warning and remained silent up until this point, as the man in the film comes closer and closer—until it seems as though he will walk out of the film into the court—the audience begins to laugh hysterically. The man's image and the film he inhabits are suddenly erased with a burst of intense white light that fills the screen of Wegener's film. This strategy is an optical effect achieved through the manipulations of film editing: the

transformation of Rabbi Loew to light to film screen and back again is a process enabled across time in the postproduction edited image.

The dazzling white light that fills the screen in these moments of transformation from the occult world of the past to the cinema as technology of the diegetic future represents an impossible leap in history that disobeys the laws of the passage of human-centered history. This abstract temporal distortion is a feature of the cinema's ability to manipulate temporality, and, according to some critics, history itself.[53] The burst of light represents an instance of simultaneity between distant past and impending future. The two find themselves side by side, inhabiting the same time frame in the celebrations at the Emperor's court in *Der Golem*. Although the events depicted in Rabbi Loew's film are unspecified, what is important is that he draws on the longevity of the history of the Jewish people to appeal to the sympathies of the court. Rabbi Loew relates this history through a medium that his audience does not yet understand. The audience's ignorance and sudden discomfort can only be explained as their mistaking of the image for reality itself. As there is nothing extraordinary, comical, or offensive about the image of the man walking out of the film with his hand outstretched, we can only assume that the audience discomfort arises out of anxiety, or perhaps genuine humor, at the novelty of Rabbi Loew's magic show in and of a medium that is not yet developed in their medieval world. This compression of historical longevity into a few minutes of screen time by a medium of the diegetic future reflects a quintessentially modern experience of time. It is only with the advent of technological media such as the radio and cinema, and forms of communication such as the telephone, that otherwise distant times and spaces can be given simultaneity and contiguity in an extended present.

An interpretation of these moments of transformation in *Der Golem* is dependent on the narrative context of the film within the film. In the beginning, when Loew reads the fate of the city's Jews in the stars, the film camera and the telescope are visually linked through their overlapping points of view to create a contiguity between the two instruments. In these opening moments of *Der Golem*, the camera and the telescope are the tools of cinematic representation and Jewish mysticism; thus their continuity extends to the relationship between these respective "belief systems." Similarly, when Rabbi Loew summons the spirit to ascertain the magic word that brings his robot to life, the cinema and cabalist magic work in tandem to enable this event. However, when Loew introduces the Golem to the Emperor, the relationship between the cinema and magic has changed. The relationship is no longer one of compatibility and mutual

cooperation. Rather, the two enter into a rivalry with each other during the Rose Day celebrations. As already noted, the film of "the history of the Jewish people" comes to a close with the man reaching out to the boisterously laughing diegetic audience as he walks toward the screen. In his screenplay, Wegener identifies the figure as Moses.[54] When Moses is on the precipice of apparently walking out of the film into the diegetic reality, his image turns into a haze of white light, and, in turn, disappears. Simultaneously, the stage and roof of the theater cave in and the Golem makes his dramatic entrance. Beams slide down between pillars, courtiers panic, musicians cower, the audience begins to be crushed. While the rabbi had shown the film as a call to the Emperor's court to rescue the Jews from extinction, it is ultimately his automaton, born of vapors and fire, that saves his people. Greedy for his life, the Emperor pleads with Loew to have the Golem save him from being crushed by the collapsing building. In return, the Emperor promises to "pardon" the Jews and allow them to remain in the city. The roofing, and all that is above it falls further and further into the courtroom, until suddenly, Rabbi Loew concedes and instructs his ancient medium to save the Gentile rulers. The great hulk of clay of the Golem then takes a few strident steps forward, holds his hands up in the air, and the ceiling of the court falls like a canopy over the people huddled around him. Technical progress and modernization in the form of the cinema may be born of magic, but they are no measure for the mystical powers of the occult. In *Der Golem,* the cinema is nothing but entertainment for the wealthy. Clearly, in his destruction of the film within the film, the Golem ensures that the most modern technology does not coexist with the traditions of the past. In addition, Rabbi Loew's gesture of saving the Jewish people could never be effected through a medium that makes people laugh. It can only be carried out in a medium for which Loew's oppressors show utmost respect, respect for the presence of a larger-than-life body, a potentially irreconcilable threat, a medium that is born of the centuries-old traditions of Jewish culture.

In these sequences at the Emperor's court we see the film's elegant manipulation of time and history summarized. *Der Golem*'s simultaneous overlaying and juxtaposing of past, present, and diegetic future in seemingly impossible ways is in fact played out across the entire narrative. The film is a mélange of time periods. Physically, or architecturally, the tale takes place in the medieval world of Prague; Rabbi Loew reaches into the mythical Jewish past to find freedom from oppression for his people; and, as critics often note, the film is a thinly disguised allegory of the historically immediate modern Jewish Question.[55] However, *Der Golem* does not

organize these different historical periods in any logical way. They are all layered one upon the other, jumbled together in the cacophonic creation that is the miracle of the screen. These different historical times can only come together through the magic of the modern cinema. Nevertheless, similar to *Faust*'s ambivalence, *Der Golem*'s destruction of the film within the film and the historical transgressions made possible through its magic simultaneously denigrate its technological advances.

*Der Golem*'s privileging of the occult world of the past over the technology of the future yields an argument for the profound significance of the historical past to the continued existence of European Jews in inter-war Germany. In addition, through annexing the perpetuity of the Jewish past over the instantaneity of the modern present and future, *Der Golem* apparently communicates a Jewish rejection of modernity. If *Faust* critiques the use of technology to manipulate history such that it is no longer governed by the rhythms and vicissitudes of human life, *Der Golem* takes the critique one step further into the realm of the political. In *Der Golem* the times and histories at stake are not necessarily in the interests of all people. They have implications for the Jews that are different from the effects on other members of the community. Such would be *Der Golem*'s potentially political discourse.

Despite the potency of this interpretation of *Der Golem* based on the privilege it affords the mythical past over the technological future, there is the nagging reminder that, like Murnau, Wegener was someone who was enthralled by the stimulating possibilities of the cinematic medium. After all, the Golem may be conjured through Rabbi Loew's recourse to cabalist myths, but it can only be created for us, the audience of *Der Golem*, thanks to the technical possibilities of lighting and camera work. Why would Wegener, Freund, and Boese produce a work in which they defame the very medium that brings their ideas to life? Perhaps more so than many other technicians working in the German studios during the Republic, Wegener, Freund, and Boese continued to explore the magical properties of the cinema. In Wegener's other films, for example, Stellan Rye's *The Student of Prague* (1913), we see mythical figures that are created through the magic of the cinema. When the student (Wegener) first sells his shadow to the strange man, we see the first of many instances of doubling through mirrors, in-camera editing, and other "trick effects" in *The Student of Prague*. For his part, Karl Freund was the cinematographer for films such as *Metropolis* and *Der Letzte Mann*, both of which revel in the magical power of cinematic special effects at key narrative moments. Similarly, in his writings, Freund was an advocate for the development

of a cinematic language that broke with all tradition and bore no resemblance to other forms of representation.[56] Clearly, Wegener would not have filmed the Golem tale if he were not concerned for the plight of the Jews under imperial rule in pre–World War I Germany, and amid the chaos of the 1920s Germany.[57] However, given his own enthusiasm for the cinema, we are also led to wonder whether he is not attracted to these old fantastic legends because they provide the opportunity for an exploration of the novelties of the cinema.[58] In particular, the creatures of the night, the inventions of the mind, and mysterious monstrosities such as the Golem are, like Mephistopheles, the perfect vehicle for indulgences in the magic of cinema.

How, then, are we to interpret celebratory moments such as the ceremonious revivification of the Golem and the magical appearance of the film within the film? What are we to make of their relationship to the film's discourse on the contemporary Jewish Question? To follow the logic already used: the figure of the Golem as the coming together of centuries-old cabalist rituals and the magic of cinema embodies the collapse of all distinction between the past and a future guided by technology. In turn, this collapse of traditional history, this flattening out of past, present, and future in the body of an animated stone hulk, is the savior of the Jewish people. By extension, we would assume that the film understands the future of the German, and even the European, Jewish population to lie in the conflation of the myths of the past with the technology of the future. The traditional passage of history is of little consequence as long as Jewish life is allowed to endure through the merging of past and future, myth and reality, magic and technology. Certainly, this interpretation would be consistent with the production crew's well-known pleasure in their medium. In addition, it would be in keeping with the film's ostensible search for a solution to the contemporary Jewish Question in 1920s Germany.

However, there is one factor that cannot be accounted for by this interpretation. Following the events at the Rose Day celebrations, Rabbi Loew "deactivates" his creation by removing the Star of David amulet on its chest. Shortly after this, the Golem is revived by Loew's daughter and Florian, her lover. During this short-lived revivification, the creature turns violent. It sets fire to its master's house, carries his daughter off by her braids, and kills Florian. It is only a little (Gentile) girl playing with her friends outside the city walls who is able to disarm the dangerous creature by, once again, removing the amulet from its breast. These later scenes represent the Golem as the destroyer (as well as the savior) of Jewish people. The Golem is a figure of destruction and repression as well

as of creation and liberation. Thus, it would be reductive to claim that the Golem, as a merging of cabalist ritual and the magic of cinema, ensures the preservation of Jewish culture; for, ultimately, the creature must be disabled in the interests of the safety of both Jews and Gentiles in the city of Prague. Accordingly, we would have to argue that *Der Golem* represents the technologically mobilized medium as destructive to the perpetuity of all human history. Certainly, the violence and danger of the Golem creature must be erased before the film can reach its narrative closure—once again marked by a reestablished status quo.

Like *Faust*, *Der Golem* is ambivalent toward the transformative effects of industrial modernization on the formations of history and temporality. In particular, the film is undecided on the impact of these changes to Jewish history and culture. Unlike *Faust*, however, for *Der Golem*, the incompatible discourses of the most modern technology and cabalistic magic as a protection against or perpetrator of the extinction of the European Jewish population are not necessarily in sustained conflict with each other. Clearly, by the end of the film, the Golem is represented as dangerous rather than compassionate.

This said, the film is more undecided than an interpretation along the lines of the narrative trajectory would allow. *Der Golem* represents an ambivalent reaction to the impact of technological advance on the continued existence of Jewish history and culture. The film marries the spectacular technologies of the cinema and light when it yokes the centuries-old rituals of the Cabala and modern technology. In turn, this marriage produces a discourse that collapses the beliefs of the past with the hopes of the future, a collapse that represents a modern experience of temporality. However, when it takes this familiar discourse to the political level of a representation of German–Jewish tensions in its contemporary historical world, *Der Golem* becomes more opaque. On the one hand, it espouses the crippling effects of the new technology on the survival of Jewish—indeed, all human—history and culture. On the other hand, the film also celebrates technological advance—via its displays of cinema and light as modern magic—and believes in its indispensability to the perpetuity of Jewish life.

Such conflicting views regarding the Jews' relationship to technological progress were common to the intellectual landscape of Germany in the 1920s. At least from the Jewish perspective, modernization was greeted with ambivalence.[59] On the one hand, modernization promised secularization, thus integration, through the embrace of the cultural, economic, and national aspirations of modern Germany. On the other hand, the growing identification with the modern, capitalist world meant that the old

bonds—social, cultural, spiritual, and psychological—to the Jewish past became weakened. This challenge to Jewish identity was underwritten by the fact that Judaism had never been spatially defined: it had always been determined by time and history. It was only through the links to the past, through the perpetuation of tradition, a simultaneous looking backward and forward, that Jewish consciousness could be maintained.[60] Modernization was a catalyst to further movement and migration. Indeed, the post–World War 1 period saw approximately a hundred thousand Eastern European Jews migrate to Germany, and Berlin in particular, in search of work in industry or as merchants and artisans.[61] Given this increased geographical displacement, the necessity of historical definition was even more pressing. Thus, the crisis in Jewish identity, which came at the crossroads of modernization, was marked by the simultaneous desire for social integration and the consequent need to perpetuate Jewish tradition.

Questions of German–Jewish relations during the 1920s are complex and necessarily inflected by centuries of rivalry. The unevenness of *Der Golem* leads to its various possible arguments regarding the issue. For example, the film's commitment to the perpetuity of the past over the exclusivity of a distended present may be interpreted for its engagement with the historical moment in which it is produced. Thus, *Der Golem* announces the history being rewritten by modernity to be one in which the Jews would become further isolated from their surroundings. Without the perpetuity of the past, without the duration of time, Jewish culture could cease to exist. In the world of medieval Prague brought to life by *Der Golem,* modern technologies such as the cinema and technically manipulated light are not tolerated. Such innovations have the potential to leave no room for the future of Jewish culture and beliefs. Alternatively, it could be argued that *Der Golem* represents the necessity of modern technology such as the cinema and light for the continuity of Jewish life and culture. After all, without Rabbi Loew's marvelous display of technological magic at the Rose Day celebrations, the Emperor and his court would have taken no notice of the plight of Loew's people. For *Der Golem,* it is only through the simultaneous reaching backward and forward that the future of Jewish emancipation can be secured.

Rather than bemoaning the irresolution of *Der Golem*'s relationship to modernity, the film's openness can be understood as being at the heart of its innovation. In this ostensible indecision, *Der Golem* encourages a critical audience reception. In the space between the two possible readings, viewers are invited to reflect on the irresolvable tensions produced by technological modernity and the potential problems it creates for the Jewish

population. Although manifest in quite a different form, like *Schatten*, the ambiguities created by *Der Golem*'s engagement with technological modernity undergird its generation of social analysis on the part of the spectator.

### Siegfried (1922–24) and Metropolis (1927)

In *Siegfried* and *Metropolis*, one a mythical drama, the other a modern city film, Fritz Lang includes brief moments of magical creation through manipulations in light and lighting. Unlike *Faust* and *Der Golem*, in neither of Lang's films do these moments enjoy a sustained narrative resonance. Thus, *Siegfried* and *Metropolis* are exceptions to the 1920s films in this book that use lighting to compose the image, structure the narrative, and articulate thematic concerns. Nevertheless, in both films, the use of these techniques engages with discourses on the changes to temporality and history effected through the advance of technological modernity. In both *Metropolis* and *Siegfried*, the representations of distortions to temporality and history are different enough from those in *Faust* and *Der Golem* that they function to extend the findings of the other two films. Similarly, in both of Lang's films, electrical light and cinema come together to describe and analyze the social conditions they simultaneously influence. Whereas *Faust* and *Der Golem* embrace the metacinematic as a mode of representing their engagement with technological transformation per se, in *Siegfried* the related sequences are less general. That is to say, for *Siegfried* it is the nature of a specifically cinematically rendered version of history that is at stake, as opposed to history and historicity in general. The film represents the contradictory historical knowledge occasioned by the cinema as a mode of production.[62] Perhaps the most striking of the magical moments in the Lang films is the animation of the machine Maria in *Metropolis*. This is more than just another act of creation through light, lighting, and cinema. In this exceptional cinematic moment, *Metropolis* represents a creation of pure technology.[63] Rotwang is not conjuring the medium through any kind of mystical religious beliefs dictated to him by a book of truth. His religion is technology itself. In addition, even though the act of creation does not stretch across the juxtaposition of incompatible historical moments, it is entwined with unimaginable transgressions of historical time. In keeping with the film's inconsistencies, the event of magical creation coheres as a merging of the Gothic past, the industrial present, and the technological future. Again, like *Faust* and *Der Golem*, *Metropolis* engages with contemporaneous debates about the conscious-

ness of transgressions of historical time resulting from technological development. First, however, Lang's earlier film, *Siegfried*.

In a scene reminiscent of Rabbi Loew's conjuring of the filmic history of the Jewish people at the Emperor's court in *Der Golem, Siegfried*'s eponymous protagonist is shown a section of a film of the history of the Nibelungen. On his journey through the dark Odenwald, on his way to meet the reputedly beautiful Kriemhild, Siegfried is attacked by Alberich, the king of the Nibelungen dwarfs, who has magically made himself invisible. In an attempt to spare his life, Alberich offers his magic cap and an invitation to be the richest king on earth to the fearless, irascible Siegfried. Alberich, king of the slaves, leads the blond warrior into his cave by the light of a magic ball, a ball of fluorescent light (Figure 9). Alberich holds the ball of magic light to the wall of the dark cave, and before them a film appears depicting the Nibelungen carefully forging the crown of the giant ice king of the Northlands (Figure 10). In a gesture that illustrates his insensitivity to the work of the Nibelungen, Siegfried is captivated by and in disbelief of the presence of the image before him. The image disappears before long, and the incredulous Siegfried rushes to the wall of the cave. He reaches out his hand to the now-absent image, as if to sense by touch what he can no longer see. And with this gesture, it is evident that Siegfried has no interest in the plight of the enslaved Nibelungen, but rather is fascinated by the production of the image in which they appeared. Alberich does not dwell at the site of the cinematic image: the film within the film over, he once again holds out his magic ball of light to illuminate the path toward the catacombs at the end of the cave in which he and Siegfried will come upon the Nibelungen treasure. The gold and jewels of the treasure are aglow in a huge urn that is held up by the dwarfs who, earlier seen forging the crown, now appear crippled, bent over, enchained. But neither the slaves nor the treasure are of interest to Siegfried. True to the naive bravura that has characterized him on his journey so far, Siegfried shows only casual interest in the riches of the Nibelungen until he finds Balmung, the wonder sword that the Nibelungen once cast in a fire of blood. When Siegfried is engrossed in his admiration of the wonder sword, Alberich tries to trick him by throwing a cloak over him. Angry at being tricked by his would-be benefactor, Siegfried throws off the cloak and kills the dwarf with a single strike of his newly acquired sword. Thus, Balmung gains its first victim in the hands of the triumphant Siegfried as he uses it to assail Alberich, the magician. In his dying moments, Alberich puts his curse on Siegfried and orders the enchained dwarfs to return with him to stone. He says: "Cursed be the inheritance for the heir! To stone turn what I created from stone."

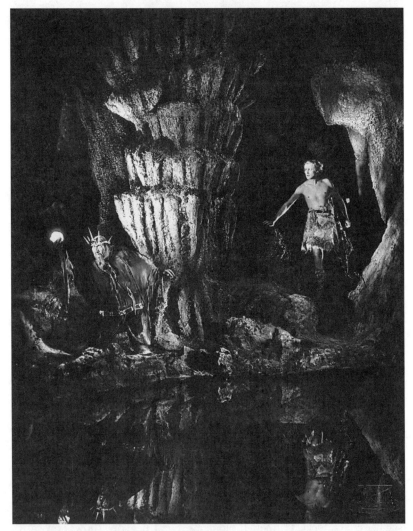

Figure 9. Alberich leads Siegfried through his cave with a magic ball of light in *Siegfried.* Courtesy Photofest.

In a breathtaking wipe that slowly moves from bottom to top of the frame, the dwarfs mutate to stone before our eyes. So ends the ignorant Siegfried's first encounter with the powers of the cinema. He pays no attention to the spectacle of transformation to stone that takes place at his feet. Rather, he is preoccupied with his triumphant victory over the Nibelungen dwarfs as he holds Balmung high in the air.

In this sequence from *Siegfried,* Alberich is the magician who conjures a representation of a bygone world through a medium of the future.

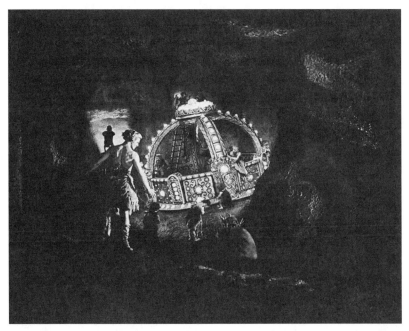

Figure 10. A film of the Nibelungen dwarfs forging the crown of the Ice King in *Siegfried*. Courtesy Photofest.

Alberich is the master of the cinema as light; he is also the director of yet another film within a film. He holds the magic ball of light that, like the cinema, leads Siegfried and us through different moments in history and remote places in a matter of minutes. With Siegfried we travel from Odenwald to the Icelands of the north and back again in minutes. Similarly, the light in Alberich's hands enables the bringing of a moment from the distant past and one in the diegetic present into a relationship of contiguity. The light leads us down the short passageway that connects the illusion of the casting of the Ice King's crown and the diegetic reality of the treasure supported by the enchained Nibelungen. Thus, if Alberich is the magician, his medium is the luminous ball in his hands. Indeed, his final act of sorcery, which sees him and his subjects petrified into timeless statues, is performed through the agency of the light in his hands. It is only through his ball of fluorescent light that Alberich is able to conjure cinematic worlds. Having lost Balmung to Siegfried, he must rely on light to articulate his wisdom. He may lose the physical battle to Siegfried, but he curses Siegfried and turns the Nibelungen dwarfs to stone in two magical gestures that will ultimately outwit the young warrior.

Like the audience in the imperial court of *Der Golem*, Siegfried is

disinterested in the content of the film within the film. Instead, he is fascinated by the production of the image. As other critics have pointed out, Siegfried does not spare a thought for the oppressed, or the history that is told in Alberich's film.[64] His sole concern is to marvel at the appearance and disappearance of the image. Siegfried is a character who impetuously follows his instincts: he is disinterested in history, historical continuity, or knowledge of any kind. Thus, he ignores the wisdom that Alberich imparts to him, and forgoes the opportunity to assume the magical power of the Nibelungen.

This metacinematic sequence from *Siegfried* does not carry significant narrative import beyond its appearance as an episode on Siegfried's journey through the Odenwald. At first glance, the narrative contextualization reveals little that we do not already know about the films of Fritz Lang. The sequence serves to reiterate the ambivalence towards technological development that has often been identified in *Metropolis* and the *Mabuse* films.[65] However, there is a difference in *Siegfried*'s claims regarding technology. In this film, the cinema's self-conscious representation is enabled through the magic of cinematic light and lighting. Furthermore, in its ambivalence toward the cinema as a modern technology, the film engages with a discourse on the history of the medium and the potential knowledge of history that can be acquired thereby. Whereas *Faust* offers the promise of power and knowledge through the cinema as magic (rather than science), and goes on to articulate its skepticism toward this promise, *Siegfried* represents the cinema as providing an access to contradictory knowledges.

Siegfried's response to Alberich's magical conjuring of the cinematic image on the wall of the cave reinforces a conception of early cinema that has by now become familiar. It is a notion of the cinema as a spectacle, an "attraction."[66] As Tom Gunning explains: the early cinema did not seek to record events or acts neutrally, and when scenes of everyday life, current events, or performances were recorded, their content was "absorbed by a cinematic gesture of presentation, and this technological means of representation that constituted the initial fascination of cinema."[67] Siegfried is the archetypal early film viewer when he approaches Alberich's film of the story of the Nibelungen with utter fascination at the spectacle before him. This is not to say that the film celebrates the notion of the cinema as spectacle. This self-display of wizardry also brings about Siegfried's death. Further along his journey, in a duel at Worms, home to the Burgundians, Siegfried himself becomes a cinematic spectacle that solicits the marvel of the audience of Lang's film. Alberich's gift of the magic cap enables

Siegfried to transform himself into a shadow without a body, an apparition in light. As an immaterial, "invisible" reflection of himself, he assists Günther to win Brunhilde as his bride in a sword fight. Hagen interprets Siegfried's invisible aid to Günther as deception. Hagen's wrath is consequently ignited and the plot to kill Siegfried is set in motion. Given the tragic consequences of those who perform the cinema of attractions in *Siegfried*—Siegfried, Alberich, and the Nibelungen—it can hardly be said that this notion of cinema is held in high regard. Nevertheless, to reiterate, although the relevant scenes may have plot consequences, their broader impact on the film's overall meaning is minimal. Therefore, it is dangerous to overanalyze the significance of the sequence in the cave—for example, by searching for the films' absent attitude toward Siegfried's vision of cinema as spectacle. Rather, it is enough to acknowledge the fact that for Siegfried, Alberich's film is a cinema of attractions. It brings him neither insight nor wisdom into the biography or legacy of the Nibelungen Jews.

There is another conception of the cinema articulated by Alberich's magical acts. Even if it is not annexed, even if it is of no interest to Siegfried, Alberich's film fragment is a representation of Nibelungen history, and the fragment is put into dialogue with their present situation. After all, the film fragment does immediately precede the venture into the catacombs to the same Nibelungen, now enchained and debilitated, holding up the treasure. The film takes Siegfried back in time and proceeds to draw the connection between the past and the present. This history of the Nibelungen—told through the cinema as an apparatus that has the capacity to conjoin disparate times and spaces—is a history from which, if he had seen it, Siegfried could have learned. It will be remembered that the Burgundians change their name to Nibelungen following the death of Siegfried, that is, at the time of their inheritance of the treasure.[68] With this gesture, the Burgundians literally assume the Nibelungen identity, and with it the fate of their namesakes.[69] They too will suffer the same cursed destruction as the slaves before them. Consistent with the curse Alberich has placed on the treasure, the former Burgundians are to be destroyed, a fate of which Siegfried remains ignorant. They will be reduced to ruins, smoke, and flames. Siegfried could have seen this in the making if he had paid attention to Alberich's magical tricks rather than being distracted by the temptations of the sword and its power. Alberich's magic cinema is perhaps a prophetic vision of the history of the Burgundians-cum-Nibelungen. This is the aspect of the cinema that Siegfried ignores, the mysterious and secret aspect that is buried with his triumph and Alberich's petrification. This is a cinema that has the agency to tell reflective stories of the past and the

present as a means to understand the possibilities of the future. Thus, Lang puts forward two contrasting visions of the cinema and the knowledge it offers in this short, but critical, sequence from *Siegfried*. The first sees the cinema as a visceral spectacle, as technological entertainment, and the second as a narrator of a particular kind of history. It is a history that connects the real and the imagined, and brings the diegetic past, present, and future into contiguity. In turn, this marriage of past, present, and future is a form of history that proffers wisdom and potential power. Nevertheless, it is not a representation of history that records events or re-presents reality. It is a history that tells stories, stories that lead toward a future mapped out by a magician (or film director) in a distant, mythical past.

These historical conceptions of cinema as both a spectacle outside of historical continuity and belonging to a strangely cyclical, mythical narrative from which knowledge can be gained show a marked digression from *Faust* and *Der Golem*. Unlike the other two films, *Siegfried* does not use the cinema as magic to relate a concept of time and history in its midst. Rather, *Siegfried* offers a history of the cinema in the brief Alberich sequence. The film represents an ambivalent or contradictory vision of the status of historical knowledge offered by the cinema's manipulation of temporality. On the one hand, the marriage of cinema and light in this metacinematic sequence represents the vacuous spectacular nature of the cinema as a mode of historical representation. Accordingly, its wondrous mode of articulation eclipses its powers of enlightenment. On the other hand, the sequence also visualizes the potential insights offered by the medium as historical representation. Here, it is not the medium itself, but the attitude of its spectators that determines its relationship to knowledge. Similarly, irrespective of the film's vision of the access to knowledge through cinema, *Siegfried* is aware that the new medium brings with it new temporalities and new constructions of history. They are constructions of history often foreign to previously known and accepted conceptions.

*Siegfried* places light and lighting at the intersection of two conflicting versions of the cinema's relation to and influence on the experience of technological modernity. Similarly, these two incompatible images are mobilized by the two different statuses afforded the sequence in question: the one, Alberich's magical creation of a momentary film within a film and Siegfried's naive fascination with the film image; the other, the meaning of the scene when placed in the context of the film's larger mythical narrative. Thus, *Siegfried* is not a film whose uses of light carry conflictual import. Neither do light and shadow disturb the moral order of the melodramatic narrative. In *Siegfried* we find a modernist film in which a

contradictory relationship to the technology of industrial modernity is captured through the heterogeneity of a single sequence.

Despite the deftness of the creation of the robot Maria in *Metropolis*, the scene has been cast into the background of discussions of *Metropolis*. It has proven far less critically compelling than, for example, the fact that Rotwang creates a machine female robot.[70] Similarly, upon the film's release in 1927, all attention was focused on the cost of *Metropolis* and whether or not it was worth the more than five million Marks spent on its production, a sum that nearly sent Ufa into bankruptcy.[71] When critics did focus on the technical virtuosity of *Metropolis,* they tended to dwell on the "trick" photography used in the creation of architectural exaggeration or the magnification of the mass of workers, both above and below ground.[72] In somewhat of a departure from contemporaneous film journalism's usual praise for the individual special effects, there is no mention of the rhythmical animation through light and lighting of the machine woman. In spite of this relative critical silence around the transformation of the robot into the evil double of Maria, the scene's technical dexterity is striking and it ushers forth yet another moment of magical creation through the marriage of light and cinema.

When the robot is first introduced to John Frederson and the audience of *Metropolis,* it is a streamlined composite of shining metal and glass. It looks as we would image a robot to look: lifeless, bulky metal. When its creator, the scientist Rotwang, promises Frederson he will transform this virtually immobile hulk of metal into a human being whose difference from the workers will be indistinguishable, we are skeptical. It seems a long way from being human. Our skepticism comes despite Rotwang's demonstration in this early scene of his control over the cognitive abilities of his creation. He lifts his hand in a gesture of anticipation, and immediately the robot stands up awkwardly, walks toward the camera, and moves its arm to boast its capacity for cognitive-generated actions. Then, following his entrapment of the good Maria, Rotwang successfully transposes her human features onto the otherwise inanimate robot.

Given Rotwang's appearance in the film up to this point, it is unsurprising that this magical creation is achieved through various industrial lighting devices, for Rotwang has been consistently associated with electrical light. His capture of the good, human Maria is enabled through the beam of light of his hand torch. Rotwang finds Maria and follows her through the eerie, dark catacombs beneath the city, and all the while his presence is signaled by the light of his torch either on her body or in pursuit of her. His spotlight roams the walls of the dank, dark cave, until it finds Maria. When

he finally catches her, Rotwang robs Maria of the candle she carries, and its soft light is replaced by the violent, harsh, and consuming light of his torch. The spotlight presses her against the wall of the cave behind her. Trapped by the harsh outline of this spotlight, Maria's face expresses her fear. She wrenches, twists, turns, desperate to escape the power of this searchlight. But she cannot. She is at the mercy of Rotwang's violent light. Eventually, this same beam pushes Maria through a trapdoor into Rotwang's Gothic house and laboratory. Thus, she is guided into captivity through the agency of a light beam. When the panicked Maria winds down the corridors of her captor's medieval laboratory, she passes along walls decorated with the coils of neon lights where we would expect hall lights.[73] Thus, through Maria's introduction to Rotwang's laboratory we learn that even though he occupies the medieval, his power and expertise are granted him through his association with industrial light. He is the scientist in whose hands the diegetic future will be determined.[74] It is a future enabled by the capacities of electrical lighting.

Back in Rotwang's laboratory, he is surrounded by magic potions, vessels of bubbling liquids, electrically generated scientific reactions. Even though his experiments are chemical in nature, his bringing to life of the robot Maria is achieved with the assistance of the magic of technology, the coming together of cinema and electrical light. The human Maria lies in a transparent womblike capsule surrounded by bubbling potions, electrical wires, and intensely beaming white lights. Rotwang pushes a lever forward on his operating board, multiple currents come from out of one of the electric lights, and Maria's encapsulated body is embraced by flashes of light. She now lies in the foreground of the image while the arms of these currents reach from a single point at the top of the screen out to the tips of her head and toes. The image resembles lightning striking each end of the body. When the film cuts back to Rotwang, he flicks another lever. The film cuts again to reveal concentric rings that travel up and down the mechanical Maria as she sits in her chair, connected by illuminated wires to other machines in the laboratory. The machine Maria is a shimmering field of electrical light.[75] The following image reveals, through superimposition, an image of both Marias in the same frame. The supine body of the human Maria, in her capsule in front of and at the feet of the machine woman, remains connected to the air around her through the charge of electrical light currents. Simultaneously, the concentric rings of light (made through the insertion of fluorescent light inside coils of glass piping) travel up and down the seated body of the machine Maria (Figure 11). This scene of transformation from inanimate to anthropomorphized, yet mechanized,

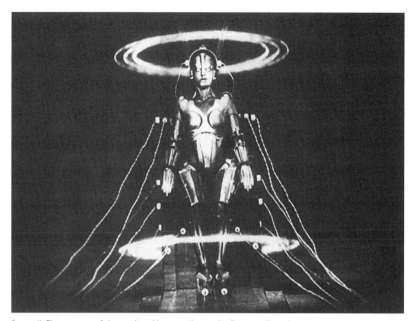

Figure 11. The creation of the machine Maria in *Metropolis*. Courtesy Photofest.

replicant is shot through frames filled with exploding sparks, zigzag flashes, and rings of fire. These lighting effects are in addition to the light currents belonging to the encapsulated human Maria, and the circles of light that define her mechanical double. The screen is alive with an explosive display of lights. When the transformation is complete, these ecstatic lights dissolve into a cauldron of bubbling potion, a potion that glows thanks to the fluorescent lights that shine upon and from within it. Across an edit, the fully developed mechanical Maria sits in her chair with a shining star on her breast, her image reduced to her insides, which are a series of electrical wires in the place of arteries. These wires transmit brilliant light. The blood that fuels her existence is electrical light. The following shot of a close-up on her face dissolves into the deceptively soft face of the human Maria.

In this transformation of machine to human, cinema, light, and lighting come together in a magical act of creation. The anthropomorphization of the machine Maria is different from the rendering animate of the Golem. Rotwang uses no ancient legend, myth, or religious scripture to conjure her body. Rather, he relies solely on the chemical and electrical reactions of his scientific experiments. The mechanical Maria who will wreak havoc in the underground world of the oppressed workers is the product of cinematic

dissolves, cuts, and sumperimpositions, stylistic techniques that overlay the technological experiments of a medieval scientist. Patricia Mellencamp quotes special-effects authorities in her description of the technical construction of this sequence of images:

> a partially transparent mirror reflected the "real" Maria whose image was simultaneously "superimposed" (via a mirror) in the camera over the image of the robot. "The effect is that of a 'phantom' or 'ghost' image . . . it is identical in appearance to the effect which is produced through double exposure or double printing." In addition, "The actress was surrounded by three different sized gas filled circulating tubes which, charged with electrical wires, were raised and lowered" around her face, the movement of these mechanical bands further masking the spectacle of transformation.[76]

The concentric circles that travel the length of the seated machine Maria's body are one of the ultimate symbols of the new technological world. The magical circles of penetrating, vibrating, neon light that move through the air either vertically or diagonally belonged to the image of modern telecommunications. They were, for example, the familiar symbol of the Berlin radio tower, itself the quintessential sign of modernity. The concentric circles of neon light were known to vibrate through the black night air night after night, as if to represent the sonorous pulse of radio transmission.[77] Here, in the animation of the inanimate metal machine, the brilliantly crafted circles of light marry the machine to the most sophisticated of technical achievements.

By the time of Lang and Freund's *Metropolis,* a tale of modern technological oppression in 1927, the cinema is no longer obliged to take recourse to the myths of the past to effect its magic. The technologies of the future—neon lights, electrical currents, and cinematic devices—are sufficient evidence of the film's power to create its own myths and realities. The German film no longer needs to rely on organic or mythical tales as a vehicle for its modernist aesthetic. Machines themselves harbor the utopian aspirations so central to the successful modernist experiment. *Metropolis* does integrate multiple myths and legends into its narrative fabric: it includes biblical stories such as the Garden of Eden and the fall, fairy tales such as that of the Grim Reaper, philosophical narratives such as that of the fall of the Tower of Babel, the myth of Prometheus. However, the film stays within the realms of the industrially inflected mythical present and technological future when it represents its one sequence of creation through light, lighting, and cinema as modern magic.

The creation through light and lighting of the robot Maria reaches into the future for the techniques that will supposedly assist human beings to reach that same future. Added to this ostensible transgression of the logic of historical progression, Rotwang is a creator associated with the future thanks to his command over electrical light. However, his house is a little Gothic cottage that sits cramped by the skyscrapers of the future. Similarly, Rotwang's cottage has the caverns and seemingly endless passageways that mirror the catacombs below the city. When young Freder runs through these passageways, we experience their circuitous and mysterious nature. The doors shut behind him of their own accord, resembling both the doors of a haunted house and electrical trapdoors. The echo of these endless passages is far from that of the rationality and order witnessed in the skyscrapers that tower above Rotwang's cottage. Similarly, the apparent systematization of Rotwang's modes of creating replicants is inconsistent with the eerie, unpredictable excess of the space that he occupies. Indeed, Rotwang's house could have been taken from the city of Prague in *Der Golem,* and his scientific experiments from the modern, alienated world of, for example, *Spione/Spies* (1928). Rotwang is curiously out of kilter with both his futuristic and his medieval environments.

Thus, these short sequences of the robot's creation are woven into the narrative only to transgress historical continuity. The impossible juxtaposition of the medieval past with scientific explorations of a world yet to come is typical of *Metropolis*'s representation of this world of temporal confusion. In *Metropolis*'s city of the year 2000, the mechanical, logical movement of time as we know it is shown to oppress and impede the well-being of the workers.[78] Ultimately, however, the film does not annex the merging of distant times for the creation of a technological future, as both the robot Maria and Rotwang are killed within the narrative. Similar to *Faust, Metropolis* opts for a conservative ending in which technology is used "humanely," for the amelioration of human relations. When the hands of the workers and the brain of the industrialists are joined by the heart of the young lovers, we recognize this as a utopian solution to the difficulties of controlling the abuse of technological power. Nevertheless, irrespective of *Metropolis*'s political significance and its all-too-easy ending, its vision of the impact of technology on historical time is significant.[79] This vision is sustained by its utopian solution. In *Metropolis,* light and the magic of the camera are used to represent a world in which the diegetic past, present, and future are confusingly intertwined. Moreover, this entanglement of historical times is the foundation for the creation of technological sophistication.

## Conclusion

In spite of their differences, *Faust*, *Der Golem*, *Siegfried*, and *Metropolis* all foreground light and lighting in their representations of the cinema as a form of modern magic. Similarly, they all conceive of the cinema as altering existing notions of time and/or history. In *Faust*, the temporal distortions realized by the medium of cinema are, on the one hand, celebrated, and, on the other hand, ironed out by the reinforcement of a utopian social order. *Der Golem* has a sense of social responsibility in its representation of the perpetuity of a past that creates spaces for Jewish culture. Even in its ambivalent relationship to modern technology, *Der Golem* espouses the necessity of the past for achieving social integration in the present and the future. *Siegfried*'s short metacinematic moment alerts us to two conflicting concepts of history that are potentially enabled by the cinema. On the one hand, cinema as pure spectacle yields a historical aporia, an emptiness. On the other hand, the film nods toward a cinema that creates cyclical histories, and, although fictional, it is a medium of potential knowledge and historical integration. In *Metropolis* light, lighting, and cinema come together in the anthropomorphization of a robot by a scientist/magician who does not take recourse to the mythical past, but is himself the product of another era. For *Metropolis*, there is no explicit knowledge at stake in the realization of these magical, scientific creations. Rather, the film represents the necessary coming together of different times and histories for the creation of its bizarre, technological world. These four films thus present different examples of the magical possibilities of the new medium, possibilities carried out through the cinematic manipulation of light and lighting.

Even when the films represent these magical moments as euphoric, with utopian dimensions, the knowledge that derives from their self-consciousness is always a historically concrete realization. The cinema may forge utopian narratives of easy moral resolution, but each of these films also uses the materiality of the cinema to examine the temporalities and historical processes in its midst. They do not, ultimately, invite their viewer to forget or transcend the contradictions of the historical present. On the contrary, *Faust*, *Der Golem*, *Siegfried*, and *Metropolis* embrace an artistic use of light that hinders the reach to totality so typical of the premodern light aesthetic. This, in turn, lies at the foundation of four films that often put forward conflicting conceptions of the impact of technological change, and, in particular, the impact on conceptions of temporality and history. Although we might be tempted to suggest that these unresolved attitudes give over to audience confusion, it is more productive to

argue that they create gaps that open up the possibility for social analysis. The films claim that the relationship to technological modernity is not so straightforward and audiences need to reflect on and consider this, rather than be given easy solutions, of which none exist.

The films' emphasis on historical processes and their nurture of a critically active spectator also contribute to their use of light and lighting to fuel secularized narratives. Once again, in these films, light is at the center of a tangible shift to the working through of moral and/or social conflict through melodramatic representation. Whether it be a conflict between knowledge and historical change in *Faust,* Jewish culture and modernity in *Der Golem,* or the use and abuse of technological power in *Metropolis,* the films instantiate and do not fully resolve a conflict between different narrational aspects, different conceptions of temporality and history. None of the films look for reconciliation through a hero's spiritual journey as would the premodern narrative. But the intensity of the inconsistencies in the modern world is displaced into the narrative eruptions of experiments in light technology. Like *Schatten*'s oscillation between a narrative of moral and social integration and a resistance to cohesion, *Faust, Der Golem, Siegfried,* and *Metropolis* all maintain the tension between displays of technical possibility and narrative unity. Together with their grounding in and commitment to the historical present, this tension marks the secularization of the films' visions in light and lighting. *Faust, Der Golem, Siegfried,* and *Metropolis* might be charged with the mystical proclivities of the premodern narrative that uses light for spiritual edification. For they are all prima facie set in mythical times and spaces. However, their contemporaneity is evident beyond the magical moments singled out here for analysis. They are all narratives that use their embrace of magic to discourse on things modern.

The conceptions of cinema as modern magic move further and deeper than the sometimes insubstantial appraisals of the same that appeared in the contemporary daily press and literary journals. However, rumination on the relationship between the cinema and magic was not solely being carried out in the popular press and literary reviews in 1920s Germany. Indeed, the affinity was remarked upon by philosophers such as Bloch and Theodor Adorno.[80] Bloch and other Marxist intellectuals of the period not only provided more sophisticated analyses of the point of intersection between cinema and magic, they also explored the sociological implications of this intersection. This said, I must stress that *Faust*'s, *Der Golem*'s, *Siegfried*'s, and *Metropolis*'s representations of cinema as magic that speak of the distortions of history in the modern technological world are of a different

species from those of Bloch and Adorno. For this reason, the films do not shed new light on the thinking of the critical theorists, and neither does the place of the cinema within Bloch's and Adorno's work enlighten the films' conceptions of historical change. However, when placed side by side with the theoretical and philosophical writings, the films can be put in dialogue with some of the issues raised by industrial capitalism and the consequent development of an instrumentally rationalized social world.

Bloch and Adorno held opposing conceptions of the place of the cinema within the landscape of modern capitalism. For Adorno, in an age of industrial capitalism, all potential radicality of the cinema as a mass cultural commodity was subsumed by the systemic apparatus in the form of the culture industry. This industry is always perpetuated in the interests of absolute domination by the capitalist economy and ideology. Thus there is very little hope that the cinema, more specifically the stylistic techniques of any given film, could escape the reification imposed on it by the industry. All aspects of film, from the mode of production, through stylistic techniques and narrative trajectories, to exhibition and consumption, have already been determined in advance by the formulaic patterns of standardization that are the one-dimensional systemic apparatus.[81] Although Adorno shows glimmers of the possibility of future nonassimilation, in the society that his work sets out to characterize, there is little suggestion that the cinema would possess the capacity to reflect critically upon the nature of history in its midst, let alone effect any changes to the course of that history. It is only ever a symptom of that history.

However, magic does have the power to escape the colonization of schematic reason. Magic, like circus acts, cannot, according to Adorno, be replaced by mechanization. The magician and his trade still occupy the grounds of a precapitalist mythical order. Magic cannot be measured by everyday language, it cannot be harnessed by scientific reasoning because it is never a representation of something else; thus, it does not strive for identicality or dominance over nature. Similarly, because the acts of the magician cannot be replaced by mechanization, they betray the temporal order. They are always presented as the preparation for an event that will never arrive. The audience apparently waits for something to happen, but nothing ever does. Similarly, unlike the length of a film sequence, the length of a magic act is not determined in advance; it is arbitrary. The measure of its duration is the length of time the magician takes to perform any one transformation. These temporal confusions and uncertainties represent magic's escape from bearing upon history.[82] For the pre–World War II Adorno, film is not and never could be a modern form of magic

precisely because of its technical production and artificiality. The cinema's very technologization renders it subservient to ideology, and ensures that it is always necessarily stitched into the fabric of late-capitalist history. The cinema is anything but a modern, technological magic.

Bloch, on the other hand, is more hopeful; indeed, his entire Marxist oeuvre is distinguished by a hope at odds with the fundamental trajectory of the society he describes.[83] In addition, for Bloch, the cinema is akin to magic. The cinema effectively presents the possibility of emancipation from the schematic logic of systemic structures.[84] The film is a modern, technological fairy tale that provides magical utopian moments in which wishes and dreams, otherwise repressed by the instrumentality of reason and authoritarian rule, are given life. In his later writings, Bloch believes that the *Vor-Schein* or anticipatory illumination of the cinema and other popular cultures reveals alternatives to the rationalization of life under capitalism.[85] In turn, these popular cultures will look forward to a future shaped by a past without struggle, rather than a past that has already been impeded by present-day antagonisms.[86] Effectively, then, the cinema as magic expresses a timelessness, a utopian promise that speaks the remainders of an "uncompleted past" (precapitalist traditions in the form of fairy tales) and a never-to-be-realized future. The cinema as magic's provision of relief—in the form of emotional fantasy or wish fulfillment—from the exigencies of everyday life in the capitalist regime is the salvation of modern technology.

Although ostensibly antithetical to the instrumentalization of Adorno's model, in these particular writings there are also continuities. Bloch's theory does not, for example, allow for the cinema to have an *immediate* impact on the formation of history. It does hold out the *promise* of enabling historical change via its influence over its consumers, who will, in turn, be mobilized to reflect upon and critique the system.[87] However, in and of itself, it has no more social or economic agency than Adorno's cinema. My focus on the narrative eruptions of light and lighting in individual films nevertheless brings them closer to Bloch's than to Adorno's conception of cinema. For example, the films share a belief in the cinema's ability to enable spectatorial criticality. Notwithstanding the proximity to Bloch's theory, just as Bloch and Adorno differ in their conceptions of the cinema, so the films are different again. For example, whereas Bloch is always looking for the possibility of social transformation, the films do not envision this transformation being fulfilled through the same utopian dreamscapes. And neither do films such as *Faust, Der Golem,* or *Siegfried* strive to be political weapons.

I do not want to suggest that these films exercised a social agency unnoticed by contemporary critical theory. Nor do I want to imply that the films are putting forward a Marxist analysis of the place of the cinema within the contemporary economic political landscape. Certainly, *Faust's* utopian ending and the setting ablaze of everyone and everything at the end of *Siegfried* (so that we would not be surprised to see the phoenix rise out of the ashes) would quickly undercut any such interpretation. Nor do I believe that Adorno, Bloch, *Faust, Der Golem, Siegfried,* and *Metropolis* are even functioning on similar registers. Adorno and Bloch provide a critical analysis of an existing social reality. In contrast, the films tell fictional, mythical tales that along the way offer insight into issues of relevance to the world beyond the diegesis. However, through juxtaposition of interpretations of *Faust, Der Golem, Siegfried,* and *Metropolis* with contemporaneous philosophical thinking, these films, like many others made in 1920s Germany, can be put in dialogue with circulating intellectual arguments. Even if they do not directly engage with the work of Adorno and Bloch, a focus on the innovations in the films' use of light and lighting points up their analytical edge. These films contributed to the richness of the German cultural fabric in a way that is rarely acknowledged. Previously, these films were considered the poor cousin of Expressionist art and theater, and, more recently, are held to belong to an international cinema that taps into questions of international modernity more generally.[88] However, in the 1920s, and still today, they are not always valued as critical reflections on the sociological and historical landscape of 1920s Germany.

Perhaps the level on which the four films engage most articulately with contemporary intellectual debates is emphasized through their reconfiguration of temporality. Despite the differences of their conceptions of cinematically inflected time and history *Faust, Der Golem, Siegfried,* and *Metropolis* all represent the concrete changes brought about by technological representation. Each film uses light and lighting as the medium of magical transformation, a transformation that is always preceded by sequences that take place in a spatiotemporality that could exist nowhere but on the surface of the film. In this way, the coming together of the modern inventions of the cinema and electrical light enables representations of innovative historical temporalities. These temporalities are also in keeping with transformations to time and history taking place in the everyday world of 1920s Germany. The two versions—cinematic and actual—of the changes to history by technological media may not be identical, but they are of the same species. They legitimate each other in a gesture of compatibility.

Likewise, in *Faust, Der Golem, Siegfried,* and *Metropolis* these meta-

cinematic moments always open up to another history; that is, the given sequence is always couched in a narrative constructed in a historical time from which it is a departure. This creates a familiar tension between the technological display in light and other aspects of the narrative. In these four films, the uneasy placement of the spectacular within the cause-and-effect narrative can be extended to articulate the difference between the historical time created by inventions such as the cinema and that of a precinematic, pretechnological world. Moreover, the films represent these historical distortions through a creative cinematic use of light and lighting. These technologies are similarly involved in experiments with temporal and historical distortions; thus, the contribution of these films to 1920s European and, in particular, German modernism via an exploration of the parameters and possibilities of their own medium.

Cinematic representation may only be a symptom, as Adorno would have it, of greater historical forces over which it has no agency. However, in their different ways, through their magical capacities *Faust, Der Golem, Siegfried,* and *Metropolis* each represent their role as contributors to these historical forces. Collectively, these films, if only through their difference from one another, strongly imply analytical tensions in the conceptions of temporality and history they represent. When the films are put into conversation with the work of intellectuals such as Adorno and Bloch, we cannot simply accept that the changes to history wrought by technological industrialization forged a flattened-out present that comes at the end of a linear trajectory that, in turn, began in the mythological past and ended with the rise of the German totalitarian state. The weave of history in the contemporary moment of 1920s Germany was more complex than this. It was a period marked by the capacity of technologies such as the cinema to distort time by forging ahistorical moments of spectacle or powerful mythical tales that look to the past to explain the possible future. And it was also a time when history had been transformed to become an extended present. The future now belonged to and was lived in the present, and it was a present in which the past was simultaneously being redefined.

# 5

## Reformulations of Space through Light in *Die Straße, Jenseits der Straße,* and *Am Rande der Welt*

In the film of the future we shall have constant change
in the speed and intensity of light; space in motion constantly
varied through the medium of light refracted from efflorescent
reflectors; flashes of light and black-outs; chiaroscuro,
distance and proximity of light; ultra-violet rays, infra-red
penetration of darkness rendered visible . . .

László Moholy-Nagy

History is not so much a measure of the quality of
our discoveries or ideas (electricity or the light bulb per se)
but more a measure of their social, political and cultural effect
(the result of lighting up the city).

Robert Irwin

One of the unique features of the cinema is its marriage of the illusory space of the screen and representations of the three-dimensional spaces of the everyday world. This is enabled through the coming together of film's mimetic and formal qualities. Through the photographic function of the reproduced image, film captures the lighting formations of the real world. Simultaneously, because the film image is a manipulation in the intensity, direction, and duration of artificial light, it is an ephemeral surface of light. Thus, in any representational cinematic image there exist

two created spaces: that of the represented pro-filmic, and that of the immaterial projected image.[1]

In this chapter, I continue to explore the relation between the cinematic and the historical worlds begun in chapter 4. Here I extend the relationship between cinematic manipulations of time and the formation of history into a consideration of the corresponding relationship between cinematic and historical or real space. Again and again in the chosen films, artificial light is manipulated to meet the dual purpose of creating the spaces of the screen and representing formations of space in the historical world. In films such as Karl Grüne's *Die Straße* and Leo Mittler's *Jenseits der Straße,* light and lighting are used to articulate the spaces of the city streets, and simultaneously, to analyze the impact of modern phenomena such as electrical lighting on the definition of these same streets. These and other films of the period employ electrical light to represent the reconfigurations of space that came hand in hand with technological modernity. Subsequently, they interrogate the social, political, and cultural effect of these developments. The films thus use the media of cinema and electrical lighting, two inventions of technological modernity, to interpret the modern life they both help to fashion.

By the 1920s, the industrialization of light that had begun in the midnineteenth century reached a moment of intensity. Among other changes, it brought with it a reconfiguration of social spaces, and consequently, transformations to the lives lived within these spaces.[2] In Berlin, Munich, and Hannover in particular, the streets of 1920s Germany became theaters for outdoor spectacles that, in turn, contributed to the radical alterations to daily life that transpired during the 1920s. Karl-Heinz Metzger and Ulrich Dunker offer details of the changes to life in the Berlin streets around Kurfürstendamm, Berlin's and Europe's "zone of pleasure" in the 1920s.[3] The wealthy of inner-city Berlin performed their wealth as they paraded their fashionable clothes and social status under the high-intensity streetlights and neon advertising signs. In addition, Metzger and Dunker note that the most prestigious companies selling luxury items such as cars, washing machines, and furs moved into the shop spaces that lined the glittering Kurfürstendamm. Of course, the film studios were among those businesses displaying their wares, and it was usual for short films or excerpts to be projected in these display windows. Such windows turned the night streets of city centers into consumer amusement parks for parading pedestrians.[4] Strollers would be enticed into watching the films and other spectacles, and ultimately, tempted into seeing the film in its entirety at the cinema. Despite the restrictions on

advertising lights by night, none were imposed on lights that emanated from *behind* the shopwindows. It quickly became understood that the brighter, more intensely lit the window display, the higher the quality of the goods on sale, thus the greater the anticipated number of customers. An advertisement for a company that provided lighting for window displays in a 1927 trade journal shows an image of night shoppers flocking to a brilliantly lit department store. The shoppers are reduced to two-dimensional silhouettes against the radiant indoor lighting of the store. The image is accompanied by the copy line: "More Light, More Buyers."[5] The accessories for the new, socially desired and desiring men and women on the streets were clearly indicated by virtue of the lights that made them possible.[6] The excitement of a life of pleasure turned once very private customs into public displays in bars, cafés, and restaurants for all to marvel at. Metzger and Dunker also describe the outrage at both men and women reapplying their lipstick and powder in public. Such activities should have stayed where they had always belonged: in the privacy of the home. The successful results of German women's struggle for equality in the early years of the century were fully exploited in the 1920s when relaxation in public spaces both at night and during the day became a way of life for the new bourgeois men and women.[7] Electrical light was at the heart of the burgeoning culture of capitalism in the technological age.

The artistic development of the cinema in 1920s Germany was contemporary with this redefinition of public and private space under powerful new electrical lights. Similarly, the cinema in Germany developed concomitant with the refashioning of living space by architects such as the Bauhaus masters.[8] The three films discussed in this chapter—*Die Straße, Jenseits der Straße,* and *Am Rande der Welt*—add yet another dimension to the already complex relationship between technological light and the spaces of modernity: they illustrate a point of intersection between the film aesthetic and the visions of modern architecture. In particular, they use electrical light for the creation and representation of new and challenging spaces. In each film, the new spatial formations are always indicated, albeit in diverse ways, as the product of technological modernization. Further, the reconfiguration of space in the films leads to their representation of varying social issues. The films engage in contemporary debates regarding the redefinition of public and private life, class structures, and, in the case of *Am Rande der Welt,* the distinction between the battlefield and the home front. *Die Straße, Jenseits der Straße,* and *Am Rande der Welt* use light and lighting to fragment, disconnect, and simultaneously extend space in order to represent the spatial and social reorganization of technological modernity. As the

films witness, the newfound indulgences of life in the radiant lights of the night were not experienced by all sections of the community.

Die Straße, Jenseits der Straße, and Am Rande der Welt use light to represent the intrusion of disorienting public spaces into the private realm of the home. Through the depiction of fragmentary, illogical patterns in light, the cohesion of public space becomes disjointed, one space continually isolated and disconnected from the next. It is not only a separation of inside and outside that is envisioned by these demarcations of space. Rather, private and public spaces also begin to bleed into one another as the lighting patterns of the outside world come to overtake the private sphere of the home. Inside and outside spaces always remain visually distinct through the use of recognizably different sets and locations. However, the lighting simultaneously confuses the relationship between them. Thus, when we see the public world penetrate that of the private, the distinctions between the two become unstable. This bleeding of otherwise distinct spaces into one another does not, however, usher forth spatial unity or coherence. Rather, it serves further to fragment and alienate the existing spaces.

The use of light and lighting in Die Straße, Jenseits der Straße, and Am Rande der Welt has two aspects. First, both are manipulated to create surfaces: rooms, buildings, streets, even entire cities are rendered as surfaces. On these occasions light and lighting are used to abstract the surface of the film into a flat, often kaleidoscopic array of patterns. Alternatively, in this same vein of abstraction, unexplained light (no source shown) forms graphic patterns on walls, pavements, or in the nighttime air of darkness in order to render strange the depicted space. Thus, in Am Rande der Welt the walls of the mill that is home to the family at the center of the film are made eerie and unreal by the uneven, inexplicable lighting that abstracts their surfaces. Second, light and lighting are used to dissociate and fragment the relationship between spaces. In Die Straße, for example, different areas of the same city are lit in strikingly different ways. In turn, the different types of lighting function to dissociate and sever the spaces of the city. Nevertheless, the different spaces are also explained, through continuity cues other than the lighting—direction of character movement, for example—to sit side by side, the one dependent on, a result of, the other. Thus, the relationship between different spaces becomes confused.[9] This confusion that results from the fragmentation of spatial demarcations corresponds to the contemporaneous reorganization of urban space, and the experience thereof.

This articulation of spaces that represent and contribute to the reconfiguration of social space in modern life is not peculiar to German films in

the 1920s. Many European and American films of this and earlier periods engage with such issues. Filmmakers such as Erich von Stroheim, directing in the interwar period in the United States, used light to demarcate space. For example, *Greed* (1924) emphasizes the importance of light and lighting to articulate the social and psychological significance of various spaces. In the harrowing sequences toward the end of the film when McTeague becomes more and more distressed by his wife's miserliness, and as their "poverty" begins to consume him, the walls of his apartment begin to close in on him. The mise-en-scène reflects McTeague's growing helplessness in the face of his wife's greed: the room that begins to entrap him becomes darker, its space smaller, and the lens used to film it becomes longer. When McTeague then escapes his crime of killing his wife and finds himself in Death Valley, face-to-face with his old enemy, he becomes trapped by light. He moves in a landscape that is at polar opposites to that of his conjugal home. In Death Valley there are no walls to trap him, and there is no wife to oppress him. Rather, here he is caught by wide-angle lenses and an infinite expanse of blinding light. Thus, light—whether its absence or intense brightness—is a key element in a mise-en-scène that imprisons the protagonist. *Greed* uses light and lighting to demarcate space and symbolically to communicate entrapment. This common concern with light in an American film of the same period draws our attention to the international reach of the modernist 1920s German film.

The juxtaposition with American counterparts also points to the distinction of the German film: In the example of *Greed*, von Stroheim does not weave cinema and light together to represent the re-formation of space in the modern technological world. Von Stroheim's use of lighting in *Greed* does function in a complex relationship to the psychological and social disposition of the protagonist McTeague. Nevertheless, McTeague's environment is not characterized as technologically modern.

The American films of émigré German director Josef von Sternberg are renowned for their representation of space through lighting. Von Sternberg's use of light and lighting configures space in ways that are said to preface the 1940s Hollywood film noir.[10] However, even in von Sternberg's films the use of light functions differently from its role in the films made in the German studios. In, for example, *Underworld* (1927), the spaces are sometimes made strange and foreboding through chiaroscuro compositions. However, the spaces themselves are always constituted through a lighting composition that is distinct from this chiaroscuro. For example, in the gangsters' apartment, the bustling café, the streets by night, even the prison cell in which Bull Weed finds himself at the end of the film, the

space is evenly lit and a low-key lighting is superimposed upon the existing space. The low-key lighting does not create the space itself. Rather, it emphasizes the shadows that pervade a space that already exists. As a result, in *Underworld* the shadows are diffused by the overall lighting of the image. Thus, in *Underworld,* however foreboding the shadows might be, they are never harsh or in total contrast with the light that surrounds them. In *The Docks of New York* (1928), the various spaces inhabited by the stoker are each carved out through a strikingly different use of light and lighting. Thus, in the engine room of the ship, the stokers are obscured by darkness, their faces and body parts only realized when they open the engine's furnace doors. On the docks all action is cloaked in a hazy but luminescent fog. However, in the bar where most of the time at shore is spent, the lighting is an even, three-point setup clearly illuminating the space and the objects and people within it. Immediately outside the bar, and particularly in and around the upstairs room where the Betty Compson character recovers from her attempted suicide, is first seduced by the stoker, and later a man is killed, the lighting is sharp, uneven, and low-key.

In *The Docks of New York,* von Sternberg uses light to demarcate spaces as different from each other, a demarcation that is further underlined by the action that takes place in the given spaces. As von Sternberg's characters move from one space to another, it is as if their actions are defined by the space rather than their internal desires. Just as they are in the three films discussed in this chapter, the spaces that generate character actions are spaces created primarily through light and lighting. On this level, there is a continuity between these 1920s films. On another level, von Sternberg's use of light and lighting is different from that of the German films. In neither *Underworld* nor *The Docks of New York* is the lighting foregrounded to articulate the effects of social transformations spawned by technology. Although von Sternberg's films possess a self-conscious use of light (and darkness) for the creation of varying spaces, they do not extend to representations of technology's impact on the social organization of space. Some of the German films emphasize a self-conscious deployment of light and lighting that can be interpreted for its representation of the social implication of technological advance. It is again the tripartite use of light and lighting in the chosen German examples that marks their difference from many of the developments taking place in the use of film lighting in other countries. Light and lighting are deployed in *Die Straße, Jenseits der Straße,* and *Am Rande der Welt* as the language of representation, to represent the reconfiguration of public and private space, and to investigate this reconfiguration in its relation to the

technologies that spawn it.[11] Although they engage in a cross-pollination with the international melodramas of the period, and the modernist artistic aesthetic more generally, the three films also testify to the originality of the German examples.

## Die Straße/The Street (1923)

*Die Straße* is yet another 1920s film animated by a conflict between a dynamic exploration of film's technical capacities and a utopian melodramatic narrative. In Grune's film, the two aspects are so dissociated that upon release of *Die Straße* in 1923, many critics ignored the existence of the story. Critics in the film and popular press did not simply assail the convenient narrative frame: they did not even acknowledge its existence. As far as they were concerned, the only aspects of *Die Straße* that warranted attention were those that took place outside on the nighttime streets.[12] Almost unanimous in their excitement for the film, these critics also agreed that the stylistically vibrant representation of the nighttime streets was the protagonist of *Die Straße*. As the reviewer in the *Licht-Bild-Bühne* succinctly stated: "Klöpfer [the lead actor] . . . is not the hero of the film, but the street is."[13] Moreover, the dynamic energy of the street is represented through the splendor of electrical light and lighting. Thus, to be more specific than the reviews, the true hero of the film is the electrical light that articulates the city by night. The eponymous street is represented as a canvas of gleaming street signs, car headlights, fun-park lights, neon advertising, glistening reflections on a rain-soaked road, and dazzling shopwindows.[14]

Despite the prominence of Karl Hasselmann's intricate light designs, we cannot ignore the frame narrative. The film's developing narrative lifts it out of the realm of near abstraction into the world of a fictionalized tale.[15] The two aspects of the film lend it a complexity that ultimately generates its meaning. *Die Straße* tells the tale of a middle-class man tempted from the banality of married life and into the sinister streets replete with illicit nighttime activities. He is lured by a prostitute, tempted into gambling, and becomes involved in a murder as the night wears on. Ultimately, however, drained of all adventure by the destructive energies of the street, the man returns home to his loving wife. Like all the deserted wives in these films, this one welcomes her husband home with open arms. If we attend to this double level of articulation—the conflict between the style and the drama—we see the struggle between a modern world colored by the explosive energy of technologies such as electrically generated light,

and a yearning for the stability of the bourgeois family. This is one of the contradictions of the era: life was at one and the same time informed by the deregulation and decriminalization of various sexual activities and marked by an increasing emphasis on middle-class morality and fidelity.

*Die Straße*'s conception of space through light and lighting is also complicated owing to this tension between style and dramatic narrative; the domestic drama of the frame takes place partly in the light of day, and in the evenly lit rooms of the bourgeois home. The glorious display of light in the streets, however, belongs to the dark of nighttime. Through its representation of the tensions between light and dark, night and day, indoor and outdoor spaces, *Die Straße* points to another facet of the cinema's impact on modern life: the demarcation and redefinition of public and private space in the technological era.[16]

On the one hand, the frenetic, kaleidoscopic lights that define both the public streets of the metropolis and the surface of the film image invade the private realm of the home throughout the night. This invasion is represented through the unusual lighting of the home. This blurring of the boundaries between public and private is one function of the film's stylistic explorations through light and lighting. On the other hand, in the closing moments of *Die Straße*, the man walks home along a clean, ordered, evenly lit street the morning after his nocturnal adventure. He has been released from jail, where he is held for a murder he does not commit. He returns to what we saw at the beginning of the film as the mundanity and monotony of life in an evenly lit home with his wife. As in the different uses of light as magic in *Faust*, this conflict between the technical and the dramatic development in *Die Straße* is sustained across the film in its entirety. Elements of style continually interrupt the coherence of the narrative development. Thus, *Die Straße* ultimately puts two conditions of modern technological life into coexistence. The enticing, thrilling goings-on of the nocturnal streets (which penetrate the otherwise stable identity of the private sphere) and the banal, yet secure, space of the patriarchal family sit cheek by jowl in the film and in an ever-changing historical world.

Herbert Jhering nods toward this uncomfortable coexistence of technical wizardry and the desire for narrative coherence in *Die Straße* in his review of the film (which is noticeably more reflective than those of his contemporaries). Jhering points to the dissociation between what he calls "action" and "technique."[17] He claims that the discrepancy between "human action" and "mechanical tricks," the imbalance between the "realistic" and the "artistic" motivations of the film, are *Die Straße*'s great weakness. However, he also recognizes that this imbalance is a step in

the right direction for German film. A marriage of the two, in a more "controlled" and "unified" image, is ultimately, according to Jhering, the future toward which German film should be looking. Jhering is calling for the integration of stylistic sophistication and a compelling and coherent human story. *Die Straße* is at least on the way toward this goal. Another interpretation of the conflict between *Die Straße*'s two levels of articulation understands it to represent the simultaneous collapse and upholding of the distinction between public and private space in 1920s Germany.

From the opening sequence of *Die Straße*, we see the outside world intrude into the home, an intrusion figured through a sophisticated use of light and lighting. As the protagonist of the film lies on his sofa at the end of the day, a spotlight gradually pans up his resting body and finds his face. His brightly lit face proceeds to dissolve into a heart-shaped masked image of his wife preparing the dinner. When the film cuts back to the man asleep on the sofa and the spotlight has been extinguished, a "shadow play" appears on the wall behind him: the stark shadows of two men meet on a step, make an exchange, and part ways. The transaction that takes place in shadows on the protagonist's living-room wall is shot through a tilted, canted, low-angle shot. Although Kracauer and other critics would have this play of shadows be the man's dream image, thus his latent desire for the magic and mystery of the streets, the film indicates that the shadows belong to the objective world of the film.[18] They are not solely the product of the man's imagination. The shot preceding the appearance of the shadows on the wall does show the man resting on the sofa with his eyes closed, thereby suggesting their status as dream or fantasy images. However, following the "performance" of shadows, the man gets up from the sofa and walks to a window opposite to look for the source of the "shadow play." He finds it in the form of an intense bright light that beams through the open window, evidently from a streetlight outside. Thus the film suggests that the two figures make their exchange under this same streetlight, resulting in the casting of their shadows through the window and onto the opposite wall of the man's apartment. These shadows could be an objective attribute of the world of the film, quite independent of the man's subjective yearnings. The film is unclear as to whether the sinister world of shady deals that beam through the living-room window and stamp the walls of the home belongs to the man's imagination or the objective world of the film. The fusion of inside and outside spaces extends here to a fusion of subjective and objective visions of the world.

The luminosity and mystery that penetrate his bourgeois world draw the man out of his apartment into the street. Following a dizzying vision of

the looming temptations of the street (achieved through a multiple super-imposition montage sequence), the man follows his instincts and heads out to embrace the exciting attractions of the world by night. He passes an optician's store, and two illuminated eyes that function as shop signage watch him as he walks underneath them (Figure 12). Later, he follows a woman we know to be connected with the criminal gang that tries to win all his money at cards. The woman is surrounded by looming, distorted shadows as she slinks through the mazelike streets. This whole world is animated by light beams, iridescent objects, the glitter of the modern, nighttime street. Car headlights weave their way over the facade of a sparklingly clean shopwindow, window dressings are luminous with lights displaying their wares, neon advertisements decorate walls, and the brilliant glow of fairground attractions form a kaleidoscopic background to the events in the street. In addition, the arc lights that dot the streets through which the man wanders shed a light that is fragmented into uneven shapes. He comes across a lifesize squiggle of light on the ground and follows it with his step. Behind him, before him, and all around him as he walks mesmerized through the streets, incandescent attractions and the dazzling whirl of reflected car headlights and fairground rides light his path.

On these streets, inside spaces are penetrated by the lights outside as often as the indoor lights stream onto the streets. As the man walks along

Figure 12. Eyes that advertise an optician's shop watch the man as he slinks through the backstreets of *Die Straße*. Courtesy Netherlands Filmmuseum.

the street, we are invited to see inside the shopwindows and marvel with him at the objects on display. Simultaneously, we note the dynamism of the reflections of passing traffic, streetlights, and neon advertising lights in these same windows. The superimposition of these two spaces, the overlaying of inside and outside, forges a blending of spaces on the reflective surface of the shopwindows. This fusion of otherwise distinct spatial elements on the surface of the shopwindows is integrated into the film's vertical assemblage of the lighting effects of the street. Thus the dizzying array of lights that illuminate the night city in *Die Straße* so overwhelms all architectural distinctions and other objects in the diegesis that they appear on the screen as a kaleidoscopic pattern in light. At these moments, the city lacks depth and structure. It comes alive as a light display on the surface of the film.[19]

Although there is a paucity of information on the production processes of *Die Straße*, we can surmise the techniques employed from a knowledge of the customary techniques for filming at night in this period. It was usual in the 1920s German studios to film nighttime sequences with the use of two distinct lighting sources. Ordinarily, the moonlight was achieved through the placement of spotlights suspended from the studio ceiling.[20] The scene would then be shot through the use of a red filter that would absorb blue light, and thus represent the light of the moon.[21] The illumination of the on-screen character was created with spotlights deflected in parabolic mirrors placed offscreen.[22] Thus the two types of illumination: one to create atmosphere and the other to articulate the human characters, if only through their shadows. The scenes that take place in the city center in *Die Straße* do not, however, as the contemporary critics so adamantly insist, foreground the human characters. Rather, the city as shining lights is the focus of these sequences. Like the much briefer sequences in Murnau's *Der Letzte Mann* when the Emil Jannings character is in the vicinity of the Atlantic Hotel, in *Die Straße*, the city center is a flurry of lights, and human beings as objects are insignificant within the image. Humans are reduced to shadows in a film more interested in a portrayal of urban life as an effect in and of light.[23]

Like most other German films of the early 1920s, *Die Straße* is shot on a set built in the studios at Stern Film.[24] The glittering, two-dimensional nighttime streets of the city center through which the man walks in *Die Straße* are created through the absence of atmospheric light and moonlight. There are no nuances of light that carve out a depth and dimensionality to this space.[25] The only lights used for the construction of this space are those of the pro-filmic city: car headlights, advertisements, streetlights,

and their reflections in windows, on the wet bitumen underfoot. As was the practice in the German studios at the time, more intense lightbulbs than those used in the streets would have been placed inside the street lanterns to ensure the on-screen intensity.[26] Mirrors and relatively sophisticated lenses would also have been used for the stylization of the lighting compositions.[27] Nevertheless, the lighting in these images comes from the lights familiar to a modern city.

The flattening out of the space of the city into a two-dimensional sea of lights is further abstracted by its disjunction from the film's action. It is true that we are taken to the spectacle of the city lights in *Die Straße* by the protagonist, who in turn is looking for excitement. However, in keeping with the depthlessness of these images, the man's experiences in these parts of the city do not impact on the forward motion of the plot. The man marvels at the elusive surfaces of the city by night. In addition, his presence in these scenes is minimal, and where he does appear, he is shown in long, even extreme-long, shot. On the few occasions that he appears in among the shimmering lights of the city, the man is so backgrounded that it is difficult to discern if indeed it is the same man we met in his apartment at the beginning of the film. For the most part, the camera is mesmerized by the excitement of the lights. Given this tension between the spectacle of city night lights and the man's journey through the film, we understand the images as a description of the city in which the narrative takes place.[28] The lights literally define the narrative space. These are images that insist on the abstraction and superficiality of the space of the city by night.[29]

The city of *Die Straße* is not always shown as a dynamic display of light. When the narrative moves to the backstreets of the same city, these spaces are dimly lit. The light source in these scenes is the same arc-light lanterns that line the city-center streets. Each lantern usually sheds two pools of light on the ground below, one on each side of the light pole. Because of the intensity of the black of the night that surrounds these lanterns, the lantern as source and the two separate pools of light they shed appear to be in the middle of nowhere. Again, it appears as though the only film lighting at these moments is that supplied by the pro-filmic events. Thus, the lighting technique bears some resemblance to that of the sequences that take place in the city center. However, in the backstreets there are only one or two, as opposed to multiple, sources.[30] Thus the relative darkness. The effect achieved through this lighting of the backstreets is one of rendering strange the partly illuminated spaces.[31] It is, in effect, another form of abstraction of the image through light. We see no familiar markers, no

recognizable objects, nothing save fragments of the bodies of the characters and the light that renders them sometimes partially visible.

Contributing to this haunting effect of the street lanterns is the film lighting used in neighboring sequences also shot in the backstreets. In particular, the eeriness of the backstreets is emphasized in sequences that are lit by sources that do not appear in the pro-filmic world, sequences in which the lighting belongs to the artificial construction of the film. For example, on a number of occasions we see characters walk through the backstreets and pass by an imposing municipal building with Romanesque facade and pillars. Each time we see this building, it is lit with a harsh side lighting such that its pillars appear to bulge forward and out toward the edges of the film frame. This building appears as if it were an image reflected by a distorting mirror. No doubt, in these sequences intense floor and side lights are used and deflected from mirrors to create the distortion. Though the city whose streets form the stage of the film's action is evidently modern—the cars, fairground, streetlights, and many of the buildings themselves indicate as much—on numerous occasions the lighting gives the backstreets a baroque character that makes them disorienting.

The distinction between the world of the modern, dazzling lights of the city center and that of the haunting backstreets is also unsettling for the viewer. This effect is born of the disconnection between the different exterior spaces, the separation of various public spaces that make up the city in its entirety. The film offers no clue as to the spatial relations between the city center and the unpredictable, ghostlike backstreets. Such a spatial relation could be established through continuity cues. For example, *Die Straße* could depict the characters walking from one space to the next. However, the film cuts on character action between discontinuous spaces. On the one hand, the continuity of character motion suggests the juxtaposition, or continuity, of the spaces. On the other hand, the difference of the lighting, the buildings, and the street activities suggest the discontinuity between these spaces.

Perhaps the most disconcerting lighting is that of the street outside the house of a man who has left his small daughter at home with her blind grandfather to join the dishonorable activities of the street. When the film takes us to the street outside this house, a partially lit wall is distorted in shape by the uneven emission of a streetlight. Immediately to the right of this area of light—an area in which there is nothing to be illuminated— we see the outline of a door, itself completely in darkness. On the right side of the frame, the jagged outline of a staircase—leading we know not where—climbs to the top right-hand corner of the frame. Protruding into

the foreground of this strangely distorted image is another geometrical pattern of light that has the enigmatic quality of changing its direction with no object in sight to cause such a defraction. What makes the design of this particular illumination so baffling is that there is neither a source nor an object to be illuminated by this light. Thus, it connot be accounted for by either the pro-filmic or filmic worlds: it is simply an abstract pattern in light. This typical composition in light of an exterior space in *Die Straße* effectively flattens out and closes down the space of the outside world. Like the dynamic and frenetic kaleidoscopic vision of the city center, the spaces of the backstreets are abstracted, pictorial renderings. However, unlike the city center's reduction to the two-dimensional surface of the film, in the backstreets, the immobile and abstract space still has foreground and background dimensions. The depth and volume of these spaces is acheived by virtue of the fact that, unlike those of the city center, the film's dramatic action takes place therein. Characters move through and around these spaces, particularly as they enter and exit the building that houses the man and his child. This character movement gives the backstreets a third dimension. Nevertheless, these spaces are still abstracted by the strange lighting (Figure 13). They are abstracted because

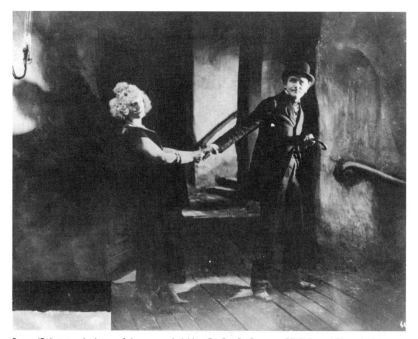

Figure 13. Leaving the home of the man and child in *Die Straße*. Courtesy BFI Stills and Photo Archive.

the lighting appears to have no practical function; rather, it obscures the space that it also creates. The light and lighting in these sequences do not illuminate anything in particular, nor do they direct our eye along a specific path. Rather, they create a curiously fragmented and ineffable space.

Through the filmic juxtaposition of the brilliant, yet transitory, sea of reflections at the city center and the spaces of the backstreets, the one becomes an accomplice to the other. Together they constitute the public world of the city at night: it is both a shimmering surface of lights and a bafflingly obscure, inert world. Like the representation of the city center, the abstracted spaces of the backstreets contribute to the definitions of the city as the film's protagonist. They are much more than the backdrop to the film's action. These strange, pictorial spaces speak the alienation and fragmentation of the public world.

The static, unfathomable strangeness of the backstreets in *Die Straße* is a visualization of widely held conceptions of the disorientation of the growing metropolis. The intoxicating and iridescent facade of the modern city was only skin deep: predictably, it also had a dark side. As modern urbanization spread, in particular in the bigger cities such as Munich, Hamburg, and Berlin, what were once rural villages or destinations for weekend outings became city suburbs. A constant flow of tenements and factories sprang up on the periphery of the city. People lost their points of geographical reference, the city was in a constant state of transformation, people lived in buildings full of strangers, wages decreased with the influx of people seeking their fortune in the city.[32] The city increasingly became a place of uncertainty and dread.[33] Berlin Detective Superintendent Ernst Engelbrecht points out that one did not need to venture to the suburbs to experience the threat of darkness in the modern city. Indeed, the underworld also lived in the city center after the lights were turned off for the night:

> Theatres and cinemas have long since closed, and the public streams out from the wide-open doors of the café-concerts and other establishments. The crowds briskly make their way home through the streets on foot, by car, by taxi, or by tram. But it takes a long time for the masses to thin out, and for the streets to become empty and lonely again. Now only a few passers-by hurry through the streets, cautiously looking around to see if harm threatens them from anywhere, *because the city night, the night of the criminal,* has begun.[34]

*Die Straße* visualizes the unfamiliarity and disorientation of its backstreets. Although they are not necessarily dangerous in that we do not see

murders or other serious crimes taking place there, through their visual obscurity they are made sinister.

The presentation of the city center in *Die Straße* as an aesthetic spectacle visualizes another concept of the modern city. This concept has, by now, become a familiar one: the city as a ceaseless fluctuation of images—produced by the processes of industrialization and commodification—that dazzles spectators and dilutes the obdurate world into formal variations. This city is consonant with, for example, the city "sensed" but not "experienced" by Benjamin's flâneur as the product of modernity.[35] Indeed, although German cultural critics such as Benjamin and Kracauer—and Simmel before them—see different consequential aspects of the modern city, the image of the city as an endless series of visually compelling images remains constant across their work.[36] It is this same city center that is depicted in light across the surface of the film screen in *Die Straße*.

It was not only in the work of critical theorists and cultural critics that this image of the modern metropolis as spectacle was explored in 1920s Germany. In addition to the reorganization of space in the metropolis through an architectural use of light, we see the painters and poets manipulating paint and language as light in their respective visions of the nocturnal metropolis. However, while *Die Straße* juxtaposes the contradictory images of the city at night through the device of film editing, in other media the tensions are often caught by the opposing forces within the parameters of a single, static image. Thus, George Grosz uses the red light of fire, blood, and passion in his allegory of modern urban life, *Dedicated to Oskar Panizza* (1917–18). Grosz's painting is not the spectacle that is Grüne's and Hasselmann's metropolis in *Die Straße*. It is nevertheless a damning critique of the city, a critique created through the violence of its stylistic composition in color as light.[37] *Die Straße*'s use of light is intimately related to that of Grosz's painting: in both artworks, formal manipulations of light and lighting are used to represent a hostile, harsh city far removed from the reflective use of light and lighting that embraced German painting only a few decades earlier. However, *Die Straße*'s vision is also unique because it returns the kinesis and abstraction of the secular, material world to the surface of the film. Thus, *Die Straße* embraces the film medium's possibilities in light to represent the transformations effected by technological light.

Despite the dynamism and multidimensionality of other 1920s German representations of the shimmering metropolis, cinema has often been noted for its affinity with the big city, an affinity that painting and poetry approach in a different way.[38] During the first few decades of the

cinema's development, the analogy to the modern metropolis was often made by filmmakers and critics alike. In the above-mentioned work of Simmel, Kracauer, and Benjamin, the analogies between the cinema and the modern city proliferate. Both phenomena are sites of "distraction," "diffusion," and "anonymity" for the masses. In 1920s Germany, there are many narrative films in which the city, and the street in particular, figure as the lens of a cinematic exploration of life in modernity. To name a few of the better-known examples: G. W. Pabst's *Die Freudlose Gasse/The Joyless Street* (1925), Bruno Rahn's *Dirnentragödie/Tragedy of the Street* (1927), and Joe May's *Asphalt,* (1929). In the avant-garde of Germany (Walter Ruttmann's *Berlin, die Symphonie der Großstadt/Berlin, Symphony of a Great City* [1927]) and other countries (for example, Dziga Vertov's *The Man with a Movie Camera* [1926]), the city is the protagonist in films that capture the rhythms and tone of modern life. In addition, scholars have pointed to the kindred status of the two as, for example, a "way of seeing" the contours of everyday life.[39] During this era, the metropolis and the cinema were both struggling to define technological modernity. And a film such as *Die Straße* contributed to this struggle. In the film, the technology of the medium is married to light and lighting to replicate the dazzling, yet disorienting, effects of the modern city at night for the spectator. Both the city and the film are shown to be surfaces of moving light that solicit the awe and wonder of their spectators. Accordingly, *Die Straße* is an example of the cinema's contribution to the revisualization of the modern technological world.

In addition to the fragmentation of exciting, yet dangerous city streets, *Die Straße* represents a confusion between interiors and exteriors, the private and public worlds. This blurred distinction between interior and exterior space can also be approached through the film's use of light and lighting. As in the opening sequence, light formations from the streets penetrate the home to create a continuity and simultaneous dissociation between the public and the private. When the action of *Die Straße* ventures inside to the spaces of the home, it is rare to see evenly lit interiors. Inside and outside spaces may be recognizably demarcated (owing to the set), but the lighting style of one often spills over into the other. By extension, the fragmentation and abstraction of the streets gives way to a simultaneous distinction and confusion between public and private space.

When the protagonist goes out into the streets to revel in forbidden pleasures, his path crosses that of another man engaged in the same activities. This second man leaves not a wife, but a young daughter, at home. He leaves her with an old blind man whom we presume to be the child's

grandfather. This second man leaves behind the pressures of his domestic responsibilities, rather than its mundanity, to enjoy the underworld of the streets. Two important scenes take place in this man's home. First, we see him depart for the night when he passes through the strangely lit back-street environment. Second, when the film reenters this domestic space later in the night, his home provides the stage for a murder. The lighting of the apartment in this sequence is typical of the chiaroscuro lighting that accompanies evil deeds committed on streets in other German films of the period.

Early in the film, the protagonist is lured into a nightclub by a woman and engaged in a game of cards with two of her friends and a third, naive provincial man. The provincial man shows off his wallet full of banknotes to the group of card players, and the woman and two friends begin to plot his murder. The film then cuts to the home of the little girl and old man. Here the protagonist of *Die Straße* becomes the scapegoat as he is enticed into an adjoining room by the woman while the two thieves kill the provincial man, the little girl's father, and flee the scene, leaving the protagonist to be framed for the murder. In the living room that adjoins the scene of the crime, two solitary light beams cut through the darkness that envelops the protagonist and woman embracing. One is the light emitted by a desk lamp on the right side of both the room and the frame. The other beam represents the piercing brightness of the lights from the streets shining through a window on the left side of the frame. The light from the public world of the city that penetrates the private space of the home also severs the space of the room through its sharpness and distinction from the darkness that surrounds it.

In the entrance hall, the criminals slay the man from the provinces in a crime of greed. The lighting that accompanies the murder is likewise unsettling in its contrast of light and darkness. In a composition that is familiar to us from the scenes in the backstreets earlier in the film, this lighting creates illogical patterns of light in the room. It is the same abstract lighting which is found in the street outside the apartment of the man with the child. The lighting consists of unevenly shaped pools of light with no apparent source. This is not the lighting that we are accustomed to seeing in the ostensibly safe, protected space of the home of a young child. In addition, the criminal events that make the private space of the home alienating are intercut with the swirling images that rotate in a 360-degree collage to represent the dizzying excitement of the gambling and dancing club in which the aforementioned card game continues. The juxtaposition reminds us of the editing together of the city center and desolate

backstreets: the immoral deviations of the city at night are linked to and, simultaneously, separated from the home of the small girl. Thus, the action that takes place in this apartment reiterates what we have already learned from the lighting: that the space of the home has become infected by the estrangement and disquiet of the world of the streets.

In addition to the use of light and lighting, *Die Straße* deploys other aspects of the cinema to underline the alienation of the metropolis. For example, the editing is also crucial to the established relationship between the three different spaces—city center, backstreets, and private spaces. In the opening scene of *Die Straße* when the "shadow play" is thrown onto the wall of the protagonist's home, the film creates inside and outside spaces that are simultaneously separate and merged. When the light from the outside street lamp penetrates the man's home, we see a superimposition of two worlds in one space. Inside and outside become momentarily intertwined and the protagonist is propelled into clarifying the distinction between the two when he walks to the window and beholds the lights of the outside world. Thus, in these sequences, simultaneous contiguity and separation of inside and outside are visualized through editing patterns. Similarly, as mentioned earlier, the differentiation of the backstreets from city center is confused through the continuity of character movement across the edited cinematic image. While the lighting and the spaces it creates change dramatically from a kinetic spectacle to a stagnant, isolated, and incomprehensible underworld, the matches on action of character movement strongly suggest the fluidity of these same distinct spaces. Thus, different aspects of the mise-en-scène are manipulated across the fragments of moving images to articulate these confusions.

The changing formations of inside and outside, private and public space, was a popular theme in the contemporary presses. In an article on the diversity of uses to which electrical light was put, Ernst Reinhardt discusses industrially produced light as the primary language through which to define space in the metropolis.[40] When he considers the transformation to space generated by electrical light, Reinhardt points out that the inside and outside of buildings assume a whole new meaning in the nocturnal light. Like the buildings of Erich Mendelsohn, by night the brightly lit interiors of department stores, factories, and sometimes office buildings are on display to the public. According to Reinhardt, the nighttime impression of the building's interior is the measure of its architectural quality. It is no longer the outside appearance of a building by day that determines its worth, but, in the age of industrial lighting, the inside at night has become its catchcry.

Traditional conceptions of private and public were also challenged as a result of the social transformations that took place during these years. Thus, for example, Benjamin describes a rearticulation of the illuminated streets as the living rooms of the renowned flâneur in Baudelaire's Paris streets that could well represent those of 1920s Berlin:

> If one can speak of an artistic device of the physiologies, it is the proven device of the *feuilleton*, namely, to turn a boulevard into an *intérieur*. The street becomes a dwelling for the *flâneur*; he is as much at home among the façades of houses as a citizen is in his four walls. To him the shiny, enameled signs of businesses are at least as good a wall ornament as an oil painting is to a bourgeois in his salon. The walls are the desk against which he presses his notebooks; news-stands are his libraries and the terraces of cafés are the balconies from which he looks down on his household after his work is done.[41]

This euphoric notion of the street as home can be found everywhere in the *flânerie* literature of the period.[42] The transformation of traditionally defined public and private space is often addressed in feminist literature that focuses on the redefinition of public space by and for women as a result of industrialization.[43] However, other sectors of the community were also affected by, for example, the escalation of the number of electrically lit streetlights in the 1920s.[44] As critics such as Janet Lungstrum and Anke Gleber point out, under the new lights, the public sphere was experienced as an interior space in which the wealthy bourgeoisie participated in an emerging and narcissistic self-awareness.[45] Their self-awareness and unashamed public display of private desires was in turn understood as the theater of the street; it was a window display full of commodities and capitalist ways of life turned inside out. The private was on display for public consumption under the dazzling light of the modern German metropolis.

*Die Straße* intersects with these discourses on the corroding distinction between inside and outside, and private and public spaces, in a particularly imaginative way. The film uses its medium to represent these confusions visually. Further, Grüne and Hasselmann's innovative deployment of light and lighting represents technologies such as electrical light (and, by extension, the cinema) as progenitors of the disruptions to more traditional conceptions of space in the technologically modern world. Light and cinema come together to represent the modern city as a complex of distinct spaces that nevertheless penetrate one another. Through images in and of light, *Die Straße* represents the invasion of the private, domestic sphere by the public in 1920s Germany. The character-centered

narrative reinforces this corruptive bleeding of the one reality into the other. We see the same abstract and ineffable patterns in light and lighting articulate the apartment of a little girl and her blind grandfather as well as the alienating suburban backstreets outside their door. The brutal and immoral events of the nighttime city spill over into the same apartment when the man is murdered.

However, the closing moments of *Die Straße* in which the protagonist returns to his wife offer a potential challenge to this interpretation of the film. This scene takes place in broad daylight. When the man chooses to leave behind the vagaries of the nighttime streets, so the film leaves behind the abstract patterns in light and lighting. In this narrative bracket, the events are bathed in diffuse sunlight as it shines through the ceiling of a glass-roofed studio. It is as though the events represented up to this point were all a dream. Yet, these final images do not cancel out the thematic concerns of the rest of the film. Rather, thematically, the happy-ever-after ending adds another dimension to the already complex vision of life in the modern metropolis. It would be naive to privilege the man's escape from the harshness of modernity through a retreat to a morally conservative heterosexual coupling. Nevertheless, industrial modernity is said to secrete a nostalgia for such utopian values.[46] This nostalgia is often complacent and results only in deflecting serious criticism of modernity's most egregious faults. Thus, at best, a conservative, utopian, melodramatic ending to an otherwise disrupted narrative can only ever feign resolution and the reinstatement of an ideal social harmony.

The same conflict between narrative resolution and the abrasions or interruptions of technological modernity within the superficial harmony of the melodramatic form that we saw in *Schatten* and *Faust* recur here in *Die Straße*. As with the other films, if we understand the stylistic experiments as equally central to the narrative construction, the film does not equivocate by its utopian ending that restores family harmony and order. *Die Straße* maintains the contradictions between the corruptive influence of the dazzling world of the metropolis at night and the bourgeois inhabitant's capacity, or tendency, to retreat from these illicit spaces. While the excitement and concomitant danger of the technologically developed world creates disquiet among the familiar organization of middle-class life, the attraction and ostensible security of the patriarchal family also remains stalwart. Both are the effects of the spread of industrial modernity. In turn, we recognize the imperative to embrace these different narrative aspects where the film's contemporary critics wanted to privilege one and ignore the other. The overall irresolution is central to *Die Straße*'s resistance to a

single conception of modernity. By extension, it is also critical that the audience recognizes and reflects on the complexity of both the film and the world it represents.

The equivocated reestablishment of a familial and social harmony at the conclusion of *Die Straße* makes it the perfect candidate for the transposition of Brooks's thesis regarding the secularization of the transcendental signified in the modern melodrama. The melodramatic ending functions as a thin cloak to the intense discordance of the modern technological world to which the drama and its protagonist belong. The conflict between the yearning hero and his dystopian environment is displaced onto a narrative built on disruptions, especially those resulting from style. It is only through a performance of coherence that the melodramatic narrative can resolve its otherwise irreconcilable tensions and confusions. And these moments of narrative stress are otherwise irreconcilable because they stand in for the incompatibilities of the different aspects and different effects of technological modernity.

As we will see again in the films discussed in chapter 6, *Die Straße*'s melodramatic narrative embraces technological experiment to represent the complexity of technological modernity. Films such as *Die Straße* do not simply represent the promise or anxiety of technological advance. In its juxtaposition of the excitement and liberation of technology with the comfort of the bourgeois family home as a necessary refuge from the thrilling streets, *Die Straße* represents the multilayered fabric of technological modernity. It was a culture in which both were manifest as the effects of Germany's embrace of technological modernity. While the streets and their nighttime allure were infinitely fascinating, the morality of familial fidelity became ever more significant as a refuge from the inhumanity of these streets.

### Jenseits der Straße/Beyond the Streets (1929)

The year 1929 saw the onslaught of the Great Depression. Although its effects were devastating in all European countries, in Germany the Depression was a crisis that became unmanageable because of the lack of confidence in the socioeconomic and political framework of the Weimar Republic. It could be argued that the Depression triggered the abandonment of a political system that had already lost its legitimacy. Unemployment rose to disastrous levels, crime increased dramatically, and traditional social and moral attitudes continued to weaken, as they had been doing since the end of World War I. The devastation and disorder of Germany at this time

(attributed as it was to the unstable political system) was slowly giving way to the rise of National Socialism. The National Socialist Party (NSDAP) promised, and indeed, went on to deliver, the eradication of these dire circumstances. With the increasing power of the NSDAP came the last-ditch efforts of the political left to speak out for socialist democracy.

Concurrently, leftist progressive film production companies such as Prometheus increased their profile on the German film landscape. For the most part, production in these studios avoided the modernist stylistic explorations that had become associated with the "embourgoisement" of cinema in Germany. By 1929, it was common for politically and socially aware films to adopt a more realist style of filmmaking that showed an ambivalence toward so-called mainstream cinema.[47] This can be seen in, for example, Piel Jutzi's *Mutter Krausens Fahrt ins Glück/Mother Krausen's Journey into Happiness* (1929), in which a mother and her son fall into ruin through poverty-driven crime. Their only hope for the future is the daughter/sister who joins the Communist Party. Films that look to a Communist future directly protested the economic, political, and social distress of this time.[48] Similarly, in keeping with the documentary-like realism of the socialist aesthetic, Jutzi's film does not indulge in the stylistic experimentation typical of the 1920s films. In *Mutter Krausens Fahrt ins Glück,* stylistic experiment is woven together into the dramatic development.[49] However, not all film production in these final years of the decade was committed to a coherent realist aesthetic narrative.

Leo Mittler's *Jenseits der Straße* critiques the social structures of 1929 Germany via the stylistic tendencies familiar to us from other silent German films. As a number of critics noted on its release in 1929, Mittler's film is innovative for its marriage of social concerns with a Soviet-style emphasis on editing.[50] *Jenseits der Straße* depicts a pessimistic image of the big city underworld and offers no alternative to the vices and immorality generated by dire poverty. It is a narrative powered as much by stylistic and aesthetic strategies as by dramatic events. In particular, the world of Mittler's streets in the harbor city is distinguished by its articulation through lighting. The innovation of *Jenseits der Straße* lies in its use of light and darkness to represent the unrelenting gloom and absolute hopelessness of its three characters—a beggar, a prostitute, and an unemployed man. The characters' lack of hope for a way out of this destructive world is also articulated through the oppressive nature of space, once again realized through abstract light and lighting. The lighting's creation of the inhumane spaces of the harbor city communicates the despair of this world. As in Hasselmann's lighting in *Die Straße,* Friedel

Behn-Grund's lighting in *Jenseits der Straße* is fragmented and abstracted through uneven, chiaroscuro compositions. However, there is a difference between the stagnant, claustrophobic space of the backstreets here and those depicted in *Die Straße*. *Die Straße* points toward the possibility of refuge from the danger of the nighttime streets in its somewhat superficial closing moments when it suggests the option of security in a daytime domestic life. For the street workers in *Jenseits der Straße*, however, there is no relief from the disconcerting, alienating darkness of the night. Even during the day, the pessimistic, tragic world of the night overwhelms the mise-en-scène, and by extension the lives of the beggar, the prostitute and the unemployed man who inhabit it. *Jenseits der Straße* thus sympathetically portrays workers who have no escape from the sordid public spaces of the night, whereas *Die Straße* is more optimistic in its vision of the bourgeois man's temptation into the nighttime streets. The pessimism of the workers' lives and the contrasting hope of the bourgeois man in *Die Straße* are also depicted through light and lighting.

In *Jenseits der Straße* a young man comes to the harbor city looking for work and befriends a beggar who offers him lodging. That night, the beggar chances to pick up a pearl necklace when it is dropped on the pavement beside him by a wealthy woman. A prostitute sees the beggar's stroke of fortune from her nearby post and sets out to steal the necklace from him. To this end, she woos the unemployed man and manipulates him to carry out her crime. Finally realizing the plot against him, one night the beggar escapes the unemployed man, runs to the harbor, falls into the water, and drowns with the pearl necklace in his hands. In this narrative of crime for survival, the only time we see the city's main streets is at night when the beggar and the prostitute are busy at work. The nighttime sequences in the city center are usually shot in close-up and marked by the fragmentation of the characters' bodies—we see the beggar's hands counting his hard-earned coins, the prostitute's legs as she walks the streets. Similarly, the lighting is not particularly striking: it is used primarily to illuminate the said body parts. However, in the backstreets, the lighting that defines the city inhabited by these underworld figures is creative.

On their way to and from their night's work, the beggar and the prostitute lead the camera into the backstreets of the harbor city. Although there are obviously a number of routes through these streets, their depiction makes them indistinguishable. As in the backstreets through which *Die Straße*'s protagonist walks, these streets are unevenly and illogically lit. Again, the sources of the street lighting are either nowhere to be seen or are inconsistent with the illumination that they supposedly cast. A feature

of these lowlife, seedy backstreets is the "Electric Bar." Appropriately, the signage for the Electric Bar is formed by dazzling neon lights that spell the word "Electric" vertically, while "Bar" is spelled out horizontally. From the outside, this bar appears as no more than the sign that advertises its existence to the street on which it stands. The signage is isolated on the left side of the image in a sea of darkness that makes it impossible to discern the building to which the sign is attached. To the left of the neon sign sits an extraordinarily bright expanse of light, apparently illuminating nothing in particular. At the top right edge of this otherwise vacant space of pure illumination is a series of three stairs, the destination of which is obscured by darkness. On the other side of the street (on the right side of the frame) we see a lonely arc lamp that casts a single pool of bright light. The edges of the pool of light are somewhat less intense. Nevertheless, in this and other images, our vision of the street is one of a plastic surface painted with arbitrary, isolated patches of bright, incandescent light. As was the case with the sequences in the backstreets of *Die Straße*, we assume that the lighting sources for these scenes are supplied by pro-filmic light fixtures. Again, the arc lamp on the right side of the frame probably contains a light more intense than the usual lightbulb, but the lamp is nevertheless the source of the light it casts. There appears to be no added lighting from an offscreen filmic source. We assume that the pattern in light to the left of the Electric Bar is created by a spotlight placed offscreen right. Nevertheless, even though the lighting sources are discernible, the effects abstract the image and create the cold and alienating public spaces at night.

Similar configurations in light and lighting describe the streets directly outside the beggar's and the prostitute's homes. On a number of occasions, the prostitute is in her room and a visitor arrives. The visitor's arrival and departure are depicted through a bird's-eye-view long shot, and, as we look down onto the street, a diagonally constructed semicircle of light on the ground below almost fills the frame. The only movement that punctuates the balance and form of this abstract pictorial composition is an unidentified dark figure, shadow-like, running along the base of the semicircular light, diagonally across the surface of the screen. Again, we presume that the shadow belongs to the character we meet in the following or the preceding scene. This visual tilting of the frame through the light pattern on both the ground of the streets and the surface of the film image does more than abstract the frame composition. It also contributes to the film's concern with the desolation and alienation of the modern city. The strange, illogical lighting that describes the backstreets creates a scene in which the forces of the city overwhelm the details and meaning

of all human action. Such is the calling card of the modern harbor city and its inhabitants.

As was the case with the representation of the city center in *Die Straße,* the lighting of the streets in *Jenseits der Straße* alienates the characters from their environment. Similarly, the film's vision of the street does nothing to advance the character-centered story. As the narrative progresses and the characters move to and from the different spaces in which the action takes place, the film always dwells on their journeys through the streets. However, when in the backstreets, the figures are always framed in an extreme high-angle long shot. Thus, the sparsity, hostility, and enigmatic nature of the world in which they move, rather than the purpose or destination of their movements, is emphasized. This privileging of the space of the city over the plight of the characters is reinforced by the lighting. Not only are the characters shot at extreme distances, but the apparently abstract formal patterns in light are never shed on the human figures. Although we witness the characters arriving at and departing from different places in medium shot, these images are always interrupted by extended explorations of the night cityscape. The length of these extended takes of the city spaces is inconsistent with their contribution to the development of the character-centered narrative. The characters' journey is thus bracketed at these times in the interests of displaying the oppressive stasis of the city at night. In *Jenseits der Straße,* it is as if the camera is hypnotized by the deathly silence and stasis of the sparsely lit streets. Effectively, the length and obscurity of these sequences also distances the viewer from the characters' actions. During these extended journeys through the streets, we are left to wonder what is happening. We are always looking to connect the sequences to the characters' plight; however, the privileged visions of the city distract us from the characters. Thus, it is not only the film frame that is fragmented through illogical patterns in light and lighting. The film narrative is also fractured when the logic of the plot is lost during these journeys through the streets. Through this fragmentation of both film frame and narrative, the lighting of the streets contributes to the film's depiction of a hostile city. It is a city that cares little for the individual, a city that pushes its social outcasts to the very edges of its parameters. As a lone figure crosses a square or a single looming shadow passes across the face of a wall, the disjunction of this silent, hauntingly stagnant city speaks the alienation and stagnation of a world that surrounds the characters, but to which they never belong.

If we continue to access *Jenseits der Straße*'s thematic concerns via the light and lighting, the desolation and alienation of the streets can be seen

to spill over into the private sphere of the homes of the beggar and the prostitute. And, if we continue to understand the lighting for its creation and interpretation of spaces, in the city of *Jenseits der Straße* there is no distinction between private and public space. Although interiors can be distinguished from exteriors through the set, the chiaroscuro lighting in the private world of the home and the public world of the streets collapses the two. Neither the beggar nor the prostitute has a large living space, and what space they do have is gloomy and claustrophobic. These spaces appear even smaller than they are owing to the scant, harsh lighting that defines them. In addition, both characters have minimal furniture in their homes, and thus the lighting is emphasized as defining the spaces in which they live. The inside of the beggar's ramshackle wooden house on the river is usually shot facing a curtainless window that looks out onto the street. At least we assume it faces the street as the shape of the window is formed by the blinding light it lets into the room day and night. Thus, we surmise that a streetlight sits immediately outside this window. The window is positioned in the center and perpendicular to the top edge of the film frame. An inexplicable strip of light, a little less intense than that which beams through the window, runs diagonally from upper left to the bottom right-hand corner of the frame. These are the sole areas of illumination in the images of the beggar's home. Again, the abstract, painterly quality of this light results partly from the fact that the source from which it is emitted remains out of sight.

A similar abstraction is achieved through the pictorial light composition of the mise-en-scène of the prostitute's home. In her room we find two very long, oval patches of light reaching from top to bottom of the frame, distinct from each other, separated by a strip of darkness. Similar to when the characters move through the streets on the way to unknown destinations, the lighting in these rooms is never dictated by the placement of the characters. Human figures are never fully illuminated. At times a body part is illuminated and the rest of the figure is obscured by shadow. At other times, the characters move around the space of the home, and yet the lighting never follows them: they simply walk in and out of the shadows. If a character's body is defined by light, it is because he or she coincidentally stands before a strong light source, such as the window in the beggar's room. In such cases, underexposure causes the head and shoulders to appear in silhouette outlined by light. Thus, lighting in these scenes never illuminates characters or objects of any kind. Rather, it creates the awkward and unwelcome space of the room in which it shines. These homes are as disaffected as the unwelcome backstreets that are the

topography of the harbor city at night. If the spaces are symbolic of the lives they define, the public life that the beggar and the prostitute lead at night has colonized any privacy they may have once had. There is no refuge, no place to go for relief from the harsh, alienating world of the streets.[51]

There is another vision of the city in *Jenseits der Straße,* and indeed, it represents the only image of hope in this otherwise unrelenting world. There is a reason why the young man has come to this city looking for work: it is home to the prospering industries of modernity. When the man disembarks from his boat moored in the harbor, the film only briefly introduces him to us before it cuts to a montage of fragments of the industry that makes the city turn. Factories blow smoke, people rush along the street, wheels of cars frantically turn, trams glide along the streets, cranes operate gracefully against the city skyline. Together, these machines create an exciting and frenetic modern city and signal the possibility of work. These images reappear later that night when they are intercut with the prostitute and the beggar hard at work. Again, when the beggar is in bed and the young man ventures out to meet the prostitute—his new acquaintance—at the Electric Bar, there is another montage of trams, cars, and other machines that signal the thrilling modern city (Figure 14). While the street workers continue their travails and visit the Electric Bar at nighttime, the city also operates

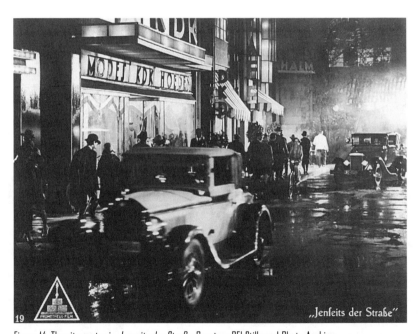

Figure 14. The city center in *Jenseits der Straße.* Courtesy BFI Stills and Photo Archive.

in full daylight. Thus, the film crosscuts between these two apparently incompatible worlds: the one of burgeoning industry by day and dazzling city lights by night, the other of the fight to survive by night. The film celebrates the vision of the city as a conglomerate of machines in motion, the city where the young man imagines his dreams will come true. However, it is a city that is remote from that inhabited by the protagonists. Through its juxtaposition with the city of struggle for survival and pitiless alienation, the montage series of the city of industry and opportunity represents a ruthless capitalist city that sits side by side with unemployment, poverty, and crime.[52] This juxtaposition is most effectively articulated through the stark contrast between the dynamic editing of machines in motion and the immobile, high-angle, long shots of the city's backstreets. Modernization is thus identified in *Jenseits der Straße* as the nemesis of the stagnant, alienating environment of the beggar, prostitute, and unemployed man. Modernization is the complement to the characters' desolation.

In *Jenseits der Straße* there is no direct mention of political or economic forces that might be responsible for the bleak situation in which the prostitute, the beggar, and the unemployed man find themselves. The film's only reference to a world beyond the city's lowlife is the momentary celebration of the machine and the excitement of industry. Although the film does not cite the growth of industry and modernization as the direct cause of the alienated life on the streets, the juxtaposition of the two polarities strongly suggests the necessary coexistence of the two. They are the twin effects of Germany's accelerated advance to industrial modernity. Similarly, the three street workers of *Jenseits der Straße* are not simply the social outcasts of a capitalist order. For this film, they are at the heart of modern society. Moreover, these characters are not part-time panhandlers; rather, their work, or lack thereof, has come to define them. Theirs is the story of thousands of German unemployed, beggars, and prostitutes in 1929. Following this line of argument, according to *Jenseits der Straße*, the alienation of public and private space, the corruption of every aspect of public and private life, have overwhelmed the world of industrial capitalism. Like *Die Straße*, Mittler's film uses artificial lighting and the medium of cinema to describe and interpret the pessimistic outlook for the modernity they help to define.

Behn-Grund's use of contrasts in light and darkness to represent the confusion between public and private space was expressed elsewhere and in other art forms at this time. It was not only the male homeless, beggars, and flâneurs who began to use the streets as their living rooms and bedrooms in the culture of modernity. The streets also began to be occupied

by women whose lives had traditionally been led inside in the space of the private.[53] Often, it was by women that the redefinition of public and private was most powerfully experienced. For example, prostitution by working- and middle-class women, as integral to the urban fabric by day and night, redefined the otherwise gendered conceptions of public space and work.[54] Atina Grossmann argues for another complex rearticulation of the blurring of public–private distinctions owing to the intensified, industrialized capitalism of the Republic.[55] Grossmann points out that the rationalization of sexuality and sexual practices by the scientific principles of the Sexual Reform Movement was no different from the rationalization of the workplace. The rationalization of sexuality and sexual practices during the Weimar Republic was considered the most effective means to reform labor practices:

> Sex Reform treated the body as a machine that could be trained to perform more efficiently and pleasurably. The goal was to produce a better product, be it a healthy child or a mutual orgasm. Finally, of course, the two goals were related, since satisfying sex produced a better quality of offspring. Sexuality served to help reproduce workers fit for work, but also to inculcate the rhythms of work in their daily lives.[56]

Thus, in the campaign to streamline the modes of industrial production to befit the principles of Taylorism in 1920s Germany, the processes of the workplace and the public sphere more generally invaded the sphere of the home and, in particular, the bedroom. Sex became a public concern. Although such social changes were made under the auspices of a progressive, democratic society, they were always in the interests of some, and disadvantaged others. Specifically, those on the margins of the social and economic structures—women, youths, prostitutes, the unemployed, and the homeless—were, as *Jenseits der Straße* indicates, dislocated and further oppressed by these changes. Although National Socialism came as a solution to the crises of the late Weimar years, for *Jenseits der Straße* there was no relief from the social turbulence into which Germany had fallen. Industrial capitalism's public prosperity had cast its shadows on the one-time security and refuge of the private world.

The unrelenting pessimism of *Jenseits der Straße* sets the film apart from other films of the 1920s. *Jenseits der Straße* is unique in its refusal to equivocate its vision of the technologically driven world. Other films maintain a tension between, for example, the vices of technological industry and the security of the bourgeois family home, or an attraction to the utopian legends of the past and a simultaneous celebration of technology's

ability to transform the legends. However, the lack of this conflict in *Jenseits der Straße* testifies to its unrelentingly pessimistic vision. There is no alternative to the dark life on the streets in this Germany. There is no mediation of the abrasions of technological modernity, no escape to the comfort of bourgeois life as there was in *Die Straße*.

However, *Jenseits der Straße* still incorporates a complex image of the contours of technological modernity. The film does not oppose the outcome of the character-centered story with a world created through technical displays in the lighting; that is, the stylistic innovations and the characters' trajectory are equally dark and without reprieve. Nevertheless, *Jenseits der Straße* still distinguishes between these two modes of articulation through the above-mentioned aesthetic abstractions. It is simply that the characters' destiny is ultimately overtaken by (rather than in conflict with) the dark forces expressed in the film's formal qualities. By extension, if technological modernity was once characterized by a division between the unsettling forces of technological attraction and a harmonious bourgeois social order, according to *Jenseits der Straße*, the two are now indistinguishable for whole sections of the society.

*Jenseits der Straße* is a narrative that does not resolve the dilemmas of modernity; it does not reach above social reality and offer a restorative, utopian image. The film ultimately stays squarely within the historical here and now, depicting it as a period of disillusion. This already-fragmented narrative whose progress is retarded by techniques in light is already a narrative of dystopia. It is a narrative that refuses to transcend the social crises, particularly as they relate to questions of class. Thus, compatibility of technological experiment and the moral narrative in *Jenseits der Straße* fully eliminates all aspirations for coherence and resolution, in favor of a demystified representation of the technologically inflected world.

### Am Rande der Welt/At the Edge of the World (1927)

The use of light in another film by Karl Grüne, *Am Rande der Welt*, appears at face value to be in contradistinction to *Die Straße* made four years earlier. Rather than using light in order to abstract and close down exterior spaces, in *Am Rande der Welt* it is the interiors that are always made unusual and somewhat abstract. In contrast, the outdoor space beyond the mill in which the action of the film takes place is extensive and opened out by an even use of naturalistic lighting. Despite these initial differences, the same phenomenon of the intrusion of the chaos of the public world into the private space of the home is realized in *Am Rande der Welt*. Once

again, it is realized through a manipulation of light and lighting. Unlike *Die Straße* and *Jenseits der Straße,* which are easily understood as belonging to the cycle of German "street films," *Am Rande der Welt* is a more difficult film to place. Nevertheless, despite the uniqueness of its content and theme, like the street films, *Am Rande der Welt* explores a historically topical issue—in this case, the horror and injustice of modern war. However, more in line with *Der Golem* and *Siegfried* than the street films, *Am Rande der Welt* is set in an artificial, timeless world. Again, like the other films, the setting of *Am Rande der Welt* is one of the primary contributors to its strangeness and disorientation. The lighting serves to underline, even exaggerate, the disturbance of the diegetic war. The lighting inside the mill becomes increasingly obscure as the private, onetime protected hermetic life therein gradually becomes colonized by the war.

The narrative of *Am Rande der Welt* takes place in an idyllic familial community that owns and works a mill in the countryside. The miller and his family share an uncomplicated pride and pleasure in the work that they do and their contribution to the community, a community that sits "far away from the motor-driven world, at the edge of the world."[57] The family leads an idyllic country life, celebrating the passing seasons and the produce that is harvested from these cycles. However, this stability and harmony is short-lived in *Am Rande der Welt.* It is, of course, that "motor-driven world" ostensibly so far away from this community that destabilizes the comfort of country life. This disturbance to the lives and home of the miller and his family is figured visually through the lighting's accentuation of the already unusual nature of the mill's interior spaces. Once again, the lighting renders these spaces abstract. The spaces created by the lighting become disorienting at a very specific moment in the narrative—once "a stranger" is taken in as a workhand. Unbeknownst to the family, he turns out to be a spy working for the approaching foreign army.

The mill as the family's house is notable for its raked spiral passageways that are presumably arranged to follow the curve of the outer wall of the conical, wind-powered mill. The unusual space of these corridors is first introduced when the new workhand is shown to the room in which he will sleep. Here, in the bedroom, the lighting is noticeable for its paucity. The space is dark and uninviting. Following the stranger's arrival, when the family is depicted in the communal living rooms, the lighting formations are noticeable for their creation of disorienting spaces. Strange nonsymmetrical, geometrically shaped patterns form on walls opposite windows. Similarly, the action takes place against these walls patterned with irregular tetragons, bisected both horizontally and vertically by the

line of a thin shadow. At times, there are multiple blocks of light falling on the walls, light forms that have no ostensible relationship to each other, but together, they fragment and abstract the space they create. No source is shown for these shapes on the walls, and there is no establishing shot of the room in its entirety. Thus, it is only after repeated images of the curved and angular walls, together with later glimpses of parts of the windows, that we recognize these shapes as the light shining through windows that also follow the uneven outline of the mill's walls. However, when perceiving the image in isolation, before seeing these other sections in the film, the viewer finds the light shapes perplexing. They appear as decorative shapes that, nevertheless, function to skew the walls on which they sit. The unsettling effect of these light patterns that fall on the walls behind the characters is exaggerated by the fact that their formations are not maintained as a continuity device; that is, the patterns are only ever present on the wall when the characters are depicted in a long or medium shot. When characters are shown in close-up, the patterns disappear. In the close-ups, the same characters who are shown against the strangely lit walls in long or medium shot are framed against a monochromatic, monotextured background. This discontinuity between long shot and close-up, a discontinuity that arises from different lighting arrangements across the edit, creates disorientation for the viewer. We are never quite sure whether the characters occupy the same space as they did in the preceding frames.[58]

These patterns of light further confuse in that, as the film develops, shadows appear momentarily to obscure the upper third of the block of light. It is only in retrospect that we recognize these strange, pulsating shadows as being cast by the revolving arms of the mill. What makes the shadows so confounding is, once again, the fact that there is never an establishing shot to indicate how they might be produced. The absence of a diegetic source renders abstract the patterns in light on the walls. Moreover, it appears as though the mill is not always at work because the shadows do not obscure the space every time the light patterns appear. However, their frequency does intensify across the course of the film. As the film progresses, the shadows appear more often and their pulsation increases. Again, it is only in retrospect that the viewer is able to make sense of these otherwise confusing formations in light. We realize toward the end of the film that as the approaching army forces come closer and closer to the mill, its interior spaces are increasingly skewed. Similarly, the intensity of the pulsations matches the proximity of the army; the closer the army, the more intense the pulsations. Thus these manipulations of the mise-en-scène through lighting and set can

be interpreted as the penetration of the horrors and injustices of war into the domestic spaces of well-meaning country folk. Thus, it is not the world immediately outside the walls of the mill that is penetrating the safety of the inner sanctum, but rather, the afflictions and disquiet of the public, motor-driven world from far away slowly beginning to impress themselves upon the once-protected private world of the premodern rural community.

This invasion of the modern, technological world into the timeless, utopian world of the miller and his family, the invasion of the public into the private, is also announced through other narrative and compositional techniques. For example, a telephone is deployed to connect the interior space of the mill with that occupied by the approaching army. The task of the stranger who was presumed to have come looking for work is to install a telephone line in the basement of the mill so that the family's home can be used as a central communications location for the approaching army.[59] Once the line is installed the communication between the stranger and the army via the telephone facilitates the establishment of spatial relations between the mill and the faraway motor-driven world. Thus, the telephone as a modern means of communication forges an artificial connection between the spaces of outside and inside. This is in addition to the increasing distortions in the lighting that represent the impending collapse of all distinctions between outside and inside, the motor-driven world and the mill.

The contrast between the outdoor and indoor lighting in *Am Rande der Welt* also announces the particularly modern conception of the world that gradually closes in on the mill throughout the film. As the soldiers approach the mill from the distance, the use of natural outdoor daylight creates a spatial depth to the image that is nowhere found in the abstract representation of the mill's indoor spaces. Intercut with the images of the mill's exterior, apparently impervious to the destruction of war, the film shows the soldiers approaching on the distant horizon. They are a mass army that approaches in a perfect order, in a straight line. In keeping with the representation of soldiers in World War I photography, the army is anonymous, depersonalized, a war machine far grander than each soldier's individuality. The soldiers' bodies form a line that indicates the single body of the mass army along the horizon line. The horizon is also the scope and length of the camera's vision. This is an image we see often among those taken on the World War I battlefield: the anonymous group of soldiers on the distant horizon. It is an image that represents the coldness, calculation, and alienation of war. And it is an image that is

represented through a medium that has the capacity to deindividualize, to represent people on a distant horizon, drained of all emotion and psychology, as belonging to a mass.[60] Furthermore, this genre of World War I representation is made possible through photography, and in this case, the cinema. The approaching troops on the distant horizon in *Am Rande der Welt* appear as specks on the horizon of a vast, coherent, evenly lit space which is the battlefield of war, thereby implying the infinity of the modern battlefield.[61]

Unlike *Die Straße* and *Jenseits der Straße*, the lighting that characterizes the spaces it creates in the external, public world of *Am Rande der Welt* does not itself spill over into the domestic environment. The interiors of the mill do not become bathed in the coherent, even natural lighting that stretches to the horizon. On the contrary, when the public world of the ever-expanding battlefield penetrates the home in *Am Rande der Welt*, the existing indoor lighting is further manipulated in order to depict the turmoil. Thus, the invasion of the outside world is still figured through a disorienting lighting formation. Nowhere, not even the edge of the world, is safe from the colonizing forces of war.

Despite the difference of these lighting formations from those in *Die Straße* and *Jenseits der Straße*, the lighting nevertheless contributes to a similar separation and simultaneous extension of two otherwise disparate spheres, the public and the private.[62] When the lighting inside the mill becomes distorted because of the approaching army, the film visualizes the "presence" of the army in the mill. Even though the soldiers are well beyond the horizon, still invisible from the mill, the literal space that lies between the center and the edge of the world is conceptually effaced. The horrors of war are realized in lighting on the walls of the mill, and thus, exterior and interior become conceptually conjoined because of their mutual implication. Yet, this metaphoric visualization indicates that the two realms remain geographically distinct. After all, if they were one and the same space, there would be no need to articulate their continuity through the abstraction of the lighting. Thus, *Am Rande der Welt* represents the expansion of the modern battlefield, not only as far as the home front, but into the family home in an idyllic, rural community at the edge of the world.

In the twentieth century it was not new, and not a particularly German phenomenon, to conceive of the extension of war beyond the classical strip of land that functioned as a battlefield. However, it was in Germany that every soldier was given a camera as part of his equipment for the front. It was common for soldiers to capture images of foreign people

(usually women and children), and send them home to their families as "souvenirs" of their travels and travails.[63] During World War I, established publishing houses such as Piper Verlag published photographic documentation of the soldiers' experience at the front.[64] It was also during World War I that photography became firmly established as a journalistic medium. It was believed that these images provided an "objective" document of the news, equal in potency and verisimilitude to that of the written word. In Germany, whole newspapers such as *Illustrierte Kriegs-Zeitung* were given over to reporting the events of war through images.[65] After the war, photographically illustrated papers continued this tradition into the 1920s. The effects and debris of World War I were communicated to civilian Germans through papers such as *Die freie Welt* and *Arbeiter Illustrierte Zeitung.*[66] Lastly, it was not only the technology of images that brought the battlefield to the home front and vice versa. Other technologies such as repeating rifles, modern communication networks, and automated transport were all noted for their contribution to the rapidly expanding theater of war.[67] Indeed, these inventions of technological modernity were widely acknowledged to furnish a link between the two previously autonomous spaces of battlefield and home front.[68] According to *Am Rande der Welt,* by 1927 this link had already evolved into the collapse of any conceivable boundary or distinction between the space of civility and that of war. When the soldiers eventually set fire to the mill at the end of the film, the timeless world of rural domesticity is completely destroyed by the ravages of war.

Like *Die Straße* and *Jenseits der Straße,* the uniqueness of *Am Rande der Welt*'s vision comes through its marriage of the medium of cinema and the electrification and modernization of the world at large. This marriage is foundational to the film's image of the colonization of the private, domestic sphere by the modern, public world. It is through the selective powers of the film frame (and the manipulation of offscreen lighting sources) that these distortions to the interior of the mill are achieved. The imbalance and estrangement of the mise-en-scène is yielded by the film's refusal to explain the lighting formations through establishing shots. Similarly, the incongruity of the walls is accentuated across the editing between medium long shots and close-ups of the characters. Although we assume that the close-ups depict the characters in the same space as that of the preceding medium long shot, we cannot be sure because the background against which they appear has changed. Lastly, the relationship between the motor-driven world and the mill at the edge of the world is only representable by the fact that these spaces are juxtaposed through

editing. The conceptual relationship of gradually increasing colonization is shown through the montage of different spaces.

## Conclusion

*Die Straße, Jenseits der Straße,* and *Am Rande der Welt* visualize variations of the disorder and alienation of space that result from the invasive effects of the advance of modern technology. The innovation of these films comes in their visualization of this disorder through a cinematic manipulation of electrical lighting. And they implement artificial light as a phenomenon that, in and of itself, contributes to the alienation of contemporary life. These three films do not explicitly refer to the cinema as complicit in the alienation of modern life. However, they do use light and lighting to represent the reconfiguration of the spaces of modernity. Moreover, in their deployment of light, these films interpret the social and political ramifications of these same reconfigurations.

The films engage with the various ways in which modernity and its spatial reconfiguration effect class distinctions. *Die Straße* represents the temptation of a bourgeois man by the dazzle of the streets. Unlike the prostitute, the beggar, and the unemployed youth in *Jenseits der Straße,* he has the option of returning to the comfort of his middle-class existence, away from the disorienting lights of the harsh world of the city streets. For the bourgeois man in *Die Straße,* his home, complete with wife to wait on him, is depicted free of the oppressive abstractions in light and lighting that he experiences in his nocturnal journeys through the streets. At least, the penetration of inside by outside seen in the opening scenes is shown to be transient. In *Jenseits der Straße,* however, there is no escape from the imposing forces of the modern industrialized metropolis for the "lumpen proletariat." If they have homes to go to, the street workers are faced with the same hostile environment in their private spaces as in the public realm. The spaces of their homes are defined through patterns in light, patterns as cold and abstracted as those that mark the streets outside their windows. In *Am Rande der Welt,* the classes are defined not according to income, but according to their affinity with technology and industrialization. The agrarian family that lives in the mill at the edge of the world is helpless in the face of the encroaching army. For those who work the land, there is no future in a world tainted by warfare that has the capacity to extend "to the edge of the world." Like the agrarian workers who were robbed of their livelihoods following World War I and the exponential growth of industrial production, the miller and his family in *Am*

*Rande der Welt* are destroyed by the machine-driven world of war. They become relegated to the impoverished classes.

The three films are not revealing a previously unstated anxiety about modernity. Their perceived pessimism and representations of alienation were repeatedly articulated in the artistic and social worlds of interwar Germany. As depicted in the films, people were unemployed, homeless, disabled by war, socially and economically oppressed. Similarly, the films point to some of the very real changes that are fashioned by the advance of technology, in particular, the way that the spatial reorganization of technological industry had destructive consequences of varying degrees for people of different social classes.

Although representations and critical discourses regarding the effects of technological advance on modern life were plentiful in Germany at this time, the films nevertheless engage in these debates in unique ways. *Die Straße* and *Jenseits der Straße* configure the space of metropolitan streets through light. They are metropolitan streets that have become alienated as a result of burgeoning industrial developments. The alienation and fragmentation of life is not restricted to the streets. Rather, all aspects of life in the modern world have been infected, to the point where in *Jenseits der Straße* there is no refuge from the harsh, pitiless world of the streets. Although *Am Rande der Welt* does not depict the changing face of the metropolis, the forces that encroach on the miller's home at the end of the world are similar to those that invade the homes of the little girl in *Die Straße* and the beggar in *Jenseits der Straße*. The vision of *Am Rande der Welt* is gloomy. If the machines and technologies that bring the flowering of industry and wealth to the city are not so distant from those that enable the annihilation of war, there is no place on earth that will provide protection from their destruction. Such is the limited reality of the historical and social world as it is mobilized through technologies such as light and cinema.

# 6

## Dazzled by the Profusion of Lights: Technological Entertainment in *Varieté* and *Sylvester*

In light-based media, light does not simply illuminate existing scenes; it creates them.
Wolfgang Schivelbusch

In an unusually large number of German silent films, the characters take part in, or are spectator to, some form of mass entertainment. In turn, many of these delightful sequences are executed through a union of camera and lighting. However, the industrially generated forms of entertainment are also a popular setting for acts of criminality and immorality. In one of the most striking scenes of this kind, in Karl Heinz Martin's *Von Morgens bis Mitternachts/From Morning to Midnight* (1920), the cashier at the center of the film, who has robbed the bank in which he works, finds himself at a six-day cycle race on his escape from the law. The objectively depicted movement of the cyclists' path around the track is remarkable for its representation through the lighting as an image of pure speed. As the cyclists circle the valedrome, they are shown to move so fast that, before a fixed camera, their images mutate into two horizontal strips of blurred light, one above the other, flattened out on the surface of the screen. Although the general definition of the human bodies on their cycles can still be identified, they are severely distorted: it is their elongated bodies as two parallel trails of light that we witness on the screen. These movements of bodies are shot through an anamorphic lens that enables their translation into movement as light.[1]

In a better-known example, the third and final story told by the young

poet in Paul Leni's *Wachsfigurenkabinett/Waxworks* (1924) tells of the phantom Jack the Ripper's appearance at the fairground. He stalks through the maze of Ferris wheel, merry-go-round, and numerous electric signs of the fairground setting of the story. The fairground provides the space for a narrative closure overshadowed by doom and turmoil. However, it is also a form of modern industrial entertainment articulated through the superimpositions, shifting surfaces, and dynamic movements of Helmar Lerski's lighting designs.[2] In addition, in this episode from *Wachsfigurenkabinett* we see one of many instances in which mass entertainment configured through the lighting is bound up with sexual excess and perversion. Jack the Ripper has chosen to stalk his victims at the fairground. The film represents a moral decadence that was also thrown into relief in everyday life in the Weimar Republic. As in the case of the representation of the cycle race in *Von Morgens bis Mitternachts,* in *Wachsfigurenkabinett,* yet again light and lighting are used to realize the entertainment's energy.

The immoral behavior spawned under the bright lights of the modern entertainment industry entered public discourse in the late nineteenth century. Once again, primarily because of the social and economic transformations of modernity, the moral decay of German society became a defining characteristic of the 1910s and 1920s. This climate of sexual perversion and extreme licentiousness associated with the entertainment industry was addressed by artists of all media. Artists such as Otto Dix and George Grosz produced numerous images that married the excitement of an industrial leisure industry and sexual decadence. Repeatedly in their paintings and drawings, we are taken into bordellos, bars, and various other playgrounds of the male bourgeoisie, only to be confronted with brutal sexual murders and wild, animalistic sexuality. Thus, for example, in Grosz's *Murder on Acker Street* (1916) we see a murderer furtively washing his hands after decapitating a woman. Or, in his painting *John, the Lady-Killer* (1918), a well-dressed man walks away from a brutally slain voluptuous woman, satisfied with his night's work. Otto Dix's grisly corpse of a prostitute who has been slain in *Sexual Murder* (1922) tells a similar story of a woman violated, murdered, and left to rot in a barbarous act of destruction. The stalking sexual serial killer of the final episode of Leni's film might be an extreme example of the much-discussed relationship between sexual decadence, moral decline, and modern industrial entertainment, but it is in keeping with a genre of representation that flourished in modern, urban Germany nevertheless.[3] As Maria Tartar claims, these images of deviance spawned by industrial entertainment not only represented the burgeoning criminal activities carried out, especially

against women, in the 1920s. They also came to signify the social debilitation, resentment, and vulnerability of a male population physically and psychologically torn apart by the brutality of war.[4]

In this chapter I analyze the use of light and lighting in E. A. Dupont's *Varieté* and Lupu Pick's *Sylvester*. Through striking moments in light, the films self-consciously contribute to and, simultaneously, analyze the modern entertainment industry that flourished in pre–World War II Germany. Because the cinema is one such industrial form of mass entertainment, there is no escaping its involvement in an industry designed to amuse, stimulate, and enthrall the paying customer with its newfound possibilities. As I illustrate in this chapter, involvement for *Varieté* and *Sylvester* took the form of an aesthetic celebration of cinema as entertainment. Furthermore, these aesthetic celebrations exaggerate representations of other forms of entertainment. In *Varieté* and *Sylvester* the spectacular moments of stylistic articulation in light add a dimension of excitement and attraction already manifest in, for example, the sporting game, the variety show, the fairground, and the modern street celebration. They are bursts of technical display that, like a cinema of attractions, create a sense of curiosity and wonder in the audience.[5] These moments legitimate the cinema as a desired modern industrial leisure activity: it is fragmented, transient, diverse, and stimulating.[6] Thus, particularly in *Varieté*, but also in *Sylvester*, through stylistic flourishes in light there is a replication of the excitement of the entertainments that belonged to the modern industrial world. Through intense moments of cinematic display, the films represent the cinema as equally, if not more sensational than the many other distractions of modern life.

Like the entertainment worlds depicted on Grosz's and Dix's canvases, there is another side to the exciting leisure industry in *Varieté* and *Sylvester*. This underside is a world of sexual perversions, immorality, and criminality. Both *Varieté* and *Sylvester* are more than a series of unrelated spectacles in technically manipulated light. Curiously, in both films the disruptions caused by the technological developments are transferred to the sexual desires, perversions, and relationships of the protagonists. Thus, we see the spectacle of lights in motion giving rise to the arousal of often transgressive sexual energies in the drama of *Varieté*. The relation between eruptions of entertainment through light and the dramatic action in *Sylvester* is more obscure. Nevertheless, both films weave spectacles of light and lighting into melodramatic narratives driven by excessive or transgressive sexual encounters. In this way, both films bring together the cinema (and other forms of entertainment), light, and sexual transgres-

sions or immorality. This relationship comes to characterize the modern technological leisure industry.

The films also imagine the destructive outcome of this otherwise energizing combination of forces. In *Varieté*, the protagonist, Boss, is first charmed, spellbound, then jaundiced and later turned into a criminal by this glittering, yet lethal, composite of attractions. In *Sylvester*, the male protagonist is driven to suicide by the struggle between a possessive mother and an unsympathetic wife—all this while the New Year's Eve celebrations are taking place on the streets outside their lodgings. In both films, the delightful images in light and lighting are always imbued with a narrative significance: these moments belong to melodramatic narratives that also explore the seething underbelly of otherwise frivolous entertainment. In both cases, this underbelly is marked as such by the chaos and destruction of an absent moral system. In turn, revelation of this darker side of the modern world functions to complicate the ostensible vacuity of such dazzling technological entertainment. This is not to say that the instantaneity and impact of the technological spectacle are lost to the melodramatic narrative in which they are couched. Rather, as has been the case with other films, *Varieté* and *Sylvester* sustain the tension between the two—spectacle and narrative consolidation. Once again, this tension provides the space for the films' potential social critique.

As was the case with films such as *Algol* and *Faust*, *Varieté* and *Sylvester* are mobilized by a contradiction between utopian narrative patterns and technological experimentation. The relationship between the stylistic explorations and moral melodramatic narrative in *Varieté* and *Sylvester* creates a tension between the ruptures of technological industry in 1920s Germany and the moral stability of the contemporary social world. In turn, this tension is the basis of the films' representation of the disorientation of sexual realities and moral systems that resulted from technological development in everyday German life. We have seen this same incongruity at work in, for example, *Schatten* and *Die Straße*. In *Schatten*, the conjugal relationship is thrown into disarray by adultery, jealousy, and murder when a shadow maker provides entertainment at their dinner party with his light machines. In *Die Straße*, the bourgeois protagonist is caught between the lure of the technologically exciting city streets, and their immoral entertainment, and the banality of a more virtuous life at home with his wife. The substantial conflicts between the moral order and technological spectacle are not fully played out in *Die Straße*. In this film, the protagonist is not seduced by the woman, he does not lose all his money at cards, and he does not commit any crime. He is tempted by and

witness to such activities, but never takes part in them. He is never fully corrupted by the intrigue of the city at night. In contrast, as in *Schatten*, in *Varieté* and *Sylvester* the characters commit all manner of crimes and immoral acts. These acts are intimately bound up with the wiles of technological modernity. However, unlike *Schatten*, *Varieté* and *Sylvester* are films that communicate a moral significance. Whereas *Schatten* is more concerned to portray the deceptive qualities of technological representation in light, *Varieté* and *Sylvester* focus on the devastating impact of such entertainment on human life within the diegesis. This shift from a focus on entertainment to those who take part in or consume it underscores the moral significance of these narratives.

Through the friction created by technological experimentation, these moral narratives engage with intellectual and cultural discourses in circulation at the time. Women are not slain in heinous sexual murders in either *Varieté* or *Sylvester* as they are in Dix's and Grosz's images. Rather, in both films it is the men who are vulnerable and impotent in their relations to both the entertainment industry and the women in their lives. These psychosexually disturbed men do not necessarily represent the distress to masculinity and patriarchy following the war. Rather, their representations follow the anxiety provoked by the cracks in a society in which the impact of technological modernity could not be fully controlled. Certainly, the war is imbricated in these social patterns, but *Varieté* does not identify it as their impetus.[7] Lastly, I understand both films as intellectual discourses that address the same issues as the writings of contemporary critics and theorists. As intellectual discourses, *Varieté* and *Sylvester* then assume an analytical substance that was never accorded to these narrative films—or any other phenomenon that belonged to the thriving industry of mass entertainment in 1920s Germany—by contemporary critics.

## Technology and the Entertainment Industry

Technology played a critical role within the development of the entertainment industry, and especially, the variety performances at the Berlin Wintergarten, in turn-of-the-century Germany. In the 1920s, the Wintergarten variety theater was housed in the Central Hotel on Friedrichstraße next to the central train station. It was a landmark for everything modern, glamorous, and technologically avant-garde. As they had prior to the war, tourists flocked to Berlin to see and experience the modern metropolis. They arrived from Paris, Vienna, and even London on the sophisticated European train system of which Berlin was the end point, the final des-

tination on a journey to the heart of urbanity.[8] Even for local bourgeois Berliners, the Wintergarten was a popular entertainment spot. The exotic plants, grottoes with fountains, the Bayreuth-style orchestra circles, and the sea of electrical lights that flooded the auditorium were a constant fascination for the crowds of fashionable Berliners.[9] Not only the theaters, but the performances themselves also drew audiences in droves. Singers, dancers, comedians, animals, mimics, actors, and acrobats came together in the diverse program of performances that constituted the variety show. Each juxtaposed performance was short, rapid, and highly energetic. The acts were full of glitter, glamour, and crowd-pleasing spectacles. Similarly, the variety theater was a place where bourgeois audiences could marvel at the latest technical innovations, scientific experiments, and "wonders of nature" such as rare plants and never before seen animals.[10] Among the technical attractions on display in the variety theaters were productions of breathtaking illusions in light and lighting:

> In the breathtakingly thrilling scene in the first act, a man sees the train
> in the headlights of his car as it comes ever closer in the darkness and over
> the mountainous terrain. The train becomes bigger and bigger, until the
> shine of its light fills the stage. At the same time the hissing and groaning
> of the enormous train and the rattle of the car are overwhelming.[11]

Such a display of light and lighting was clearly an "act" that staged and inspired awe in the technological advances of this era. The cars with their headlights and prominent rattles, the train winding its way toward the audience with exaggerated, familiar noises were the sights and sounds of the most up-to-date modern world. From its beginnings in 1895 with the Skladanowsky brothers' exhibition to a paying audience, film was at home in the variety shows of the famous Wintergarten and other theaters in Berlin, such as the Apollotheater and the Passagetheater.

In Germany, the blossoming of the variety show—as the birthchild of industrialization—was tightly linked to the rapid expansion of the state after 1870.[12] In keeping with Germany's unfolding economic strength and industrial production power, variety as the entertainment of the bourgeoisie was considered a profitable investment, and money was thus advanced for the building and renovation of suitable theaters.[13] By the postwar period, variety entertainment had a prominence in the cultural landscape of capital city leisure time. At the turn of the century in Germany, there were only a handful of variety theaters, but by 1921 there were 298 variety theaters in 147 German cities, and in 1923, the number had reached 360.[14] Yet, as Kracauer reminds us, the artistic standards of

the variety show were not always appreciated by even the most generous of critics. Kracauer himself was among the most scathing critics of the flourishing entertainment in the 1920s when he claimed variety to be programs of "distractions" raised to the level of "culture," "rubbish and outdated entertainment of the upper class" designed to give the masses the illusion of social superiority and cultural domination.[15] Despite these attacks, the variety shows were not designed to be works of art: they were only ever light entertainment for the pleasure of those with increasing, disposable incomes. They were another form of entertainment akin to spectator sports, the cinema, and the dance hall at which the New Men and Women were encouraged to spend their money and be seen as eager participants in modern industrial life. These shows were not motivated by the development of artistic skill and creativity. Rather, they closely resembled the visual display of commodities in a capitalist market. Much effort was directed toward the spectacle of presentation, the sensationalism of production, and, like the average time afforded a shopwindow display on the fashionable Leipzigerstraße, an average variety number lasted approximately seven minutes.[16] Similarly, all of the pauses were meticulously filled with novelties, scenes constantly changing, orchestral music.[17] There was no such thing as time wasted in the variety theaters of 1920s Berlin. The variety performances received their legitimacy not from the artistic value, but from their economic success, a success in turn determined by the level of sensation, spectacle, and instant gratification solicited by the act.[18]

As was the case in other countries, the variety theaters were the exhibition forum for the earliest examples of film in Germany. By the 1920s, the majority of narrative films were screened in cinema theaters designed and built in Germany's major cities. Nevertheless, once films were screened in purpose-built picture palaces from the 1910s onward, the program for a night at the movies included more than one or two feature films. As a leftover from the days when film was shown in the variety format, the programs often included a mixture of different "attractions"; dancing, acrobatics, circus acts, singing with chorus girls, and/or other spectacles preceded the climax of the evening—the feature film. Waldemar Lydor describes the "prologue" to *Varieté* at the Heilberg in 1926:

> First of all one saw the rising curtain in a faint light, uncertain glowing
> lights, and heard fairground music from the organ. Gradually it became
> light and one saw showbooths whose entire surface carried the word
> "Varieté." Artists came and produced single tricks, girls danced, jugglers

worked, until the darkness sank in again and one saw only the shadows of the working artists. Only the torchlight of the jugglers glowed, similar to the word "Varieté" and the ornamental lamps of the showbooths. A gauze curtain fell unnoticed; immediately the fairground film appeared. Mixed with the fading image of the stage, the "white wall" came down. This and all the original prologues lasted fifteen to twenty minutes, just enough time for the spectator to prepare for the coming film.[19]

Even in the 1920s, when film was sanctioned as an entertainment genre all its own, cinema and variety shows were believed to be intimately related. Their relation was characterized by their common purpose of developing and utilizing the technical necessities of contemporary life. The association of cinema and variety show persisted into the 1920s—if only in the imagination of the audience—for a logical reason: both produced illusions that defied the logic of time and space through the creation of technical attractions.[20] However, the relationship between film and variety acts was only ever admitted and explored in the popular press in Germany. To admit that one of the rationales of the most revered of films could have been economic success would have been a violation of the critic's obligation to art and culture. Even today, references to the variety acts included in the programs in which the "great German films" were first shown—*Die Nibelungen, Das Cabinett des Dr. Caligari, Nosferatu, The Golem*—are rare. German film history has no place for a new "art form" defined, at least in part, by its relations to the "lowly" spectacles of the variety stage.[21] Yet, as the popular press attests in its reviews of these colorful occasions, the presentation of feature films in the 1920s often aped the showtime extravaganza of the variety show.

The programming of variety acts with feature films was not a uniquely German practice. The cinema everywhere intersected with the thriving leisure industries that went hand in hand with the development of industrial capitalism. However, there was also a singularity to the nature of the relationship between cinema and variety in the German context. In the United States, films were integrated into the vaudeville culture from the earliest days of the narrative cinema.[22] Even into the 1920s, in the United States, films in the large picture palaces were introduced by showmen stunts, live trailers, musical performances, and, at times, production numbers as lavish as those of a Broadway review. Of the Western countries with dominant film industries, it was only in France that the program in the picture palaces was devoted entirely to films in the post–World War I period.[23] However, in the United States, the vaudeville and circus acts that

accompanied the feature film presentation were always chosen for their obvious relation to the film, even as a prologue to the film. Thus, in an example cited by Richard Koszarski, in 1920 when a lion was brought into New York's Belleclaire Hotel, it was in observance of *The Return of Tarzan*, which was premiering on the same night.[24] In Germany, the variety extravaganzas of rope twirlers, acrobats, animal tricksters, and musicians had no conceivable relation to the content of the feature film or films to come. The sole relationship between these different media was their status as spectacular, breathtaking, and transient entertainment. E. A. Dupont's *Varieté* uses movement in light and lighting to create a product that fills the criteria often demanded of film as variety entertainment.

### *Varieté* (1925)

In a narrative that is familiar to us from *Die Straße* and a number of other films, *Varieté* tells of the moral decline, punishment, and redemption of the circus master Boss Huller. Boss is, according to formula, tempted from the security (and mundanity) of his home in a small Hamburg circus by the lure of an adulterous liaison with a young dancer-cum-showgirl and the dazzle of the bright Berlin lights. The film is told in flashback and, as we discover at the end of the film, Boss narrates his story while he is imprisoned for the murder of the man who falls in love with his mistress, Bertha-Maria. Again, in keeping with the redemptive endings of many 1920s German films, Boss is absolved of his sins by the prison director to whom he repentently tells his story. Boss Huller, Bertha-Maria, and her eventual lover Artinelli are all involved in the entertainment industry. When we meet Boss he is a circus master in Hamburg, and minutes into the film a man arrives on the doorstep of his caravan with the orphaned Bertha-Maria, a song-and-dance girl. Once Boss and Bertha-Maria escape the "oppressive eye" of Boss's wife through a move to Berlin, they join the famous Artinelli—who also arrives from out of town—to stage a daring and skillful trapeze act in Boss's circus. This circus is the space in which the greater part of the film narrative takes place. It provides the rationale and subject matter for both the innovative explorations of the marriage of camera and lighting in *Varieté* and the overall melodramatic narrative, which tells of Boss's downfall and ensuing redemption. *Varieté* is at one and the same time a melodramatic tale of fallen morality and an allegory of the thrill of technologically inflected entertainment such as the cinema and the circus or variety show.

The opening frame of *Varieté* is filled with a rotating outline in lights

of a fairground Ferris wheel. Moments later, when an intertitle introduces Boss introducing an acrobatic performance, we learn it is his circus. Each time the nighttime entertainment of the circus is depicted in *Varieté*, it is done through a dazzling display of lights. Similarly, in the later sequences representing the variety show at the Wintergarten in Berlin, the intoxicating events are figured through displays of glowing lights and dizzying camera work. From the moment that Boss and Bertha-Maria arrive in Berlin, they are introduced in the capital city on the stage at the Berlin Wintergarten, at night, in rehearsal, under the beam of stage lights. Light and lighting creates and depicts the excitement of the fairground and large-scale variety show: all that is captivating and magical is shown under the bright lights of modern entertainment. However, these climactic moments of sheer visual delight are also more than simple diversions from, or excesses of, the narrative. They are always imbued with significance in a narrative that, despite its utopian aspirations, is marked by the conflict of the technological eruptions themselves.

Although there are only two occasions in the film when we actually see the artists performing their act on the high wires, the frenetic rhythm and pitch of these two scenes pervade those that precede and follow them. They are the set pieces of the film. On the first occasion that we see the newly formed trio perform to a packed Wintergarten audience, the evening opens with a series of stage shows in which dancers and musicians exhibit their talents in the eye of single beaming spotlights. Without warning, one of the spotlights turns to follow a performer offstage left and, in what is an obvious attempt to stir the adrenaline of both diegetic and film audiences, this light glides across the densely packed heads in the auditorium at the Wintergarten. Another spotlight in the top left-hand corner of the stage is picked up in the path of the first, seen in a high-angle long shot through a camera to the upper left of the audience. In turn, this light, in anticipation of the thrill of what is to come, creates patterns in light as it weaves its way across and around the heads of the audience. It stops moving, and in its distant eye, we see a single trapeze artist climbing a rope ladder that leads to the top of the Wintergarten. The trapeze artist's ascent to the heavens of the theater is intercut with an abstract display of three beaming spotlights: one shines from offscreen left, one from offscreen right, and the third sits just inside the left-hand edge of the film frame. Again, we are spectators to this display from an extremely high-angle long shot, taken way at the back of the auditorium. These seemingly abstract patterns of sharp beams of light that cut through the enveloping darkness of the auditorium are eventually the same lights that will illuminate the marvelous performance

of the three trapezists. The beams begin to move around and upwards, reaching to the ceiling of the Wintergarten. On their seemingly arbitrary journey upwards, they find the three bodies of the trapeze artists. The camera sits high in the upper reaches of the theater, and in this distant long shot, we are unable as yet to distinguish the bodies of Boss, Artinelli, and Bertha-Maria from each other. They are reduced to anonymous figures whose distant forms are fixed by a beam of light on one side and the camera on another. As the objects of anticipation and subjects of death-defying acts, these anonymous bodies are revealed to us by the coming together of film camera and the lighting.

Immediately following the arrival of the three trapeze artists at their place in the Wintergarten heavens, the film cuts to a depiction of the illuminated ceiling (Figure 15). The sprinkling of lights represents the star-strewn sky on the Wintergarten ceiling. Unlike the early modern theaters, the sky is no longer painted.[25] Rather, the representation of a nighttime constellation of stars on the theater ceiling is now executed in hundreds of electrical lights. As if by an act of magic, the lights are activated row by

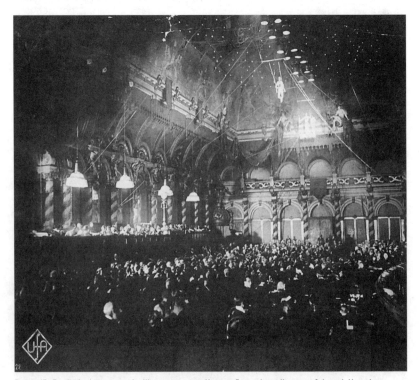

Figure 15. On the high wires at the Wintergarten in *Varieté*. From the collection of Joseph Yranski.

row in fast motion as the camera watches. Seconds later, this ceiling of twinkling stars is severed by the three beams of light as they reach across the face of the frame, as though refocusing the audience's attention on the dramatic events, or perhaps the spotlights are simply looking for the artists. When the camera finds the trapeze artists at the top of the theater, the space of the film becomes disorienting for *Varieté*'s spectator. In both medium-long and long shots, the camera now sees from the point of view of the spotlights that illuminate the three performers. Thus, the horizon and all perspective along a horizontal axis is lost to the dizzying, random, and foreshortened field of vision of a camera, at times mounted on a trapeze swing, high in the sky of the theater top. In the background to the trapeze artists swinging on suspended crossbars we see a shifting array of stars, cables, ropes, swings, and ladders, all of which are isolated by the spotlights and camera from the darkness that surrounds them.

The multiple points of view offered to us as spectators by *Varieté* consolidate the exaggerated thrill of cinematic representation of and as a variety act. Once the three artists begin to display their acrobatic feats for the diegetic audience, the point of view preferred by the camera shifts from that of the spotlights that animate and mimic the movements of the performers. The camera takes Boss's point of view as he swings upside down, holding on to the swing with the backs of his knees. He swings back and forth to gain the momentum needed to catch Artinelli by the wrists when he flies from his swing to Boss on the other side of the auditorium. This point of view reveals a shower of floating lights. As Boss flies faster and faster through the air, through his eyes we see the lights of the star-studded ceiling and the intensely lit faces of the expectant audience below bleed into a huge continuous sea of electrical lights.[26] Artinelli executes his world-famous triple somersault twist and the film cuts to an omniscient point of view shot horizontally parallel with the artists to give full view of this daredevil act. At this moment, the spotlights that illuminate him come back into view, one on either side of the top of the frame. When Artinelli, Boss, and Bertha-Maria begin to fly, the camera oscillates between the three points of view of performers, audience, and objective images that belong to no human characters. This privileged access to three different points of view offers the audience of *Varieté* three different versions of the entertainment. We are invited to experience the adrenaline-filled anticipation of the trapeze artists. Similarly, we experience the awe and wonder of the audience as they sit tight, their faces still, their minds on edge, hoping that the potential result of falling will not take place. Lastly, through the objective frames, shot from the level of

the trapezes, the audience of *Varieté* is able to perceive the atmosphere, the lighting, the movements in their entirety. This objective point of view offers a filmed version of the acrobatics. We, *Varieté*'s spectators, have privileged access to the heightened delight of both trapeze acts and their cinematic representation.

When the act is over, the camera and spotlights together follow Artinelli, Boss, and Bertha-Maria as they leave their trapezes, scale down the rope ladders, and ecstatically run through the crowd, having skillfully executed their performance. As they stand on the stage to take their curtain calls, the artists are captured in close-up through the binoculars of a spectator who is shown in the reverse shot. When the diegetic spectator's optical point of view of dilated bodies is presented in order to offer *Varieté*'s spectator a closer shot of the trapeze artists, *Varieté*'s camera, not the binoculars, is our eyeglass. Similarly, even in these closing moments of the sequence, the camera continues to see from the point of view of one of the Wintergarten spotlights. The spotlights do not sit with the woman in the audience; they are high in the back of the auditorium. Again, we are offered a privileged point of view in these closing moments of the first trapeze act as the camera shifts between the point of view of the diegetic audience and the objective vision enabled by the spotlights, and we see the coming together of camera and light once again. It is only we, not the diegetic audience, who are treated to this performance of film and light as itself a variety act. Through this privileged point of view we experience the heightened excitement, the exhilaration of a cinematic representation of the trapeze act, a representation that is simultaneously a variety act.

It is significant that *Varieté* embraces the most up-to-date technologies in its presentation of this spectacle; for in the 1920s, the measure of a groundbreaking variety act lay in its use of technological innovation. As Michael Esser explains, for the filming of the scenes in which the camera follows the artists as they fly through the air on trapezes, a camera was strapped to trapezes opposite the actors in order to capture the movement and path of the acrobatics.[27] Similarly, it was necessary to install many more lights than was usual in the Wintergarten to achieve the play of light that mimics the actors' vertiginous movements through the air, and the rich star-filled sky of the cupola. To photograph a potential fall of Artinelli later in the narrative, the spotlight and camera running at slow speed were lowered by a cable; thus, when projected, the motion of the falling body would be fast.[28] As Esser explains, *Varieté* served as a vehicle for all of Ufa's high-production values and aesthetic trademarks, including a rhapsodic display of the moving camera and a rich, dramatic

use of lights and lighting: "The moving camera, shadow-rich, dramatic light, the star quality of Emil Jannings, the erotic radiance of Lya de Putti [Bertha-Maria], the rich, detailed architecture, the exotic fairground and, the finishing touch of German sentimentality" are all in the interests of publicizing Ufa's production potential.[29] Notwithstanding the important role played by the studio in the production of *Varieté*, it is also significant that Karl Freund was the cameraman, and was thus involved in the lighting compositions and constructions for the film. As in his collaboration with Paul Wegener on *Der Golem*, Freund used the material of the story to experiment further with the possibilities of his medium.[30] These sophisticated technical strategies, in particular the use of light and lighting to mimic the movement of bodies through the air, are among the innovations of *Varieté*. In this film, it is not only the camera, but also the potential movement of electrical light that creates a new, modern form of variety entertainment. These explorations of artificial light, in their marriage with the film camera, articulate the uniqueness and fascination of the film for contemporary audiences. As in the historical examples, when Boss, Bertha-Maria, and Artinelli perform in the Berlin Wintergarten, the excitement, energy, and precision of their performance is reiterated in the most vanguard of technologies: through the conjunction of light, lighting, and camera.

Contemporary reviews of *Varieté* applauded its technical experiments in light and camera work. Generally speaking, critics believed these innovations to justify the film's status as a variety act, or, alternatively, as a new form of visual art. In an extension of the contemporary reviews, we will see how *Varieté* is actually more complex than either a variety act or a new visceral art form of technological splendor. Rather, the film integrates these technical innovations into a sociologically reflective melodramatic narrative. It is ultimately *Varieté*'s complexity that fuels its engagement with the heterogeneity of the culture it represents.

In their almost unanimous applause for the technical innovations of *Varieté*, again and again critics were enraptured by the crafting of, for example, "the photographic and technical scenery." Superlatives of the highest order were bestowed upon the camera effects, the "trick photography," and the "spectacular lighting" of the scenes that take place in the fairground, at the Wintergarten, and in a very emotional scene in a café.[31] There were even critics who celebrated *Varieté* because the extended sequences of technical display were enough to elevate film as a medium into the ranks of variety performance. Thus, according to Heinrich Stürmer, Dupont's film is a "spectacular" example of a hybrid between the

*Kammerspielfilm* and the *Sensationsfilm*.[32] It is as a "Sensationalism" that *Varieté* discloses its worth and legitimacy as a variety act. For Stürmer, the best variety acts are those that do not last more than a few seconds, acts such as a seal balancing a ball, or Nina Payne on an "eccentric" bicycle.[33] The successful variety act also had to be pleasurable to the eye and induce breathlessness in the audience. Breathlessness resulted because either the audience was on edge, hoping the ball or Nina Payne would not fall, or the act was aesthetically exciting to witness. In *Varieté*, the act in which the trapeze artists fly through the air, followed by dizzying spotlights against a sea of sparkling stars at the top of the Wintergarten, was deemed to be one such event. Stürmer was less enchanted with *Varieté*'s longer narrative sequences, which he considered superfluous to the variety act. Nevertheless, for Stürmer, *Varieté* marked an achievement in German film as it fulfilled the demands of the audience and of the variety act alike. *Varieté* was both entertaining and commercially successful.

Other 1920s critics argued that *Varieté* was a shining example of the new medium of film as an art form, rather than a variety entertainment. According to the well-known film critic Balthasar, through the brilliance and dexterity of the camera at the fairground, the fireworks, the Wintergarten, in short, in all of the scenes in which technical innovation in the lighting comes together with the camera, *Varieté* boasts a unique form of visual representation. As Balthasar says, *Varieté* uses the medium of film as an art that effectively "shatters" the literariness of the manuscript. As he explains, in moments of plastic rendition cameraman Freund and Dupont are able to manipulate the features of the image and push it to artistic extremes. Nevertheless, like Stürmer, Balthasar is not impressed with the construction of the narrative, primarily because its flow is always interrupted by these moments of technical magnificence:

> With all due admiration for the text, but also with (perhaps) too much
> compliance, from time to time the director shatters the manuscript.
> [Freund and Dupont] represent, for example, the Wintergarten program
> as a magnificent performance, and yet, they also let the action drag.
> They split up the events into extremely artistic and charming images.
> However, consequently, they hinder the flow of the film. Again and
> again their filming shows self-purpose, as they fiddle with, improve
> upon, and repeat the process. Thus, they break the structure of the film
> into fragmented images.[34]

Both Stürmer and Balthasar are skeptical of the successful integration of technical experiments into the narrative development. Nevertheless, it is

clear from both that the stylistic manipulations of light and camera create an inspiring and curious new form of representation. Even if the film does not always seamlessly integrate the two narrational modes, it does move beyond the conventions of the 1920s variety act to embrace the principles of narrative. However fragmentary this narrative, the film still puts a narrative together through an innovative combination of images. Thus, Stürmer's and Balthasar's differing estimations of *Varieté*'s moments of technical punctuation are collectively significant for their illustration of the layering of the film's narrational discourses. For the German filmgoing audience, the film represents a new form of variety performance within a narrative formulation. It is through its interaction of these two discourses—spectacle and character-centered drama—that *Varieté* formulates a potential critique of the destruction of modern technological entertainment.

If we turn our attention to the scenes that lie on either side of the extravagant displays of camera and electrical light in *Varieté*, the film moves beyond its status as a form of visceral excitement worthy of the best variety acts. Through the scenes that follow the light displays, the film represents modern industrial entertainment as inextricably bound to a charged, sexual energy, usually of an illicit and destructive nature. *Varieté* understands the intoxicating effects of the technical displays through light and camera as characteristic of an industry that fuels illicit sexual encounters. In turn, if we consider the scenes of technical display within their melodramatic narrative, we can understand the film's larger claims regarding the implications of such forms of entertainment. The bright lights of the world of mass entertainment shine upon an exploration of immoral and uncontrollable sexual adventures.

Intoxicating and death-defying acts on the trapezes go hand in hand with acts of seduction and sexual infidelity. This we see almost immediately after Boss and Bertha-Maria move to Berlin. Before her promiscuous and self-possessed dance in the circus in Hamburg, Boss is disinterested in her, and is almost resentful that she is staying in his house. However, once he is among the audience of men that ogles Bertha-Maria onstage performing a dance of seduction, Boss needs no convincing to leave Hamburg, and his wife and child. In the very next scene, the film cuts to the stage at the Wintergarten, framed by the lights of the proscenium arch. On the night of the threesome's first performance in Berlin, Boss is oblivious to the passion developing between his two acrobatic partners. In celebration of their achievement, the three artists go to a cabaret night-club together: they dance on tables, watch a juggler skillfully juggle his pins, and become lost to the rhythm and beat of the music. These carefree

celebrations appear to be fueled by the adrenaline of the acrobatics on the trapezes. The lighting wavers over the glass window through which the image is shot for *Varieté*'s spectators. Thus the energy of the acrobats on their trapezes bleeds over to energize their uncontrollable sexual desires at the after-show celebrations.

This pattern of technological wizardry continues the next night when Artinelli takes Bertha-Maria to a fairground with Boss's permission. As a token of his "gratitude" and a marker of the successful premiere group performance described earlier, in a scene immediately following that on the high wires, Artinelli offers Bertha-Maria a ring. At no stage prior to this scene have we witnessed the pair's mutual attraction. However, as Artinelli half tenderly, half lecherously looks into Bertha-Maria's eyes, we understand that the partners on the ropes are destined to become sexual partners. Boss, however, is not privy to the amorous relationship developing between Bertha-Maria and Artinelli. He thinks it is a harmless friendship between his mistress and his circus partner. Thus, when the two go to the fairground, Boss stays home and plays cards with his friends in a café. As the couple arrives at the fairground on an island, the film shows a captivating spectacle of brilliantly luminescent fireworks exploding all around them (Figure 16).[35] From the moment the two characters arrive at

Figure 16. Artinelli and Bertha-Maria on the riverbank in *Varieté*. From the collection of Joseph Yranski.

their destination, the film camera stands back and watches the display of the luminous fireworks in long shot with apparent fascination. The camera is as interested in the bursts of light that enliven the mise-en-scène as it is in the scandalous lovemaking of Artinelli and Bertha-Maria on the riverbank. The camera pans, and sometimes cuts between the two scenes, giving each as much attention as the other: it revels in the luminescence and excitement of fireworks over water, and intermittently steals itself away from this spectacle to inform the audience of the affair between Artinelli and Bertha-Maria. As is always the case in *Varieté*'s love scenes, the lighting that accompanies the lovers on the bank is a standard, three-point setup. It is in no way striking other than for its difference from the fireworks display. Thus, the magic and technical accomplishment of the film as a medium that can record rotating suns, effervescent stars, and blazing bursts of fire sits side by side with otherwise conservative techniques that portray the drama of lust, deception, and infidelity.

In the days of industrial modernity, the Baroque *Gesamtkunstwerk* of fireworks that had once been integrated into a stage drama's narrative trajectory was reduced to a wondrous, yet conceptually vacuous, form of entertainment announcing, for example, the opening and closing of a holiday event.[36] This shift away from a narratively motivated use of fireworks is maintained into the twentieth century. However, the fireworks that punctuate Bertha-Maria and Artinelli's lovemaking on the shore of an island in *Varieté* are arguably more than a simple feast for the eyes. When the marvelous display of fireworks on the water is seen juxtaposed with the scenes that surround them, the film marries the display of a dark, night space transformed into a symphony of exploding lights with an illicit sexual encounter. The adulterous passions are yoked together with the spray of lights that forms the fever and excitement of the culture of fairgrounds and variety shows in 1920s Germany. The love affair, clouded in secrecy and betrayal, is intensified by the spectacular displays amid which it sits in the narrative design. Furthermore, this relationship between wondrous spectacles of nighttime entertainment and sexual promiscuity had become a feature of the 1920s cultural and social landscape.

Over the years of its development, the variety show in Germany went through a number of dramatic changes, many of which were attributable to more general developments in technology. When, for example, various renovations of the Wintergarten took place, such as the building of the new revolving stage in 1928, the acts were transformed to accommodate, even boast, the latest technological advances.[37] Other developments in the variety show were determined by audience demands and changing social

mores. In Germany, the explicit eroticism for which the variety show was known in Paris, for example, was translated into a "theatrical display of flesh" around the mid-1920s, during the heyday of the German variety show. Women's thighs, breasts, legs, and backs became the substance of many a variety show for all the world to devour.[38] There is no definite logic to the colonization of variety by the titillating displays of, for example, kick-line girls. Some critics, such as Kracauer, claim that this type of "spiritless," corporeal entertainment was motivated by the audience's hunger for cheap thrills and titillation. As Kracauer reminds us, the two—technical innovation and erotic performances of flesh—go hand in hand in these years of capitalist solidification in Germany. Like the machines that have become part of everyday life in the industrial city, the chorus- and kick-line girls in the variety show are distinguished for the identity of their bodies, the generic nature of their costumes, the automation of their movements. They are the ultimate representation of a capitalist order in which sex and flesh have become naturalized as commodities.[39] Dr. Max Bauer, however, believes that the display of sexually titillating performances during these years can be traced back to a disintegration of moral conduct. This disintegration was begun by the dehumanizing treatment of soldiers on the front during World War I.[40] Alternatively, authors such as Conrad Alberti argue that vaudeville extended the arena of values and "ways of life" encouraged in the workplace: "The passionate partiality for gymnastics, for bodily agility and exercise, accords well with an age in which technology rules everything, in which dexterity and practical ability outweigh philosophical thought and aesthetic perception."[41] Thus, for Alberti, it is of no consequence that the "gymnastics" and "bodily agility" were always performed by women in the variety show. Lastly, there is a commonsense explanation that accounts for the growing commodification of women's bodies in various stages of undress: the recent abolition of censorship after the war.[42] The titillating display of women's breasts and thighs was perhaps performed because it could be.

Irrespective of the logic behind the interrelation of technologically developed forms of mass entertainment and sexual promiscuity, there is ample evidence of the perceived connection between the two in some of the most renowned artistic works of the period. In addition to the violent sexuality that plagues the images of Grosz and Dix, the hero of, for example, Alfred Döblin's *Berlin, Alexanderplatz* (1929) is also confronted by an urban milieu of decadence, sexual experimentation, and an over-abundance of stimuli.[43] Journalists and critics also remarked upon the imbrication of the contemporary entertainment scene and sexual shame-

lessness. Author and theater critic Carl Sternheim details the imbrication of the entertainment industry and sexual liberties in the electrically illuminated streets of 1920s Berlin. On a journey through the nighttime sea of lights of the gleaming capital city of the German Reich, one would be met with the following scenes:

> From 7 to 10 o'clock, the audience's erotic instincts were stimulated by the seductions and adulteries presented in theaters and opera houses. After 11 o'clock, Berlin and its dance floors, bars, cabarets, *chambres séparé[e]s*, dark alleys, and niches of the Tiergarten turned the new consumer into an unprecedented matter of production, and turned the bars into licentious brothels where even high schoolers were already participating.[44]

The élan of the modern bourgeois lifestyle, complete with licentious morals, was everywhere present, transforming the fabric of quotidian life in Germany.

Through the juxtaposition of the technical wizardry of the trapeze acts and the sexual adventures of Artinelli and Bertha-Maria, Dupont returns the association between technically inflected mass culture and sexual decay to both the style and plot development of his 1925 film. In *Varieté*, the variety theater and its thrilling performances of technical innovation go hand in hand with the arousal and exploration of illicit sexual desire. However, Dupont, unlike Kracauer and other journalists and writers, does not judge this immorality. On the contrary, Bertha-Maria is not condemned by the film, and although Artinelli is killed by Boss, thus removed from the narrative, his death is significant less as punishment for his own acts than as a representation of Boss's act of irrational jealousy. Whether *Varieté* is interpreted as punishing Boss for leaving his wife and child to be with Bertha-Maria depends on our understanding of the epilogue depicting his redemption. This question, however, must be held in abeyance while we consider the masterful depiction of Boss's act of jealousy, for the complexity of *Varieté*'s moral claims is woven into these final scenes.

When Boss inevitably hears of his mistress's infidelity via a friend who saw the lovers on the riverbank at the fairground, he is understandably enraged.[45] Shortly afterwards, the film visually reveals his plans for sought-after revenge on Artinelli. In yet another example of Freund's skillful representations of physically or emotionally intense moments, the camera and an array of lights are interwoven to produce a dizzying, disorienting preparation for the events to come. Indeed, we assume that the images we see are those of Boss planning his murderous revenge on Artinelli. Boss's role is to catch Artinelli at the completion of his famous

triple somersault twist. Thus, the easiest means to exact revenge is for him to drop his enemy "by mistake" and watch him fall to his death amid the scattering crowd. In his mind, there are multiple trapeze artists in miniature flying through the air. Then, directly following a closeup of Boss's face, we see him "fail" to grasp Artinelli's wrists. From Boss's point of view, high in the sky, we see Artinelli plummet rapidly to the ground, falling into the densely packed audience. When Boss, Artinelli, and Bertha-Maria then prepare for the performance that Boss has just imagined, we, the film audience, are on edge: we have been led to believe that Artinelli's fate will be sealed within moments, and that we, through Boss's mind's eye, have witnessed Artinelli's impending fate. As the three trapeze artists take their introductory bow, each sporting a death mask on the chest of their leotards, we are led to anticipate murder. The suspense is overwhelming.

When the actual performance on the trapezes begins, much like the earlier one, the buildup to the death-defying feats is executed through dramatic displays of light and lighting. The spotlight beams create patterns over and around the heads of the audience, slicing the image of the blackened Wintergarten auditorium into pieces with their intense light. Similarly, the camera watches the trapeze artists climb up their ladders from a distance, cutting into close-up on their arrival at the top of the Wintergarten, as the adrenaline begins to flow. We are also given access to Boss's point of view as he hangs upside down on his swing in preparation for the performance to come. Once again, the heads of the people are represented as lights in the distance. They blur into one with the stars on the Wintergarten ceiling when the camera traces Boss's semicircular path through the air. Thus, consistent with the earlier images from Boss's point of view upside down on his swing, the camera follows a dizzying semicircular trajectory, disorienting and confusing us with its vision, Boss's vision. Then there is a cut to the audience, motionless, awaiting what it has paid its money to see and experience. When the film cuts back to Boss, he is always centered in the frame as he sits on the bar of his trapeze. This time, the background of stars continues to move, a movement that is the source of disorientation while Boss stays centered and vertically positioned in a back view throughout the sequence. Unlike the first scene of the trapeze acts, our view through Boss's eyes is interrupted, and the film shifts to an "objective" point of view of the scene at hand. This tension between Boss and the space around him—demarcated by the ceiling stars and spectators' heads—places him in an environment in which he is totally out of kilter, an environment with which he is no longer rhythmi-

cally in tune. As he sinks further and further into his own musings, Boss has a series of hallucinatory visions not unlike the dreams of young Freder in Lang's *Metropolis*. Boss's visions are represented as a surrealist montage of multiple kaleidoscopic disembodied eyes. These images we understand to be Boss's conscience reminding him of the irrationality of his fantasies; he knows he is being watched by an audience that he reduces to the eyes that behold him. He has become paranoid, and at some point during his hallucination, he realizes he must confront Artinelli face-to-face rather than cowardly "fail" to catch him in his path of flight. Thus, we breathe a sigh of relief when we see Boss catch Artinelli. However, hand in hand with this release of tension is the foreboding sense that now we have no idea of if, when, and how Boss will realize vengeance.

Boss commits the murder in Artinelli's hotel room in the following scene. Yet again, it is the resplendent performance on the high wires that leads to the sexually inspired act of revenge. Boss then takes himself to the police to confess his crime. In the film's penultimate scene, we are presented with an image of Boss ten years later, a prisoner reduced to the number 28 on his back, telling the story we have just witnessed, the telling of which is the price Boss must pay for a pardon from the prison governor. The prison governor sits behind a desk, bathed in a mystical light, beneath a crucifix. He is prison governor, God, and priest. When we finally see Boss's face, it is covered in a lumbering dolefulness, worn by years in jail. However, the governor grants Boss redemption from his sins, and the prison doors open in a grand gesture of freedom onto a forest pierced by a brilliant sun.

If we accept this epilogue as *Varieté*'s logical ending, then there is little confusion over the moral outcome of Boss's evil doings. His wife has come to take him back and he is delivered from his sins by a secular authority who acts as a Godhead.[46] The film would thus be claiming that there is always room for hope and salvation in an otherwise spiritually defunct world of modern industrial entertainment.

An alternative interpretation would understand this happy ending as a mediation of the abrasive experience of technological modernity that we have witnessed throughout the film. This reading interprets the technological stimuli of light and camera work that punctuate the film as undermining the unity and stasis of *Varieté*'s moral universe. The social status quo represented in the melodramatic narrative is disrupted by the intrusion of the modern world. Thus, when Boss leaves his bourgeois nuclear family and is tempted by the glitter and glamour of modern industrial entertainment, he disturbs a social order with the family as its foundation. Or, on

the microlevel, the spectacles in electrical light and camera always lead into a sexual adventure that destroys the moral status quo as it previously existed. However, the film compromises this overt critique of the distress generated by technological industry when it restores cohesion and moral order through the addition of a happy ending.[47] In an ending that bears similarities to that of *Die Straße*, the seriously wronged wife forgives unquestioningly and the bourgeois patriarchal family is restored. Certainly, such a compromise, the superficial ironing out of the transgressions (for *Varieté*, both sexual and moral) caused by technological advance, could be understood as the work of the studios and exhibitors looking for the film's commercial success.[48] Similarly, we will note that in the happy-ever-after myth, Boss's freedom is granted him by a secular authority, a representative of systemic order. Boss must rely on political and legal legitimization for his supposed moral transformation. Simultaneously, we as spectators rely on the mythical form of the melodrama to provide a stable moral universe in this depiction of a post-sacred era. The melodramatic narrative provides the continuous and coherent moral universe in a world devoid of religious mores. Thus, on all levels of the film—mode of production, textual, reception—we can account for the institutional forces that demand a "seamless," utopian ending. As a result, we are left to wonder whether the spiritual redemption is no more than the transparent mechanism of systemic industries that so conveniently, yet halfheartedly, hide the ruptures and wounds that are left to fester in an alienating, modern world. Such an interpretation accords with the claims of Kracauer and other social theorists that such a film is the exemplary product of a system that appropriates all radicality in order to perpetuate itself.

There is, however, a third, preferred, interpretation of *Varieté*. This would argue that the conflicts staged between the self-conscious eruption of technological stimuli into the melodramatic narrative as preexisting moral order create tensions that are never resolved. Like the ambiguous and open narratives of *Schatten*, *Faust*, or *Die Straße*, *Varieté* sustains the excess of its spectacular displays in light and camera movement. In turn, this stylistic energy hinders moral resolution of the melodramatic narrative, thus creating tensions that potentially demand social analysis. Like critics such as Stürmer and Balthasar, despite *Varieté*'s ending, we still come away from the film amazed at the camera's dexterity and the breathtaking display of light in motion. Simultaneously, we are sensitive to the skillful elaboration of Boss's moral decline as the legacy of the modern entertainment industry in which he takes part. Thus, the film places these two incompatible images in conflict. Seen in its entirety, then, *Varieté* sus-

tains this tension between the moral decadence of modern industrial life and a celebration for the technological phenomena—such as cinema and variety shows—that produce it. This is not to say that through this irresolution *Varieté* equivocates either its critique or its celebration of a technologically inflected mass entertainment. On the contrary, the conflict adds a vibrancy and complexity to the film that makes it neither simply radical nor reactionary. By creating narrative tensions through eruptions of technological spectacle, *Varieté* represents the Janus-faced advance to a technologically inflected modern Germany. On the one hand, the advent of such spectacular entertainment was genuinely thrilling to its audiences. On the other hand, such wonders disturbed preexisting value systems, namely, a moral universe underwritten by family and sexual fidelity. Thus, in *Varieté* we see an outstanding example of the German silent film's tendency to displace the mystical search for transcendental knowledge through representations of light onto an exploration of conflicts in the moral fabric of the secular, historical world.

Significantly, this unresolved relationship between entertainment, such as the cinema, and sexual promiscuity engages with contemporaneous ideas about the impact of technology on the everyday. In turn, *Varieté's* engagement with these discourses gives it a critical potential that was not realized in its contemporary moment of perception. Critics at the time of the film's release were too focused on its technological wizardry to observe the tension between technological excess and moral critique. Such a focus on the new was customary for contemporary critics, especially those of the stature of Stürmer and Balthasar. In their urge to validate film as a unique medium that had a legitimate place within the cultural or artistic landscape, responsible critics invariably attended to the innovations of a given film.[49] They did not have the language, the interest, or the advantage of hindsight to consider that what might otherwise appear as artistic inconsistencies were, in fact, innovations that preface *Varieté's* potential for critical reception.

In conclusion, *Varieté* engages with the widespread coupling of the burgeoning entertainment industry and a decline in sexual and moral standards in 1920s Germany. Like renowned Marxist theories of social process under capitalism from the time, *Varieté* places the vitality of mass entertainment and the culture industry in a cause-and-effect relationship with the breakdown of familial and moral relations.[50] Although the film's melodramatic narrative may appropriate the ruptures to fuel its moral consciousness, the disruptions are never blunted by this structure. *Varieté* might regard as inevitable the retardation of morality caused by

the excitement of secular entertainment. However, the film never forgets that the excitement of these spectacles in light and cinema is breathtaking and pleasurable. Although critical theorists of the day were ready to dismiss the products of the "culture industry"—of which a film such as *Varieté* is a prime example—as the superficial reinforcements of the spiritual vacuity of modern life, the film itself can be interpreted as representing something else.[51] The friction between *Varieté*'s moral narrative trajectory and the film's status as an intensified variety show underlines its vision of the variance of technological modernity. *Varieté*'s return of the tension between technology and its effects to the form of its melodramatic narrative—as a secularized version of a longing for spiritual transcendence—casts the film as an articulate embodiment of German film's contribution to European modernism. Through its very processes of articulation and performance of this "damaged" existence, *Varieté* is not as superficial or empty as might otherwise be claimed.

### *Sylvester* (1923)

In *Sylvester*, the final, most abstract episode of Lupu Pick's so-called *Kammerspielfilm* trilogy, we see the dazzle and excitement of modern urban entertainment on *Sylvesternacht*, or New Year's Eve.[52] Once again, the spectacular light displays on the streets are woven into a melodramatic narrative. In their home at the back of a tavern in the city, the relations within a family—a man, his mother, his wife, and their child—spiral into disintegration as a result of familial jealousies and perversions. The glowing lights of the city streets in *Sylvester* are familiar to us from Grüne's city center in *Die Straße* (Figure 17). As midnight approaches, fireworks explode, windows are filled with light, and silhouettes are seen to clink glasses. Streamers of light twist around and across the surface of the image. Similarly, the faces of celebrators are brushed by the lights that catch their movements. As in *Die Straße*, these streets are veritable theaters of light. The centerpiece of the public world of festivities in *Sylvester* is the brilliant shining face of a clock whose hands creep closer to midnight as the film progresses. Even though the clock is surrounded by an array of luminescent objects—the beat of sharply flickering lights, including a neon sign revealing the proximity of a variety theater directly behind it—its brilliance dominates the city square. The clock also dominates the film frame and commands audience attention. Throughout the film, the face of the clock remains more distinct in shape, more centered, and brighter than other objects that are also accentuated through the lighting. The clock sits

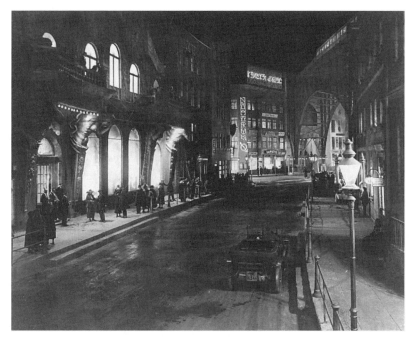

Figure 17. The city center in *Sylvester.* Courtesy BFI Stills and Photo Archive.

at the center of a background in long shot for the first half of the film. As the plot creeps closer to midnight, as the moment of narrative reckoning approaches, so the magically moving camera is drawn increasingly closer to the face of the clock, as if intrigued by its command of the city square. As Carl Mayer, the scriptwriter and cameraman explains,

> The centrality of the town clock in a New Year's Eve film, for which midnight represents the raison d'être of all celebrations, necessitated the invention of the moving camera: . . . the clock had to be dramatic—it had to be *the* film, the central point around which went all the action. . . . For this it was necessary that the camera should be mobile, able to move at will, smoothly, without fuss."[53]

The importance of the clock is exaggerated through the lighting. It is represented as a disc of white light. Thus, the modern invention of standardized, public time enabled by an age of electricity is the fulcrum of the film.[54] Moreover, it is light in the form of the electrically lit clock face that represents the compositional, narrative, and thematic pivot of *Sylvester.* The clock is a lever to yet another instance of a threefold use of light and lighting in 1920s German cinema.

Unlike the eponymous street in Grüne's film, the street in *Sylvester* does not attempt to entice the petit bourgeois protagonists of the melodramatic narrative into its seductive and immoral arms. Rather, this street forms a backdrop against which the film's drama of intimacy takes place. Moreover, this backdrop is rarely visually connected to the indoor spaces in which the melodrama is played out. Neither the spaces nor the action that takes place in the family home is ever penetrated by the lights and action of the street celebrations. Inside and outside remain visually distinct from beginning to end. Curiously, *Sylvester* was also filmed by two different cameramen: Guido Seeber shot all outdoor scenes and Karl Hasselmann shot those indoors. The distinction between two apparently independent spaces—inside the living quarters of a tavern and outside in the colorful streets—is at the heart of what critics such as Kurt Pinthus refer to as the "absence of textual binding" in the film.[55]

In his foreword to the screenplay, Carl Mayer describes the space of the street as the *Umwelt,* or environment, in which the melodrama takes place.[56] Thus, the bright lights of the urban center, the effervescence of a dance hall, an opera theater, and an opaque, black cemetery sliced apart by three sharp beams of light (Figure 18) provide a frame that defines the

Figure 18. The cemetery severed by light in *Sylvester.* Courtesy BFI Stills and Photo Archive.

limits and conditions or the set of influences within which the melodrama is developed. The world indoors is revealed as closed, claustrophobic, and deeply oppressive. This oppression is defined in part by its isolation from the expressive streets. The world of the family drama is cocooned away, marked by its oppositional differentiation from the frame that surrounds it. Moreover, the gap between the boldly and artistically lit spaces of the outside world and those of the softly lit, intimate living quarters is extended to describe the relations of the characters to each other. As the world in which this drama takes place is alienated from the social environs of the streets, so the characters in the domestic melodrama are alienated from themselves and from each other. Lupu Pick attests to this in his clarification of the film's subtitle, "a play of light," in his preface to the published screenplay: "Carl Mayer . . . may well have intended to disclose brightness and darkness . . . within the soul itself, that eternal alternation of light and shadow characterizing the psychological relations between human beings."[57] Thus, the psychological drama of conflicting wills played out in the backrooms of the tavern is also played out in the conflict between light and darkness, between outside and inside worlds.

The complexity of the relation between the spaces of the streets and those of the backrooms of the tavern was the subject of a number of contemporary criticisms of the film. Although the reviews in general celebrated the use of the lighting and the camera work, those that looked a little deeper into the use of these techniques were not always so in awe of the narrative results. Unlike Pinthus, who goes on to applaud the technical finesse required to produce the burning, swelling "light environment," a review of *Sylvester* in the contemporary *Der Kinematograph* condemns the film on the basis of the absent connection between the domestic and the public worlds. The writer wants to see *Sylvester* use New Year's Eve more significantly. He claims that the drama of jealousy and death could take place on any night of the year; the film does not need the outdoor celebrations in order to convey its meaning.[58] For this writer, the lack of continuity between "environment" and drama is detrimental to the success of *Sylvester*. However, as I shall argue, in an extension of Mayer's claims regarding the street celebrations as environment, the distinction between the glitter and glamour of the public world and the gloom and depression of the private influences a narrative that explains both as the offspring of industrial modernity. In effect, the urban environment of an increasingly developed industrialization produces festivities in electrical light and other resplendent forms of mass entertainment. In turn, these forms of entertainment and festivities in light give way to alienating and

crippling familial relations. For *Sylvester,* the coexistent outside and inside worlds are enabled by the modern leisure industry. In turn, this industry retards emotional development, and induces an existential despair in human relations. The louder and brighter the goings-on outside, the more stagnant and fraught the relations are between the family that inhabits the backrooms of the tavern. As the increasingly raucous celebrations depicted in light reach their dizzying climax, the male melodramatic protagonist sinks deeper and deeper into despair, taking his life at the stroke of midnight.

The formal fracturing or splitting of drama and environment in *Sylvester* is characteristic of what Elsaesser calls the pictorial tendency of 1920s German film. Similar to the logic of the opening scenes of *Faust* described earlier, according to Elsaesser, spatial and temporal continuity relations across edits are sacrificed to an emphasis on pictorial composition as narrative signifier.[59] According to the logic of Elsaesser's argument, to claim that the excess of, for example, lighting displays on the streets is dissociated from narrative action at any given moment is to impose a notion of linearity onto a cinema whose structural logic is of a different order.

In a 1924 article that makes reference to *Sylvester,* Ernst Ulitzsch in *Der Kinematograph* discusses the representation of the nighttime cities and their tendency to become clichéd in the current films.[60] According to Ulitzsch, the fantastic images of urban centers by night have no narrative function in films such as *Das unbekannte Morgen/The Unknown Morning* (1923), *Der Traum vom Glück/My Dream of Happiness* (1923), and *Sylvester.* These night scenes are no more than ornamentation: they simply boast the special effect du jour.[61] However, if the street scenes in light are accepted as pictorial compositions that capture a secular festival in the modern industrial world, then, through their juxtaposition with the tragic melodrama that develops indoors, we understand that the significance of the narrative is realized in the space between psychological interiors and celebratory outdoor spaces. The nighttime streets are, by necessity, much more than simple decoration. Similarly, if we believe that Pick was able to realize his theoretical beliefs in the fabric of his films, we must heed his assertion that form, like language, bolsters the meaning at all times: it never exists for its own independent reasons.[62] Thus, the stylistic displays in light must be accepted as always more than spectacular excesses. *Sylvester* is a film in which the psychological drama of the characters is only fully realized through the exchange between the light of the streets and darkness of the backroom of the tavern. In addition, through the narrative conflicts created by lighting special effects in an otherwise

sober melodramatic narrative, *Sylvester* represents the complexity of industrial modernity in 1920s Germany. As in *Varieté*, the modern entertainment industry is here represented for its intimate relationship with sexual and moral perversions. Again, like *Varieté*, the conflict between the stylistic excess and the melodramatic also creates the space for potential audience reflection.

This symbolic drama in light and lighting is set in motion from the early stages of *Sylvester*. A few scenes into the film, the peace of the young couple becomes clouded by an evil black shadow cast on their kitchen window, behind the blinds that otherwise protect their privacy from the outside world. The young couple is shown in the kitchen preparing for the Sylvester celebrations: the man cleans glasses while the woman cooks their celebration dinner. Previously, we have seen both serving drinks with carefree laughter to the customers in their tavern. In the kitchen, the woman pulls back the curtain in their small room to reveal a silhouetted profile of an old woman with a scarf over her head, holding out her hand as if to the young woman who holds back the curtain. This shadow fills the single pane of glass that is left exposed by the drawn curtain. The camera holds this image for an extraordinarily long duration, a length of time that causes the shadow to lose its threatening appearance across the take. The shadow gradually becomes melancholy, excluded, isolated. This change in our response to the shadow is effected through the couple's response to it. While the man seems unperturbed by the shadow, his young wife is visibly disturbed by its presence. We assume that she is resentful of the shadow because this person is evidently going to change their Sylvester dinner for two into a Sylvester dinner for three. We think that she is being selfish, while her husband is the more obliging of the two.

Consistent with the first two episodes in Mayer's *Kammerspiel* trilogy, *Sylvester* carries no intertitles.[63] Therefore, the appearance of a silhouette at the window is mysterious for the viewer. We are left uncertain as to who it represents and the nature of its relation to the young couple until two scenes later. While the young woman melancholically reflects on their dining table set for two and gets another plate from the dresser, the man ventures out into the bustling, giddying rhythms of the street and guides the old woman, who was the shadow on the wall, into their home. The old woman is, we realize, his mother. Furthermore, it is her possessive and competitive love for a son who has turned his attentions to his bride that sets in motion the melodramatic narrative of struggle and ultimate death.[64]

Thus the decline of the young couple's carefree home is triggered by the appearance of a shadow, the profile of an old woman whose image is

blackened out by the lights of the frenetic streets at night that function as backlighting. When the shadow becomes an embodied character, the mother who has never accepted that her son left her for a young bride makes her entrance. The wife is understandably hesitant to accept her mother-in-law's suffocating affection for and attachment to her husband. The tension between mother and wife spawns the ensuing narrative conflict. Surprisingly, the man, caught in the middle of the two women, chooses his mother's unexamined possessive instincts over his wife's more socially acceptable love. When he is unable to make a choice between the two, he ultimately breaks down, falls to his knees, and rests his head helplessly on his mother's bosom while she caresses his head. Thus, neither mother nor son is able to overcome a perverse regressive attachment. When the wife proceeds to comfort her husband, she puts her arms around him, goes to kiss him, and sensing that he is being used as the rope in a tug-of-war, the husband stands up immediately. He violently throws both women from him and the camera stays still on his empty chair while he helplessly staggers out of the room. The women go to the door of his room, where they presume he has retreated. He has locked the door, and despite their frantic attempts, they cannot break in. Within moments we learn that the man has taken his life. His corpse is found on the floor of his room as the clock strikes midnight.

This tragic melodrama is punctuated throughout with images of the wild, vertiginous Sylvester celebrations of other city dwellers. All of these entertainment events are underlined by the glamour and dazzle of light. For example, when the film cuts from the slowly unwinding nightmare of domestic jealousy to the streets, at certain moments we find ourselves outside what appears to be an enormous theater into which well-dressed citizens step. The camera is enticed by the lights to journey inside the theater: a spectacle of shining lights glitters over the face of enormous wall-length windows and vibrates around a central revolving door that mesmerizingly turns to enable the crowds to enter.[65] The camera tracks forward to the revolving door, which reflects the glittering lights of the city; it watches people go in, cuts away to the scene outside the theater, then finally goes inside. Outside on the streets, streamers dazzle as they catch the light. In this city, windows form blocks of light that seem to float in the sea of darkness, the buildings to which they belong being obscured by the night. There are streetlights, car headlights, advertisements for the various types of entertainment that line the street, and the faces of the pedestrians who anticipate with excitement the turn of the New Year are aglow with the reflection of lights that animate the night. These dynamic

events and images point up, on the one hand, the thrill of modern industrial life, and, on the other, a trigger to the disintegration of traditional family relations.

Variety theater was not the only form of mass cultural entertainment that enjoyed exponential growth in the 1920s. The intensification of modernity during the interwar years in Germany saw a simultaneous expansion of diverse popular and mass entertainment that had been born at the turn of the century—theater, vaudeville, nude dancing, revue, agit prop, operetta, popular music, dance crazes, and sport. For many critics, these sensational and stimulating distractions mirrored the substance, however ephemeral, of a new urban way of life. This new way of life was marked by fluctuations, dizziness, multiplicity, fragmentation.[66] As is the case in Grüne's *Die Straße,* the night lights of *Sylvester* painted on a surface of darkness are, as Kracauer would have it, the spectacle of industrial capital intensified into a one-dimensional image. The society of leisure, the rise of mass media, the expansion of advertising, and the colonization of everyday life by the machine are writ large as a spectacle of distraction in this instance of light on the film surface.

Nevertheless, these images are more complicated than they might appear. As mentioned earlier, these scenes in the streets are the formal antithesis to the depth and profundity of that which takes place among the three characters in the soft, dim, gas-lit domestic space. In turn, the formal distinction between the revelry of the streets and the destructive incidents of the indoors extends to the thematic distinction of the underside of city life. Unlike *Die Straße* and *Jenseits der Straße,* for *Sylvester* the disquieting aspect of industrial modernity is not one that can be avoided by the bourgeois family. This supposedly stable social institution is also deeply imbricated in the alienation of modern city life. Thus, in their juxtaposition with the indoor drama, the light displays of the outdoors on New Year's Eve contribute to the multifaceted image of industrial modernity in *Sylvester.*

The one-dimensionality of the nighttime distractions in light is epitomized in the opening images of the film, when we are introduced to the street on which the family's tavern is located. In the opening images, we see the "consumers" and camera alike being lured by light, seduced into marveling at the spectacle on the street. The film opens with a vertical wipe following the opening credits. We see a street demarcated as such by two windows along the right side of the screen, taking up two-thirds of the frame. These patches of light are so bright that it is impossible to distinguish the buildings to which they belong: they are surrounded by a sea

of blackness. People walk past these two uneven fields of light and because they are so bright, the intensity reduces the passing figures to silhouettes. The entirety of the action in this scene is carried by the silhouettes moving across the frame. These figures periodically pass through what is revealed to be a door to the right of the large windows. The scene continues until, in a graceful and unassuming pan left, the camera wanders away from the windows and turns to face the street. The street is revealed as the surface of flashing, celebratory lights: the usual streetlights, windows, advertising, shop signage, car headlights, and, of course, the clock in the distance. The camera then gently pans to look diagonally at the left-hand side of the street and there it sees the bright lights of a restaurant. When it returns to observe the right-hand side of the street, pausing for a moment to survey the hurly-burly of the city center directly perpendicular to its horizontal axis, once again, the camera tracks into the same windows and door outside of which it stood in the opening image. Finally, the opening scene ends with a cut when the camera is at the door of the bar. In the ensuing scene, the film takes up the raucous action on the inside of the same bar. Thus the camera, light, and lighting come together to represent and lure us, the film's spectators, into the heart of the modern leisure industry.

In these sequences from *Sylvester,* the camera and electrical light are not synonymous in their depictions of this world. The one is always complementing the other. The interaction between camera, light, and lighting is the basis of *Sylvester*'s creation of meaning. This is especially so when meaning is produced in the space between stylistic extravagance and dramatic action, the space between the public and private worlds of industrial modernity. Again and again in *Sylvester* the camera appears as an inquisitive onlooker, and is tempted inside by the lights that emanate from within. In the opening scene, for example, the camera tracks toward the lights in the bar, and inside the revolving door of the theater. At the end of the film, the fireworks and bright lights of the central square on which the clock sits entice the camera down to see the nerve center of a New Year's Eve party in close-up.[67] Like the camera, the consumer is enticed by the lights and drawn to engage with the entertainment within. Thus, the camera interacts with the lights and crosses between outside and inside, between the spectacle of the street and the plight of the family in the tavern. Consequently, audiences are alerted to the conflicting forces that weigh upon the modern consumer.

For Carl Mayer and contemporary critic Herbert Jhering, the interaction of the subtle, yet daring camera movements and the glistening, independent light as the defining elements of the film give it a reliable,

constant "rhythmical feel." In turn, the "rhythmical feel" founds the film's larger concerns that develop out of complex relations between outside and inside, light and darkness, public celebration and private trauma. For these critics, the heights and depths, and dizzying rhythms, of this alienating world are captured in the partnership of the gentle movements of the camera through and around the three-dimensional space of the city, with the intensity and distribution of, at times, flickering electrical light.[68] For Jhering, of all the German narrative films to date, *Sylvester* is closest to the absolute films of Ruttmann because its logic is built on the rhythm and motion of the relationships within and between sequences where each sequence takes place in a clearly defined space.[69] "Never," claims Jhering, "was the German film closer to an absolute film art than it is here, as the stark reality of the environment is awoken into a fantastic movement."[70] For Jhering, this rhythm was the product of a concerted use of lighting, camera and editing.

The rhythm of the intercutting between the couple's home and the streets binds a film in which the action in one space never directly touches the action in any other space. Nevertheless, it is misleading to attribute the musical logic or overall coherence of, for example, *Berlin, die Symphonie einer Großstadt* (1927) to *Sylvester*. The film certainly builds toward midnight as the narrative crescendo through frequent cutaways to the clock. Similarly, there is an interrelation between the intensification of light and the kinesis of the streets and the spiral toward destruction in the tavern. However, unlike Ruttmann's film, which follows the movements and internal logic of symphonic form as it moves through a day in the life of Berlin, *Sylvester* has no identifiable musical structure. It is closer in form and structure to a D. W. Griffith parallel-edited narrative. Thus, although Jhering's respect for the more abstract design logic of *Sylvester* nods toward an alternative understanding of the film as musically determined, his claims must be accepted with some reservation. Nevertheless, his interpretation of the rhythmical logic that binds the film's otherwise distinct spaces and the events that take place therein infer the influential relationship between the melodramatic plot and the outdoor spectacles.

Again, rather than dismissing the film because the street scenes and melodramatic action are divorced from each other, to acknowledge the rhythmical qualities of the juxtaposed fragments provides access to the film's complex representations of industrial modernity. What Jhering identifies as the rhythmical patterning of *Sylvester* enables cognition of an otherwise absent relationship between its two distinct worlds. As the pace and rhythm of the activities on the streets intensify, so that of

the drama indoors begins to drag, almost into slow motion. As the one becomes more rapidly cut and the human figures more raucous, so the other indoors becomes increasingly somber, static, and pessimistic. The living quarters behind the tavern and the streets outside are never explicitly connected through visual techniques such as character movement. However, the pace and rhythm of the action that takes place within the two spaces are placed directly in an inverse relationship. According to this logic, the cause-and-effect trajectory is established through pace and rhythm rather than through the imbrication of narrative events. Through the concerted rhythmical movement in opposite directions, *Sylvester* represents the imbrication of the spectacles of a leisure industry that distracts in and through light and the moral repercussions of that which spawns this same spectacle. The film does more than simply replicate the intensely alienating shimmer of light on a surface that is the capitalist spectacle. Through its tragic domestic melodrama, *Sylvester* reveals the psychological perversions that are the same legacy of this alienating world.[71] Although the technological excess and the traumatic outcome of the melodramatic action are common effects of industrial modernity, the film suggests more specifically that the breakdown of familial relations is the legacy of modernity's intense manifestation in, for example, the modern leisure industry.

*Varieté* is a film that explicitly shows the impact of the technological excitement of the variety world on the deteriorating morality of those who take part in this technological feast. Alternatively, in *Sylvester* the melodramatic events are cocooned away, protected from an environment defined as a spectacle of light and movement. The melodrama is only represented as the dark underbelly of the same world that can conceive and produce such excitement through the conflicting rhythms and movements of opposing fragments. It is an underbelly of jealousy, transgressive desires, and unhealthy familial attachments from which there is no escape. Although we could not claim that, in *Sylvester,* the New Year's celebrations directly cause or arouse the forbidden familial desires, the two forms of decadence are certainly characteristic of modern life. They are inextricably linked through their opposing rhythms and speeds. The dazzling lights and movements of the streets in an age of mass entertainment have an underside, an underside that is also demarcated through the spatial location of the family home. It is the space at the back of the hotel, hidden away, out of the light of the modern era. Once again, we see a retardation or oppression of sexuality as the underside of a milieu of excitement and entertainment. As in *Varieté,* here the man is the weak character, the

character unable to make the decisions and take the action that could alleviate the disquiet of familial relations. Similarly, the male protagonist is forced to accept responsibility for his inability to restore harmony to the family, an inability that leads to his moral confusion. There is no salvation for a man who is so emasculated and disturbed. Nevertheless, *Sylvester* also noticeably departs from *Varieté*: nowhere does the petit bourgeois family provide shelter from the wiles of modern life. The petit bourgeois family is the very site of disturbance and alienation.

The moral chaos that overwhelms the male protagonist and narrative of *Sylvester* is connected to a similar loss of moral standards that befell a postwar, secular Germany and Europe. The sexual transgressions and disintegration of bourgeois and proletarian family existence in Germany at this time are well documented. For Adorno and Horkheimer, hand in hand with a liberation from the ideology of love comes the elevation of an ideology of sex. The bonds of love—not only for God, but also between men and women, mothers and children, within families as the ground of all tenderness and social emotion—also disintegrate in this climate of secularity amid the rigors of Enlightenment. Thus, for example, in their alienation from one another, men no longer render women powerless by placing them on pedestals as icons of idolatory. Rather, they render women powerless by making them objects of sex, devoid of all associations of love and reproduction. In Adorno and Horkheimer's schema of the decline into Enlightenment, love and sex have been decoupled. In keeping with the Cartesian division of human beings into mental and physical substance, romantic love has disintegrated behind a curtain of mechanized sex in an age of reason.[72]

Regardless of the validity of Adorno and Horkheimer's Marxist analysis, there was an increasing prevalence of instances of sexual decadence, sexual transgression, and sexual cynicism in modern Germany. Similarly, the observations on the decoupling of sex and love in conjunction with a mechanization of human affection in the age of industrial Enlightenment would account for the transformation to sexual mores and certain demographic shifts of the time.[73] Up to and following World War I, prostitution became a thriving business and the prostitute was held up as a symbol of female sexuality in Germany.[74] One only has to look as far as the plethora of paintings devoted to coquettes, prostitutes, and showgirls by Kirchner, Georg Tappert, Baluschek, Grosz, and Dix.[75] There was also great concern leading to the staging of debates about the future of moral education in schools with the phasing out of religious instruction.[76] Contraception and contraceptive advice became integrated into the fabric of daily life;[77]

"sexual indecency" became recognized as a punishable crime under state legislation;[78] the debate over abortion began;[79] and obscene and heinous sexual murders became common occurrence in 1920s Germany.[80] All of these and other circumstances and events profoundly altered the processes and foundations of social existence. In turn, these examples indicate the way that sexual conduct, sexual representation, and more general moral standards were publicly called into question in 1920s Germany. As radical groups struggled to promote the legalization and access to birth control or the legalization of prostitution, marriage as the foundation of the family, and the family as foundation of moral consciousness of society, dissolved.[81] Consequently, this loss of social stability that relied on the private sphere was one of a number of triggers to a disintegrating moral system in early modern Germany.

We may not want to subscribe to Adorno and Horkheimer's thesis that the cult of the machine and the development of industrial capitalism through the culture industry were responsible for the disintegration of conventionally conceived morality. However, as increasingly sophisticated forms of technological entertainment developed, familiar moral markers did dissolve into obscurity. The connections between the social shifts and the sexual transgressions and alienating familial ties represented by *Sylvester* may seem far removed from each other. Nevertheless, these aberrations of intimacy are, after Freud, always documented as the result of such social change, the developments of such forms of civilization. The mother's obsessive love for her son and vice versa in *Sylvester* is explicable, after Freud, as a response to the demands of advanced civilization. In particular, the perversion is explicable as the result of a social regulation of those relationships that affect a person, and force a sacrifice and neurotic displacement of the instincts.[82] Thus the kinds of perverse attachments witnessed in *Sylvester* are explicable within its cultural and intellectual milieu. According to *Sylvester,* this was a culture in which apparently emotionally and sexually perverse women preyed upon vulnerable, helpless men with a destructive social outcome. Similarly, it was a culture in which the celebration of technology was only one aspect of that which was ushered forth with the advent of electrical light and other such technologies. Crippling moral and sexual transgressions were inevitably nurtured as the underbelly of this otherwise thrilling world.

*Sylvester* engages with the widespread contemporary phenomenon of the imbrication of shifting notions of sexual morality and the burgeoning of industrial entertainment in 1920s Germany. Like the renowned Marxist theories of social process under capitalism from the time, *Sylvester* places

the seething vitality of mass entertainment and the culture industry in relationship with the breakdown of familial relations. The film understands the two phenomena to coexist on the same terrain. Both are the effects of the rapid advance to technological modernity in Germany that was experienced in the 1920s. If the illuminated spectacle of the nighttime streets represents a typical feature of technological modernity, then the breakdown of familial relations that takes place behind closed doors in *Sylvester* is spawned by this rousing world.

Despite its fabricated closure of hope and spiritual redemption, *Sylvester* represents the devastating destiny of a man unable to negotiate the perverse complexities of his human relations. If only because the film has its protagonist commit suicide, its vision is bleak. Even with its salutary happy ending, *Sylvester* regards the disintegration of the family circle simultaneous with the excitement of secular celebration as inevitable.[83] Such concerns were not peculiar to Germany at this time, and indeed, were commonly discussed in other technologically developing nations. However, they were particularly emphasized in Germany owing to the intensity of the impact and experiences of the belated advance to technological modernity. A film such as *Sylvester* thus takes international concerns and weaves them into a specifically German context. Moreover, like the other films, it appropriates the tools of a broadly international film modernism, and yet is further evidence of the German cinema's preoccupation with the prominence of technical light in the formation of both its medium and the world that it represents.

Although social theorists of the day were ready to dismiss the products of the "culture industry" (of which a film such as *Sylvester* is a prime example) as reinforcements of the existential vacuity of modern life, the film itself suggests otherwise. The devastating bleakness of *Sylvester* would strongly suggest that film as modern entertainment was not so blind to the traumas of technological modernity. In both *Varieté* and *Sylvester,* the entertainment world is shown to thrive on its technically powered production. However, neither film puts forward a one-dimensional image that is designed for the frivolous entertainment of its audiences. In both cases, the moral underside of their respective worlds is always envisioned. In addition, both films create a friction between the moral narrative trajectory and the technological wizardry in light. This conflict between the two aspects not only puts forward a vision of the variance of technological modernity. Rather, the friction between technological excess and moral critique opens up the space for potential audience reflection. Rather than interpreting these conflicts as artistic inconsistencies, as did the

contemporary critics, they can be understood as innovations that preface *Varieté*'s and *Sylvester*'s potentially critical dimensions. Through their use of various discourses in light, these representations of the multivalence of technological modernity were more profound than some contemporary critics had recognized.

# Conclusion

The cinematic and cultural engagement with electrical light and lighting continued both in Germany and abroad into the 1930s. While the films made by the Ministry of Propaganda are not known for their stylistic experiments, much less for their interest in developing lighting techniques, a preoccupation with light is a feature of other forms of cultural production from the period.[1] The fascination with the power of electrical light is taken up in the spectacular displays at Nazi rallies and in the staging of Nazism in everyday German life. Accordingly, there are a number of continuities between the aesthetic, technology, and ideas explored by the contributors to the 1920s culture of light and artistic and cultural production under National Socialism. These continuities do not lead to new interpretations of either the films here discussed or Nazi cultural production in the 1930s and 1940s. However, when seen through the lens of the culture of light, the juxtaposition of the two strengthens the basis of our existing understanding of Nazi art and culture. In particular, the comparison contributes to the ongoing project to excavate the deep ambivalence toward modernist representation in Nazi film and culture.[2] Similarly, the comparative approach functions to bolster my argument regarding the complexity and depth of the chosen 1920s films' engagement with technological modernity.

## Light and Film/Film and Light in the 1930s and 1940s

While Joseph Goebbels appreciated the power of technological aspects of the cinema to woo an audience, he also recognized the appeal of the

melodramatic narrative as a container for ideological persuasion.[3] Thus, many of the films produced by the ministry were genre or documentary films designed to construct a sympathetic audience. Similarly, they were designed for easy consumption: little overt ambiguity or contradiction, and few glimpses of everyday life in National Socialist Germany. As Eric Rentschler points out, "Film was redesigned as a mechanized means to animate primal emotion, a modern technology to stir the soul's inner speech. It was to move the hearts and minds of masses while seeming to have little in common with politics or party agendas."[4] Nevertheless, as Rentschler also points out, despite the ideological proclivities of the Nazi cinema, all too often these films inherited the stylistic legacy of those produced in the 1920s. He cites films such as Hans Steinhoff's *Hitler Youth Quex* (1933) for its evocation of Weimar urban, working-class spaces, and Josef von Baky's *Münchhausen* (1943) for its use of the central figure of a double who controls people.[5] Notwithstanding the argument that these films were not as seamless as one might imagine, they did not lay claim to the unwieldy, confusing narratives that had become familiar to German audiences in the 1920s; for whatever the ambiguities of the late 1930s and early 1940s genre films, they did not embrace technological interruption to their smooth narrative progression. Any new technology explored by these films was necessarily subservient to the linear progression of narrative and desired audience response. Thus, while being stylistically dependent, the genre films did not continue the specific strain of German modernism that had been so skillfully articulated in the German silent film.

However, there were other successful films sanctioned by the Ministry of Propaganda with narrative trajectories or surface stories that were punctuated by the exhibition of technical prowess. Most often, these tendencies were found in documentaries such as those of Leni Riefenstahl. Riefenstahl's films present perhaps the most familiar examples of stylistic experiment creating uneven temporal narratives.[6] Klaus Kreimeier points to other documentaries that continued to experiment with technique into the late 1930s and 1940s. Willy Zielke (*Das Stahltier* [1935]) and Curt Oertel (*Michelangelo* [1940]), for example, single-mindedly followed the urge to experiment with the medium. In both films, the innovation of stylistic elements took precedence over the creation of seamless narratives. Thus the camera of *Das Stahltier* glides lovingly across the pistons, cogs, rods, and other machine parts in the steelworks where train parts are manufactured. The camera fragments and decontextualizes these machine parts. And, as it watches them move through their rhythmical motions, it transforms them into abstract images of speed and motion. These and other

moments—such as a 360-degree rotation of the image when the camera is strapped to a train wheel—burst out of a narrative about the evolution of the German railway. For *Das Stahltier,* the wondrous motions and mechanisms of contemporary railway technology are infinitely more fascinating than the discovery of ore in the 1800s. However, neither *Das Stahltier* nor *Michelangelo* was officially sanctioned by the Ministry of Propaganda.[7] For the most part, films produced by and for the Ministry of Propaganda were required to de-emphasize stylistic virtuosity in the interests of easily consumable narrative.

This said, there were examples of 1930s documentaries that continued to promote the experimental over the "informational," while still working within the confines demanded by the ministry. Chief among these were the films of Walter Ruttmann. Ruttmann made films such as *Metall des Himmels* (1934), *Mannesmann* (1937), and *Die Waffenkammern Deutschlands* (1940) as propaganda for the German arms-building industry and the National Socialist conquest. Both *Metall des Himmels* and *Mannesmann,* for example, are industry films in the vein of *Das Stahlwerk der Poldihütte.* These narratives celebrate, as an intertitle in *Metall des Himmels* reminds us, Germany as "the chief European steel-producing nation." As in *Das Stahlwerk der Poldihütte,* we see the complicated process of steel production move through its various phases from the shaping of molten iron to the glorious ships that will transport Germany's soldiers to victory. And in a representation more enthused than *Das Stahlwerk der Poldihütte* by steel as light, *Mannesmann,* in particular, repeatedly abstracts the image and sees the mechanized processes and the material of production dance, pulsate, and wind its way around both the film frame and the Mannesmann Röhrenwerke factory. Sparks of light fly like fireworks through the air as the unformed iron is filed and shaped. When the molten ore is poured into the ovens, it is a veritable fluid mass of glowing light. And when the iron is removed from the ovens, similar to the pre–World War I industry film, blocks of light isolated by a surrounding darkness weave their way around the factory. Ruttmann's industrial films are odes to the beauty and magic of steel production in wartime Germany. And, like his predecessors, Ruttmann uses the technical possibilities of the film medium to underline the enchantment of steel production. Extreme high angles, stop-motion photography, balletic camera movements, and intertitles in kinetic neon light are used to deliver the spectacle of steel as light. Like pre–World War I industrial films such as *Das Stahlwerk der Poldihütte,* Ruttmann's *Mannesmann* and *Metall des Himmels* deploy techniques that are at times as wondrous as the processes of production

and materials that they represent.[8] In this way, the films are infused with narrative tensions between style and "dramatic action" similar to those of the 1920s films.

Ruttmann's films aside, there was a general decline in focus on the possibilities of film lighting in 1930s Germany. The most obvious explanation for this would prioritize the Nazi desire to manipulate audiences through easily consumed fictional narratives. Certainly, in spite of the documentary examples, the Ministry of Propaganda was not overtly enthusiastic about technical experiment.[9] But the narrative films produced by the Ministry of Propaganda were still keenly aware of the importance of integrating the latest technical advances into their product. Technical advance in the film medium was of primary significance to the appeal and persuasive power of film for the German audience. For example, Goebbels was determined to pursue the endless possibilities of colored film stock. In accordance with contemporary findings, he believed that color could heighten the emotional persuasiveness of the image.[10] Similarly, the sophisticated use of sound, and especially music, in many narrative films made under the auspices of the Ministry of Propaganda is evidence of the fascination with new film technologies.[11] As filmmakers all over the world had by this time come to recognize, music had the capacity to smooth over the cracks in the narrative, to draw the spectator into the sugar-coated world of propagandistic entertainment.[12] Given the shift in focus to imaginative uses of sound and color, perhaps the waning interest in the narrative and compositional foregrounding of technical displays of lighting was not only dependent on the political motivations that overwhelm our understanding of late 1930s and early 1940s German cinema. Irrespective of the political party at the helm of German filmmaking, historically, light was no longer the cutting-edge technology that had to be pursued in all its potentiality. With the coming of sound and color film stock to the cinema, light lost its novelty as a defining characteristic of the medium. Spectacular creations in light and lighting no longer sufficed as attractions in and of themselves.[13]

For all the continuities between technical experiment and dramatic development in the German silent films and those of the late 1930s and early 1940s, even Riefenstahl's and Ruttmann's films do not interrogate social and cultural modernity through the tools of the same. Unlike the 1920s films at the center of this book, Riefenstahl's and Ruttmann's films do not use technological light to explore social experience.[14] Nevertheless, there is enough resonance between the 1920s and 1930s–1940s films to underline the Nazis' known ambivalence toward the formal modernist

experiments that preceded them. Even though the documentaries tended to couch their technical experiments in narratives that promoted a certain image of the German nation, the abstractions and narrative ellipses demonstrate a debt to, thus a certain belief in, some of the radical artistic experiments of the 1920s. Whereas all of the films discussed in chapters two through six maintain the conflict between stylistic exploration and development of the plot, the relationship between these narrative aspects was often rearticulated in the films of the propaganda ministry to meet more conservative ends. Nevertheless, in the Nazi films, experiment was not automatically subservient to ideological purpose. Films such as Riefenstahl's and Ruttmann's that were built on discursive conflict surely hold out the potential for critique, even if they did not overtly pursue the possibility. At the very least, their celebrations of the film medium momentarily distract the spectator from the films' overall purpose, and thus, open themselves up to alternative readings.

As much as the continuities with the proponents of the 1920s culture of light provide another foundation on which to argue the Nazi debt to the irresolution of the modernist product of the 1920s, the discontinuities are just as revealing. These discontinuities underline all of the aspects that make the 1920s German films' contribution to the culture of light unique: the sustenance of the tension between aesthetic experiment and the linear trajectory of a cause-and-effect narrative; the depth of social commitment; the conscious refusal to deliver easily consumable narratives; the serious and reflective engagement with a culture of technological modernity. But first, a word on the vivid appropriations of light and lighting elsewhere in the 1930s and 1940s cultural arena.

## Light Spectacles

Albert Speer, Hitler's chosen architect, well understood the power, flexibility, and extensive reach of electrical light. Like the avant-garde architects of the 1910s and 1920s, Speer placed light at the center of his plans for a public, community-oriented National Socialist state. In the same way that we must be wary of Kracauer's language of premonition, we cannot establish a causal connection between the cultural celebrations in light of the Ministry of Propaganda and those of the 1920s film studios. Clearly, public displays of light and lighting were taken up to meet different political ends in the 1930s and 1940s. Similarly, in the case of these public spectacles, the Nazis attempted to drain their representations in light of all contradiction and irruptive qualities. These displays of light were pure

spectacle, designed to awe a mass audience, to sweep the *Volk* up into enthusiastic commitment to a political party with power and purpose. Prima facie, there were no echoes of the tensions of technological modernity in these light performances.

The 1920s culture of light saw the use of technically produced light and lighting in artistic representation and on the streets in ways that explored its multiplicity and, perhaps most important, the unevenness of its impact on a diverse population. Thus, films such as *Die Straße* use the available light and lighting technologies as the medium of their images. In addition, they use these and other cinematic strategies to represent the visual appearance of the technologically modern world, a world marked by the contributions of light and cinema themselves. And to complete their tripartite engagement with light, the films explore how technological modernity shaped daily life for a full range of social groups. Between them, the films here examined address the specific impact of technological modernity on the rich and the poor, the unemployed and the street worker, men and women, Jews and Gentiles, farmers and urbanites. Always, these films assume the responsibility of interrogating the disparities in effects for different sections of the community. In turn, the films' collective vision of technological modernity is one of simultaneous celebration and skepticism, mobilization and entrapment, euphoria and disease. In National Socialist Germany, light was mobilized to interrogate none of the difficulties of life in its midst. The primary motivation in its deployment was, indeed, the very opposite: to veil all doubt and inequality. Light was the celebratory symbol of the power, wealth, and magnificence of the third German Reich.[15] Nevertheless, the aesthetic still capitalized on previous achievements: it still blithely appropriated the technological developments in electrical light that were so central to the social critique of the 1920s culture of light.

Under the aegis of the Ministry of Propaganda, public buildings in everyday use and many official buildings were brilliantly lit every night, usually to ensure the luminosity of the swastika banners that draped the length of the buildings.[16] The all-important public rituals of the Third Reich, in which a sense of community was fostered in the *Volk*, were also dominated by the radiance of thousands of lights.[17] The rallies, ceremonies, and, in the early years of the National Socialist reign, mass demonstrations were often held in purpose-modified urban squares. Similarly, according to Hitler's prescriptions, they were commonly held at night.[18] Hitler's appointment as Reich's Chancellor on the night of 30 January 1933 was heralded with a magnificent torchlight parade through the main streets of Berlin, and again, similarly spectacular illuminations were or-

dered to celebrate the "Day of Labor" on May 1 of the same year.[19] From then on, all important National Socialist festivities were observed through exhilarating shows in light.

These occasions provided an opportunity for masses of people to join together and unify themselves "in one will and one readiness."[20] Speer describes the Day of National Labor celebration held at Berlin Templehof: "The mountain of flags made radiant by thousands of lights stood with its glowing red in stark contrast to the dark blue of the evening sky, while all irrelevant and intrusive elements sank away into the evening twilight."[21] As is evident from Speer's description, light was fundamental to the creation of an enclosure or framework within which the people could be molded. During Hitler's speeches, the masses were held silent and still in the darkness—as they would be in a cinema—while they looked at the glittering light display and listened to their Führer. Then, at the conclusion of the event, they were united with their hero in mutual glorification when a single searchlight cast its eye over the masses and Hitler alike. Powerful searchlights and spotlights on towering lampposts also flanked the perimeter to demarcate further the space of congregation and to accentuate the feeling of inclusiveness in the event. An outstanding example of this architecture through light was also created for the closing ceremony of the 1936 Olympic Games. Searchlights that beamed high into the night sky were placed around the perimeter of the outside wall of the stadium. The people were molded both physically into the larger pattern or whole and ideologically into a sense of togetherness through the literal and metaphorical energy of electrical light. Light was the tool through which Germany as a nation of power and mystique, simultaneous surprise and reliability, was continually reinforced by the Nazis. Light was a primary material for the articulation of a belief in their own superiority.[22]

Community rallies that encouraged people to experience a new sense of German unity and innate connection to the German soil and nature were also held in vast open spaces. It was for such arenas that Speer designed his spectacular *Lichtdöme,* or Cathedrals of Light, of which the display at the closing ceremony of the Olympic Games was a memorable example.[23] Although there was one cathedral of light planned for each German city, few were ever built. For the cathedral in Nuremberg, which was built in 1937 for the Reich Party Congress, Speer directed 150 searchlights fifteen kilometers into the night sky, where they eventually came together through the clouds. These were, according to Speer, "a fantastic thing, like being in a Gothic cathedral."[24] True to the Nazi imperative for a unity with nature, the beams of light reached up into the sky to open out

into the natural world, and simultaneously to enclose the people in that natural world. These great open spaces were still bounded by (in the case of Nuremberg) the walls of a stadium, or the natural walls of, for example, a mountain slope or a natural depression in the earth.

Although the scale of Speer's designs in light was significantly greater than those buildings conceived by the Expressionist and Bauhaus architects, the principles behind the spaces of public gathering in the Third Reich bore important similarities to the earlier buildings. They used light for the same purpose of defining a public experience of integration. Furthermore, like the designs of Taut and his circle, it was an experience of integration between a community of German people and the natural world. Despite the radical difference of the historical periods, political systems, and ideological beliefs, like the earlier designs, of primary importance to the National Socialist "stadium" was the use of the most up-to-date light technology. The light displays introduced the glory and magnificence of the high officials of the Nazi Party. In turn, their voices were disseminated clearly and forcefully throughout the stadiums via state-of-the-art sound technology. Again, despite the difference of the ideological uses to which these performances were put, their conception and execution in and of light were reminiscent of the utopian dreams of the 1910s and 1920s architects.[25] Technological manipulations in light and lighting were key to a belief in the affluence and strength of Hitler's Third Reich. Thus, they resonated with the role played by technological light and lighting as an advertisement of the optimism and strength in the pre–World War I years especially.

The architecture and performances of the Third Reich were clearly built on principles developed within the modernist German culture of light. Even if Speer did not directly acknowledge earlier twentieth-century developments in the relationship between technical light and the other arts, his designs were founded on the principles of his most immediate and, at times, more distant historical predecessors. It was not only the building materials that reiterated the dreams of earlier architects and artists. In their urge to sustain an integration of the individual into the community, and the community into nature, conceptually, Speer's structures also mirrored the goals of their socialist ancestors. These historical continuities across different historical periods and political regimes are further compelling evidence of the Nazis' profound dependence on their immediate cultural predecessors for inspiration and execution of their cultural discourses. Despite their professed disdain for modernist aesthetic and cultural production, when observed parallel to the 1920s culture of light,

the evidence to the contrary is indisputable. The 1920s culture of light provides yet further evidence that monumental classicism was not their only inspiration.[26] Indeed, certain of the 1930s and 1940s examples extend the concerns of the culture of light, albeit in a reconceived form, into the late 1930s and early 1940s.

There were, of course, striking differences between Speer's *Lichtdöme* and the designs of the 1910s and 1920s artists, architects, and filmmakers. For example, unlike films such as *Algol* and *Schatten,* the architectural structures of the Bauhaus masters or Piscator's plays, Speer and the commissioners of his projects were not interested in using light for the critical examination of technology and its role in the construction of everyday life. To be sure, any critical or complicating edge to the use of technology was concealed either at the level of Speer's designs themselves or at that of the uses to which they were put. Despite Speer's own claims, light was deployed to celebrate and flaunt the utopian dreams of life under National Socialism. If there was any overt, self-conscious reference to technology, it tended to be an ostentatious display of the productivity of life in the sway of technology. During the Third Reich, an interaction of artificial light assumed a familiar role in the utopian aspiration for communal integration. The National Socialist use of light lacked the complexity and the critical edge for which it had been exploited in 1920s Germany. This is not to argue that the light culture was free of contradiction and complexity per se. Rather, these characteristics were not identifiable on the same level as in the 1920s proponents of the light culture.

At the rallies and public functions, all the symbols and metaphors of Hitler and his power—the German eagle, the swastika flags, the wings of the Luftwaffe, and so on—were consistently lit as would be an image of God, his angels, and lambs in classical painting.[27] Intense lights were placed behind or underneath them so as to radiate the light of purity, goodness, and supreme power. Light in National Socialism once again found itself an instrument of utopian idealism. Gone were the conflicts between technological light and the materiality of modern life. Gone were the tensions between different registers of light, the contradictions between different aspects of the environment in which light was articulated. Light and lighting in the Nazi era may have had everything to do with the climate of technological modernity, but they consistently covered over rather than exposed the undulations and inconsistencies thereof. In late-1930s and early-1940s Germany, light and lighting were once again in the service of a mystical utopianism, albeit ideologically rather than spiritually defined.

We must not forget that the various artistic and cultural phenomena in light always intersected with global capitalism and consumer culture. In the 1930s and 1940s, the use of high-voltage spotlights and searchlights that were so popular in the traditional ceremonies of Nazi Germany were also found in the artistic and cultural products of other countries. MGM celebrated the opening of *Gone with the Wind* with a fanfare of searchlights beaming into the sky in 1939. And the opening of the Paris 1937 World Exposition was marked by an ostentatious display of double light cones emanating through and around the Eiffel Tower.[28] Speer and his fellow Nazis may have perfected the design and ideology of public performance in light, but it was also an internationally popular means of both corporate and state advertisement during these years. As in the teens and the twenties, Hollywood and the emergent art cinema in other European countries were intimately tied to the uneven developments of an international modernization and modernity. Yet again, Germany may have guided the exploratory possibilities of electrical light to their logical depths; however, it was not alone in its determination to communicate, enthrall, and persuade through electrical light in the approach to World War II.

Without diminishing the complexity of Speer's *Lichtdöme* and the intricacies of everyday public lighting in Nazi Germany, their juxtaposition with the films of the 1920s lays bare all of the uncertainty and contradiction that characterized this group of films. If we think of *Algol*'s and *Schatten*'s commitment to exploring the ramifications of their technology or *Varieté*'s and *Sylvester*'s interrogation of the moral consequences of the indulgence in spectacular entertainment within modernity, the questioning, critiquing, and searching are brought to the fore in these narratives. Although the parallel appropriations of light technology in these different periods reveal some of the contradictions in the 1930s and 1940s works, these contradictions are on an altogether different level from those of the 1920s examples. The engagement with time and concepts of history in *Der Golem, Faust, Siegfried,* and *Metropolis,* for example, is unlike the Nazi dependence on past modes of representation because it is thematized. And this thematization underlines the self-reflection assumed by the films, and thus their artistic value as modernist works. It also reinforces the fact that the 1920s films here analyzed go even deeper when they investigate the ramifications of the proliferation of technological modernity on different sections of the population. This investigation witnesses their commitment to the material fabric of everyday life and their social responsibility. Certainly, there is no equivalent to these layers in the Nazi artistic and cultural products. The latter may be profound in other ways, but they do not engage with social issues.

This is perhaps the most outstanding characteristic of the 1920s German films here discussed when viewed for their place within an ongoing culture of light: they engage at every level of their articulation—production, aesthetic, and exhibition—with the material changes of their contemporary world. As I have argued in this book, this engagement is intimately tied to their marriage of, among other things, technical light and the film medium to create modernist representations. The films' tensions are brought alive through the modernist commitment to the problems of formal articulation and, in this case, the representations of the historical world in which the films were produced. Within my narrative, both of these layers of films such as *Algol* and *Schatten*, *Faust*, *Metropolis*, *Jenseits der Straße*, and *Sylvester* are generated through explorations in light and lighting.

Through their connection to other 1920s art and cultural works, this group of films contributes to a culture of light that, in turn, was instrumental in the cultural definition of interwar Germany. The films within the culture of light are central to a particular vein of silent German national cinema, a cinema characterized by its commitment to exploiting the tools of its own definition and that of the technological world in its midst. Similarly, this cinema is driven by an impetus to represent the effects of both on everyday life. However complicated the relations, the fascination with technological proponents of modernity such as light and lighting resonated across the first three decades of twentieth-century German artistic and cultural production. Clearly, films such as *Der Golem*, *Varieté*, *Siegfried*, and *Schatten*, their aesthetics and their concerns, cannot speak on behalf of all German film production in the 1920s. Nevertheless, if we anchor the films in their continuity with works produced in the teens, twenties, late thirties, and early forties, their significance must be acknowledged. Within this culture of light, we find a cinema that can be interpreted to imagine Germany's accelerated advance to technological modernity as critical to its self-conception and the presentation of this conception in the international arena.

# Notes

## Introduction

1. The exception here would be the handful of critics who have looked at some of the more technical aspects of film lighting. See Barry Salt, *Film Style and Technology: History and Analysis,* 2d ed. (London: Starword, 1992); Barry Salt, "The Unknown Ince," *Sight and Sound* 57, no. 4 (autumn 1988): 268–73; Lea Jacobs, "Lasky Lighting," in Paolo Cherchi Usai and Lorenzo Codelli, eds., *The DeMille Legacy* (Pordenone: Edizioni Biblioteca dell'Immagine, 1991), 250–60; Lea Jacobs, "Belasco, DeMille, and the Development of Lasky Lighting," *Film History* 5 (1993): 405–18. The other vein of history that references, but does not necessarily foreground, the importance of lighting to the development of a cinematic language can be found in David Bordwell's attention to the mise-en-scène as historically determined. See, for example, David Bordwell, *On the History of Film Style* (Cambridge: Harvard University Press, 1997), especially 198–251. Another notable exception is Patrick Désile's *Généalogie de la Lumière. Du panorama au cinéma* (Paris: L'Harmattan, 2000). As the title suggests, the book is concerned with various uses of light and lighting in pre- and early cinematic forms. Désile considers the centrality of light and lighting not only to the realization of these art forms, but for the epistemological ramifications.

2. Richardson is the cinematographer for the later Martin Scorsese films and the post-*Platoon* films of Oliver Stone. His extremely high-key lighting effects wash out the frame.

3. Rudolf Arnheim, "Lighting," *Film Essays and Criticism* (Madison: University of Wisconsin Press, 1997; originally published 1934); Siegfried Kracauer, *From Caligari to Hitler: A Psychological History of the German Film* (Princeton, NJ:

Princeton University Press, 1947); Peter Baxter, "On the History and Ideology of Film Lighting," *Screen* 16, no. 3 (Autumn 1975): 83–106.

4. Actual light was used in paintings many years before the availability of artificially generated light. Of note here are Caspar David Friedrich's transparencies from 1835 such as *Mountainous River Landscape.* The full effect of the transparency could only be experienced when viewed with a device that enabled light to fall through a small aperture, while the rest of the room was in darkness. The source of light was usually a candle. The one transparency that survives today depicts a landscape on both sides of a sheet of translucent paper. When viewed with the appropriately placed light source, the double-sided image reveals two variant versions of the same landscape: the one of day, the other of night. When the light source is placed in front of the painting, we see a river valley in daylight. And when it is placed behind the image the river landscape is luminescent under the light of the moon at night time. This surviving transparency is housed in the Gemäldegalerie in Kassel. See Birgit Verwiebe, "Transparent Painting and the Romantic Spirit," in Keith Hartley, Henry Meyric Hughes et al., eds., *The Romantic Spirit in German Art: 1790–1990* (London: Thames and Hudson, 1994) 171–77.

5. The interweaving of all representational levels of the image is not limited to the cinema's ontology. As I argue in chapter 2, when technically manipulated light is the substance of architecture, theater, and photography, then these forms also invoke the tripartite structure.

6. See also Tom Gunning's compelling argument for the way in which Loïe Fuller's performances on film at the turn of the last century bring together color, light, and bodily motion to realize the unique attraction of the cinema ("Loïe Fuller and the Art of Motion: Body, Light, Electricity, and the Origins of Cinema," in Richard Allen and Malcolm Turvey, eds., *Camera Obscura, Camera Lucida: Essays in Honor of Annette Michelson* [Amsterdam: Amsterdam University Press, 2003], 75–89).

7. The most significant historical circumstance here is World War I. In Germany, the effects of the war on industrial production were different from those in other countries. The differences stemmed primarily from the patterns around production of armaments and supply and demand for industrially produced goods (such as electricity) for the continuation of the war effort. See chapter 2 for more details.

8. Scheerbart was a poet whose writings on architecture formed the basis of Taut's revolutionary buildings that, for the most part, remained on the drawing board. See Paul Scheerbart, "Glass Architecture," in Dennis Sharp, ed., *Glass Architecture by Paul Scheerbart and Alpine Architecture by Bruno Taut,* trans. James Palmes (New York: Praeger, 1972).

9. On this photographic movement, see Anne Hoormann, "Lichtspiele," in *Licht* (Jena: Botho-Graef-Kunstpreis der Stadt Jena, 1998), 10–19.

10. László Moholy-Nagy, "Problems of the Modern Film," in Richard Kostelanetz, ed., *Moholy-Nagy: An Anthology* (New York: Da Capo, 1970), 131–38.

11. See Christian Huygens, *Treatise on Light,* trans. S. P. Thompson, in *Great Books of the Western World,* vol. 34, *Newton, Huygens* (Chicago: Encyclopaedia Britannica, 1952); Isaac Newton, *Optiks* (New York: Dover, 1952); and Albert Einstein, *Relativity: The Special and General Theory* (New York: Smith, 1920).

12. Leo Charney and Vanessa Schwarz's *Cinema and the Invention of Modern Life* (Berkeley and Los Angeles: University of California Press, 1995) has spawned much work in this field. For more recent studies on the subject, see, for example, Ben Singer, *Melodrama and Modernity: Early Sensational Cinema and Its Contexts* (New York: Columbia University Press, 2001).

13. For a canonical account of the social effects of technology and industry, see Lewis Mumford, *Technics and Civilization* (New York: Harcourt Brace and Company, 1934).

14. Donald Crafton's "Electric Affinities," in *The Talkies,* makes a similar argument about American film's engagement with technologies, including light. I would like to thank the anonymous reader for University of Minnesota Press for pointing me in this direction. See Donald Crafton, "Electric Affinities, in *The Talkies: American Cinema's Transition to Sound, 1926–1931,* History of the American Cinema, vol. 4 (New York: Simon and Schuster/Macmillan, 1997), 23–61.

15. Industrialization followed unification of Germany in 1871. The small German states of the south were unified with the ever-expanding sphere of Prussian domination following the Franco-Prussian war of 1870. See Thorstein Veblen, *Imperial Germany and the Industrial Revolution* (Westport, CT: Greenwood Press, 1984; originally published by Viking Press, 1939), for details of the spread of modernization at this time. For a comparative study, see also Adolf M. Birke and Lothar Kettenacker, eds., *Wettlauf in die Moderne: England und Deutschland seit der industriellen Revolution* (Munich: K. G. Saur, 1988).

16. This attitude is expressed in works ranging from philosophical and sociological reflections on the Weimar period to analyses of the artistic and cultural products. Peter Sloterdijk's *Critique of Cynical Reason* (trans. Michael Eldred [Minneapolis: University of Minnesota Press, 1987])discusses the Weimar Republic as a particularly concentrated example of the skepticism and contradiction that feeds modernity. Most film critics from Lotte Eisner and Siegfried Kracauer on reference this culture of ambivalence and conflict in some way. The conception founds even the most recent works, for example, Tom Gunning's argument regarding Fritz Lang's films in *The Films of Fritz Lang: Allegories of Vision and Modernity* (London: British Film Institute, 2000).

17. The notion of the Weimar Republic as a separate political and historical entity sandwiched between the collapse of the Wilhelmine Empire and the turmoil of Nazi Germany is one that, for years, led film historians to adhere to the notion that the films of the Weimar period, like the German nation, bear the seeds of National Socialism or the debris of imperial autocracy. These types of histories were inaugurated by the work of German film's founding historians, Kracauer and Eisner. Although the critiques of these works are now well rehearsed, a surprising

number of scholars are led to similar conclusions—that is, that in some way, the films of the Weimar period foreshadow the inevitability of National Socialism. The force of Kracauer's legacy is telling as we saw this argument resurfacing in the 1990s. See, for example, Paul Monaco, *Cinema and Society: France and Germany during the Twenties* (New York: Elsevier, 1976); Bruce Murray, "The Role of the Vamp in Weimar Cinema: An Analysis of Karl Grüne's *The Street (Die Straße),*" in Sandra Frieden and Richard McCormick et al., eds., *Gender and German Cinema: Feminist Interventions,* vol. 2, (Providence, RI: Berg, 1993), 33–41. In his recent work on Weimar cinema, Thomas Elsaesser departs from this model through drawing the connections between the Weimar film and the American film noir. See Thomas Elsaesser, *Weimar Cinema and After: Germany's Historical Imaginary* (London: Routledge, 2000).

18. This notion of cinema's involvement in modern life was written about extensively in the Weimar years. As Walter Benjamin, Kracauer, and Béla Balázs would have it, one of the great innovations of the cinematic camera is its capacity to capture a crowd of people in motion. Motion and the masses were two concepts central to the characterization of modern industrial life. Similarly, mechanized transportation—cars, trains, streetcars—and communications systems were the very icons of industrial modernity. And the cinema is, of course, by definition, a series of moving images. Similarly, the anonymous mass as opposed to the integrated individual was one of the most salient features of the rationlization of all areas of life from the workplace to leisure time. And one of the excitements of the cinema was its attraction of a large, class-undifferentiated audience. Motion had reached a hypostasized state of abstraction in the form of electricity as the invisible flow of energy from unseen sources to the flick of a light switch.

19. There is a group of films, made primarily in the final years of the Republic, that directly addresses the political climate of the day. However, because these films do not represent their concerns through foregrounding manipulations in light and lighting, they lie beyond the purview of this study. The two well-known examples from this body of films are Bertolt Brecht's *Kuhle Wampe* (1931) and Piel Jutzi's *Mutter Krausens Fahrt ins Glück* (1929). For an account of these political films, see Bruce Murray, *Film and the German Left in the Weimar Republic from* Caligari *to* Kuhle Wampe (Austin: University of Texas Press, 1990).

20. Despite the concerted attempt to move away from such historical models, I would argue that a surprising number of works on this period of German film still fall back into this position. For particularly salient examples, see those offered in note 17 above. There are, of course, some recent publications that also address the need for historical revisionism through other approaches. The majority of these, however, are sociohistorical accounts that do not analyze the film aesthetic. See, for example, the excellent essays collected in Tim Bergfelder, Erica Carter, and Deniz Göktürk, eds., *The German Cinema Book* (London: British Film Institute, 2002).

21. On the complex question of conceptualizing a national cinema, and the

different theoretical positions in the debate, see the essays collected in Mette Hjort and Scott MacKenzie, eds., *Cinema and Nation* (London and New York: Routledge, 2000), especially Part II, "The Concept of National Cinema," 61–117.

22. Wolfgang Mühl-Benninghaus, "Deutsche-russische Filmbeziehungen in der Weimarer Republik," in Michael Schaudig, ed., *Diskursfilm* 8 [Münchner Beiträge zur Filmphilologie] (Munich: Positionen deutscher Filmgeschichte, 1996). See also Oksana Bulgakowa, ed., *Die ungewöhnlichen Abenteuer des Dr. Mabuse im Lande der Bolschewiki* (Berlin: Freunde der Deutschen Kinemathek, 1995).

23. Thomas Saunders, *Hollywood in Berlin: American Cinema and Weimar Germany* (Berkeley and Los Angeles: University of California Press, 1994).

24. See, for example, Kristin Thompson, "*Im Anfang war* . . . : Some Links between German Fantasy Films of the Teens and the Twenties," in Paolo Cherchi Usai and Lorenzo Coldelli, eds., *Before Caligari: German Cinema, 1895–1920* (Pordenoue: Edizioni Biblioteca dell'Immagine, 1990), 138–60. This issue is discussed more extensively in chapter 1.

25. Elsaesser's article "Film History and Visual Pleasure" was instrumental to the attempt to depart from Kracauer's psychological model of 1920s film history while retaining the principles of a materialist history. See Thomas Elsaesser, "Film History and Visual Pleasure: Weimar Cinema," in Patricia Mellencamp and Philip Rosen, eds., *Cinema Histories/Cinema Practices* (Los Angeles: University Publications of America, 1984), 47–84; and Elsaesser, *Weimar Cinema and After.*

26. This position is commensurate with that held by "anti-technological determinists" such as Brian Winston (in cinema studies) or the historians Merritt Roe Smith and Leo Marx. See Brian Winston, *Technologies of Seeing: Photography, Cinematography and Television* (London: British Film Institute, 1996); and the essays collected in Merritt Roe Smith and Leo Marx, eds., *Does Technology Drive History? The Dilemma of Technological Determinism* (Cambridge: MIT Press, 1994).

27. Lewis Mumford, *Technics and Civilization* (New York: Harcourt, Brace and World, 1963), 3.

28. I am indebted to Tom Gunning for this notion of the technological rupture in an otherwise utopian narrative as the disquieting conflict of the experience of technological modernity. See Tom Gunning, "The Whole Town's Gawking: Early Cinema and the Visual Experience of Modernity," *Yale Journal of Criticism* 7, no. 2 (1994): 189–201.

29. Steve Neale, "Art Cinema as Institution," *Screen* 22, no. 1 (1981): 11–39.

30. This begins with Eisner's groundbreaking conception of the same films as Expressionist. For Eisner, the art-historical categorization facilitates her argument regarding the films' representation of the German soul in crisis. The "distorted" mise-en-scène represents an outward expression of a character's (usually the protagonist's) disturbed psychological disposition. In turn, Eisner elevates this disposition to represent that of German consciousness in general. More recently, critics have been interested in using the Expressionist label for its ancestral relations to Romanticism. See Gilberto Perez, "Nosferatu," *Raritan* 13, no. 1 (summer 1993):

1–29, or works such as Angela Dalle Vacche, "F. W. Murnau's *Nosferatu*: Romantic Painting as Horror and Desire in Expressionist Cinema," in *Cinema and Painting: How Art Is Used in Film* (Austin: University of Texas Press, 1996), 161–96.

31. Thomas Elsaesser, "Expressionist Film or Weimar Cinema?" in *Weimar Cinema and After*, 18–60. There is no doubt that many of the narrative films made in the 1920s German studios display Expressionist characteristics. Well-known films such as F. W. Murnau's *Tartüff/Tartuffe* (1926) or *Der Letzte Mann/The Last Laugh* (1925) even use light to meet expressive purposes. However, to explain them as Expressionist fails to account for what makes the films unique. Moreover, when the 1920s film is described as Expressionist, critics often have a very vague notion of Expressionism.

32. The situation of 1920s German film in its relationship to an aesthetic tradition is an extension of Lotte Eisner's *The Haunted Screen*. This concern with the influence of German and European painting, theater, and literature on the 1920s film aesthetic is taken up by Anton Kaes, "The Expressionist Vision in Theater and Cinema," in Gertrud Bauer Pickar and Karl Eugene Webb, eds., *Expressionism Reconsidered: Relationships and Affinities* (Munich: Wilhelm Fink Verlag, 1979), 89–98.

33. As critics such as Anton Kaes have already argued, in this film, it is primarily the editing that enables the discourse on the (im)mobility of power. See Anton Kaes, "The Cold Gaze: Notes on Mobilization and Modernity," *New German Critique*, no. 59 (spring/summer 1993): 105–17.

34. Other well-known directors such as Murnau implemented light for the purposes of articulating new modes of vision. See, for example, *Der Gang in der Nacht/Journey into the Night* (1920), which focuses on a blind artist whose sight is restored through the expertise of a Dr. Börne. Blindness and vision also take on a more metaphorical significance in this film. Blindness is the signifier of knowledge and profound insight, whereas to be blessed with sight is also to be confused by the obscurities of the emotions.

35. See, for example, Arnold Fanck, *Der Heilige Berg/The Holy Mountain* (1926) and *Die Weisse Hölle vom Piz Palü/The White Hell of Piz Palü* (1929). I would like to thank the anonymous reviewer for University of Minnesota Press for pointing out this counterargument.

36. Eric Rentschler, "Mountains and Modernity: Relocating the *Bergfilm*," in Terri Ginsberg and Kirsten Moana Thompson, eds., *Perspectives on German Cinema* (New York: G. K. Hall & Co., 1996), 693–713; 697.

## I. The Electrification of Life, Cinema, and Art

1. The small German states of the south were unified with the ever-expanding sphere of Prussian domination following the Franco-Prussian war of 1870. See Thorstein Veblen, *Imperial Germany and the Industrial Revolution* (Westport, CT: Greenwood Press, 1984; originally published by Viking Press, 1939), for details

of the spread of modernization at this time. For a comparative study, see also Adolf M. Birke and Lothar Kettenacker, eds., *Wettlauf in die Moderne: England und Deutschland seit der industriellen Revolution* (Munich: K. G. Saur, 1988).

2. The first gas streetlights were lit in London in 1814 and in Paris in 1820. Although Berlin's first gas streetlights were turned on in 1826 and indoor lights in 1847, Berlin did not enjoy the consistency of developments that took place in the other cities. See *Osram Nachrichten,* special edition to celebrate the 145th Jubilee of Osram service to the community, 20 February 1937, for facts and figures regarding various European cities' entrée into modernity through artificial lighting.

3. The expanding use of electricity was particularly important in this period, and we see the effects of the transition from coal to electrical energy in Hans Werckmeister's *Algol* in chapter 3.

4. See the essays in Adolf M. Birke und Lothar Kettenacker in *Wettlauf in die Moderne.* See also Veblen, *Imperial Germany and the Industrial Revolution.*

5. For a more detailed history of the modernization processes during the Weimar period, see Eberhard Kolb, *The Weimar Republic,* trans. P. S. Falla (London and New York: Routledge, 1988).

6. Richard Birkefeld and Martina Jung, *Die Stadt, der Lärm und das Licht* (Hannover: Kallmeyersche Verlagsbuchhandlung, 1994), 173–84.

7. Thomas P. Hughes, *Networks of Power: Electrification in Western Society, 1880–1930* (Baltimore and London: Johns Hopkins University Press, 1983), 144–45.

8. Janet Ward captures the zeal with which German industry and commerce exploited the brilliance and intensity of light in their pursuit of an image of modern spectacle in the 1920s in *Weimar Surfaces: Urban Visual Culture in 1920s Germany* (Berkeley and Los Angeles: University of California Press, 2001).

9. For the dramatic increase in the use of electrical power in Berlin between 1900 and 1930 in Berlin (an increase of approximately 400 percent), see C. Matschoß, E. Schulz and A. Th. Graß, *50 Jahre Berliner Elektrizitäts Werke, 1884–1934* (Berlin: VDI Verlag, 1934); figures from p. 63.

10. See Herbert Liman, *Mehr Licht: Geschichte der Berliner Straßenbeleuchtung* (Berlin: Haude & Spener, 2000).

11. See, for example, "Die elektrische Beleuchtung von Kirchen," "referate: Beleuchtung und Kunst," and "Die Beleuchtung einer Schwimmhalle," *Licht und Lampe,* no. 14 (3 July 1913): 529–32, 532, and 533.

12. Dr. H. Lux, "Die Beleuchtung von Schulen, Kirchen, Festsälen und Theatern," in Dr. L. Bloch, ed., *Lichttechnik* (Munich and Berlin: R. Oldenbourg, 1921), 390–432.

13. See W. Wissmann, *Die Elektrische Straßenbeleuchtung,* reprinted from *Licht und Lampe,* no. 8 (1926): 3. As early as 1845, delegates from the London firm of Barlow and Company visited the then technical epicenter of Braunschweig in Lower Saxony in search of inspiration for their own designs. See Stephanie

Beuster and Johannes Graf, *Licht und Schatten: die Entwicklung der künstlichen Beleuchtung im 19. Jahrhundert in Braunschweig* (Braunschweig: Braunschweigisches Landmuseum, 1997), 26.

14. Hughes, *Networks of Power*, 182.

15. "Die Verwendung des elektrischen Stromes an der Front," *Elektrotechnische Zeitschrift*, no. 52, 27 December 1917, 606.

16. Hughes, "War and Acquired Characteristics," *Networks of Power*, 286–90.

17. Reynolds and Adams, "Die Elektrizitätsversorgung der Textilfabriken," *Elektrotechnische Zeitschrift*, no. 1 (4 January 1917): 12.

18. Wissmann, *Die Elektrische Straßenbeleuchtung*, 50.

19. Hughes, *Networks of Power*, 286.

20. See, for example, Lux, "Die Beleuchtung von Schulen, Festsälen und Theatern," and L. Bloch, "Künstliches Licht für Photographie und Reproduktion," in Bloch, *Lichttechnik*, 407–31, 523–36.

21. See, for example, the lighting of a gallery through the *Soleil-Bogenlampen*, the Manhattan beach, and the streets of Westminster, London, in Ernst Rebske, *Lampen, Laternen, Leuchten: Eine Historie der Beleuchtung* (Stuttgart: Franckh'sche Verlagshandlung, 1962).

22. Prof. Dr. J. Teichmüller, "Eine Neue Epoche in der Lichttechnik," lecture on 2 April 1925 to the Austrian Technical Light Society in Vienna.

23. *Osram Nachrichten*, special issue in honor of the Osram factory, 20 February 1937, 25.

24. Heinz Udo Brachvogel, "Lichter in der Nacht," *Der Kinematograph*, no. 942 (8 March 1925): 15.

25. Anonymous, "Neue Art der Reklame," *Der Kinematograph*, no. 1111 (3 June 1928): 11. See also "Werbung durch Licht," *Die Reklame* (1 January 1929): 26.

26. Discussions of these regulations can be found throughout the popular press of the period.

27. Anonymous, "Der Kampf um die Lichtreklame," *Licht-Bild-Bühne*, no. 113 (27 September 1924): 24.

28. Dr. Egon Zeitlin, "Die Besteuerung der Lichtreklame: Ein Reklamefreundliches Urteil des Reicederichts," *Die Reklame* (2 April 1929): 286–88.

29. See Richard Birkefeld and Martina Jung, "Abends aber ist es am schönsten in diesen Straßen," in *Die Stadt, der Lärm und das Licht*, 163–73.

30. See Anonymous, "Die Wanderschrift. Eine Verbesserung der Lichtreklame," *Der Kinematograph*, no. 960 (12 July 1915): 32. In one of a number of books published concomitant with these rapid developments in electrical lighting, Berthold Monasch discusses, among other things, the physiological reasons behind the different perception of certain types and colors of light. See Berthold Monasch, "Physiologisches," in *Electrische Beleuchtung* (Hannover: Max Janecke, 1910): 24–27. Monasch was an engineer, so unlike the empirically based articles in the trade press, his argument was mathematically determined. He computed the intensity of the light waves and their impact on the eye. He also offered com-

putations for the impact of light waves of different colors transmitted at different voltages.

31. In addition to those sources already cited, see M. Püchler, "Neue Wege der Lichtreklame," *AEG Mitteilungen*, no. 4 (April 1928): 149–51; Walter Dexel, "Die Jenaer Reklamelampen," *Die Form*, no. 7 (April 1926): 153; W. Riezler, "Organisierte Lichtreklame," *Die Form*, no. 9 (1 May 1929): 238–39.

32. *Berlin im Licht*, festival program with an introduction by Mayor Böß, Berlin, *AEG Mitteilungen* (10 October 1928); "Berlin im Licht," *Berliner Illustrirte Zeitung*, 28 October 1928. Other European capitals also staged a "Light week"; however, they do not appear to have been given the significance of that in Berlin in October 1928. See, for example, August Endell, "The Veils of Night," *Daidalos*, no. 27 (15 March 1988): 36, for reference to the Amsterdam Edison Light Week in 1929.

33. See the epilogue to Jörg Junker's review of the festival in which he quotes Mayor Böß "Berlin im Licht," *Die Weltbühne*, no. 43 (1928): 646.

34. "Berlin im Licht," *Die Kinotechnik*, no. 20 (20 October 1928): 545.

35. Mayor Böß, "Berlin als die neue Lichtstadt Europas," *Berlin im Licht*.

36. See, for example, Dr. K. Th. F., "Berlin wird helle . . ." *Berliner Tageblatt*, no. 427, 9 September 1928; Alexander Flinsch, "Weiße Nächte der Großstadt," *Berliner Börsen-Courier*, no. 483 (14 October 1928): 17–26; W. L., "Berlin im Licht," *Die Form*, no. 12 (1 November 1928): 358–59.

37. Erik Verg, *Licht für Hamburg: 600 Jahre Öffentliche Beleuchtung, 100 Jahre Elektrizität Straßenbeleuchtung in Hamburg* (Hamburg: Electricitätswerke Ag., 1982), 57; K. Klöne, "Großstadt im Licht: Hamburg," *Das Licht* 2, no. 10 (15 October 1931): 230–31.

38. Kim H. Kowalke, *Kurt Weill in Europe* (Ann Arbor: UMI Research Press, 1979), 70.

39. Thomas Saunders, "The Setting: Weimar Germany and the Motion Picture," in *Hollywood in Berlin: American Cinema and Weimar Germany* (Berkeley and Los Angeles: University of California Press, 1994), 20–24.

40. As Janet Ward points out, the film did not live up to the expectations set by this spectacular advertisement (*Weimar Surfaces*, 169).

41. See Uta Berg-Ganschow and Wolfgang Jacobsen, eds., "Die Zweite Haut," in . . . Film . . . Stadt . . . Kino . . . , (Berlin: Argon, 1987), especially 39–43. See also the facade of the Kurfürstendamm theater where *Unheimliche Geschichte* was playing in 1932, in Joachim Schlör, *Nights in the Big City: Paris, Berlin, London 1840–1930*, trans. Pierre Gottfried Imhof and Dafydd Rees Roberts (London: Reaktion Books, 1998), 247. See also Dennis Sharp, *The Picture Palace, and Other Buildings for the Movies* (New York: Praeger, 1969).

42. See Dr. M—l, "Kinoläden," and Mendel, "Filme im Schaufenster," *Der Kinematograph*, no. 1044 (20 February 1927): 39–40.

43. Not only did film as a display in light outside the theater extend the technological appeal of the new medium. As Leo Hirsch writes, even the ventilation system at the Ufa-Palast in Berlin was a sensation: "in the intermission,

an electrical zeppelin passed through the house and sprayed Eau de Cologne" ("Kinos," *Berliner Tageblatt,* 15 November 1927).

44. Manfred Lichtenstein, "The Brothers Skladanowsky," in Paolo Cherchi Usai and Lorenzo Codelli, eds., *Before Caligari: German Cinema, 1895–1920,* (Pordenone: Edizioni Biblioteca dell'Immagine, 1990), 312–25. See also Jan-Christopher Horak, "Oskar Messter: Forgotten Pioneer of German Cinema," *Historical Journal of Film, Radio and Television* 15, no. 4 (October 1995): 569–74. For more on the development of technology in the German film studios, see various articles in Thomas Elsaesser, ed., *A Second Life: German Cinema's First Decades* (Amsterdam: Amsterdam University Press, 1996); and Hans Helmut Prinzler, *Chronik des Deutschen Films: 1895–1994* (Stuttgart/Weimar: J. B. Metzler, 1995).

45. The Manhattan Biograph studio built on New York City's 14th Street in late 1902 to early 1903, for example, was fully outfitted with artificial light from Cooper-Hewitt. Then, with the beginnings of the transformation and expansion of the American film industry around 1907, competition ensured that other studios were also outfitted with the latest technical developments, including those in light and film lighting. See Charles Musser, *The Emergence of Cinema: The American Screen to 1907* (Berkeley: University of California Press, 1990), 337. See also Hermann Lemke, "Das Kalklicht, seine Bedeutung und Verwendung für den Kinematographen," *Der Kinematograph,* no. 2 (10 July 1928).

46. Helmut Herbst, "The Altmeister. Guido Seeber, 1879–1940: Film Pioneer, Cameraman, Technician and Publicist," in Usai and Codelli, *Before Caligari,* 276. This claim contradicts Barry Salt, who says that there was no use of electrical light in films in Germany before 1919. See Barry Salt, *Film Style and Technology: History and Analysis,* 2d ed. (Hollywood: Starword, 1992).

47. This was also the case for lighting in the British and French studios. It was only in the United States that artificial light was used as the sole lighting source up until World War I.

48. See, for example, the many advertisements for Osram light development in journals such as *Mitteilungen der Berliner Elektricitäts-Werke* from the 1900s.

49. Chief Engineer Lebegott, "Kinematographische Aufnahmen aus der Technik," *Mitteilungen-Siemens und Halske* 1, no. 5 (November 1913).

50. See Friedrich Felix, "Die Bogenlampe," *Bild und Filme* 3, no. 2 (1913–14): 42–44; Friedrich Felix, "Lichtquellen," *Bild und Filme* 4, no. 1 (1914–15): 17–18.

51. The independence of the German film industry toward the end of the war can be traced to the state's isolationist policies toward foreign film. In an attempt to stem the influx of foreign propaganda, and to propagate nationalist sentiments toward the German war, the foreign ministry banned all foreign films in 1916, and established the use of film as a propaganda weapon. In 1917, the state poured money into the establishment of the Ufa Studios. See Hans Barkhausen, "Die französische Periode," and "Wirtschaftswerbung mit Hilfe des Films," in *Filmpropaganda für Deutschland im Ersten und Zweiten Weltkrieg* (Hildesheim: Olms, 1982), 7–20.

52. For discussion of early cinema-going practices in France, see Richard Abel,

*The Ciné Goes to Town: French Cinema 1896–1914* (Berkeley and Los Angeles: University of California Press, 1998). Miriam Hansen's reconsideration of Emilie Altenloh's *Zur Soziologie des Kinos* argues that there were also elements of early cinema culture that "ran against the grain of capitalist modes of production and consumption." Notably, the cinema provided a place for working-class women to spend their leisure time, and effectively created a public sphere for women that was at odds with the alienation and fragmentation of the mechanized work process. See Miriam Hansen, "Early Silent Cinema: Whose Public Sphere?" *New German Critique*, no. 29 (spring/summner 1983): 147–84. Questions of early German film reception and exhibition have been largely neglected in English-language studies of this period. See Corinna Müller, *Frühe deutsche Kinematographie: formale, wirtschaftliche und Kulturelle Entwicklungen, 1907–1912* (Stuttgart: Wetzler, 1994), for what is the most comprehensive examination of the subject.

53. This aspect of the American and French cinemas in particular has been much studied over recent years. See, for example, the essays in Leo Charney and Vanessa Schwartz, eds., *Cinema and the Invention of Modern Life* (Berkeley: University of California Press, 1995).

54. See William Uricchio, "The *Kulturfilm*: A Brief History of an Early Discursive Practice," in Usai and Coldelli, *Before Caligari,* 356–78. For some of the novel uses to which the film camera was put, see Julius von Berg, "Die Kinematographie," *Erste Internationale Film Zeitung*, no. 16 (20 April 1912): 38–44. See also Wolfgang Mühl-Benninghaus, "Der dokumentarische Film in Deutschland zwischen erzieherischem Anspruch und wirschaftlicher Realität," in Ursula von Keitz and Kay Hoffmann, eds., *Die Einübung des dokumentarischen Blicks*: Fiction Film *und* Non Fiction Film *zwischen Wahrheitsanspruch und expressiver Sachlichkeit 1895–1945* (Marburg: Schüren, 2001), 81–102.

55. As would continue to be the case during World War I and into the 1920s, the domestically produced cinema was used in school classrooms, military training sessions, scientific experiments, even to entertain the masses. Film became so integrated into the fabric of everyday life in early-twentieth-century Germany that it was even used as a mode of police surveillance. The educational documentaries were always mobilized in the interests of reinforcing German cultural values and industry for both domestic and international consumption. Although these films were produced in an otherwise internationally developing film culture, their representations catered specifically to a German audience. For more on the distinctions of the German aesthetic of this period, see, for example, Barry Salt, "Early German Film: The Stylistics in Comparative Context," and Sabine Hake, "Self-Referentiality in Early German Cinema," in Elsaesser, *A Second Life,* 225–36, 237–45. In addition, see Kristin Thompson, "*Im Anfang war* . . . : Some Links between German Fantasy Films of the Teens and the Twenties," in Usai and Coldelli, *Before Caligari,* 138–60. Thompson also points to the success of certain oft-cited films from the period such as *Der Andere* (Max Mack, 1913) and *Der Student von Prag* (Stellan Rye, 1913) in her discussion of the development of the

film aesthetic. She claims that the peculiarities of the 1920s German film actually have their origins in the films of the prewar period.

56. For examples of these arguments—which were not necessarily shared by all intellectuals of the time—see Oskar Kanehl, "Kinokunst," in Anton Kaes, ed., *Kino-Debatte: Texte zum Verhältnis von Literatur und Film 1909–1929* (Tübingen: Deutscher Taschenbuch, 1978), 50–53; Julyus Hart, "Kunst und Kino," in Fritz Güttinger, ed., *Kein Tag ohne Kino* (Frankfurt: Deutsches Filmmuseum, 1984), 287–92. Kristin Thompson also notes that Paul Wegener's prewar writings contain interesting illuminations on the possibilities of film as a medium of experimentation (Thompson, "*Im Anfang war . . . ,*" 144).

57. "Am Lichte hängt, zum Lichte drängt doch alles!" *Lichtbild-Bühne,* 14 June 1913. See Robert Müller, "Lichtbildner," in Cinema Quadrat e.V. Mannheim, ed., *Gleißende Schatten: Kamerapioniere der zwanziger Jahre* (Berlin: Henschel, 1994), 45–49, for a discussion of the shift from "Glashaus" to "Kunstlichtatelier" in Germany.

58. The great break with cultural tradition occurred, in Germany as elsewhere around the turn of the century. This was also a period of change in the social and natural sciences. Painting, literature, and music had already been radicalized by the wave of experimentation that took place in Wilhelmine Germany. Similarly, in film, the seeds of the 1920s film aesthetic had already been planted in the teens with the films of Wegener, Mack, and Rye.

59. Thomas Saunders claims that domestic production in the 1920s burgeoned because of the isolationist policies of Germany at this time. Thus, the demands of a filmgoing audience ensured that the ban on the import of French, British, and Italian films incited the mobilization of financial resources to sustain the demand for large-scale production. See Saunders, "The Setting," 20–26. More recently, Jeanpaul Goergen and Rainer Rother, for example, indicate the influence of self-advertising, product promotion, and military propaganda on transformations in the German film industry around the beginning of World War I. See Jeanpaul Goergen, "Julius Pinschewer: A Trade-mark Cinema," and Rainer Rother, "Learning from the Enemy: German Film Propaganda in World War I," in Elsaesser, *A Second Life,* 168–74, 185–91.

60. See, for example, Rafal Landau, "Lichteffekte in der Kinematographie," *Der Kinematograph,* no. 1123 (1 July 1928): 23–26.

61. See, for example, the developments made by K. Weinart, Elektrotechnische and Bogenlampenfabrik, as it is documented in *Filmtechnik,* no. 9 (1925): 189–90. The aesthetic innovations of the 1920s film, innovations that brought the industry success in the international arena, can also be understood to have developed out of a world at war. The particularities of the German silent film's mise-en-scène— the geometricization of the set, the highly gesticulated acting, and of course the outstanding deployments of light—are all influenced by contemporary movements in the other arts and in day-to-day life. The violence and devastation of

war is everywhere present in the fractures, displacements, and disturbances to the forms of 1920s German painting, theater, and literature, for example.

62. See Salt, *Film Style and Technology*, 122.

63. Müller, "Lichtbildner," 48.

64. For example, the "sunlight arc," which was widely used in Hollywood prior to 1920, gradually came into usage in Germany around this time. Salt explains the sunlight arc thus: "a beam focussed by a large parabolic mirror behind the arc" (Salt, *Film Style and Technology*, 151).

65. The discussion concerning light and lighting in the prewar years often focused on the shortcomings of natural daylight and the urgency of developing artificial possibilities for the practical and artistic necessities of film production and projection. See, for example, Hans Richard, "Film-Fehler," *Erste Internationale Film-Zeitung* 3, no. 32 (5 August 1909).

66. Anonymous, "Die Beleuchtung auf der Kino- und Photo-Ausstellung," *Die Kinotechnik* 7, no. 21 (10 November 1925): 544.

67. Anonymous, "Sind Spiegellampen empfehlenswert?" *Reichsfilmblatt*, no. 30 (28 July 1923): 5.

68. Otto Stindt, "Lichttechnische Lügen," *Filmtechnik*, no. 19 (1926): 375–78.

69. D. M—I, "Das wandernde Licht," *Licht-Bild-Bühne*, no. 122 (18 October 1928): 32–33; Anonymous, "Licht ohne Stromkosten," *Der Kinematograph*, no. 1156 (16 September 1928): 18. See the analysis of *Sylvester* in chapter 6 for an example of how this technology might be used.

70. R. Thun, "Bücher über Lichttechnik," *Die Kinotechnik*, no. 1 (5 January 1929): 9. Articles were also written on the subject of filming the eclipse of the sun in 1927 (Anonymous, "Die Sonne wurde gefilmt," *Filmtechnik*, no. 15 [1927]: 292; Anonymous, "Sonnenfinsternis," *Filmtechnik*, no. 20 [1927]: 361).

71. Rafal Landau, "Lichteffekte in der Kinematographie," *Der Kinematograph*, no. 1120 (24 June 1928): 17–20.

72. Anonymous, "Zweckmäßige Notbeleuchtung," *Reichsfilmblatt*, no. 12 (26 March 1927): 29.

73. In *The Cabinet of Dr. Caligari, Von Morgens bis Mitternachts, Genuine* (Robert Wiene, 1920), and *Raskolnikow* (Robert Wiene, 1923), when there is a contrast between light and shadow it is not necessarily constructed through light itself: often it is painted onto the set with white and black paint. There are, of course, instances in which light and darkness—as opposed to their painted substitutes—are contrasted in these films. However, the claim to an affinity with the Expressionist use of light is somewhat dubious. On the now accepted limitations of the Expressionist label for the films see Leonardo Quaresima, "Expressionist Film as an 'Angewandte Kunst,'" in Stephanie Barron and Wolf-Dieter Dube, eds., *German Expressionism: Art and Society* (New York: Rizzoli, 1997), 91–98. Similarly, as Rudolf Kurtz, writing in the 1920s, illustrates, in all of the films that supposedly constitute the Expressionist canon, the unsettling exaggeration of decor, makeup, costume, and performance communicates disquiet

through abstraction. See Rudolf Kurtz, *Expressionismus und Film* (Berlin: Verlag der Lichtbildbühne, 1926); and Jürgen Kasten, *Der expressionistische Film* (Münster: MAkS Publikationen, 1990).

74. It was in the sphere of the *Stilfilme* that the innovative use of lighting was carried out. See Thomas Elsaesser, "Kunst und Krise," in Hans-Michael Bock and Michael Töteberg, eds., *Das Ufa-Buch*, (Frankfurt am Main: Zweitausendeins, 1992), 100, for an explanation of the two types of films—the *Großfilme* and the *Stilfilme*—made in the 1920s.

75. Scholars have various opinions regarding the reasons behind the uniquely German film aesthetic. Mike Budd, for example, attributes it to the peculiar cross-pollination of Hollywood and German studios; Anton Kaes sees it as growing out of the influence of the debate about cinema that took place among intellectuals in Germany at the time. See Mike Budd, "The Moments of Caligari," in Mike Budd, ed., *The Cabinet of Dr. Caligari: Texts, Contexts, Histories* (New Brunswick, NJ: Rutgers University Press, 1990), 7–119; Anton Kaes, "The Debate about Cinema: Charting a Controversy (1909–1929)," trans. David J. Levin, *New German Critique*, no. 40 (winter 1987): 7–33.

76. The "Two-Sun-Phenomenon" is a simultaneous atmospheric lighting and a directional lighting in the same shot. I describe this scene in chapter 4.

77. Fritz Lang, "Arbeitsgemeinschaft im Film," *Der Kinematograph*, no. 887 (17 February 1924); reprinted in Rolf Aurich and Wolfgang Jacobsen, *Werkstatt Film. Selbstverständnis und Visionen von Filmleuten der zwanziger Jahre* (Munich: edition text + kritik, 1998), 15–19.

78. Ibid., p. 19.

79. Karl Grüne, "Das Filmkollektiv. Fehler der Produktion," *Film-Kurier*, no. 101 (28 April 1928); reprinted in Aurich and Jacobsen, *Werkstatt Film*, 28–30. Without this arrangement, the director might have turned to set architects, dramaturges, actors, and so on from the theater or other arts. However, these artists would not exploit the full potential of the film production process, and the films on which they worked had been proven an impoverished product.

80. *Bauhütte* was the name given to the collective of church masons and artists' guilds that built the Gothic cathedrals. See Erwin Panofsky, *Gothic Architecture and Scholasticism* (New York: Meridian, 1951), 23–24. See also Lars-Olav Beier, *Teamwork in der Traumfabrik, Werkstattgespräche* (Berlin: Henschel, 1993). This includes interviews in which film workers talk about their experiences in the studios. These collectives were also known as *Werkstätte* (workshops).

81. Klaus Kreimeier, "Wie in einem Taumel: Die Kamera im deutschen Film der frühen zwanziger Jahre," in *Gleißende Schatten*, 10.

82. This strategy is very common in Weimar film criticism. For example, Kurt Pinthus attributes the 1924 film *Sylvester* to the cameraman Carl Mayer (whose work on the film included the lighting design). See Kurt Pinthus, "Sylvester," *Das Tage-Buch*, no. 3 (19 January 1924). As was often the case with Emil Jannings's

films, Balthasar attributes *Varieté* to Jannings ("Varieté," *Das Blaue No.,* no. 5 [1 December 1925], 163–64).

83. See the common claim in relation to *Varieté* that it is impossible to separate direction (E. A. Dupont) from photography (Karl Freund); for example, "Varieté," *Berliner Morgenpost,* 18 November 1925. See also Lotte Eisner, "Murnau, the Camera, and Lighting," in *Murnau* (Berkeley and Los Angeles: University of California Press, 1973), 71–88. In this chapter in particular, Eisner cites various people who worked with Murnau over the course of his German career, and they all disagree over the role played by Murnau as opposed to the others in the production crew.

84. To the left of the merry-go-round a showman attempts to draw the spectator's attention with his mystical attractions, but every discernible head is turned to the shimmering lights of the merry-go-round. The form of Baluschek's painting holds no compositional interrogation of the possible tension between foreground and background, and neither does it question the thrill of a world lit up by the artificially colored lights of the merry-go-round.

85. Alfred Döblin, *Berlin Alexanderplatz: The Story of Franz Biberkopf,* trans. Eugene Jolas (New York: Ungar, 1983).

86. See, for example, Richard Abel's descriptions of Gaumont's *La Vie du Christ* (1906) and Pathé's *Les Invisibles* (1906) (Richard Abel, "The Transition to a Narrative Cinema, 1904–1907," in *The Ciné Goes to Town: French Cinema 1896–1914,* 102–78).

87. See Plato, *The Republic,* book VII, 514–21. Even though Plato's renowned "Myth of the Cave" tells of the obstruction of knowledge through shadows as representations in light, this obstruction is, nevertheless, an epistemological truth in itself.

88. See Carla Schulz-Hoffmann, "Transparent Painting and the Romantic Spirit: Experimental Anticipations of Modern Visual Arts," in Keith Hartley, Henry Meyric Hughes et al., eds., *The Romantic Spirit in German Art: 1790–1990* (London: Thames and Hudson, 1994), 171–205.

89. Galilei Galileo, *Dialogue concerning the Two Chief World Systems: Ptolemaic and Copernican,* trans. S. Drake (Berkeley and Los Angeles: University of California Press, 1971); Albert Einstein, *Relativity: The Special and General Theory* (New York: Smith, 1920). Einstein's theory of relativity enables, among other things, the measurement of the speed and direction of light. I call the light quantified by the scientists a technically manipulated light because, from Galileo on, they all used lenses of varying degrees of sophistication for their observations and measurements. For an excellent study of the history of light in philosophical representation and in scientific experiments, see David Park, *The Fire within the Eye: A Historical Essay on the Nature and Meaning of Light* (Princeton, NJ: Princeton University Press, 1997). Park organizes his work historically rather than along disciplinary lines. However, the distinction between the mythical and the technological use of light is easily discerned from his history. For examples

of the way in which light is used to represent the relationship of the individual to the world, and the ways in which this relationship has changed throughout history, see Hans Blumenberg, "Light as a Metaphor for Truth: At the Preliminary Stage of Philosophical Concept Formation," trans. Joel Anderson, in David Michael Levin, ed., *Modernity and the Hegemony of Vision* (Berkeley: University of California Press, 1993), 30–62. For a different thesis on the same, see Sidney Feshbach, "The Light at the End of the Tunnel Is Coming Right at Me, or, the Dialectic of Elemental Light and Elemental Dark," in Anna-Teresa Tymieniecka, ed., *The Elemental Dialectic of Light and Darkness: The Passions of the Soul in the Onto-Poesis of Life* (Boston and London: Huwer Academic Publishers, Dordrecht 1992), 55–84.

90. Werner Oechslin argues that the two are merged from antiquity onward, from Pythagoras to Descartes, in scientific experiments that are always shrouded in a mythical and religious atmosphere. See Werner Oechslin, "Light: A Means of Creation between Reason and Emotion," *Daidalos*, no. 27 (15 March 1988): 23–38.

91. Here I am thinking of the films of Moholy-Nagy, Oskar Fischinger, and to some extent Hans Richter or Walter Ruttmann. I discuss some of these later in this chapter. See also Anne Hoormann, *Lichtspiele. Zur Medienreflexion der Avantgarde in den zwanziger Jahren* (Munich: Wilhelm Fink, 2003).

92. Peter Brooks, *The Melodramatic Imagination: Balzac, Henry James, Melodrama, and the Mode of Excess* (New Haven and London: Yale University Press, 1976), 14.

93. This is also a notion pursued by Georg Lukács in his critique of modernism in *History and Class Consciousness*, trans. Rodney Livingstone (Cambridge: MIT Press, 1971).

94. One has to look no further than the most celebrated modern novels to identify this tendency. See, for example, James Joyce's *Ulysses* (1937), Gustave Flaubert's *Sentimental Education*, trans. Robert Baldick (New York: Penguin, 1964), and Franz Kafka's *The Trial* (New York: Schocken, 1946).

95. Lewis Mumford, *Technics and Civilization* (New York: Harcourt Brace, 1934).

96. Ibid., 156.

97. On the complexity of the spectatorial response to the Weimar film, and its expression of a particularly historical subjectivity, see Thomas Elsaesser, *Weimar Cinema and After: Germany's Historical Imaginary* (London: Routledge, 2000).

98. *Ibid.*, 67.

99. Glass is thought to be an ancient discovery of the Egyptians. However, as Lewis Mumford points out in his exhaustive history of the history and prehistory of technology: "Beads of Glass have been found as far back as 1800 BC and openings for glass windows were found in the excavation of Pompeian houses. Clear and colored glass has enjoyed a long and changing history as a functional and an aesthetic material. Its mass production at the time of the first industrial revolution brings about significant changes in the quality of glass as

well as the uses to which it is put ("Through a Glass, Brightly," in *Technics and Civilization*, 124).

100. The Crystal Chain group was a group of architects devoted to the fashioning of a revolutionary environment based on the same principles as those espoused by Taut. However, each architect was invited to conceive of the realization of the goals on an individual basis. The group came together through a chain of written letters and sketches distributed to all involved. See Dennis Sharp, ed., *Glass Architecture by Paul Scheerbart and Alpine Architecture by Bruno Taut*, trans. James Palmes (New York: Praeger, 1972); Bruno Taut, *Die Stadtkrone* (Jena: Diedrichs, 1919); Iain Boyd Whyte, ed., *The Crystal Chain Letters: Architectural Fantasies by Bruno Taut and His Circle* (Cambridge: MIT Press, 1985; originally published as an exhibition catalog, *Die gläserne Kette: visionäre Architekturen aus dem Kreis um Bruno Taut 1919–1920* [Berlin: Akademie der Kunst, 1963]).

101. See Iain Boyd Whyte, *Bruno Taut and the Architecture of Activism* (Cambridge, England: Cambridge University Press, 1982). There is no doubt that this project was not only utopian, but also nationalistic. See Wenzel Hablik's reference to the German nation groveling in the dust following the sacrifices of World War I, and the consequent need to be born again. (Wenzel Hablik, "Das Buch," in Whyte, *The Crystal Chain Letters*, 39–41). Note also that they are all very different in the details of what they are looking for; there is a certain individuality to their visions and I discuss what is common to all of the architects.

102. Taut leans heavily on the visionary writings of poet Paul Scheerbart, who was writing in Berlin before the war. See Paul Scheerbart, "*Glasarchitektur* (Berlin: Maun [Gebr.], 2000).

103. Taut's designs were heavily influenced by the architectural visions (that remained at the level of conception) of Scheerbart. Indeed, in many cases, Taut's buildings were the realization of Scheerbart's visions. See Paul Scheerbart, *Das große Licht* (Leipzig: Dr. Sally Rabinowitz Verlag, 1912).

104. This concept is clearly derived from the Gothic *Baumeisters* who opened up the windows of the great Gothic cathedrals. This created a connection between the cathedral and the villages that surrounded them. See Norbert Nussbaum, *Deutsche Kirchenbaukunst der Gotik: Entwicklung und Bauformen* (Cologne: DuMont Buchverlag, 1985).

105. Sharp, *Glass Architecture*, 52.

106. Ibid., 54.

107. Georg Simmel, "Tendencies in German Life and Thought since 1870," *International Monthly* (New York), no. 5 (1902): 93–111, 166–84. Simmel explains that the inadequacy of religion for the fulfillment of the soul is owing to the fact that the church has extended the sphere of its powers to political organization. This power had been on the decline, and then around 1870, German Catholicism developed decisively.

108. The Bauhaus moved from Weimar to Dessau in 1925 and to Berlin in 1932, the final year of the Republic. In February 1928 Gropius was replaced as

director by Hannes Meyer, who, in turn, was expelled by the Dessau authorities and replaced by Ludwig Mies van der Rohe in 1930. Mies headed the school until 1933, when it was closed down by the Nazis.

109. Lyonel Feininger's woodcut for the cover of the Bauhaus manifesto in April 1919 shows a glistening, towering cathedral of glass as the *Gesamtkunstwerk* toward which all arts should turn.

110. See their *Monument to Joy* (1919). See also Dennis Sharp, *Modern Architecture and Expressionism* (New York: George Braziller, 1966), 118; and Wolfgang Pehnt, *Expressionist Architecture* (New York: Praeger, 1973).

111. This glass-and-steel office building designed for Friedrichstraße, in Berlin in 1919 was so radical that it was never built.

112. Among the few buildings that survived World War II are Walter Gropius's "Master's Houses" of the Bauhaus in Dessau, built in 1926 and Mies van der Rohe's Tugendhat house in Brno, Czechoslovakia, 1930. For information on the Bauhaus workshops, including architecture, a comprehensive collection of Bauhaus documents is replicated in Hans M. Wingler, ed., *The Bauhaus: Weimar Dessau Berlin Chicago,* trans. Wolfgang Jabsand Basil Gilbert (Cambridge: MIT Press, 1969). For the authoritative general reference source, see Magdalene Droste, *Bauhaus, 1919–1933* (Cologne: Taschen, 1990).

113. A very good example of this is Mies van der Rohe's postwar Farnsworth House built in Plano, Illinois (1946–50).

114. Philip C. Johnson, *Mies van der Rohe* (New York: Museum of Modern Art, 1978), 7. We see this in its most articulate form in the Seagram Building on Park Avenue, New York (1954–58).

115. Around this time A.G. für Glasfabrikation began to fabricate glass bricks. They were used for the walls and roofs of office buildings. Thus Wassili and Hans Luckhardt and Alfons Anker's "Königin Bar" and Office Building, on Kurfürstendamm, Berlin, 1929 could be seen from above. The glass roof was a distinguishing feature of the German train station and Exhibition buildings around the world from the mid-nineteenth century onward.

116. On Expressionist architecture, see Sharp, *Modern Architecture and Expressionism,* and Pehnt, *Expressionist Architecture.*

117. See Erich Mendelsohn, *Complete Works of the Architect: Sketches, Designs, Buildings,* trans. Antje Fritsche (New York: Princeton Architectural Press, 1992). For further discussion of the use of light to disconnect buildings from their environment, see Marietta S. Millet, "Light Revealing Space," in *Light Revealing Architecture* (New York: Van Nostrand Reinhold, 1994), especially 102–12.

118. For a very general discussion of the illumination of the city streets with the effect of creating a sea of light, see Wolfgang Schivelbusch, *Licht, Schein und Wahn: Auftritte der elektrischen Beleuchtung im 20. Jahrhundert* (Berlin: Ludwig Ernst und Sohn, 1992), especially "Elektropolis," 61–80.

119. One could argue that buildings such as those of Mendelsohn were the very basis of the metropolis as a spectacle for the sheer entertainment of the

masses. Mendelsohn's architectural rhetoric is, at night, arguably no more than a superficial ornament of capitalism. His buildings are the type that make up the spectacularly illuminated city discussed by Schivelbusch (ibid).

120. These goals are reiterated in a number of 1920s German films. As we shall see in chapter 5, Karl Grüne's *Die Straße* and Leo Mittler's *Jenseits der Straße* both take up the issue.

121. See Anton Kaes, "The Expressionist Vision in Theater and Cinema," in Gertrud Bauer Pickar and Karl Eugene Webb, eds., *Expressionism Reconsidered: Relationships and Affinities* (Munich: Wilhelm Fink, 1979), 89–98. See also Jürgen Kasten, "Strukturelemente der Ästhetik expressionistischer Filme und ihre filmischen oder theatralen Qualitäten," in *Der expressionistische Film,* especially 150–55.

122. See Carl-Friedrich Baumann, *Licht im Theater. Von der Argand-Lampe bis zum Glühlampen-Scheinwerfer* (Wiesbaden: Steiner, 1988).

123. See Peter Jelavich, "Wedekind's *Spring Awakening:* The Path to Expressionist Drama," in Stephen Eric Bronner and Douglas Kellner, eds., *Passion and Rebellion: The Expressionist Heritage* (New York: Universe Books, 1983), 129–50. Jelavich examines Wedekind's play for its dependence on the German classicist tradition and its prefacing of the concerns of Expressionist theater.

124. Adolphe Appia, *"The Work of Living Art": A Theory of the Theater,* trans. A. D. Albright, and *Man Is the Measure of All Things,* trans. Barnard Hewit (Coral Gables: University of Miami Press, 1981). See also Edward Gordon Craig, *On the Art of the Theater* (New York: Theater Arts Books, 1956), and Edward Gordon Craig, *Craig on Theater,* ed. J. Michael Walton (London: Methuen, 1983).

125. Reinhardt's theatrical revolution of theater is usually acknowledged to be enabled by two technological advances: electrical lighting and the construction of the revolve stage. See Ernst Stern and Heinz Herald, eds., *Reinhardt und seine Bühne: Bilder von der Arbeit des Deutschen Theaters* (Berlin: Eysler, 1919).

126. Reinhardt never wrote theoretical works on the theater, or elaborations on his techniques. All information on his productions must therefore be ascertained from the contemporary reviews, photographs, publicity materials, production notes, and analyses.

127. In his urge to make theater the servant of the people, Reinhardt gave familiar classics such as *Hamlet, Faust,* and *Oedipus* a modern, contemporary staging. For a taste of Reinhardt's striking use of light in his staging of *Danton's Tod* in 1916, see Siegfried Jacobson, "Georg Büchner, Danton's Tod," in Walther Karsch, ed., *Jahre der Bühne: Theater kritische Schriften* (Hamburg: Rowohlt, 1965).

128. One of the characteristics of these postwar German plays was their use of unidentified, generalized, or symbolic characters called "the Man," "the Son," "the Stranger." In this sense, the charactrs were always allegorical, but then they were also real individuals because they had an inner, emotional life. For more on the "New Man" in literature of the period, see Douglas Kellner, "Expressionist Literature and the Dream of the 'New Man,'" in Bronner and Kellner, eds., *Passion and Rebellion,* 166–200.

129. Quoted by G. Rühle, *Theater für die Republik* (Frankfurt am Main: S. Fischer Verlag: 1967), 127. Incidentally, it was Karl Heinz Martin in Germany who, not having the use of a front curtain at the Tribüne Theater, introduced the now commonplace practice of denoting the end of a scene by blacking out the stage.

130. In the Expressionist theater, the body and the mind were equal and harmonious counterparts, both in need of rehabilitation.

131. Sorge clearly indicates their significance as "projections of the poet" in the stage directions. See Reinhard Sorge, *The Beggar*, trans. Walter and Jacqueline Sokel, in Walter Sokel, ed., *Anthology of German Expressionist Drama* (New York: Anchor, 1963), 23.

132. Walter H. Sokel, *The Writer in Extremis: Expressionism in Twentieth-Century German Literature* (Stanford, CA: Stanford University Press, 1959), 41. This depiction of thoughts as physical space is a concept that Expressionist playwrights such as Sorge derive from August Strindberg: "all states of mind are in fact places."

133. This sanctioning of the importance of the individual was especially forceful in Britain and Europe. It can also be identified in the legitimation of, for example, psychoanalysis for its ability to explain the war neuroses of World War I soldiers. The relation of Expressionism to the science of psychoanalysis is what sets it apart from Romanticism's brand of subjectivity. The prediction of the erosion of public life and the ascendancy of the individualism of capitalism is argued by Marx. Hannah Arendt famously critiques the argument in *The Human Condition: A Study of the Central Dilemmas Facing Modern Man* (New York: Anchor, 1959), 101–16.

134. See Wolfgang Schivelbusch, "The Stage," in *Disenchanted Night: The Industrialization of Light in the Nineteenth Century*, trans. Angela Davies (Berkeley: University of California Press, 1988), 203–21. Schivelbusch discusses the revival of the open, communicative stage–audience relation as indicative of a more profound attempt to break the illusionism of the stage play. In Italy, Luigi Pirandello was making similar advances to breaking the barriers between audience and stage. In *Six Characters in Search of an Author*, Pirandello had the audience actually sit on the stage. See Dominico Vittorini, *The Drama of Luigi Pirandello* (New York: Russell and Russell, 1969).

135. A similarly jarring conflict between stylistic innovations in film lighting and the melodramatic narrative is a common aspect of the 1920s German film.

136. Erwin Piscator, *Theater Film Politik*, ed. Ludwig Hoffmann (Berlin: Henschelverlag, 1980).

137. Piscator developed the genre of documentary theater in which he represented the political and social tensions of the time. See Erwin Piscator, "Das politische Theater," in *Theater Film Politik*, 84–85.

138. He also used film to comment on the action onstage, to provide biographical information for the characters, and as an interlude communicating the passing of time. See Erwin Piscator, "The Film" and "The Function of the Film,"

in *The Political Theater,* trans. Hugh Rorrison (New York: Avon, 1978); originally published in 1929, 236–40.

139. Erwin Piscator, "Confrontation with the Times: Hoppla, Such Is Life!" in *The Political Theater,* 206–21.

140. For the redesigns of the German theater by figures such as Reinhardt, together with information on the technological advances—such as electrical lighting and the construction of the revolve stage—see Stern and Herald, *Reinhardt und seine Bühne. Bilder von der Arbeit des Deutschen Theaters.*

141. Even the catalog essays for the groundbreaking Film-Foto exhibition of 1929 do not focus on the relationship between the two media. See Ute Eskildsen and Jan-Christopher Horak, *Film und Photo in der zwanziger Jahre* (Suttgart: Verlag Gerd Hatje, 1979).

142. Peter Panter, "Neues Licht," *Die Weltbühne,* no. 35 (1929): 323–27; 323–24. The other genre of photography commonly explored before the Great War in Germany was, of course, that which documented life on the urban streets.

143. These are the photographs that Benjamin refers to when he talks about the decay of the aura, owing to the confrontation of all attempts at contemplation through such aspects as the spatiality of the reproduced image. See Walter Benjamin, "The Work of Art in the Age of Mechanical Reproduction," Hannah Arendt, ed., in *Illuminations: Essays and Reflections,* trans. Harry Zohn (New York: Schocken Books, 1968), especially sections 3–4, 222–24.

144. László Moholy-Nagy, "Production-Reproduction," in Christopher Phillips, ed., *Photography in the Modern Era: European Documents and Critical Writings, 1913–1940* (New York: Metropolitan Museum of Art/Aperture, 1989), 80.

145. See, for example, Ewald Thielmann, "Photographische Lichtstudien," *Der Kinematograph,* no. 1130 (7 June 1929): unpaginated. Thielmann's examination of the use of light in both indoor and outdoor photographs was not alone in Weimar explorations of photography as light. In addition, his certainty that the formal problems of photography were the problems of light and dark was also a commonly held belief.

146. *Bauhaus Photography,* no. 11. It was not only Moholy-Nagy's students at the Bauhaus who were influenced by his work. A number of photographers working in 1920s Germany were heavily influenced by him. Photographers such as Anton Stankowski, Gyorgy Kepes, and Umbo (né Otto Umbehrs) followed Moholy-Nagy's experiments with unfamiliar camera angles and abstraction through light. See Wolfgang Kemp, "Das Neue Sehen: Problemgeschichtliches zur fotografischen Perspektive," in *Foto-Essays zur Geschichte und Theorie der Fotografie* (Munich: Schirmer/Mosel, 1978), 79–98.

147. The creation of light as an object that is the subject of an image is not only found in the cinema. On the contrary, Moholy-Nagy's photography students at the Bauhaus were all required to make light modulators out of paper and light. By illuminating the manipulated paper from different angles, emphasizing different surfaces, he showed how light created space, illusions of depth, and surface. See

László Moholy-Nagy, "Make a Light Modulator," in Richard Kostelanetz, ed., *Moholy-Nagy: An Anthology* (New York: Da Capo, 1970), 99–104.

148. See László Moholy-Nagy, "Light: A New Medium of Expression," in Kostelanetz, *Moholy-Nagy*, 151–55; and László Moholy-Nagy, "Light—A Medium of Plastic Expression," in Nathan Lyons, ed., *Photographers on Photography: A Critical Anthology* (Englewood Cliffs, NJ: Prentice Hall, 1966), 72–73. As Moholy-Nagy rightly points out, artificial light is different from natural light, it has different properties, that in the time of Moholy-Nagy were still to be discovered.

149. László Moholy-Nagy, "From Pigment to Light," in Lyons, *Photographers on Photography*, 77.

150. László Moholy-Nagy, "The Contribution of the Arts to Social Reconstruction," in Kostelanetz, *Moholy-Nagy*, 21.

151. Moholy-Nagy refers to this function of cinema as light moving in time in most of his writings on film. However, it is most directly articulated in László Moholy-Nagy, "Problems of the Modern Film," in Kostelanetz, *Moholy-Nagy*, 131–38. Moholy-Nagy was not alone in his conception of these new light media as the artistic form of the future. Indeed, numerous artists, including Ludwig Hirfschfeld-Mack, explored the possibilities of light as the new mass medium. See Anne Hoormann, "Lichtspiele," in *Licht* exhibition catalog (Jena, 1998), 10–19.

152. Moholy-Nagy here refers to a type of community festivals that include electrical versions of fireworks displays produced from airplanes. See Moholy-Nagy, "Light Architecture," in Kostelanetz, *Moholy-Nagy*, 158–59.

153. There are few films that I discuss in the ensuing chapters that refrain from intertwining the self-reflective uses of lighting with a narrative trajectory that moves toward either mystical and pseudoreligious philosophies of salvation or a banal heterosexual unity as happy ending.

154. I assume here a juncture of cinema and modernism in which the cinema both reflects on and is related to the processes and experiences of industrial-technological modernity. This notion of a cinematic modernism in the late nineteenth century is elaborated upon in the essays collected in Leo Charney and Vanessa R. Schwartz, eds., *Cinema and the Invention of Modern Life* (Berkeley: University of California Press, 1995). One of the uniquenesses of the German product is its development in the late silent cinema period, in the 1920s.

155. See also films such as Marcel L'Herbier's *L'Inhumaine* (1924).

156. See Richard Abel, "The Narrative Avant-Garde," *French Cinema: The First Wave, 1915–1929* (Princton, NJ: Princeton University Press, 1984), 279–526. In this chapter, Abel discusses those French films from the period that mix narrative techniques for purposes similar to the German examples.

157. See Thomas Elsaesser, *Weimar Cinema and After: Germany's Historical Imaginary* (London: Routledge, 2000).

158. This notion of the films as intellectual discourses that meditate upon the uneven landscape of the modern world is one articulated by Tom Gunning in reference to Fritz Lang's films. Although I formulated this status of the Weimar film

independent of Gunning's recently published monograph on Lang, our conceptions are almost identical. See Tom Gunning, *The Films of Fritz Lang: Allegories of Vision and Modernity* (London: British Film Institute, 2000), especially, x–xi.

159. See Siegfried Kracauer, "Lichtreklame," *Frankfurter Zeitung*, 15 January 1928; "Ansichtspostkarte," *Frankfurter Zeigtung*, 26 May 1930; and *Straßen in Berlin und anderswo* (Frankfurt: Suhrkamp, 1964).

160. See Siegfried Kracauer, "Straßenvolk in Paris," in *Straßen in Berlin und anderswo*, 127–32.

161. The protocinematic term of "phantasmagoria" is a man-made artifact that hides the traces of its production.

162. Walter Benjamin, "The Paris of the Second Empire in Baudelaire," in *Charles Baudelaire: A Lyric Poet in the Era of High Capitalism* (London: New Left Books, 1973), 37.

163. Walter Benjamin, *Das Passagenwerk* (Frankfurt am Main: Suhrkamp, 1983), 677.

164. See Ernst Bloch, *Geist der Utopie* (Frankfurt: Suhrkamp, 1964), and *Heritage of Our Times*, trans. Neville and Stephen Plaice (Berkeley and Los Angeles: University of California Press, 1990).

165. Ernst Bloch, "Artificial Center," in *Heritage of Our Times*, 25.

166. Ernst Bloch, "A Victory of the Magazine," in ibid., 33.

167. Ernst Bloch, "The Artistic Illusion as the Visible Anticipatory Illumination," in *The Utopian Function of Art and Literature: Selected Essays*, trans. Jack Zipes and Frank Mecklenburg (Cambridge: MIT Press, 1988), 141–55.

168. The most extended discussion of this potential radicality in the photographic image comes in Siegfried Kracauer, "On Photography," in *The Mass Ornament: Weimar Essays*, trans. and ed. Thomas Y. Levin (Cambridge: Harvard University Press, 1995), 65–73.

169. Walter Benjamin, "A Small History of Photography," in *One-Way Street and Other Writings*, trans. Edmund Jephcott and Kingsley Shorter (London: New Left Books, 1979), 240–57.

## 2. Bringing Cinema to Life through Light

1. See Gabriele Kilchenstein, *Frühe Filmzensur in Deutschland: Eine vergleichende Studie zur Prüfungspraxis in Berlin und München (1906–1914)* (Munich: diskurs film, 1997). See also Wolfgang Mühl-Benninghaus, "German Film Censorship during World War I," *Film History* 9 (1997): 71–94.

2. On the cinematic inventions and explorations of Oscar Messter, see, for example, Jan-Christopher Horak, "Oskar Messter: Forgotten Pioneer of German Cinema," *Historical Journal of Film, Radio and Television* 15, no. 4 (October 1995): 569–74. See also Wolfgang Mühl-Benninghaus, "Oskar Messters Beitrag zum Ersten Weltkrieg," and Tiziana Carrozza, "The Eye over the Hill: Aerial Photography up to the First World War," in Frank Kessler, Frank Sabine Lenk, and

Martin Loiperdinger, eds., *Oskar Messter. Erfinder und Geschäftsmann* special issue of *KINtop 3 Schriften* (Frankfurt: Stroemfeld/Roter Stern, 1949): 103–28.

3. See Jeanpaul Goergen, "Julius Pinschewer: A Trade-mark Cinema," in Thomas Elsaesser, ed., *A Second Life: German Cinema's First Decades* (Amsterdam: Amsterdam University Press, 1996), 168–74.

4. See Wolfgang Mühl-Benninghaus, "Newsreel Images of the Military and War, 1914–1918," in Elsaesser, *A Second Life*, 175–84.

5. On the use of film by industry in the pre–World War I period, see Manfred Rasch, Karl-Peter Ellerbrock, Renate Köhne-Lindenlaub, and Horst A. Wessel, eds., *Industriefilm. Medium und Quelle: Beispiele aus der Eisen- und Stahlindustrie* (Essen: Klartext, 1997).

6. Steel and iron industries continued using light-sensitive slides and films to educate their workers into the 1920s. Similarly, the genre developed and expanded with the introduction of various technical devices and apparatuses. For example, with portable projection facilities at the beginning of the 1920s, screenings became more frequent and took place in subsidiaries and branch factories where before they had been limited to the industry's main site. See Deutsche-Lichtbildgesellschaft a.V., eds., *Der Film im Dienste der Industrie* (Berlin, 1920). In the 1920s, the Dortmund company of Hoesch Iron and Steelworks also became a major producer of industry films. See Karl-Peter Ellerbrock, "Im Mittelpunkt steht der Mensch—Zur Geschichter der Hoesch-Filmproduktion," in Rasch et al., *Industriefilm*, 24–40.

7. My knowledge of these films is indebted to Ivo Blom's generous sharing of his intimate knowledge of the Desmet Collection at the Nederlands Filmmuseum.

8. This narrative of a young man having to prove his manhood through a negotiation of technology is everywhere in the pre–World War I genre films. See Heidi Schlüpmann, "Verbrechen und Liebe in den Dramen der Vorkriegszeit 1913/14," in *Unheimlichkeit des Blicks. Das Drama des frühen deutschen Kinos* (Frankfurt am Main: Stroemfeld/Roter Stern, 1990), 163–85.

9. This is one of the recurring features of the German film of this period. The detective films always employ all manner of mechanical, industrial apparatuses as the vehicles for both the criminals' getaway and the police chase. Thus, the Joseph Delmont character's movement through the spaces and narrative of *Das Rechts auf Dasein* via electrically operated pulleys, motor-powered ships, cars, and trains is a common spectacle for these films.

10. The dactyloscope was an apparatus used for reproducing photographic impressions of fingerprints.

11. Yuri Tsivian discusses this use of reflection to create space in Hofer's films as one of the techniques used by filmmakers of the teens to "out-theater theater." Tsivian argues that, to us, Hofer's use of mirrors may appear unremarkable through these mirrors. However, the creations of space were in fact highly medium-specific for the contemporary audience. See Yuri Tsivian, "Two 'Stylists' of the Teens: Franz Hofer and Yevgenii Bauer," in Elsaesser, *A Second Life*, 264–76.

12. On the detective drama, see Sebastian Hesse, "Kult der Aufklärung. Zur Attraktion der Detektivfilm-Serien im frühen deutschen Kino (1908–1918)," in Corinna Müller und Harro Segeberg, eds., *Die Modellierung des Kinofilms: zur Geschichte des Kino-programms zwischen Kurzfilm und Langfilm 1905/06–1918* (Munich: Fink, 1998), 125–52.

13. Compare Hofer's use of light here to Joseph Delmont's otherwise sophisticated film, *Der Geheimnisvolle Klub/The Mysterious Club* (1913). In memorable chase scenes through the canals of Rotterdam, the camera goes with the boats through numerous bridges and tunnels. Always as the boats go under the bridges and through the tunnels, the human figures disappear in the darkness, then turn to silhouettes as they emerge, shot against the oncoming beam of the sunlight. Only when they are fully surrounded in sunlight, away from the bridges and tunnels are the figures returned to embodiment.

14. In addition to Heckel's paintings discussed in chapter 1, Feininger's fractured images of cathedrals and bridges are like shards of color as light pieced together on the surface of the canvas. See, for example, Lyonel Feininger, *Bridge III*, 1917, and *Barfüsser Kirche in Erfurt*, 1917.

15. Delmont's film *Der Geheimnisvolle Klub* is also replete with examples of this type of abstraction. In particular, the space of the club in which the card-players play is, during the day and night, an image of shapes in light.

16. On the standard uses of color in silent film, see Monica Dall'Asta, Guglielmo Pescatore, and Leonardo Quaresima, eds., *Il Colore nel Cinema Muto* (Udine: Gieornate Internazionali di Studio e documentazione sul Cinema, 1995); Daan Hertogs and Nico de Klerk, eds., *'Disorderly Order' Colours in Silent Film* (Amsterdam: The 1995 Amsterdam Workshop, Stichting Nederlands Filmmuseum, 1996). The essays in both these anthologies also reinforce the necessity of approaching each film's use of color on its own terms. As William Uricchio argues, color was used for any number of purposes depending on the individual film—for example, to create narrative tension, dramatic identification, and shifts in temporality. See William Uricchio, "Reflections on Color: The Possibilities for Dramatic Articulation in "The Lonedale Operator," in Dall'Asta, Pescatore, and Quaresima, *Il Colore nel Cinema Muto*, 191–98.

17. Heide Schlüpmann nods toward this distinction in her comments at session 3 of the Amsterdam Workshop. See "A Slippery Topic: Colour as Metaphor, Intention or Attraction," in Hertogs and de Klerk, *'Disorderly Order' Colours in Silent Film*, 43.

18. On the aural effects of silent films, see John Fullerton, "The Jump Cut and 'Trickality' in Early Danish Comedies," in Richard Abel and Rick Altman, eds., *The Sounds of Early Cinema* (Bloomington: Indiana University Press, 2001), 87–94; on the visualization of sound, see Bernard Perron, "The First Transi-Sounds of Parallel Editing," in Abel and Altman, *The Sounds of Early Cinema*, 79–86.

19. See, for example, the analysis of *Die Straße* and *Jenseits der Straße* in chapter 5.

20. See my discussion of Paul Wegener's *Der Golem* in chapter 4.

21. Notable here is the stark contrast between the sepia, evenly lit shots of nighttime sequences, and the shining, black-and-white or bluish tints of the outdoor shots that depict Gerd leaving on his ship.

22. Werle disguises himself here as a Hasidic Jew.

23. Self-referentiality is widespread among the prewar films, and again, it is a theme that abounds in the 1920s film. See Sabine Hake, "Self-Referentiality in Early German Cinema," in Elsaesser, *A Second Life*, 237–45.

24. See, for example, Wolfgang Dittmar, *Leuchtürme* (Hamburg: Ellert and Richter, 1986); H. J. Jürgens, "Aus der Geschichte der Leuchtfeuer und Seezeichen" (Kiel, 1929).

25. F. W. Otto Scholze, "Leuchtürme und Leuchtbaken," *Handbuch für Eisenbetonbau*, vol. 4 (Berlin: Wilhelm Ernst und Sohn, 1927), 352–65.

26. The close connection between the psychic condition and the social transformations of the technological, modern world are integral to the psychoanalytic conception of the mind. The relationship forms a structural layer of Freud's case study analyses, for example. Works such as Eric Santner's on Schreber's memoirs and John Farrell's on the paranoia of modernity extend Freud's theories in interesting ways to offer characterizations of modernity. See Eric L. Santner, *My Own Private Germany: Daniel Paul Schreber's Secret History of Modernity* (Princeton, NJ: Princeton University Press, 1996); John Farrell, *Freud's Paranoid Quest: Psychoanalysis and Modern Suspicion* (New York: New York University Press, 1996).

27. See Eric de Kuyper, "Und das Licht Erlosch (1914)," in Daniela Sannwald, ed., *Rot für Gefahr, Feuer und Liebe* (Berlin: Stiftung Deutsche Kinemathek, 1995), 54–56.

28. On the film as a technological spectacle of steel production and its relation to the celebration of industrial production during the war, see Kimberly O'Quinn, "The Reason and Magic of Steel: Industrial and Urban Discourses in DIE POLDIHÜTTE," in Elsaesser, *A Second Life*, 192–201.

29. Other such films would include the films produced and shown to workers by companies such as AEG and Krupp. See Rasch, "Zur Geschichte des Industriefilms und seines Quellenwertes. Eine Einführung," in Rasch et al. *Industriefilm*, 9–21.

30. See G. A. Fritze, "Die Kinematographie im Dienste der Industrie," *Bild und Film*, no. 3 (1913–14): 124–28; W. D., "Die Kinematographie im Dienste der Industrie," *Licht-Bild-Bühne* 6, no. 11 (15 March 1913): 18–20.

31. Renate Köhne-Lindenlaub, "Filme von Krupp. Anmerkungen zu ihrer Entstehung, Nutzung und Überlieferung," in Rasch et al., *Industriefilm*, 42–43.

32. Rasch, "Zur Geschichte des Industriefilms und seines Quellenwertes, 13.

33. W. Kaemmerer, "Die Internationale Industrie- und Gewerbeausstellung in Turin 1911," *ZVDI*, no. 55 (1911): 1141–45, 1244–51.

34. See Rasch, "Zur Geschichte des Industriefilms und seines Quellenwertes, 13–14.

35. Ibid. Other films of the genre include titles such as *Stahlerzeugung im Thomaswerk, Die Leipziger Frühjahrsmesse 1918, Erz und Eisen* (Friedrich Krupp AG), *Aus des Deutschen Reiches Waffenschmiede.*

36. See O'Quinn, "The Reason and Magic of Steel," 192–201. My analysis here is indebeted to O'Quinn's insightful reading of the film.

37. Ibid., 198.

38. Ibid, 198–201.

39. The obvious film for comparison here is Dziga Vertov's *Enthusiasm* (1929), in which a similar celebration of the wonders of steel production is often depicted through a movement in light. However, in Vertov's film the tension that drives the narrative forward is not held within single frames, but rather is communicated across edits between shots of the workers and the machines in motion. See Dziga Vertov, "Let's Discuss Ukrainfilm's First Sound Film: *Symphony of the Donbas,*" in Annette Michelson, ed., *Kino-Eye: The Writings of Dziga Vertov* (Berkeley: University of California Press, 1984), 106–15.

40. This tendency is discussed extensively by Thomas Elsaesser in his references to the pictorial emphases of German film of the 1920s. See, for example, Thomas Elsaesser, "NOSFERATU, TARTUFFE and FAUST: Secret Affinities in F. W. Murnau," in *Weimar Cinema and After: Germany's Historical Imaginary* (London: Routledge, 2000).

41. See Martin Koerber, "Oskar Messter—Stationen einer Karriere," in *Oskar Messter: Filmpionier der Kaiserzeit,* special issue of *KINtop Schriften* 2 (Frankfurt: Stroemfeld/Roter Stern, 1994), 50.

42. See Herbert Birrett, *Lichtspiele. Der Kino in Deutschland bis 1914* (Munich: Q-Verlag, 1994), 59. Birrett also explains that the same problems were encountered with the projection as with the filming. For the most part, davy lamps that burned a type of acetyne gas were used. The flammability of the film material made the search for safe light beams urgent.

43. Ibid.

## 3. Legends of Light and Shadow

1. This atavism is a defining characteristic of a whole range of 1920s narrative films. We see it again and again in films such as Lang's *Die Nibelungen* (1922–24), *Der müde Tod,* Arthur von Gerlach's *Zur Chronik von Grieshaus/On the Chronicle of the Grey House* (1925), and Dimitri Buchowetzki's *Der Galiläer/ The Galilean* (1921).

2. This double movement backwards and forwards could easily be conceived as the German ambivalence toward technology that is always cited to set it apart from the euphoria over technology expressed by the Soviets and the French filmmakers of the same period. The denial and simultaneous acceptance of the

break between technological modernity and the past is, however, independent of whether or not the films represent technology as enabling or damaging to human progress. See Andreas Huyssen's canonical article "The Vamp and the Machine: Fritz Lang's *Metropolis*," in *After the Great Divide: Modernism, Mass Culture, Postmodernism* (Bloomington and Indianapolis: Indiana University Press, 1986), 65–81.

3. Novalis, "Hymnen an die Nacht," in Hans-Joachim Mähl und Richard Samuel (eds.), *Novalis. Werke in Einem Band* (Munich: dtv., 1995), 147–77.

4. The same union of lovers in the dark of night, in the "streaks of wavering" (heavenly) light, can be found in Eduard Mörike's "Song for Two in the Night." As in Novalis's "Hymns to the Night," when daylight dawns the lovers are forced to leave the world of the imagination and are unable to "create" their visions. See Eduard Mörike, "Gesang zu zweien in der Nacht" (1825) in Friedrich Hölderlin and Eduard Mörike, *Selected Poems*, trans. Christopher Middleton (Chicago: University of Chicago Press, 1972), 134.

5. See, for example, Carl Gustav Carus, *View of Dresden from the Brühl Terrace* (c. 1830–31); Ludwig Tieck, "Der Runenberg," in Konrad Nussbächer, ed., *Märchen*, (Stuttgart: Reclam, 1996), 25–50; Johann Gottfried Herder, "Journal Meiner Reises im Jahr 1769," in Rainer Wisbert with Klaus Pradel, eds., *Johann Gottfried Herder. Werke*, vol. 9 (Frankfurt am Main: Deutscher Klassiker Verlag, 1997), 11–126.

6. See August Langen, "Zur Lichtsymbolik der Deutschen Romantik," in Hugo Kuhn und Kurt Schier, eds., *Märchen, Mythos, Dichtung: Festschrift zum 90. Geburtstag Friedrich von der Leyens am 19. August 1963* (Munich: Beck, 1963), especially 455–60.

7. This tendency is taken up by the Expressionist poets in the 1910s in Germany. In Georg Trakl's "Twilight" the sick look both forward to their impending death and back to the "golden times" of lives well lived. Thus, the time of the day expresses the liminal state of those "enfolded" by illness who are, nevertheless, not yet the specters that have begun to appear at this same time of day. See Georg Trakl, "Dämmerung," in *Gedichte* (Leipzig: Kurt Wolff Verlag, 1913), 23. Trakl has another poem, "The Rats," which seems to be a direct predecessor for *Nosferatu*. A shadow comes to life in the glow of the autumn moon, and brings with it a pungent vapor of death, a stench that in turn makes the "moon beams tremble like ghosts." (Georg Trakl, "Die Ratten," in *Gedichte*, 44).

8. See Karl Friedrich Schinkel, *Gothic Cathedral on the Water* (1813), *Medieval City on a River* (1815), and *Gothic Cathedral on a Rock at the Sea* (1815).

9. This famous quote by Böcklin is cited in William Vaughan, *German Romantic Painting* (New Haven: Yale University Press, 1980), 239.

10. Johann Wolfgang von Goethe, "Faust. Eine Tragödie," in *Johann Wolfgang von Goethe. Sämtliche Werke*, vol. 7, ed. Albrecht Schöne (Frankfurt am Main: Deutscher Klassiker Verlag, 1994), 23–464.

11. On the sixteenth-century origins of the *Faust* legend, see H. Pongs, "Licht-

symbolik in der Dichtung seit der Renaissance. II," *Studium Generale,* 13, no 6 (1960): 682–706. The first version of the Faust theme is from Spies's *Historia* (1587).

12. H. Sedlmayr, "Das Licht in seinen künsterischen Manifestationen," *Studium Generale* 13, no 6 (1960): 314–15.

13. See, for example, Grünewald's *The Crucifixion from the Isenheim Altarpiece* (c. 1510–15) and Dürer's engravings such as *Saint Jerome in His Study* (1514) or *Melancholia I* (1514).

14. Note that in the religious works by Caravaggio and Rembrandt, the contrast between light and darkness is used to represent the conflicted situations and states of the earthly and the mystical, life and death, bounded time and eternity, rationality and the imagination. See Peter Andreas, *Licht und Farbe bei Caravaggio: Studien zur Ästhetik und Ikonologie des Helldunkels* (Stuttgart: F. Steiner, 1992).

15. See also Angela Dalle Vacche, "F. W. Murnau's *Nosferatu*: Romantic Painting as Horror and Desire in Expressionist Cinem." in *Cinema and Painting: How Art Is Used in Film* (Austin: University of Texas Press, 1996), 161–96.

16. Ludwig van Beethoven, *Overture zum Ballet: Geschöpfe des Prometheus* (1801) (Leipzig: Peters, 1855); Franz Schubert, *Lieder*; Johann Wolfgang von Goethe, "Prometheus," in *Johann Wolfgang von Goethe. Sämtliche Werke,* vol. 4, ed. Dieter Borchmeyer, 407–20.

17. Carl Spitteler, *Prometheus der Dulder* (Jena: E. Diederich, 1924); Carl Orff, *Prometheus* (Mainz: Schott, 1967).

18. Thus, for example, we also see Rotwang create the machine-Maria in Fritz Lang's *Metropolis* (1927) from fire and light in the name of scientific progress. In chapter 4 I discuss Murnau's *Faust* and Paul Wegener's *Der Golem* (1920), two very different tales that both create mythological figures out of fire in the pursuit of creativity, knowledge, and power. Like *Algol,* these other films draw on a theme that is a constant preoccupation to German artistic tradition, particularly that of the Romantic period.

19. See Wolfgang Schivelbusch, *Licht, Schein und Wahn. Auftritte der elektrischen Beleuchtung im 20. Jahrhundert* (Berlin: Wilhelm Ernst und Sohn, 1992), especially 61–79, 101–9.

20. Ibid., 67.

21. Karl Wernicke, "Grosslicht-Reklame im Steilblick," *Die Reklame,* 1 March 1929, 170.

22. It is interesting to note that the victim of Herne's machine is a man whose name, Hell, in German is the adjective meaning light.

23. Richard Birkefeld und Martina Jung, *Die Stadt, der Lärm und das Licht. Die Veränderung des öffentlichen Raumes durch Motorisierung und Elektrifizierung* (Hannover: Kallmeyersche Verlagsbuchhandlung, 1994), 14.

24. Thomas Hughes, *Networks of Power: Electrification in Western Society, 1880–1930* (Baltimore and London: Johns Hopkins University Press, 1983).

25. This unqualified celebration of mechanization, especially in the realm of labor, by 1920s critics such as Ernst Jünger, Carl Schmitt, and Oswald Spengler

is termed "reactionary modernism" by Jeffrey Herf. See Jeffrey Herf, *Reactionary Modernism: Technology, Culture, and Politics in Weimar and the Third Reich* (Cambridge and New York: Cambridge University Press, 1984).

26. Although *Wilhelm Meister* ends on the optimistic note that, in the future, technical and social progress will be advancing hand in hand, Goethe's idea of progress is primarily humanist, based on the labor of the individual for the common good. Goethe welcomed industrialization, but knew that it would have a detrimental effect on human life. The radicality of Goethe's and Schiller's work was that its skepticism towards industrialization was not colored by a nostalgia for the preindustrialized era. *Algol* does not take a stand on such issues, and obviously, it does not have the philosophical complexity of Goethe's bildungsroman. See Johann Wolfgang von Goethe, *Wilhelm Meisters Wanderjahre oder die Entsagenden*, Werke V (Stuttgart: Cotta'sche Buchhandlung, 1969), 21–23.

27. See Werner Hofmann, "Der Tod der Götter," in Tilmann Buddensieg and Henning Rogge, eds., *Die nützlichen Künste: Gestaltende Technik und bildende Kunst seit der industriellen Revolution* (Berlin: Quadriga Verlag, 1981), 35–41. Hofmann is citing Sigrid Hinz, ed., *Caspar David Friedrich in Briefen und Bekenntnissen* (Munich: Roger & Bernhard, 1968), 102–4.

28. For a concise summary of the *Neue Sachlichket* in painting, see John Willett, *Art and Politics in the Weimar Period: The New Sobriety 1917–1933* (New York: Da Capo Press, 1978), 111–17. See also Minneapolis Institute of Art, *German Realism of the Twenties: The Artist as Social Critic* (Minneapolis: ex. Cat., 1980). In addition to revolutionaries such as Weber, Adorno, Horkheimer, Brecht, and so on, reactionary modernists such as Schmitt, Spengler, and Jünger also came forth with their differing opinions on the relationship between man and technology. See Herf, *Reactionary Modernism.*

29. See, for example, F. W. Murnau's *Tartüff.*

30. Joseph von Eichendorff, *Werke,* ed. Wolfdietrich Rasch (Munich: dtv., 1995), 246.

31. See Caspar David Friedrich, *Moon Setting at the Sea* (1822), *Moonlit Night at the Beach with Fishermen* (1817), *Two Men at the Sea* (1817).

32. Roland Schlacht, "Schatten," *Die Weltbühne* 11, no. 34 (1923), 202–3.

33. Kurt Pinthus, "Schatten," *Das Tage-Buch* 4, no. 31 (4 August 1923): 1124.

34. Anonymous, "Schatten," *Licht-Bild-Bühne,* no. 30 (28 July 1923), 24.

35. Cited in *Der Kinematograph,* no. 870 (21 October 1923): supplement.

36. See Michael Baxandall, *Shadows and Enlightenment* (New Haven: Yale University Press, 1995), chapter 1, for a detailed description of the physical constitution of shadows, and a differentiation of the physical types of shadows.

37. Critics and historians are always eager to point to the difference between the silhouette and the shadow. The perfection of the silhouette as likeness reached its apotheosis in the physiognomic portraits of John Caspar Lavater (1741–1801). The shadow, on the other hand, is traditionally considered to be a distortion of the object or person to whom it belongs. See R. L. Mégroz, *Profile Art through the Ages*

(New York: Philosophical Library, 1947). Although the silhouette films of Lotte Reiniger were not especially popular in Germany in the 1920s, her work did enjoy a popularity among other filmmakers and fragments of her work can be found in many successful films of the period. Thus, for example, the scenes of rat-infested Hamelin in Paul Wegener's *The Pied Piper of Hamelin* (1918) and the devil's manipulation of human shadows in *Der verlorene Schatten/The Lost Shadow* (Rochus Gliese, 1920) are both animated through the use of Reiniger's groundbreaking animation techniques. See Lotte Reiniger, *Shadow Theaters and Shadow Films* (London: Batford, 1970). For the art-historical discourse on attached and cast shadows, see E. H. Gombrich, *Shadows: The Depiction of Cast Shadows in Western Art* (London: National Gallery, 1995), and Thomas Kaufmann, "The Perspective of Shadows: The History of the Theory of Shadow Projection," *Journal of the Warburg and Courtauld Institutes* 38 (1975): 258–87.

38. The novelty of the film's relationship to reality was reputedly a source of perplexity to early cinema audiences. It was often thematized and represented in early cinema. See, for example, *Uncle Josh at the Moving Picture Show* (Edison, 1902).

39. Johann Caspar Lavater, *Essays on Physiognomy: Designed to Promote the Knowledge and the Love of Mankind,* 12th ed. (London: William Tegg, 1862). Lavater's method of drawing silhouettes for physiognomic purposes is often considered to be one of the direct predecessors to photography.

40. See Gombrich, *Shadows,* 57. This kind of performance, which uses shadows in order to suggest figures that are absent, descends from Plato and his famous myth of the cave in which the chained prisoners believe the shadows cast on the wall above to be reality itself.

41. The shadow play is said to have originated in China. These were reproductions of the stage plays for ladies who were not allowed into the theaters. Oskar Kokoschka's interest in Oriental art during this period produced the shadow play *Das getupfte Ei/The Spotted Egg* in 1907. After designing and painting the figures on paper, he glued them to copper sheet cut accordingly. The figures, which were movable at the joints rather like marionettes, were placed within a box lighted from the inside and were manipulated by a spring mechanism. Their silhouettes were then projected by means of a large mirror. See Rainer Reusch, *Die Wiedergeburt der Schatten: zur gegenwärtigen Situation des internationalen Schattenspiels* (Schwabisch-Gmund: Einhorn-Verlag, 1991), for an overview of the various techniques still used in shadow plays around the world today.

42. Peter Jelavich, *Berlin Cabaret* (Cambridge: Harvard University Press, 1993).

43. See Charles Musser, "The Magic Lantern," in *The Emergence of Cinema: The American Screen to 1907* (Berkeley: University of California Press, 1990), 20–24.

44. This notion of the conflict between the different effects of technological modernity is discussed further in chapters 4–6.

45. Anonymous, "Schatten," *Licht-Bild-Bühne,* 24: "Und diese selbst, im grausigsten Moment nur in den Schatten an der Wand sich abmalend, von einer

künstlerischen Dezenz, wie sie den ganzen Film hindurch eben nur ermöglicht wird—durch die Schatten."

46. This is the interpretation given the film by Siegfried Kracauer, *From Caligari to Hitler: A Psychological History of the German Film* (Princeton, NJ: Princeton University Press, 1947), 113–14.

47. Paul Coates, "The Forecast of Shadows," in *Film at the Intersection of High and Mass Culture* (Cambridge, England: Cambridge University Press, 1994), 154–57.

48. Carl Einstein, "Die Pleite des deutschen Films," in Anton Kaes, ed., *Kino-Debatte: Textezum Verhältnis von Literatur und Film, 1909–1929* (Tübingen: Niemeyer, 1978), 156–59.

49. Ibid., 157.

50. Kurt Biebrach, "Bühne und Film in ihrem Verhältnis zur Wirklichkeit," *Kunst und Künstler* (1932), 451–54. Biebrach's article belongs to the wider debate among Weimar literary and cultural figures that sought to distinguish between theater and film in order to prove that the film was indeed more than a poor imitation of the theater.

51. Ibid., 453.

52. See, for example, Tom Gunning, "Animated Pictures," *Michigan Quarterly Review* 34, no. 4 (Fall 1995): 465–85; X. Theodore Barber, "Phantasmagorical Wonders: The Magic Lantern Ghost Show in Nineteenth-Century America," *Film History* 3, no. 3 (1989): 73–86.

53. Peter Brooks, *The Melodramatic Imagination: Balzac, Henry James, Melodrama, and the Mode of Excess* (New Haven: Yale University Press, 1976).

## 4. The Spell of Light

1. Friedrich Sieburg, "Die Magie des Körpers," in Fritz Güttinger, ed., *Kein Tag ohne Kino: Schriftsteller über den Stummfilm* (Frankfurt: Deutsches Filmmuseum, 1984), 419–25.

2. Ibid., 419.

3. Walter Muschg, "Filmzauber," in Güttinger, *Kein Tag ohne Kino*, 462–67.

4. It can be surmised that the disdain shown toward film by many German intellectuals of this era was born of an anxiety regarding the fact that the cinema was slated to replace the art forms in which they themselves were already working. Similar suspicions toward the integrity of cinema as an art form are echoed in much of the early film criticism by journalists in other countries, suspicions motivated by similar competition. Thus, competition is likely to have been foregrounded in the minds of many German playwrights and other literary figures when they dismissed film as vacuous. See, for example, George Abbott, "The Big Noise," *Vanity Fair* 32 (April 1929): 80, and Deems Taylor, "The Drama's Speaking Likeness," *Vanity Fair* 32 (March 1929), 55.

5. See Alfred Polgar, "Kino-Zauber," *Film-Kurier*, no. 79 (6 September 1919): 1–2.

6. Maximilian Maulbecker, "Kinetischer Kulissenzauber," *Film-Kurier,* no. 36 (17 July 1919): 1. Maulbecker strives to expose the mechanisms that make the film appear magical by describing the production processes. See also, Anonymous, "Wunder des Films," *Der Kinematograph,* no. 26 (31 January 1929): unpaginated. Although writers did use the word *trick* to describe the innovations of film representation, "Der Trickfilm" was commonly translated as "cartoon film." See, for example, "Die Technik der Trickfilmherstellung," *Reichsfilmblatt,* no. 42 (22 October 1927): 18. Thus, *magic* was the preferred term for manipulations of the film material. On the "magical" uses of lighting to create the lie of the screen, see Otto Stindt, "Lichttechnische Lügen," *Filmtechnik,* no. 19 (1926): 375–78.

7. German critics were not the only ones to identify the cinema as a form of technological magic. Most obviously, the films of Georges Méliès as technological magic attracted much critical attention. See Georges Sadoul, *Georges Méliès* (Paris: Hachette, 1973), and Paul Hammond, *Marvelous Méliès* (New York: St. Martin's Press, 1974). Nevertheless, until recently there has been a paucity of literature that examines the full implications of the connection between cinema and magic. The first book-length study of the cinema as magic was Parker Tyler, *Magic and Myth of the Movies* (New York: Henry Holt and Co., 1947). Tyler believes that the movies are a form of myth, a modern equivalent of ancient Greek myths. Thus, he understands the movies as dreamlike fantasies, or projections of the spectator's belief systems. Thus, for Tyler, movies are psychoanalytic symbols of repressed desires and fears. More recently, Eric Barnouw examines the cinematographic illusions used in stage magic performances throughout the nineteenth century. He locates these magical performances as a precursor to the cinema of Méliès and other filmmakers. In so doing, Barnouw contributes to the 1980s revision of the notion that the cinema was born before the night in the Grand Café in Paris in 1895 when the Lumière brothers projected films on a screen for a paying audience. See Eric Barnouw, *The Magician and the Cinema* (New York: Oxford University Press, 1981). For a sampling of the more recent work that attempts to analyze the complexity of Méliès's "magic," see André Gaudreault, "Theatricality, Narrativity and Trickality: Reevaluating the Cinema of Georges Méliès," *Journal of Popular Film and Television* 15, no. 3 (fall 1987): 110–19, and Lucy Fischer, "The Lady Vanishes: Women, Magic and the Movies," *Film Quarterly* 33, no. 1 (Fall 1979): 30–40. Rachel O. Moore examines the magical elements of the cinema as the presence of the premodern or primitive in this otherwise technologically modern medium in *Savage Theory: The Cinema as Modern Magic* (Durham, NC: Duke University Press, 2000). Moore's primary focus is on the coincidence of elements of primitive ritual and belief in early film theory and avant-garde film practice.

8. See Klaus I. Berghahn, "Georg Johann Heinrich Faust: The Myth and Its History," in Reinhold Grimm and Jost Hermand, eds., *Our Faust? Roots and Ramifications of a Modern German Myth* (Madison: University of Wisconsin Press, 1987), 3–21.

9. Mary Ann Doane offers an erudite discourse on the cinema's imbrication in the transformation to time of machine-dominated modernity. She takes up many of the discourses on time and modernity that are represented in these films. She is concerned to argue for the epistemological result of the cinema's urge to bring continuity to discontinuity, to archive the ephemeral, and to structure contingency within modernity. See Mary Ann Doane, *The Emergence of Cinematic Time: Modernity, Contingency, the Archive* (Cambridge: Harvard University Press, 2002).

10. Arguments regarding either the need for a specifically German product or the identification of the "Germanness" of German film abounded in the film press at this time. See einer Amerikaner, "Deutsche—macht deutsche Filme!" *Licht-Bild-Bühne*, no. 26 (30 June 1923): 14–15; Walter Thielemann, "Der deutsche Spielfilm," *Reichsfilmblatt*, no. 8 (23 February 1924): 14–15. On the perceived imperialism of American film in the Republic, see, for example, Anonymous, "Der Imperialismus der amerikanischen Kinematographie," *Licht-Bild-Bühne*, no. 17 (24 April 1920): 12–13.

11. On Faust as the German myth *par excellence,* see Hans Schwerte, *Faust und das Faustische: Ein Kapitel deutscher Ideologie* (Stuttgart: Klett, 1962). For a discussion of the necessity of creating a national Weimar cinema see Thomas Saunders, "History in the Making: Weimar Cinema and National Identity," in Bruce A. Murray and Christopher J. Wickham, eds., *Framing the Past: The Historiography of German Cinema and Television* (Carbondale and Edwardsville: Southern Illinois University Press, 1992), 42–67.

12. I do not do justice to the highly complex nature of German–Hollywood relations in this period. For a thorough analysis of the relations and their far from straightforward implications, see Thomas J. Saunders, *Hollywood in Berlin: American Cinema and Weimar Germany* (Berkeley: University of California Press, 1994). On the proliferation of debates regarding the form that a German cinema should take, see Heinz-B. Heller, *Literarische Intelligenz und Film* (Tübingen: Niemeyer, 1985); Anton Kaes, *Kino-Debatte: Texte zum Verhältnis von Literatur und Film, 1909–1929* (Tübingen: Niemeyer, 1978); Güttinger, *Kein Tag ohne Kino,* Sabine Hake, *The Cinema's Third Machine: Writing on Film in Germany, 1907–1933* (Lincoln: University of Nebraska Press, 1993). On the interaction of film and literature, and the question of film as an art form, see Thomas Koebner, "Der Film als neue Kunst. Reaktionen der literarischen Intelligenz," in Helmut Kreuzer, ed., *Literaturwissenschaft-Medienwissenschaft* (Heidelberg: Quelle and Meyer, 1977), 1–31. As Thomas Elsaesser points out, these fantastic tales also provided filmmakers with the opportunity to explore themes such as the uncanny forces of alienation, once identified as the effect of the changing relations of production during the Romantic period, now applicable to the emergent conditions of technological production (Thomas Elsaesser, "Social Mobility and the Fantastic," in Mike Budd, ed., *The Cabinet of Dr. Caligari: Texts, Contexts, Histories* [New Brunswick, NJ: Rutgers University Press, 1990], 171–89).

13. A number of critics have applauded Hoffmann's "breathtaking" use of light in *Faust* as a vehicle for creating a mood at once opaque and opalescent: a disquieting, dark, gloomy environment intermittently carved apart by the sharp brilliance of light formations, at times necessitated by narrative events, at others, of inexplicable significance. However, none discuss the art of light in motion that is so strikingly deployed in *Faust*. See, in particular, Lotte Eisner for her reverence toward *Faust* as the "climax of chiaroscuro" lighting (*The Haunted Screen*, trans. Roger Greaves [Berkeley: University of California Press, 1965], chapter 18; first published in France in 1952). See also Jo Collier, *From Wagner to Murnau: The Transposition of Romanticism from Stage to Screen* (Ann Arbor and London: UMI Research Press, 1988), 146–48. Most notable here is Eric Rohmer's still-authoritative book on *Faust*'s mise-en-scène. On Hoffmann's deft creations in light for the organization of space and pictorial composition as a unique attribute of *Faust,* see Eric Rohmer, *L'Organisation de l'espace dans le* Faust *de Murnau* (Paris: Union Générale d'Éditions, 1977). On the symbolic use of light and dark to portray good and evil, see, for example, Jacques Aumont, "'Mehr Licht!' Zu Murnaus 'Faust' (1926)," in Franz-Josef Albersmeier und Volker Roloff, eds., *Literaturverfilmungen* (Frankfurt am Main: Suhrkamp, 1989), 59–79.

14. Holger Jörg, "Faust—Eine deutsche Volkssage (1926)," in *Die sagen- und märchenhafte Leinwand. Erzählstoffe, Motive und narrative Strukturen der Volks- sprosa im "klassischen" deutschen Stummfilm (1910–1930)* (Sinzheim: Pro Univer- sitate Verlag, 1994), 270.

15. The use of light and darkness to differentiate good and evil had, by the time *Faust* was produced in 1926, become standard in German cinema. The film that is always celebrated for its introduction of this technique is Robert Wiene's *The Cabinet of Dr. Caligari* (1921) with Cesare always dressed in black, depicted in darkness, and the virginal Jane in her flowing white gowns depicted in full key light. Although there is never any question over the fact that there is nothing particularly innovative about Wiene's creation of these lighting effects—they are always recognized for what they are, standard three-point lighting—many critics will attribute Weimar cinema with the development of the *use* of lighting configu- rations as leitmotifs belonging to individual characters. It will also be noted that these German films were not the first to use cast shadows for expressive purposes. Although it was rare, Cecil B. DeMille, for example, began distorting shadows cast by unseen objects and people to convey sinister atmospheres as early as 1915. The well-known example of this is the shadow of the prison bars falling on the husband in *The Cheat* (1915). See also DeMille's *The Whispering Chorus* (1918) and Maurice Tourneur's *The Whip* (1917). Rather than crediting the German films with the use of light and shadow for expressive or moral purposes, I would prefer to consider their innovation to lie in the extraordinary sophistication that they bring to otherwise established cinematic conventions.

16. This notion of the myth's inherent engagement with its own historicity

is explored in Thomas Metscher, "Faust's End: On the Present Significance of Goethe's Text," in Grimm and Hermand, *Our Faust?*, 22–47.

17. For this argument, see Marshall Berman, "Goethe's Faust: The Tragedy of Development," in *All That Is Solid Melts into Air* (New York: Penguin, 1982), 37–86.

18. There are numerous productions of the myth, not only in Germany, before 1926. Perhaps the most well known were those of Georges Méliès: *Le Cabinet de Méphistophélès* (1897), *Damnation de Faust* (1904), and *Faust et Marguerite* (1904). See Ernest Prodolliet, *Faust im Kino. Die Geschichte des Faustfilms von den Anfängen bis in die Gegenwart* (Freiburg, Switzerland: Walter-Verlag, 1978), for information on the more than one hundred film adaptations of the Faust myth.

19. This, of course, is the same as the ending of Part I of Goethe's *Faust*. Most versions of *Faust* only represent this first part. As Berman says, Goethe's *Faust*, Part II, is much more profound because this is where the play moves away from the self-development of the Faust character into the social transformations he brings about. However, it is also much slower and more pensive, thus making it not so appealing to an audience looking for entertainment at the movies.

20. This argument in relation to the films of Douglas Sirk is everywhere in Sirk criticism. See, for example, Thomas Elsaesser, "Tales of Sound and Fury: Observations on the Family Melodrama," in Marcia Landy, ed., *Imitations of Life: A Reader on Film and Television Melodrama* (Detroit: Wayne State University Press, 1991), 68–91.

21. Bernard von Brentano, "Faust," *Frankfurter Zeitung*, no. 776, 18 October 1926. On this rejection of the film based on its rendering superficial the metaphysical power of Goethe's work, see also F. H., "Faust," *Reichsfilmblatt*, no. 42 (16 October 1926): 27; Anonymous, "Faust," *Kinematograph*, no. 1026 (17 October 1926), 15. Note that not all of the critics are as vitriolic in their disapproval of the film as Brentano.

22. Willy Haas, "Faust," *Literaraischen Welt* 2, no. 44 (1926): 7.

23. Some critics praised the film. See, for example, the review in *Licht-Bild-Bühne* 19, no. 211 (1926), which praises the film for its "rhythmical displays of light, shot compositions, reflexive uses of the camera," and so on. However, *Faust* was generally rejected upon its release.

24. Thomas Elsaesser, "Secret Affinities," *Sight and Sound* 58, no. 1 (winter 1988–89): 37.

25. Thomas Elsaesser, "Nosferatu, Tartuffe, and Faust: Secret Affinities in F. W. Murnau," in *Weimar Cinema and After: Germany's Historical Imaginary* (London: Routledge, 2000), 223–59.

26. Eisner identifies this opening scene of *Faust* as a high point for transformations in light and dark in German film (Lotte Eisner, "Murnau, the Camera, and Lighting," in *Murnau* [Berkeley and Los Angeles: University of California Press, 1973], 71–88). See Jörg, "Faust—Eine deutsche Volkssage (1926)," 275.

27. This effect would appear to be achieved through a double exposure of the

same negative filmstrip. The same mise-en-scène shows a man lying dead on the street, having been struck down by the plague. The scene is shot through blazing flames, the source of which is unclear.

28. Johann Wolfgang von Goethe, "Faust I," lines 1260–1320, in Stuart Atkins, ed. trans., *Goethe: The Collected Works*, vol. 2 (Princeton, NJ: Princeton University Press, 1994), 34–35. See Aumont, "'Mehr Licht!'" 70.

29. Thomas Brandlmeier, "Deutsche Bilderwelten," in Hans-Michael Bock and Michael Tötenberg, eds., *Das Ufa-Buch* (Frankfurt am Main: Zweitausendeins, 1992), 128–29.

30. See, for example, Dietrich Kuhlbrodt, "Fast ein Shakespeare: Murnau in seiner Zeit," in *Friedrich Wilhelm Murnau. 1888–1988*, Publikation zur Austellung Friedrich Wilhelm Murnau 1888–1988 (Bielefeld: Bielefelder Verlagsanstalt, 1988), 57–67. As Elsaesser points out, even though there is convincing evidence to suggest Murnau's disinterest in the "nuts and bolts" of the apparatus itself, the sheer exuberance of the technical effects in a film such as *Faust* is testimony to his fascination with what they can do (Elsaesser, "NOSFERATU, TARTUFFE and FAUST").

31. The analogy between these creatures of the night and the cinematic medium has been referred to by, for example, Gilberto Perez, "Nosferatu," *Raritan* 13, no. 1 (summer 1993): 1–29. Similarly, critics have likened Cesare in *The Cabinet of Dr. Caligari* to the cinematic medium; however, to my knowledge the connection has not been made with reference to Mephistopheles in *Faust*.

32. Like the cinema, these creatures come alive in the dark, they successfully capture the attention of their audiences, are no more than illusory specters, move through impossible times and spaces. See, for example, Judith Mayne's discussion of the translation of *Dracula* from literary work to screen in Murnau's *Nosferatu* (1922): "Dracula in the Twilight: Murnau's *Nosferatu* (1922)," in Eric Rentschler, ed., *German Film and Literature: Adaptations and Transformations* (New York and London: Methuen, 1986), 25–39.

33. This, of course, is the traditional use of magic in the fairy tale. As Jack Zipes points out, the German fairy tales from the period of industrialization (the late eighteenth century) are narratives that center on the quest for change. In its social context, the German Romantic fairy tale of the age of Enlightenment looked for changes to bring about aesthetic and moral superiority to everyday life. See Jack Zipes, *Breaking the Magic Spell: Radical Theories of Film and Fairy Tales* (Austin: University of Texas Press, 1979), especially 41–92.

34. The ending of the film resembles that of Part I of Goethe's *Faust*. The utopian nature of this "liturgy of love" is usually understood as important to the logic of the play. Through love, Gretchen will educate Faust and lead him to higher spheres. See Heinz Schlaffer, "Fausts Endes," *Das Argument* 99 (1976): 772–79.

35. The material on the changes to time and history brought about by industrialization and technologization is extensive. For a comprehensive review of the literature within the social sciences on the subject, see Helga Nowotny, "Time

and Social Theory: Towards a Social Theory of Time," *Time and Society* 1, no. 3 (1992): 421–54. Although not specifically following any one conception of time and history in relation to modernity, my interpretations of all three films have been developed against the background of the following books: Helga Nowotny, *Time: The Modern and Postmodern Experience,* trans. Neville Plaice Polity Press, 1994); Hans Blumenberg, *Lebenszeit und Weltzeit* (Frankfurt am Main: Suhrkamp, 1986); E. P. Thompson, "Time, Work-Discipline and Industrial Capitalism," *Past and Present* 38 (December 1967): 56–97; Lewis Mumford, *Technics and Civilization* (New York: Harcourt, 1934).

36. Kracauer discusses this situation in which the white-collar workers of the Republic, those who would have ordinarily embraced the changes, were threatened with marginalization. See, for example, Siegfried Kracauer, "Those Who Wait" and "The Little Shopgirls Go to the Movies," in *The Mass Ornament: Weimar Essays,* trans. and ed. Thomas Y. Levin (Cambridge: Harvard University Press, 1995), 129–40, 291–304.

37. V. R. Berghahn, *Modern Germany: Society, Economy and Politics in the Twentieth Century* (Cambridge: Cambridge University Press, 1982). Figures from Tables 23, 24, 25.

38. Rembert Unterstell, *Mittelstand in der Weimarer Republik* (Frankfurt: Lang, 1989).

39. For an excellent overview of the understanding of cinema's distortion of time by early filmmakers, see Matt K. Matsuda, "Spectacles: Machineries of Magic," in *The Memory of the Modern* (New York and Oxford: Oxford University Press, 1996), 165–83.

40. Matuszewski was a writer and publicist in France fascinated by the new medium and, in particular, its capacity to stop time. See ibid., 167–68.

41. Rosen was interested in the use of film images for reporting and disseminating the daily news in Britain in the 1910s. When he wrote of the "instant" transmission of images, he referred to the use of film footage for the representation of events taken the same day in a distant place. Thus, it was not quite the "instantaneity" of satellite television, but Rosen was correct to point to the gradual destruction of the time lapse between the happening of an event and its appearance in a news report in a far-off place. See ibid., 171. In his post–World War II writings Siegfried Kracauer believes the cinema's proclivity to capture the ephemeral and transient aspects of material life is the animating desire of the cinema. See Siegfried Kracauer, *Theory of Film: The Redemption of Physical Reality* (Princeton, NJ: Princeton University Press, 1997; originally published 1960), especially 41–74.

42. Matsuda, "Spectacles," 173.

43. For both Benjamin and Kracauer, the technological image has the potential to ameliorate the human relationship to this historical world. See, for example, Walter Benjamin, *One-Way Street and Other Writings,* intro. Susan Sontag, trans. Edmund Jephcott and Kingsley Shorter (London: New Left Books, 1979); "Paris,

Capital of the Nineteenth Century," in Peter Demetz, ed., *Reflections*, trans. Edmund Jephcott (New York: Schocken Books, 1978), 146–62. For a reading of the place of cinema through Benjamin's Weimar writings, and in particular, *One-Way Street*, see Miriam Hansen, "Benjamin and Cinema: Not a One-Way Street," *Critical Inquiry* 25, no. 2 (winter 1999): 306–43. See also Siegfried Kracauer, "On Photography," in *The Mass Ornament*, 47–63; Kracauer, *Theory of Film*. It is true that much of what Kracauer says in *Theory of Film* went left unsaid in the interwar years; however, the earlier Weimar pieces are more than precursors of what is to become fully conceptualized in Kracauer's American years.

44. In an undeveloped reference to the same equation between Loew and the film director, Noah Isenberg discusses the way that Loew "has the power over the spectacle—over the aesthetic medium—a power that is repeatedly emphasized throughout the film" ("Weimar Cinema, the City, and the Jew: Paul Wegener's *Der Golem*," in *Between Redemption and Doom: The Strains of German-Jewish Modernism* [Lincoln: University of Nebraska Press, 1999], 85–86). Isenberg is interested in the general power of the Jew in modern society, as opposed to the self-reflective qualities of *Der Golem*.

45. Eisner, *The Haunted Screen*, 64–74.

46. "Ein Gespräch mit Paul Wegener. Einführendes zum 'Golem,'" *Film-Kurier* 2, no. 244 (29 October 1920): 2.

47. Ibid.

48. Another type of spatial abstraction and disorientation through uneven lighting is seen in, for example, those scenes in which Rotwang chases the human Maria through the cavernous catacombs with his torchlight in *Metropolis*. Here it is almost impossible to trace the characters' path through the catacombs because of the minimal lighting.

49. Andrej, "Der Golem, wie er in die Welt kam," *Film-Kurier* 2, no. 245 (30 October 1920): 1. See also Barthélemy Amengual, "Quand le décor est le film: Notes sur l'expressionnisme allemand cinématographique," *Positif*, no. 331 (September 1988): 39–44.

50. In addition to the use of light for the construction of space in the films analyzed in chapter 5, well-known films such as *Nosferatu, Dr. Mabuse der Spieler*, or *Zur Chronik von Grieshaus/Chronicle of the Gray House* (Carl Mayer, 1925) all boast similar, although not identical, representations of space in light.

51. Frank Kessler posits that *Der Golem* can be seen to belong to the filmic tradition in which an inanimate figure is given a soul through a process of occult magical creation ("Beschwörung, Erscheinung, Beseelung—wie der Golem in die Welt kommt," *Sequenz* 7 [1994]: 232–37). Although Kessler explores the analogy between technology and magic, he is more interested in montage as a form of magic. Similarly, although he acknowledges the fact that these magical moments are never empty of narrative meaning, he does not go into detail on what their significance might be in *Der Golem*.

52. "Ein Gespräch mit Paul Wegener," 2.

53. Film technology's imbrication with the reorganization of temporality and history was a primary concern of the Weimar critical theorists in their diagnostic approaches to the cinema. In addition to Benjamin's and Kracauer's thoughts on the relations between technology and temporality, for thinkers such as Bloch and Adorno, history is necessarily implicated in the relentless burgeoning of popular culture. Technological representation and entertainment is woven into the logic of capital, which, necessarily, provides the model of historical progress for these Marxist materialists.

54. "Paul Wegener, "The Golem," in Dr. Roger Manvell, *Masterworks of the German Cinema* (London: Lorrimer Publishing, 1973), 41.

55. See Isenberg, "Weimar Cinema, the City, and the Jew," 87–88, and Anonymous, "Der Golem, wie er in die Welt kam," *Film Blätter*, no. 98 (1963). As Isenberg also points out, the film blurs the distinction between the mythical and the historical. This is reinforced by the interview with Wegener cited earlier.

56. See Karl Freund, "Die Berufung des Kameramannes" and "Wir brechen mit der Tradition!" in Rolf Aurich und Wolfgang Jacobsen, eds., *Werkstatt Film. Selbstverständnis und Visionen von Filmleuten der zwanziger Jahre* (Munich: edition text + kritik, 1998), 19–25, 65–67.

57. See Kai Möller, *Paul Wegener. Sein Leben und seine Rollen* (Hamburg: Rohwohlt, 1954).

58. See, for example, Eduard Korrodi, "Golem—Wegener—Poelzig" (1921), reprinted in Güttinger, *Kein Tag ohne Kino*, 323–26. As I indicated in chapter 3, the attraction to these myths and legends could be explained by their familiarity and popularity among 1920s audiences. Korrodi draws attention to the very cinematic nature of the magic scenes, the gestures of Wegener as the Golem, and the highly stylized crowd scenes. Korrodi, like Sieburg, celebrates the magical explorations in technology as the site of *Der Golem*'s departure from theater or literature. Wegener also wrote articles and gave lectures on the developments of film as a medium in the prewar years. Wegener's ideas were influential among Weimar filmmakers and theoreticians. See, for example, Paul Wegener, "Von den künstlerischen Möglichkeiten des Wandelbildes," *Kunstwart* 2 no. 30 (1916–17): 13–15.

59. See, for example, Paul R. Mendes-Flohr and Jehuda Reinharz, eds., *The Jew in the Modern World: A Documentary History* (New York and Oxford: Oxford University Press, 1980), especially Part VI.

60. George Konrad, "The Modernization of the Jews," *Partisan Review* 63, nos. 3–4 (1996): 571–79.

61. Trude Maurer, *Ostjuden in Deutschland, 1918–1933* (Hamburg: Hans Christians, 1986), 95; statistic from Mendes-Flohr and Reinharz, *The Jew in the Modern World*, Table V, 529.

62. The lighting in Lang's retelling of the *Nibelungenlied* has received much critical applause. See, for example, Sabine Hake, "Architectural Hi/stories: Fritz Lang and *The Nibelungs*," *Wide Angle* 12, no. 3 (July 1990): 38–57. Hake is interested in Lang's use of light and darkness for its "symbolic significance" and "ma-

terial force." Eisner also admires the way in which the lighting in *Die Nibelungen* gives "depth"—by which she means expressive potency—to people, objects, and landscapes (*The Haunted Screen*, 151–60).

63. Frank Kessler points to this difference between the creation scene in *Metropolis* and that in *Der Golem*, although he does not venture to interpret the distinction. See Frank Kessler, "Beschwörung, Erscheinung, Beseelung—wie der Golem in die Welt kommt," *Sequenz* 7 (1994): 232–37.

64. See Siegfried Kracauer, *From Caligari to Hitler: A Psychological History of the German Film* (Princeton, NJ: Princeton University Press, 1947), 91–95. Although Siegfried might be the protagonist of the *Nibelungenlied*, he is no hero and neither is he heroized after his death. He is, rather, vulnerable and fated to die from the beginning.

65. See Tom Gunning's analysis of Lang's work in *The Films of Fritz Lang: Allegories of Vision and Modernity* (London: British Film Institute, 2000). See also Andreas Huyssen, "The Vamp and the Machine: Fritz Lang's *Metropolis*," in *After the Great Divide* (Bloomington: Indiana University Press, 1986), 65–81; Anton Kaes, "Metropolis: City, Cinema, Modernity," in *Expressionist Utopias: Paradise, Metropolis, Architectural Fantasy* (Los Angeles: Los Angeles County Museum of Art, 1994), 146–65. The ambiguity and contradictions of Lang's films with regard to the emergent technologies often arise from the unevenness of the narrative trajectory and the inconsistencies in, for example, Lang's use of allegorical symbols. And if *Siegfried*'s claims regarding the cinema are in any way innovative, unlike *Faust* and *Der Golem*, the innovations are not consciously conceived by this inconsistent, and at times overrefined, film. In a more recent interpretation of the trademark Lang ambivalence toward technology, Elsaesser interprets it for its staging of the irony and cynicism of a contemporaneous way of seeing the world. See Thomas Elsaesser, "Traps for the Mind and Eye: Fritz Lang's Dr Mabuse and Other Disguise Artists," in *Weimar Cinema and After*, 145–95.

66. Tom Gunning, "'Now You See It, Now You Don't': The Temporality of the Cinema of Attractions," in Richard Abel, ed., *Silent Film* (New Brunswick, NJ: Rutgers University Press, 1996), 73. For Gunning's original article on the cinema of attractions, see Tom Gunning, "The Cinema of Attractions: Early Film, Its Spectator and the Avant-Garde," in Thomas Elsaesser, ed., *Early Cinema, Space Frame Narrative* (London: British Film Institute, 1990), 56–62.

67. Gunning, "'Now You See It, Now You Don't,'" 73.

68. Although this is the only connection between the Burgundians and Alberich in Lang's film, traditionally, as is the case in Wagner's *Ring* cycle, Alberich is Hagen's father.

69. This is a typical example of the fragility of identity expressed through shifting names and masks in Lang's films, discussed by Tom Gunning in *The Films of Fritz Lang*.

70. The majority of contemporary critics who attend to the presence of the robot Maria consider how she functions as a projection for the fears and desires

of a masculine sexual identity. See Patricia Mellencamp, "Oedipus and the Robot in *Metropolis*," *Enclitic* 1 (spring 1981): 20–42; Roger Dadoun, "*Metropolis* Mother-City—'Mittler'—Hitler," *Camera Obscura*, no. 15 (Fall 1986): 138–73. To a certain extent, this is also the concern of Andreas Huyssen, "The Vamp and the Machine," 65–81.

71. For details of Ufa's loss of control of the money that went into the making of the film, see Michael Tötenberg, "Der Turmbau zu Babelsberg: Fritz Lang's 'Metropolis,'" in Bock and Tötenberg, *Das Ufa-Buch*, 180–82.

72. On the use of the camera to create these crowd scenes, see Theodor Heuss, "Metropolis," *Hilfe*, no. 33 (1927): 108–9. On the marvelous architectural creations, see the review in *Der Kinematograph*, no. 1039 (16 January 1927): 21. The overwhelming response to the film upon its release was one of dismissal on the basis of the fact that the technological experiments are empty of meaning. See, in particular, Herbert Jhering's vilification of the film in which he calls it a "Weltanschauungsfilm" without a "Weltanschauungsfilm" ("Der Metropolis-Film," reprinted in *Von Reinhardt bis Brecht: Vier Jahrzehnte Theater und Film*, vol. 2, *1924–1929* (Berlin: Aufbau, 1958), 523–24.

73. Haghi, the evil bank manager (played by Rudolphe Klein-Rogge, the same actor who plays Rotwang) has the same light fixtures on the walls of his private quarters in *Spione* (1928). However, for Haghi it is not light, but other technological contraptions—telephones, radios, clocks, and sophisticated intercommunication systems—that facilitate his work as a spy.

74. Like Alberich and Rabbi Loew, Rotwang is a Jewish magician overseeing the creation of a human being through light and cinema. However, *Metropolis* does not narrativize his Judaism. On the anti-Semitism of this introduction and almost immediate abandonment of Rotwang's Judaism, together with the fact that he is coded as evil and falls to his death at the end of the film (and is therefore disposed of by the narrative), see Roger Dadoun, "*Metropolis* Mother-City."

75. Heide Schönemann likens the articulation of the mechanical body to those of Oskar Schlemmer in which the torso is circled by electrical wire. Certainly, Lang was not the first artist from the period to conceive of an "electrical human." See Heide Schönemann, "Berlin und die Avantgarde," in *Fritz Lang. Filmbilder Vorbilder* (Potsdam: Filmmuseum Potsdam, Edition Hentrich, 1992), 56.

76. Mellencamp, "Oedipus and the Robot in *Metropolis*," 39.

77. In Lang's *Spione* (1928) such circles establish the connection between sensational news and the radio tower that emits this news. The neon rings emanate from a radio tower and then there is a cut to a newspaper headline announcing the misdeeds of the spies. From the corner of the newspaper, identical concentric circles of neon light emanate. See Heide Schönemann, "Im elektrischen Feld," in *Fritz Lang*, 57.

78. In one of the film's most memorable images, we see Moloch the machine explode and its mouth consume the workers when the overworked operator of the manual clock cannot move its hands at the pace necessary to keep the machine

functioning. Thus, on the one hand, the micromanagement of time in the factory is oppressive, and, on the other hand, the film embraces multiple historical transgressions for the creation of a robot, the workers' potential liberation.

79. For a more recent article on the politics of *Metropolis,* particularly in relation to Nazism, see R. L. Rutsky, "The Mediation of Technology and Gender: *Metropolis,* Nazism, Modernism," *New German Critique,* no. 60 (fall 1993): 3–32.

80. For a semiautobiographical history of the Frankfurt School and its participants, see Martin Jay, *The Dialectical Imagination: A History of the Frankfurt School and the Institute for Social Research, 1923–1950* (Boston: Little Brown, 1973). As Jay explains, the choices left to Central European Marxists at this time were threefold: they could scorn the Russian experiment and support the "soft" socialism of the Republic, join the German Communist Party and work to undermine the Weimar Republic's bourgeois compromise, or, alternatively (the path they chose), to undertake a theoretical reexamination of classical Marxist doctrines.

81. See Theodor Adorno, "The Schema of Mass Culture," in J. M. Bernstein, ed., (London: Routledge, 1991), 53–84.

82. Here we see Adorno's shortsightedness of magic, because what he does not account for is the fact that every magic trick can be scientifically explained; it is simply that the explanation is withheld to maintain the audience's awe. Magic tricks tend not to be repeated many times, because once an audience understands the mechanism of the trick, it ceases to be magic. See Barnouw, *The Magician and the Cinema.*

83. Walter Benjamin was among the first of many to criticize Bloch in his now-famous allegorical critique of *Heritage of Our Times.* He writes: "The serious objection which I have of this book (if not of its author as well) is that it in absolutely no way corresponds to the conditions in which it appears, but rather takes its place inappropriately, like a great lord, who arriving at the scene of an area devastated by an earthquake can find nothing more urgent to do than to spread out the Persian carpets—which by the way are already somewhat moth-eaten—and to display the somewhat tarnished golden and silver vessels, and the already faded brocade and damask garments which his servants had brought" (quoted by Anson Rabinbach, "Unclaimed Heritage: Ernst Bloch's *Heritage of Our Times* and the Theory of Fascism," *New German Critique,* no. 11 [spring 1977]: 5).

84. See Ernst Bloch, "The Fairy Tale Moves on Its Own in Time," in *The Utopian Function of Art and Literature: Selected Essays,* trans. Jack Zipes and Frank Mecklenburg (Cambridge: MIT Press, 1988), 163–66, and "Die Angst des Ingenieurs," in *Gesamtausgabe,* vol. 9 (Frankfurt am Main: Suhrkamp, 1965), 362–67. See also Ernst Bloch, "Technik und Geistererscheinungen," in *Verfremdungen I* (Frankfurt am Main: Suhrkamp, 1961), 177–85.

85. I am grateful here to Jack Zipes for drawing my attention to the relevance of Bloch's notion of *Vor-Schein* for my argument. See Ernst Bloch, "The Artistic Illusion as the Visible Anticipatory Illumination," in Zipes and Mecklenburg, *The Utopian Function of Art and Literature,* 141–55.

86. See Ernst Bloch, "Nonsynchronism and the Obligation to Its Dialectics," trans. Mark Ritter, *New German Critique*, no. 11 (spring 1977): 22–38.

87. Herein lies the nostalgia for Romanticism in Bloch's thesis. He still believes in the possibility of knowledge through transcendence, albeit emotional or psychological rather than spiritual.

88. See, as an example of this trend, Anton Kaes, "The Cold Gaze: Notes on Mobilization and Modernity," *New German Critique,* no. 59 (spring/summer 1993): 105–17. For a discussion of the debate over whether these films should be considered national or international, see Kristin Thompson, "National or International Films? The European Debate during the 1920s," *Film History* 8, no. 3 (1996): 281–96.

## 5. Reformulations of Space through Light in *Die Straße, Jenseits der Straße,* and *Am Rande der Welt*

1. This characteristic cannot always be extended to abstract images. When filmmakers such as Stan Brakhage work directly with the surface of the filmstrip, they are deliberately renegotiating this aspect of the medium.

2. For a limited history of the spatial definition of medieval towns at night, created as it was by the night watchman's torch as he moved through his rounds after curfew, see Wolfgang Schivelbusch, *Disenchanted Night: The Industrialization of Light in the Nineteenth Century,* trans. Angela Davies (Berkeley: University of California Press, 1988), 82. For another reference to the medieval spatial definition through light, see Reyner Banham, *The Architecture of the Well-Tempered Environment* (Chicago: University of Chicago Press, 1969), 55. Banham gives a detailed account of how industrial and technological inventions, such as the power of heat and light, transformed the design of the modern environment.

3. Karl-Heinz Metzger and Ulrich Dunker, *Der Kurfürstendamm. Leben und Mythos des Boulevards in 100 Jahren deutscher Geschichte* (Berlin: Knopka, 1986), especially chapter 3, "1918–1933."

4. See Dr. M—I, "Kinoläden," *Licht-Bild-Bühne,* no. 159 (22 August 1925): 12–13, for a discussion of the considerations that go into dressing the windows of film companies such as Ufa. See also, Dr. Victor Mendel, "Filme im Schaufenster," *Der Kinematograph,* no. 1044 (20 February 1927): 39–40, on the technical strategies for the projections of film in shopwindows.

5. This advertisement can be found in Janet Ward Lungstrom, "The Display Window: Designs and Desires of Weimar Consumerism," *New German Critique,* no. 76 (winter 1999): 141. Janet Ward's book on the bright lights of consumer display culture and its lure of the consumer in the Weimar Republic gives extensive detail of such phenomena (*Weimar Surfaces: Urban Visual Culture in 1920s Germany* (Berkeley and Los Angeles: University of California Press, 2001).

6. See Heinz Udo Brachvogel, "Lichter in der Nacht," *Der Kinematograph* 942 (8 March 1925): 15.

7. See Renate Bridenthal, Atina Grossman, and Marion Kaplan, eds., *When Biology Became Destiny: Women in Weimar and Nazi Germany* (New York: Monthly Review Press, 1984). See also Ute Frevert, *Women in German History: From Bourgeois Emancipation to Sexual Liberation,* trans. Stuart McKinnon-Evans et al. (Oxford: Berg, 1989).

8. Siegfried Kracauer's writings on Weimar mass culture remain the most sophisticated analysis of the relationship between cinema and the changes to everyday life brought about by modernity in Germany. See his articles in *The Mass Ornament: Weimar Writings,* trans. and ed. Thomas Y. Levin (Cambridge: Harvard University Press, 1995). See also Dietrich Neumann, "The Urbanistic Vision in Fritz Lang's *Metropolis,*" in Thomas Kniesche and Stephen Brockmann, eds., *Dancing on the Volcano: Essays on the Culture of the Weimar Republic* (Columbia, SC: Camden House, 1994), 144–62. See also Miriam Hansen, "Early Cinema: Whose Public Sphere?" in Thomas Elsaesser, ed., *Early Cinema: Space, Frame, Narrative* (London: British Film Institute, 1990), 228–46.

9. This is often achieved in other films from the period through the use of editing. A notable example would be *Metropolis* when Freder walks from his bedroom into the cathedral to meet Maria as though a doorway connects the two spaces. Thus, the innovation is not always done in light, but it is characteristic of the cinema of the period.

10. See Sybil Del Gaudio, "A Developing Aesthetic, *The Salvation Hunters* and *Underworld,*" in *Dressing the Part: Sternberg, Dietrich, and Costume* (London and Toronto: Associated University Presses, 1993), 23–28.

11. Although scholars of Weimar and Wilhelminian film do not privilege the use of light in their analyses, they do often attend to the centrality of spatial articulations as a metaphor for social dynamics. See, for example, Leon Hunt, "The Student of Prague," in Elsaesser, *Early Cinema,* 389–401; Thomas Elsaesser, "Social Mobility and the Fantastic," in Mike Budd, ed., *The Cabinet of Dr. Caligari: Texts, Contexts, Histories* (New Brunswick, NJ: Rutgers University Press, 1990), 171–89. See also Patrice Petro, *Joyless Streets: Women and Melodramatic Representation in Weimar Germany* (Princeton, NJ: Princeton University Press, 1989), especially chapter 4.

12. See Stephan Grossmann, "Meister der Films," *Das Tagebuch* 4, no. 50 (15 December 1923): 1726–27; Anonymous, "Die Straße," *Berliner Börsen-Courier,* no. 562, 30 November 1923.

13. Anonymous, "Die Straße. Resumé einer Filmaufnahme," *Licht-Bild-Bühne,* no. 34 (21 August 1923): 15.

14. In contrast to the contemporary reviews, Lotte Eisner elevates the melodramatic narrative to the status of carrying *Die Straße*'s meaning (*The Haunted Screen,* trans. Roger Greaves [Berkeley: University of California Press, 1965], 252–56).

15. The review in *Der Kinematograph* actually claims that *Die Straße* is a Dadaist vision that dissolves into a vision reminiscent of a Raoul Hausmann painting. See Anonymous, "Die Straße," *Der Kinematograph,* no. 876 (2 December 1923): 7.

Karl Hasselmann had already worked on projects with Urban Gad, Stellan Rye, and E. A. Dupont by 1923. His most outstanding work in light to date (which bore striking resemblances to the design of the backstreets in *Die Straße*) was with Leopold Jessner and Paul Leni in *Hintertreppe* (1921). He would also go on to do the indoor light design in Lupu Pick's *Sylvester* (1923), discussed in chapter 6.

16. This argument, made in particular by the reviewer for the *Licht-Bild-Bühne,* is an early journalistic articulation of a phenomenon that today continues to capture the imagination of critics, namely, that the cinema brings to life the emotional and mental experience of life in the metropolis. To put it another way, the cinema can imitate the impact of the metropolis on the senses. See Anonymous, "Die Straße. Resumé einer Filmaufnahme," and Manfred Georg, "Die Straße," *Die Weltbühne* 2, no. 51 (1923): 640. These reviews may be less nuanced, but they bear the essence of arguments such as those of James Donald, "Light in Dark Spaces: Cinema and City," in *Imagining the Modern City* (Minneapolis: University of Minnesota Press, 1999), 63–92. Donald, of course, acknowledges the critical conceptualization of the equation between the experience of cinema and that of life in the modern metropolis as taking place in Weimar Germany.

17. Herbert Jhering, "Die Straße" (30 November 1923), reprinted in *Von Reinhardt bis Brecht: Vier Jahrzehnte Theater und Film,* vol. 1, *1909–1923* (Berlin: Aufbau, 1958), 469–71.

18. Siegfried Kracauer, *From Caligari to Hitler: A Psychological History of the German Film* (Princeton, NJ: Princeton University Press, 1947), 121.

19. This image of the city as a two-dimensional film of light is not peculiar to *Die Straße.* In German photography, for example, Gyorgy Kepes's *Untitled* of 1930, taken in the vicinity of Zoo train station, represents a clash of neon lights, streetlights, and those emanating from inside. It is a similar two-dimensional, dynamic image of the city at night. Similarly, in Man Ray's *Rayogram* of 1931, Paris at night is identified by the shape of the Eiffel Tower in lights, surrounded as it is by a flurry of neon. What is unique about a film such as *Die Straße* is the use of this image as the vehicle for a narrative film on the city.

20. See Henri Alekan, "The Magic of Light in Film, *Daidalos,* no. 27 (15 March 1988): 86–92. See also Robert Müller, "Lichtbildner. Zur Arbeit des Kameramannes," in Cinema Quadrat e.V., ed., *Gleißende Schatten* (Berlin: Henschel, 1994), 35–62.

21. See Rafal Landau, "Lichteffekte in der Kinematographie," *Der Kinematograph,* no. 1123 (1 July 1928): especially 24–25, on the creation of night light in the studio through use of filters. A good example of this strategy can be found in the often-cited sequence at the end of G. W. Pabst's *Die Büchse der Pandora/Pandora's Box* (1928), in which Lulu wanders through the streets of London and lures Jack the Ripper. The eerie, fog-filled streets are always lit from above as well as through discrete key lights placed perpendicular to the characters. This lighting setup forges both the ghostly atmosphere of a foreboding London and the visual articulation of the characters as three-dimensional bodies. However,

when we see Jack the Ripper leave Lulu's apartment from Alwa's point of view, a single offscreen right light source pierces the dense fog to turn the murderer into a silhouette as he passes into the night.

22. On the placement and use of lights in the Weimar studios, see also Gert Koshofer, "Die Filmmaterialien," in *Gleißende Schatten*, 111–22.

23. See Klaus Kreimeier, "Naheinstellung: Karl Freund," in *Gleißende Schatten*, 25–32. Interestingly, Kreimeier also quotes a section of the script of *Der Letzte Mann* that focuses on the collapse of the inside and outside worlds in the sequences shot through and around the revolving door of the hotel. Again, it is a blurring of the distinction between inside and outside through a use of light.

24. The first time that action was shot on the streets at night in Germany was for the scene in which von Wenck (having just been overpowered by Mabuse's will and seen the letters "Tsi Nan Fu" on the cards) chases Dr. Mabuse through the streets from the secret gambling club back to his hotel in *Dr. Mabuse, der Spieler.* Thus, it is only in 1922, one year before *Die Straße,* that on-location outdoor footage is shot at night.

25. On the sensitivity to the tension between surface and depth constructed through editing and lighting, see Hanns Marschall, "Der plastische Film," *Deutsche Filmwoche,* no. 15 (7 August 1925): 9.

26. Otto Stindt, "Aufnahmelampen," *Filmtechnik,* no. 9 (1928): 160–64.

27. There was ongoing discussion in the film magazines regarding the search for appropriate intensities of film lighting. The solution to these problems involved consideration of more than simply the power of the light source. It was also a question of the effects of the lenses, film stock condensors, and mirrors that were used in any given setup. Moreover, the appropriate placement and shape of the mirrors was also much discussed. See, for example, Anonymous, "Aufnahmelampen," *Der Kinematograph,* no. 942 (8 March 1925): 58; Anonymous, "Der Einfluß der Beleuchtungsanordnung," *Der Kinematograph,* no. 1036 (26 December 1926): 50; H. P., "Die wahre Lichtstärke des Objektivs," *Der Kinematograph,* no. 1045 (28 February 1927): 36; Dr. A. Sonnefeld, "Beleuchtungsspiegel—im Spiegel der Zeit," *Filmtechnik,* no. 20 (1928): 395–96.

28. It is this prolonged attention to the facade of the city with no apparent narrative significance that presumably prompts the Weimar critics to posit the city as the film's protagonist.

29. In another very poignant, but narratively unintegrated scene, the blind grandfather of the little girl whose father is caught up in gambling and womanizing follows her outside of the apartment when she runs after her father who has just committed a murder. But he cannot find her because he cannot see her. The film dwells on him as he stands in full view to all, directly under a streetlight. He distressingly turns about himself, but is helpless, he cannot see. Without sight, these streets are impenetrable: they are no longer tactile and the noise level is presumably so high that it is impossible to filter out all but the sought-after sounds. The street sees the grandfather, it is alive with eyes, but he cannot see it. If such a

scene has relevance to the remainder of the film, it is not a relevance that pertains to the cause-and-effect narrative. Rather, its relevance can only lie in its further detailing of the streets as dangerous.

30. Again, the intensity of the light given out by these streetlights in the backstreets is inconsistent with their customary intensity: it is far too bright. We can assume that Hasselmann has replaced the original bulbs of the streetlights with a stronger source.

31. This strategy of rendering space strange through partial illumination is common in Weimar cinema. The difference in *Die Straße* is that the source of the light is given as the streetlights, rather than the viewer assuming that it is cinematic lighting, that is, lighting employed solely for the purpose of constructing the artificial image.

32. For statistics and descriptions of migration from country to city and its effects, see Dietmar Petzina, *Die deutsche Wirtschaft in der Zwischenkriegszeit* (Wiesbaden: Steiner, 1977), and Jürgen Reulecke, *Geschichte der Urbanisierung in Deutschland* (Frankfurt: Suhrkamp, 1985).

33. For accounts of this darker side of modernization in Germany, see any of the major histories of the Republic. For insight into the gross injustices committed by authorities against some sectors of the community at this time, see Robert W. Whalen, *Bitter Wounds: German Victims of the Great War, 1924–1939* (Ithaca, NY: Cornell University Press, 1984). As mentioned in chapter 1, war veterans were one demographic that the authorities did not have the resources to integrate into the larger community. Thus, their situation simply grew worse.

34. Cited by Joachim Schlör, *Nights in the Big City: Paris, Berlin, London 1840–1930*, trans. Pierre Gottfried Imhof and Dafydd Rees Roberts (London: Reaktion Books, 1998), 141; emphasis in the original.

35. Walter Benjamin, "The *Flâneur*," in *Charles Baudelaire: A Lyric Poet in the Era of High Capitalism* (London: New Left Books, 1973), 35–66.

36. Simmel's most famous writing on this topic argues that the inhabitant of the metropolis assumes the frenetic energy and neuroses of his or her mechanized surroundings. For Simmel, the mass media mediated between the reality of the metropolis and its imaginary place in mental life. See Georg Simmel, "The Metropolis and Mental Life," in David Frisby and Mike Featherstone, eds., *Simmel on Culture: Selected Writings* (London: Sage, 1997). In his book on the development of the technologically modern landscape of Berlin at the turn of the century, Peter Fritzsche identifies the newspapers as the medium of mediation (*Reading Berlin 1900* [Cambridge: Harvard University Press, 1996]). See also Siegfried Kracauer, *Die Angestellten: Aus dem neuesten Deutschland*, ed. Karsten Witte (Frankfurt: Suhrkamp, 1971 [1930]); Georg Simmel, "The Metropolis and Mental Life," in Kurt Wolff, ed., *The Sociology of Georg Simmel* (New York: Free Press, 1950), 413–44. In German film, this image is also familiar to us from Walter Ruttmann's *Berlin, Symphony of a City* (1927).

37. See also the number of poetry collections from the period in which artificial

light is the common denominator in representations of the technologically mod-
ern city. See, for example, Hermann Kesten, "Licht Werbung," in *Ich bin der ich
bin. Verse eines Zeitgenossen* (Munich: Piper, 1974), 11. See also the collections Karl
Riha, ed., *Deutsche Großstadtlyrik* (Munich: Artemis, 1983); Robert Seitz, ed., *Um
uns die Stadt: Eine Anthologie neuer Großstadtdichtung* (Berlin: Reclam, 1931).

38. See, for example, William Uricchio, "The City Viewed: The Films of Leyda,
Browning, and Weinberg," in Jan-Christopher Horak, ed., *Lovers of Cinema: The
First American Film Avant-Garde 1919–1945* (Madison: University of Wisconsin
Press, 1995), 287–314.

39. See, for example, Donald, "Light in Dark Spaces."

40. Ernst Reinhardt, "Gestaltung der Lichtrekleme," *Die Form* 4, no. 4 (15 Feb-
ruary 1929): 73–84. Reinhardt takes his examples from Moholy-Nagy's "Foto-
gramms" through signal lights at the Berlin airport to the advertising columns on
Kurfürstendamm.

41. Walter Benjamin, "The Paris of the Second Empire in Baudelaire," in
*Charles Baudelaire*, 37.

42. See Susan Buck-Morss, "The Flâneur, the Sandwichman and the Whore:
The Politics of Loitering," *New German Critique* 39 (fall 1986): 129. See also Anke
Gleber, *The Art of Taking a Walk: Flanerie, Literature, and Film in Weimar Culture*
(Princeton, NJ: Princeton University Press, 1999).

43. See Katharina von Ankum, ed., *Women in the Metropolis: Gender and
Modernity in Weimar Culture* (Berkeley and Los Angeles: University of California
Press, 1997).

44. In most cities the number of electrically lit streetlights increased by ap-
proximately one thousand every year. See Richard Birkefeld and Martina Jung,
"Abends aber ist es am schönsten in diesen Straßen," in *Die Stadt, der Lärm und
das Licht* (Hannover: Kallmeyersche Verlagsbuchhandlung, 1994), 165.

45. Gleber, *The Art of Taking a Walk*, 31–35; Janet Lungstrum, "The Display
Window: Designs and Desires of Weimar Consumerism," *New German Critique*,
no. 76 (winter 1999): 115–60.

46. On this notion of the nostalgia within modernity, see Max Horkheimer
and Theodor W. Adorno, "Juliette or Enlightenment and Morality," in *Dia-
lectic of Enlightenment*, trans. John Cumming (New York: Continuum, 1993),
81–119.

47. See Helmut Korte, ed., *Film und Realität in der Weimarer Republik* (Munich:
Carl Hanser, 1978); Bruce Murray, *Film and the German Left in the Weimar Repub-
lic: From Caligari to Kuhle Wampe* (Austin: University of Texas Press, 1990).

48. Jutzi's film was made in the same year by the same studio (Prometheus)
as *Jenseits der Straße*.

49. *Mutter Krausens Fahrt ins Glück* is usually referred to as complying with
the *Neue Sachlichkeit* movement in art and literature of the Weimar period. For a
description of the characteristics of *Neue Sachlichkeit*, see John Willett, "Neue Sa-
chlichkeit," in *Art and Politics in the Weimar Period: The New Sobriety 1917–1933*

(New York: Da Capo Press, 1996), 111–18; originally published in 1978. Despite the tenacity with which film critics have held on to this categorization, *Mutter Krausens Fahrt ins Glück* and other films such as Brecht's *Kuhle Wampe* (1931) have little in common with the concerns of *Neue Sachlichkeit*, their only point of intersection being a common social commitment. Although the films always display a relatively sober, "objective" camera and style, they lack the examination of the matter or essence of their object so critical to the *Neue Sachlichkeit* work of George Grosz, Otto Dix, or photographers such as Renger-Patzsch or August Sander.

50. Anonymous, "Jenseits der Straße," *Der Kinematograph*, no. 238 (11 October 1929): supplement; Felix Henseleit, "Jenseits der Straße," *Reichsfilmblatt*, no. 41 (12 October 1929): 17.

51. Only two other indoor spaces are shown in the film, and both are public spaces—the café where the film opens and closes, and the Electric Bar. The café is never shown in its entirety; rather, we simply see a rich man reading a newspaper that reports the death of the beggar. Disinterested in this article, he peers over the top of his paper to spy the prostitute's legs enticing him to put down the paper and follow her out of the café. The interior of the Electric Bar is, like other indoor spaces, lit in a strange, uneven way.

52. Reviews of the film published at the time of its release praised the first-time film director for the unusual editing and camera work, techniques they identified as being influenced by the Soviets and, in particular, Pudovkin or Eisenstein. Although the use of montage techniques was familiar to German film by this time, the dynamism and potentiality of the city as a conglomerate of machines was more unusual, but by 1929 such images had become commonplace to Soviet film. What is interesting about Mittler's appropriation of the montage technique is the fact that he uses it to depict capitalism in all of its vices, rather than as an ode to the Communist city, as was the practice among the post-revolutionary Soviet filmmakers. See Gero Gandert, ed., "Jenseits der Straße," in *Der Film der Weimarer Republik, 1929: ein Handbuch der zeitgenössischen Kritik* (Berlin: Walter de Gruyter, 1993), 324–28.

53. The paintings of Otto Dix and the drawings of George Grosz engage with the public life on the streets. For example, in Grosz's ironically titled drawing *You can be sure of the thanks of the fatherland* (1924), a one-armed, legless soldier on the street is ignored by two businessmen who, in customary Grosz fashion, smoke fat cigars. The war veteran is likewise ignored by a Turkish man who hangs out a window above him, and the cigarette vendor with whom he shares the corner. Dix's *The Matchseller* (1920) represents a psychologically disturbed, legless, blind man who hawks his matches on a street otherwise reserved for the well-to-do in their pin-striped suits or, in the case of the women, stockings and high heels.

54. See Katherina von Ankum, "Gendered Urban Spaces in Irmgard Keun's *Das kunstseidene Mädchen*," in *Women in the Metropolis*, 164.

55. Atina Grossmann, *Reforming Sex: The German Movement for Birth Con-*

*trol and Abortion Reform, 1920–1950* (New York and Oxford: Oxford University Press, 1995).

56. Atina Grossmann, "The New Woman and the Rationalization of Sexuality in Weimar Germany," in Ann Snitow, Christine Stansell, and Sharon Thompson, eds., *Powers of Desire: The Politics of Sexuality* (New York: Monthly Review Press, 1983), 164.

57. This quotation is taken from the film's expositional intertitle.

58. Note that at the time of the film's release in 1927, reviewers attributed the film's confusion to the set, a "jerky" use of the camera, and the "evasion of film conventions." See Karl Wagner, "Am Rande der Welt," *Die Kinotechnik,* no. 21 (5 November 1927): 574–75; Anonymous, "Am Rande der Welt," *Kinematograph,* no. 1044 (20 February 1927): 16. There are other aspects of *Am Rande der Welt* that contribute to the spectator's disorientation, but I am emphasizing the role of the lighting here.

59. The telephone as a technological means of production was critical to the definition of World War I as a modern battlefield. Work has been done in cinema studies on the synchronicity of the telephone and cinema as sibling instruments of technological modernity. See, for example, Tom Gunning, "Heard over the Phone: *The Lonely Villa* and the de Lorde Tradition of the Terrors of Technology," *Screen* 32, no. 2 (summer 1991): 184–96. See also the essays collected in Forschungsgruppe Telefonkommunikation, ed., *Telefon und Kultur. Das Telefon im Spielfilm* (Berlin: Volker Spiess, 1991). See also Jan Olssen's "Framing Silent Calls," in Jan Olssen and John Fullerton, eds., *Allegories of Communication: Intermedia Concern from Pre-Cinema to the Digital* (Indianapolis: John Libbey/ Indiana University Press, forthcoming).

60. See John Keegan, *The Face of Battle* (London: Penguin, 1976), for a discussion of the way in which the increasing sophistication of technology changed the face of the battlefield. For examples of these images, see *Die Letzten Tage der Menschheit: Bilder des Ersten Weltkrieges,* ed., Rainer Rother (Berlin: Deutsches Historisches Museum, 1994), especially 180–93. See also Bernd Hüppauf, "Experiences of Modern Warfare and the Crisis of Representation," *New German Critique,* no. 59 (spring/summer 1993): 41–76, for a detailed discussion of the notion that the photographic apparatus was a technology that contributed to the vision of World War I as the first truly modern battlefield.

61. Again, these and other images of the World War I battlefield are not the property of German film or photography. For example, in a notable example from the opening of Alexander Dovzhenko's *Mother* (1926) we see the silhouetted soldiers on the horizon in Russia.

62. As a reviewer for the *Reichsfilmblatt* argues, this breaking down of borders between disparate spaces around the world in *Am Rande der Welt* is one of the innovations of the cinema. See Dr. W. Lo, "Am Rande der Welt. Karl Grüne und sein Film," *Reichsfilmblatt,* no. 1 (8 January 1927): 24.

63. Bodo von Dewitz, "Zur Geschichte der Kriegsphotographie des Ersten Welt-krieges," in Rother, *Die Letzten Tage der Menschheit,* 165–70.

64. Ibid., 175.

65. Ibid.

66. Bernd Weise, "Photojournalism from the First World War to the Weimar Republic," in Klaus Honnef, Rolf Sachsse, and Krain Thomas, eds., *German Photography 1870–1970: Power of a Medium* (Cologne: Dumont, 1997), 52–67.

67. Keegan, *The Face of Battle.*

68. The most renowned advocate of this concept was writing around the same time as Grüne's film was produced; see Ernst Jünger, *Feuer und Blut: Ein kleiner Ausschnitt aus einer grossen Schlacht* (Magdeburg: Strahlhelm, 1925), and *Der Arbeiter: Herrschaft und Gestalt* (Hamburg: Hanseatische Verlaganstalt, 1932).

## 6. Dazzled by the Profusion of Lights

1. Lotte Eisner refers to this sequence as a "pre-avant-garde" example of pure cinema in *The Haunted Screen,* trans. Roger Greaves (Berkeley: University of California Press, 1965), 32–33.

2. Helmar Lerski was a Swiss-born portrait photographer known for his use of light as a medium to make the eternal veracity of the invisible soul visible in the contours of the face. Among other strategies, he contrasted lighting, supplement-ed the usual diffuse top lighting with side and back lighting, and directed light through mirrors. See Ute Eskildsen and Jan-Christopher Horak, *Helmar Lerski, Lichtbildner: Fotografien und Filme 1910–1947* (Essen: Museum Folkwang, No-vember 1982); Jan-Christopher Horak, "Helmar Lerski: The Penetrating Power of Light," in *Making Images Move: Photographers and Avant-Garde Cinema,* (Washington and London: Smithsonian Institution Press, 1997), 55–78.

3. For an analysis of the Ripper's sexual murders in London in 1888 and the construction of the Jack the Ripper myth, see Judith R. Walkowitz, "Jack the Rip-per and the Myth of Male Violence," *Feminist Studies,* no. 8 (fall 1982): 542–74. This myth took hold of the popular German imagination in the first three decades of the twentieth century, and it is seen not only in *Wachsfigurenkabinett* but in other well-known representations, including, after Frank Wedekind's play of 1895, G. W. Pabst's *Die Büchse der Pandora* (1928) and George Grosz, "Jugen-derinnerungen," *Der Kunstblatt,* 13 June 1929, 172–74.

4. Maria Tartar, *Lustmord: Sexual Murder in Weimar Germany* (Princeton, NJ: Princeton University Press, 1995).

5. Tom Gunning, "The Cinema of Attractions: Early Film, Its Spectator and the Avant Garde," in Thomas Elsaesser, ed., *Early Cinema: Space Frame Narrative* (London: British Film Institute, 1990), 56–62.

6. This notion of mass entertainment in the age of technological industri-alism is now a familiar one. However, in what follows, I will expand upon the

characteristics of an entertainment, or leisure activity, that befits the contours of modern industrial life.

7. By contrast, Dix's and Grosz's populating of their canvases with war veterans leaves no doubt in the viewer's mind of the cause of social unrest and moral confusion.

8. Wolfgang Jansen, "Der Wintergarten," *Das Varieté: Die glanzvolle Geschichte einer unterhaltenden Kunst* (Berlin: Hentrich, 1990), 89–104.

9. Ibid.

10. For a comprehensive history of the variety theater in Germany, France and Britain, see Ernst Gunther, *Geschichte des Varietés* (Berlin: Henschelverlag, 1981); quotation from p. 42.

11. Uta Berg-Ganschow and Wolfgang Jacobsen, eds., . . . *Film* . . . *Stadt* . . . *Kino* . . . *Berlin* . . . (Berlin: Argon, 1987), 37. Film was often the last number in a variety show. In these cases, all of the other acts led up to the film as the climax of the evening.

12. For a sophisticated analysis of the more political entertainment spheres of cabaret in Weimar Germany, see Alan Lareau, *The Wild Stage: Literary Cabarets of the Weimar Republic* (Columbia, SC: Camden House, 1995); and Peter Jelavich, *Berlin Cabaret* (Cambridge: Harvard University Press, 1993).

13. Gunther, *Geschichte des Varietés*, 140.

14. Ibid., 149.

15. Siegfried Kracauer, "The Cult of Distraction," in *The Mass Ornament: Weimar Essays*, trans. and ed. Thomas Y. Levin (Cambridge: Harvard University Press, 1995), 323–30. Kracauer's critique is far more sophisticated than I represent it here.

16. Gunther, *Geschichte des Varietés*, 142–43. Although the popularity of the variety show rose to prevalence at the turn of the century, after World War I it took on a different form and flavor. Before the war, the revues and variety shows were more topical, more concerned with local political and social commentary. With the internationalization of Germany following its defeat in the war, the variety and revue shows came to reflect the style and increasing Americanization of life in the modern metropolis. Thus, attention was increasingly turned to the formal aspects of the act, away from a content that discussed issues pertinent to the Wilhelmine empire or the hectic nature of Berlin as a city. See Peter Jelavich, "Variety Shows and Nietzschean Vitalism," in *Berlin Cabaret*, 20–30. In later chapters, Jelavich discusses the same shift from the political to the "entertaining" in the cabaret shows. See "Political Satire in the Early Weimar Republic" and "The Weimar Revue," in *Berlin Cabaret*, 118–53, 154–86.

17. Jelavich, *Berlin Cabaret*, 118–86.

18. This concept of "spectacle" and "spectacular society" has become overextended in recent scholarship. It was only theoretically addressed by the Situationist International in mid-1960s France as part of the implications for capitalist society of the progressive shift within production toward the provision of

consumer goods and services, and the accompanying "colonization of everyday life." However, traces of the concept of a society of the spectacle are everywhere present—without using the term explicitly—in the 1920s critical and theoretical writings of intellectuals such as Kracauer, Benjamin, and Bloch. Certainly, their Marxist theories of imperialism are underwritten by the same "making into commodities" of whole areas of social practice that is found in the Situationist International theorists. This is so despite the different phases of capitalism conceptualized by the two intellectual communities.

19. Waldemar Lydor, *Reichsfilmblatt*, no. 30 (24 July 1926): 2.

20. See Anonymous, "Rund um das Varieté," *Der Kinematograph*, no. 951 (10 May 1925): 22.

21. See Uta Berg-Ganschow and Wolfgang Jacobsen, "Die Bühnenschau," in . . . *Film* . . . *Stadt* . . . *Kino* . . . *Berlin* . . . , 37–42, for one of the only contemporary discussions of this aspect of the film industry.

22. See Richard Koszarski, "Going to the Movies," in *An Evening's Entertainment: The Age of the Silent Feature Picture, 1915–1928*, History of the American Cinema Series (New York: Maxwell Macmillan International, 1990), 9–61.

23. See Richard Abel, "Exhibition: We're in the Money," in *French Cinema: The First Wave 1915–1929* (Princeton, NJ: Princeton University Press, 1984), 49–59. In France, the usual program consisted of the feature-length film and a number of other kinds of films—a travelogue, a newsreel, a serial episode, and perhaps one or two comic shorts. In the latter half of the decade, the French picture theaters began to refine their programs to the feature film and an accompanying serial, perhaps with a newsreel.

24. Koszarski, "Going to the Movies," 38.

25. Until 1907, the Wintergarten had a glass ceiling and the stars of the Berlin sky were seen through the transparent roof. In other grand theaters, the stars otherwise painted on the ceilings were changed to electrical lights around the turn of the century. See Carl-Friedrich Baumann, *Licht im Theater: von der Argand-Lampe bis zum Glühlampen-Schweinwerfer* (Wiesbaden: Steiner, 1988).

26. Eisner refers to this use of light by Dupont and Karl Freund the cameraman as Impressionist, (*The Haunted Screen*, 278–84). Although it might resemble the Impressionists' preoccupation with surfaces radiating with light, there seems to be little Impressionistic about it.

27. Michael Esser, "Der Sprung über den Großen Teich. Ewald André Duponts 'Varieté,'" in Hans-Michael Bock and Michael Tötenberg, eds., *Das Ufa-Buch* (Frankfurt am Main: Zweitausendeins, 1992), 160–65.

28. Beaumont Newhall, *Kino: Eye of the Twenties*, Museum of Modern Art clipping file.

29. Esser, "Der Sprung über den Großen Teich," 160.

30. *Varieté* was slated to be directed by Murnau, but at the last minute Erich Pommer at Ufa gave the film to Dupont. Some sources say this was because Dupont had previous experience with vaudeville, others because Pommer thought

Murnau too "sexless" for the emotion-packed film. See *Monthly Film Bulletin* 46, no. 546 (July 1979): 160–61. The film is based on the novel by Felix Holländer, *Der Eid des Stephan Huller.*

31. See, for example, "'Varieté," Der Grosse Deutsche Film," *Der Kinematograph,* no. 979 (21 November 1928): 21; Heinrich Stürmer, "Varieté," *Das Tage-Buch* 47, no. 6 (21 November 1925): 1759–61; Balthasar, "Varieté," *Das Blaue Heft,* no. 5 (1 December 1925): 163–64.

32. Stürmer, "Varieté," 1759–61. This critical notion of the *Kammerspielfilm* was conceived by Max Reinhardt to denote those films that were more intimate dramas played out among the psychologies of a handful, usually four, characters. The *Sensationsfilm* is Stürmer's own label.

33. Nina Payne was a famous variety star of the time.

34. Balthasar, "Varieté," 163–64.

35. The modern use of light as spectacle has its origins in the Baroque fireworks. See Werner Oechslin, "Light: A Means of Creation between Reason and Emotion," *Daidalos,* no. 27 (15 March 1988): 29.

36. For a short discussion of the integration of fireworks from Baroque to modern times, see Richard Alewyn, "Das Feuerwerk," in *Das große Welttheater. Die Epoche der höfischen Feste* (Munich: C. H. Beck, 1989), 26–27.

37. Gunther, *Geschichte des Varietés,* 147.

38. Ibid., 148.

39. See Siegfried Kracauer, "The Mass Ornament," in *The Mass Ornament,* 75–88. Kracauer was not the only critic of the time to bemoan the spiritless state of affairs in the new mass entertainments. Thus, for example, Artur Moeller-Bruck claimed that the appeal of this vaudeville-type attraction and entertainment for the masses was a fulfillment of the desire to experience the instinctive sensuality that he is forced to repress in the industrial workplace. See Artur Moeller-Bruck, *Das Varieté,* (Berlin: J. Bard, 1902), 22.

40. Quoted in Gunther, *Geschichte des Varietés,* 148.

41. Quoted in Jalevich, *Berlin Cabaret,* 23.

42. On the integration of sexual issues ranging from the scientific through the moral into public discourse following the lifting of imperial restrictions, see Magnus Hirschfeld, *Sittengeschichte des 20. Jahrhunderts,* reprint (Hanau am Main: Karl Schustek, 1966).

43. See Maria Tartar, *Lustmord: Sexual Murder in Weimar Germany* (Princeton, NJ: Princeton University Press, 1995), and Beth Irwin Lewis, "*Lustmord*: Inside the Windows of the Metropolis," in Charles W. Haxthausen and Heidrun Suhr, eds., *Berlin: Culture and Metropolis* (Minneapolis: University of Minnesota Press, 1990), 111–40, for discussions of these representations in the paintings of Dix and Grosz. For a discussion of the discourses that coupled sexual depravity with jazz, see Cornelius Partsch, "Jazz in Weimar," in Thomas W. Kniesche and Stephen Brockmann, eds., *Dancing on the Volcano: Essays on the Culture of the Weimar Republic* (Columbia, SC: Camden House, 1994), 105–16.

44. Carl Sternheim, *Berlin oder Juste Milieu* (Munich: Kurt Wolff, 1920), 60.

45. This scene is, in itself, a skillful piece of narrative and cinematic representation. Having gone back to the bar where he and his friends were playing cards to collect his forgotten cigarette case, he sees a sketch drawn by his friend on the tablecloth. In the sketch Artinelli and Bertha-Maria are caught in passionate embrace and Boss, to the side, has grown the horns of the devil. He knows now that his mistress has betrayed him for Artinelli, the more adept, thus virile, acrobat. Stunned with disbelief at his realization, Boss has a hallucination in which crowds of people appear to rush frantically past his eyes. The camera moves through streets in such fast motion that it becomes impossible to determine individual objects and buildings. Everything blurs into a surface of pure speed. Boss turns back to the table on which the unwanted revelation is laid bare, picks up a plate, smashes it in fury, and runs down the stairs and onto the street. Reminiscent of the sailor's smashing of the plate in Sergei Eisenstein's *Battleship Potemkin* (1925), Boss's action of smashing the plate is both depicted in slow motion and repeated to underline his sheer anger at this deceit.

46. Indeed, it is quite common for the Weimar film to resolve its representations of violence and immorality with a mystical happy ending. We see this strategy at work in, for example, F. W. Murnau's *Faust* (1924), *I.N.R.I*, directed by Robert Wiene (1923), and *Von Morgens bis Mitternachts,* directed by Karl Heinz Martin (1920). Although not a spiritual redemption, the epilogue of Murnau's *Der Letzte Mann* could be understood to function as a mediation of the experience of modernity.

47. Tom Gunning, after Peter Brooks, discusses how the melodramatic narrative's staging of the central conflicts of modernity, conflicts between the eruption of technological stimuli and established moral order, is often used to veil the disturbances and dilapidation of modern life. See Tom Gunning, "The Horror of Opacity: The Melodrama of Sensation in the Plays of André de Lorde," in Jacky Bratton, Jim Cook, and Christine Gledhill, eds., *Melodrama: Stage Picture Screen* (London: British Film Institute, 1994), 50–61. See also his article "The Whole Town's Gawking: Early Cinema and the Visual Experience of Modernity," *Yale Journal of Criticism* 7, no. 2 (1994): 189–201. Here Gunning discusses the disruptive and shocking effects of the attraction as an interaction between the audience and cultural objects that produce an experience of the fragmentation of modernity.

48. *Varieté* has a very complex censorship history both in Germany and internationally. Following the contemporary reviews, in particular their disillusion with the pace of the film, the film was cut substantially. Most significantly, rather than opening with the prison sequence in which Boss is seen explaining his story to the prison director, *Varieté* was reedited to begin with the first scenes in the Wintergarten. Therefore, in these versions, there is no frame narrative that sees Boss's redemption, and neither is he an adulterer. Even today, this is the version in circulation in the United States (file no. 17916, Bundesarchiv-Filmarchiv, Berlin).

49. This was the legacy of the *Kino-Debatte,* a debate about cinema carried out by intellectuals—including filmmakers, writers, and producers—in literary journals and the daily and avant-garde presses. One aspect of the debate raised the concern that the cinema should legitimate itself vis-à-vis literature as it was perceived by some to be a poor imitation of either the novel or the theater. Accordingly, it was the work of the "artist" to fashion the film into a "culturally legitimate" and unique object. See Anton Kaes, ed., *Kino-Debatte: Texte zum Verhältnis von Literatur und Film 1909–1929* (Tübingen: Deutscher Taschenbuch, 1978).

50. See Max Horkheimer and Theodor W. Adorno, "Juliette or Enlightenment and Morality," in *The Dialectic of Enlightenment,* trans. John Cumming (New York: Continuum, 1993), 81–119, especially 106–19.

51. In addition to Kracauer's musings on the failure of film to provide a radical critique of capital in articles such as "Film 1928," in *The Mass Ornament,* 307–20, see Theodor W. Adorno, "The Schema of Mass Culture" and "The Culture Industry Reconsidered," in J. M. Bernstein, ed., *The Culture Industry* (London: Routledge, 1991), 53–92.

52. The first two films in the trilogy are *Hintertreppe* (1921) and *Scherben* (1921). Like *Sylvester,* in both of these films the love attachments that transpire are deeply perverse. In *Hintertreppe* the postman assumes the identity of the maid's lover and ultimately must kill the lover to maintain this stolen identity. *Scherben* also tells the story of retarded family relations. A mother suicides when she freezes to death on a walk into the snow after having seen her daughter sexually engaged with a young man. Following the mother's death, the father murders the lover and the daughter goes mad. One of the biggest nights of the year at the Wintergarten was the Sylvester celebrations. See the photo in Jansen, "Der Wintergarten," 93, of the Sylvesterball, in which the Wintergarten is literally glittering with all of the electrical light decorations.

53. Cited in Jürgen Kasten, "Sylvester. Ein Lichtspiel (1923)," in *Carl Mayer: Filmpoet. Ein Drehbuchautor schreibt Filmgeschichte* (Berlin: Vistas, 1994), 165.

54. For a general summary of the consequences of the rationalization of time in the modern industrial world, see Stephen Kern, "The Nature of Time," in *The Culture of Time and Space 1880–1918* (Cambridge: Harvard University Press, 1983), 10–35. On the political manipulations and implications of time in modernity, see Peter Osborne, *The Politics of Time: Modernity and Avant-Garde* (London and New York: Verso, 1995).

55. Kurt Pinthus, "Sylvester," *Das Tage-Buch* 3, no. 5 (19 January 1924): 88.

56. Carl Mayer, "Vorwort," in *Sylvester: Ein Lichtspiel* (Potsdam: Kiepenheuer, 1924).

57. Lupu Pick, "Vorwort des Regisseurs," in *Sylvester: Ein Lichtspiel,* 9.

58. Anonymous, "Sylvester," *Der Kinematograph,* no. 882 (13 January 1924): 13.

59. See, for example, Thomas Elsaesser, "Film History and Visual Pleasure: Weimar Cinema," in Patricia Mellencamp and Philip Rosen, eds., *Cinema Histories/ Cinema Practice* (Los Angeles: University Publications of America, 1984), especially

56–59. See also Thomas Elsaesser, "Secret Affinities," *Sight and Sound* 58, no. 1 (winter 1988–89): 33–39.

60. Dr. Ernst Ulitzsch, "Die nächtliche Straße," *Der Kinematograph*, no. 894 (6 April 1924): 7.

61. Grüne's *Die Straße* is the exception to Ulitzsch's argument. In Grüne's film, the dazzling lights of the city street by night are utilized for the same reasons that light in its contrast with darkness is used in other arts: the chiaroscuro comes to symbolize the uncanny. In these unstable worlds, secrets and criminals become a reality, creatures somewhere between life and death live on the streets at night. Predictably, Ulitzsch gives no justification for his singling out of *Die Straße*.

62. Lupu Pick, "Der Regisseur," in Rolf Aurich und Wolfgang Jacobsen, eds., *Werkstatt Film. Selbstverständnis und Visionen von Filmleuten der zwanziger Jahre* (Munich: edition text + kritik, 1998), 169–70.

63. The effects created through the absence of intertitles in *Sylvester* should not be taken as disadvantageous to an understanding of the film. On the contrary, the resulting confusion adds mystery and drama to the sequence. *Scherben* has one intertitle. The father announces to the driver of a train that calls at his station: "I am a murderer."

64. This scenario between a man's wife and his mother fighting for sole possession of the man is a long way from the Oedipal scenario of a man fighting over a woman to replace the father that is, according to Kracauer, the staple recipe of the Weimar melodrama film.

65. The revolving door reappears one year later in the sequences at the Atlantic Hotel in Murnau's *Der Letzte Mann,* which was also written by Mayer.

66. Again, this correlation between industrialized entertainment and modern consciousness has become familiar to us through the work of the critical theorists of the Frankfurt School and those, such as Benjamin and Kracauer, on its periphery. See also Georg Simmel, "Die Großstädte und das Geistesleben," *Jahrbuch der Gehe-Stiftung zu Dresden*, no. 9 (1903): 188, 193, 195, and *The Philosophy of Money*, trans. Tom Bottomore and David Frisby (Boston: Routledge, 1978). The connection was established, albeit in far less sophisticated ways, by many Weimar journalists and writers.

67. This is one of the German cinema's first examples of an establishing shot through the use of a moving camera. See Jürgen Kasten, "Sylvester. Ein Lichtspiel (1923)," 165. The tracks and pans that join the spaces of the town are made possible by the development of a mobile trolley onto which the camera, complete with tripod, is mounted (ibid., 57). However, these complex camera movements were never repeated in the German cinema because the trolley that enabled them was dismantled after the film. Nevertheless, other apparatuses were built, including trolleys for creating light in motion. See Bernhard Deltschaft, "Lichtwagen," *Filmtechnik*, no. 9 (1928): 164–67.

68. See Mayer, *Sylvester: Ein Lichtspiel*, 15–16; and Herbert Jhering, "Sylves-

ter," *Berliner Börsen-Courier*, 4 January 1924; reprinted as "Sylvester" in Herbert Jhering, *Von Reinhardt bis Brecht*, vol. 2, (Berlin: Aufbau-Verlag, 1959), 471–73.

69. Mayer also wrote *Berlin, die Symphonie einer Großstadt* (1927). This use of rhythm as the basis of the creation of oppositions through editing is reiterated in the more recent criticism. See, for example, Kasten, "Sylvester. Ein Lichtspiel (1923)," especially 166–67.

70. Jhering, *Von Reinhardt bis Brecht*, 471. It was not only the most eminent film critics of the time that applauded *Sylvester* for its musically rythmical structure of crescendos and diminuendos achieved through both camera movement and the movement across scenes and spaces. See, for example, Anonymous, "Silvester," *Film-Kurier* 4, no. 4 (4 January 1924): 1.

71. The other clearly defined space of the film is that of nature, in particular, a stormy sea. The sea and its undulations signify the mood of the events of the family melodrama. Once again, these spaces are constructed as such through the use of light. Early in the film, the diegesis is interrupted by an image of wild breaking waves of the sea crashing against rocks. Then, as the Sylvester party on the streets and in the other bourgeois spaces becomes more and more frenetic, and the goings-on in the domestic dining room become increasingly fraught, the film cuts to the wild sea once again. This second image of the sea follows that in which the man chooses his mother by holding on to her as if she were his lover and prompting the wife to pack her belongings and leave her husband. Thus, the sea here gives definition to the frenzy and violence of the storm that blows through the family. On this occasion, the fragments of the natural landscape also include a hill on which a cemetery lies, an otherwise gentle slope that leads down to the crashing waves of the sea. In the final scenes of the film, once the husband has taken his life and the streets have died down and the excitement of New Year's Eve celebrations subsided, we see the lights of a horse-drawn hearse carrying the body of the film's protagonist coming down the road approaching the cemetery. As in the previous instance that the film visits this space, the cemetery is only recognizable as such by the light that beams down the hill and catches the form of crosses on its path. These intense spotlights that effectively fracture a landscape of death and devastation emanate from both diegetic and nondiegetic sources. They represent a combination of the lighting of the film and that of a source within the narrative world. Whatever their source, the severity of the lighting accompanies the fury of the sea to articulate the volatility of the narrative events (Figure 18).

72. See Horkheimer and Adorno, "Juliette or Enlightenment and Morality."

73. On questions of sexual cynicism and the relevance of Adorno and Horkheimer's argument to the culture of liberal sexuality and moral disintegration in Weimar Germany, see Stephen Brockmann, "Weimar Sexual Cynicism," in Kniesche and Brockmann, *Dancing on the Volcano*, 166–80.

74. In addition to the sources cited in chapter 5, see, for example, Katharina Scheven, "Die sozialen und wirtschaftlichen Grundlagen der Prostitution," in

Anna Pappritz, ed., *Einführung in das Studium der Prostitutionsfrage* (Leipzig: Barth, 1919), 139–75, on prostitution, thus the resulting corruption of morality, as the problem of men and their treatment of women as sex objects.

75. See, for example, the section devoted to such images in the catalog of the 2001 exhibition at Berlin's Neue Nationalgalerie, *Der Potsdamer Platz: Ernst Ludwig Kirchner und der Untergang Preußens* (Berlin: G & H Verlag, 2001).

76. Alfons Steiniger, "Moral in der Schule," *Das Blaue Heft*, no. 3 (1 December 1922): 134–35.

77. Magnus Hirschfeld, "Die 'Erste Sexualberatungsstelle,'" *Die Weltbrille*, no. 4/5 (August/September 1928): 16.

78. Anonymous, "Sexualberatung beim Reichsgericht," *Die Weltbühne*, no. 16 (1930): 597–98.

79. Atina Grossmann, *Reforming Sex: German Campaigns for Birth Control and Abortion Rights 1920 to 1950* (New York: Oxford University Press, 1995).

80. See Tartar, *Lustmord: Sexual Murder in Weimar Germany*, and Lewis, "*Lustmord*: Inside the Windows of the Metropolis."

81. Of course, the disintegration of traditional family structures was not necessarily mourned by all the "new" German men and women of the Republic. My point here is simply that this decline that has its corollary with increasingly rationalized society brings with it a decline in public morality that becomes a contested issue at the time. For an excellent overview of the factors that contribute to the "rationalization of sex and reproduction as integral to the organization of a modern progressive republic," see Grossmann, *Reforming Sex*, 3–13.

82. See Sigmund Freud, "Civilization and Its Discontents," in *Civilization, Society and Religion*, vol. 12, trans. James Strachey (London: Penguin, 1961), especially Parts III and IV, 274–97.

83. Following the energetic cutting of the stormy sea with the hearse weaving its way through darkness to the cemetery, balance is restored to the narrative world and the new day dawns in an unconvincing epilogue. After momentarily cutting back to an image of the now fatherless baby playing in its carriage, the film ends with a picturesque view of a calm, peaceful sea. The camera tilts up and, in a gesture of hope and redemption we have come to expect from the 1920s German film, the sunlight beaming through the clouds overwhelms the final image. Thus, the next generation will be shone upon by the glory of nature. Once again we see an epilogue of convenience rather than one of internal coherence to an otherwise very dark film.

## Conclusion

1. The aversion to formal experiment of any kind was made clear relatively early when Hitler made the distinction between the art to be sanctioned under National Socialism and the degenerate, so-called un-German art of modernism. This was done through the "Entartete Kunst" exhibition at the Munich Haus der

Kunst in 1937. See *"Degenerate Art": The Fate of the Avant-Garde in Nazi Germany,* (Los Angeles: Los Angeles County Museum of Art, and New York: Harry N. Abrams, 1991).

2. The Third Reich's troubled relationship to modernism and modernization is now attended to by most scholars of the period and its cultural production. For recent examples of film studies, see Thomas Elsaesser, "Moderne und Modernisierung: Der deutsche Film der dreißiger Jahre," *Montage/av 3,* no. 2 (1994). See also Robert Reimer, ed., *Cultural History through a National Socialist Lens: Essays on the Cinema of the Third Reich* (Rochester, NY: Camden House, 2000). Sabine Hake examines this ambivalence as it is found in the architecture and organization of real and imaginary spaces of film ("Cinema, Set Design and the Domestication of Modernism," in *Popular Cinema of the Third Reich* [Austin: University of Texas Press, 2001], 46–67). This scholarship typically moves beyond the totalizing discourses that understand Third Reich art and culture as being overwhelmed by the regime's propagandistic impulse or ideological agenda.

3. Goebbels insisted on having Veit Harlan's film *Kolberg* (1945) made in technicolor because of the supposed ideological persuasion of color over black and white. See Richard Taylor, *"Kolberg,"* in *Film Propaganda: Soviet Russia and Nazi Germany* (New York: Harper and Row, 1979), 216–29. (I discuss the Nazis' belief in the persuasive abilities of color later in this section). The Nazis also keenly exploited the possibilities of sound, both in the cinema and on the transistor radio, for the persuasion of the masses.

4. Eric Rentschler, *The Ministry of Illusion: Nazi Cinema and Its Afterlife* (Cambridge: Harvard University Press, 1996), 19. As Rentschler also argues, despite the apparent one-dimensionality of these propaganda films, they were highly complex products that could not be easily dismissed as "hate pamphlets, party hagiography, or mindless escapism."

5. Ibid., 60–62, 205.

6. We cannot forget the breathtaking sequences of the divers at the 1936 Berlin Olympic Games as they were shot by Leni Riefenstahl in *Olympiade/Olympia* (1936). As the divers fly like birds into the air, as they break the surface of the water and glide to the bottom of the pool, the camera catches their every move. Even underwater, camera focus and aperture are changed according to the movement of the divers, as if the capacity of the camera to shoot underwater were not enough to awe the audience. These sequences see the film move away from a documentation of the sporting event. Through the technical virtuosity that captures the health, vitality, and proximity to nature of the German athlete (and, by extension, the German people) Riefenstahl digresses from the linear trajectory of her plot. In these spectacular displays of the divers, for example, we see the same celebration of technology interrupt the hermetic fictional world. See also Rentschler's discussion of the modernist similarities between *Das blaue Licht/The Blue Light* (1932) and Murnau's *Nosferatu.*

7. Klaus Kreimeier, "Dokumentarfilm," in Wolfgang Jacobsen, Anton Kaes,

and Hans Helmut Prinzler, eds., *Geschichte des deutschen Films* (Stuttgart and Weimar: Metzler, 1993), 402.

8. While working to promote a historically and politically different German Reich, Ruttmann's films nevertheless indicate the similar objectives for the use of the wonder of steel of almost two decades later. No doubt Ruttmann's and Riefenstahl's appropriation of the modernist conflict between style and narrative coherence can be accounted for by their respective backgrounds—Ruttmann's as a filmmaker whose interest in technical developments grew out of his work as an experimental filmmaker of the 1920s and Riefenstahl's from the influences of her mentor, Arnold Fanck.

9. Rentschler, *The Ministry of Illusion*, 216.

10. In addition to Taylor, *Film Propaganda*, see Michael H. Kater, "Film as an Object of Reflection in the Goebbels Diaries: Series II (1941–1945)," *Central European History*, vol. 33, no. 3 (2000); and Peter Paret, "'Kolberg' (1945) as Historical Film and Historical Document," *Historical Journal of Film, Radio and Television* 14, no. 4 (1994): 433–48.

11. Hermann Wanderscheck, "Die Macht der Musik im Film," *Film-Kurier,* 19 January, 1942, 1.

12. See Lutz Köpnick, *The Dark Mirror: German Cinema between Hitler and Hollywood* (Berkeley and Los Angeles: University of California Press, 2002).

13. There is a similar waning of color films around the end of the 1910s in Germany. Daan Hertogs speculates that the decline in tinting comes in an effort to "[make] sure people are listening, rather than distracting them with color. I wonder if there's a sense around this time [introduction of panchromatic film stock] of concentrating on one dominant channel of meaning or sensation at a time." See Daan Hertogs and Nico de Klerk, eds., *'Disorderly Order' Colours in Silent Film* (Amsterdam: The 1995 Amsterdam Workshop, Stichting Nederlands Filmmuseum, 1996), 47.

14. Riefenstahl uses light in *Das blaue Licht* for the exploration of a type of earthly transcendence. There is ample evidence in the film to argue that the mysterious light motivating the protagonists' climb up the mountain lifts them to a higher order of understanding.

15. In line with a number of other critics who make this now commonly accepted claim, Janet Ward argues that the Nazis may have appropriated the use of light as the signifier par excellence of consumer capitalism and taken it to extremes. However, they also abused it by emptying it of its material content. Thus, for the Nazis, the displays of electrical light are no more than empty, monumental ruses of ideological persuasion. See Janet Ward, *Weimar Surfaces: Urban Visual Culture in 1920s Germany* (Berkeley and Los Angeles: University of California Press, 2001), 132–33.

16. Peter Reichel, "Aesthetisierung des Außergewöhnlichen: Die SS," in *Der schöne Schein des Dritten Reichs: Faszination und Gewalt des Faschismus* (Vienna: Hanser, 1991), 222–34.

17. These ideological ceremonies and the centrality of the spectacle of light will be remembered from the relevant sequences in Leni Riefenstahl's *Triumph of the Will,* the film of the 1934 Nazi Party rally in Nuremburg.

18. Adolf Hitler, *Mein Kampf* (Boston: Houghton Mifflin, 1962), 475.

19. Wolfgang Schivelbusch, *Licht, Schein und Wahn: Auftritte der elektrischen Belenchtung im 20. Jahrhundert* (Berlin: Wilhelm Ernst und Sohn, 1992), 81.

20. Goebbels, expressing the desired effect of the mass public rallies, quoted by Robert R. Taylor, *The Word in Stone: The Role of Architecture in the National Socialist Ideology* (Berkeley: University of California Press, 1974), 178.

21. Quoted by Anna Teut, ed., *Architektur im Dritten Reich 1933–45* (Berlin: Ullstein, 1967), 187–88.

22. See Peter Reichel, "Politische Magie und Militärische Macht," in *Der schöne Schein des Dritten Reichs,* 209–22.

23. On the Cathedrals of Light, see Frances Livings, *Lichtdöme von Albert Speer* (Maberg: Magisterarbeit, 1997).

24. Quoted by Taylor, *The Word in Stone,* 70–71.

25. Speer was adamant that his glamorous designs were not conceived to espouse the ideology of the party, nor were they simply ornamental. Rather, they were intended solely to enhance the "community experience" had within their limits. See Albert Speer, *Inside the Third Reich: Memoirs,* trans. Richard and Clara Winston (New York: Macmillan, 1970), 59.

26. There is also a whole strand of avant-garde modernism that can be argued to preface the monumentality and utopianism championed by Nazi artistic and cultural production that I do not discuss here. See Andrew Hewitt, *Fascist Modernism: Aesthetics, Politics, the Avant-Garde* (Stanford, CA: Stanford University Press, 1993).

27. There are numerous examples of such paintings. See, for example, Raphael's *Transfiguration* in the Vatican Museum, or Correggio's *Notte,* a nighttime nativity scene in Dresden, both of which include strong supernatural light emanating from the figure of Christ.

28. See Schivelbusch, *Licht, Schein und Wahn,* 88–89.

# Index

**Frances Guerin** is a lecturer in film studies at the University of Kent, Canterbury. She has published on German and European cinema and film theory in a number of journals, including *Cinema Journal* and *Film and History*.